Off the Wall
American Art to Wear

the wall

American Art to Wear

EDITED BY
Dilys E. Blum

WITH ESSAYS BY
Dilys E. Blum and Mary Schoeser

AND A CONTRIBUTION BY
Julie Schafler Dale

Philadelphia Museum of Art
IN ASSOCIATION WITH
Yale University Press
NEW HAVEN AND LONDON

Contents

vibrations

articulations

reverberations

foreword

Some years ago, in a conversation I was having with Dilys Blum, our senior curator of costume and textiles, about the development of the museum's collection in her field, she mentioned Julie Schafler Dale's remarkable collection of artist-made clothing of many different types, in a relatively unknown genre that had come to be called art to wear, and asked if it might be of interest. Her enthusiasm for this work was obvious, and it was not long before I, too, became a convert to the cause.

This publication and the exhibition it accompanies, though not envisioned at that time, are the result of that initial conversation. And we could not be happier with the outcome, which includes—perhaps most significantly—the gift of forty-eight works from Dale's collection to the Philadelphia Museum of Art. We are deeply grateful for this gift, for it comprises some of the finest examples of art to wear by the pioneers of this movement and reflects the pivotal role that Dale played as a gallerist and persuasive advocate for these artists, who set out to find a new and uniquely individual form of expression and, in the process, tested the boundaries of contemporary art.

Collections like those of the Philadelphia Museum of Art are almost invariably formed by gifts from individuals who deeply believe in the significance of what they collect and have a passion for sharing it with others. Julie Schafler Dale is one such collector. She opened Julie: Artisans' Gallery on Madison Avenue in New York in September 1973, giving one of the first platforms to the art-to-wear movement. This was only a few years after the artists she has championed began to reinvent traditional techniques and embrace new technologies to create unique works that could be not only exhibited but also worn on the body, and thus pushed contemporary art in a novel and somewhat unexpected direction.

Off the Wall: American Art to Wear provides a compelling account of this movement, from its origins in the 1960s to the beginning of the new century. Like much of the most innovative art being made at that time, art to wear did not respect bound-aries, but rather drew inspiration from many different quarters, from fiber art to contemporary illustration. It was meant to be performa-

tive, experienced not solely on the walls of a gallery, but in many different settings and, most importantly, in motion. Moreover, as the essays in this catalogue make clear, art to wear was very much of its time, committed to a buoyant and defiant sense of self-expression and to a spirit of social and political engagement that feels as timely today as it did a generation ago.

Julie Schafler Dale's connection with our museum dates back to 1977, when she organized a fashion show here on the occasion of the first Philadelphia Museum of Art Craft Show, which also included a selection of art to wear chosen by her. Therefore, it is fitting that a number of the most important works in this genre that she has assembled over time find a place in our collection.

We are grateful to Ms. Dale for her generous support of this publication and the exhibition of art to wear, which includes her gifts along with works from our collection, as well as from other museums, private collectors, and artists, many of which have never before been exhibited. Thanks are due as well to PNC, The Coby Foundation, the Arlin and Neysa Adams Endowment Fund, Catherine and Laurence Altman, the Center for American Art at the Philadelphia Museum of Art, and other generous donors for their assistance with this project. I would also like to take this opportunity to acknowledge the many lenders to the exhibition who responded so graciously to our requests to borrow works from their collections.

It is a great pleasure to express my appreciation for the contributions to the exhibition and catalogue made by so many members of our staff. As always, they have done a remarkable job. Above all, special thanks go to Dilys E. Blum, the Jack M. and Annette Y. Friedland Senior Curator of Costume and Textiles, and her colleague, textile historian Mary Schoeser, for organizing the exhibition and coauthoring this catalogue, which chronicles the art-to-wear movement and examines it in the context of contemporary culture.

Timothy Rub
THE GEORGE D. WIDENER DIRECTOR AND CHIEF EXECUTIVE OFFICER

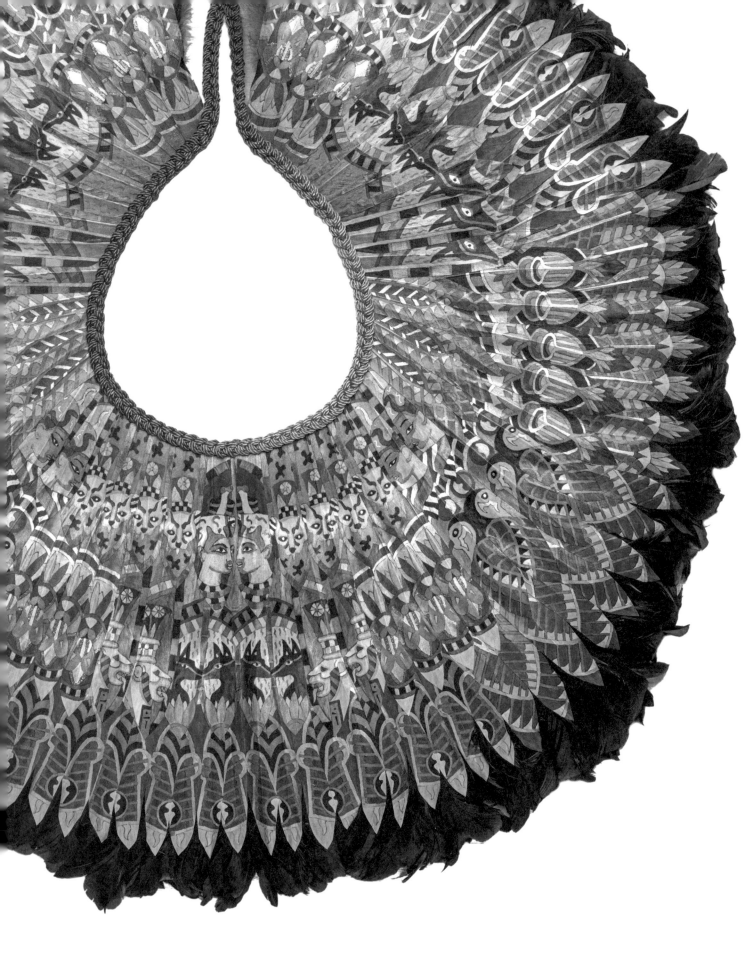

introduction

Dilys E. Blum and Mary Schoeser

Today, an internet search on the term "art to wear" produces millions of results. This indicates the wide acceptance of the concept of artistic garments, but also how amorphous the term is, given that it encompasses both hand- and machine-made items from amateur and professional practitioners, as well as jewelry and collectables of various origins and intent. This catch-all phrase has also long been a subject of debate among the first generation of artists to turn to body-related forms to express their personal visions. Jean Cacicedo articulated the conundrum this way: "We don't say throwable art for pottery, or blowable art for glass, so why wearable art for fiber-based garment shapes?"[1]

The title of this book and exhibition is a compromise that reflects these concerns. "Off the wall" underscores our belief that the period between 1967 and 1997, the focus of our essays, witnessed a distinct American phenomenon that was grounded in radical rethinking of art education and practice, as well as presentational risk taking by a few forward-thinking galleries and museums. "Art to wear" is our chosen descriptor for what others, including artists, have called "wearables," "artwear," "wearable art," and permutations thereof. We chose "art to wear" to emphasize the word *art* by placing it first. The chapters that follow focus on singular examples of artistic production, grouped by intent and set within the larger context of contemporary American art and culture.

At the beginning of this period, American institutions were under threat, challenged by a younger generation whose viewpoints were buffeted by seemingly unresolvable oppositional forces: love and war, peace and violence. It was a time of great turmoil

ductionintroductionintroductionintroductionintroductionintroductionintroductionintroductionintroductionintroductionintroductionintroductionintroductionintrod

2

and cultural crisis, framed by the Beatles' anthem "All You Need Is Love" and San Francisco's Summer of Love in 1967, and the end of the Vietnam War in 1975. In 1968 two peacemakers—Martin Luther King Jr. and Robert Kennedy—were assassinated, and antiwar protestors were beaten by police at the Democratic National Convention in Chicago. In 1968–69 college campuses erupted across the United States, the Stonewall Riots in New York's Greenwich Village launched the Gay Liberation Movement, and Native Americans occupied Alcatraz Island in San Francisco Bay. That August, more than 500,000 attendees spread love at the Woodstock music festival in Bethel, New York, while four months later chaos and violence marred the free rock concert at Altamont Speedway in Northern California. The following year, the United States invaded Cambodia, widening the war in Southeast Asia, and National Guardsmen massacred protesting students at Kent State University in Ohio; the Beatles released "Let It Be" and then disbanded. The nation felt uprooted. Was it a new beginning or the end? There was no immediate answer in sight. This was the churned-up field on which the art-to-wear movement landed.

During the same period, craft-intensive art education in the United States was undergoing pruning, grafting, and modification. Black Mountain College in North Carolina, which carried forward Bauhaus thinking from 1933, had closed in 1957, while Cranbrook Academy of Art—granting degrees from 1942—increasingly focused its Scandinavian weaving traditions on design for industrial production. An older generation of outliers such as Lenore Tawney, Claire Zeisler, and Sheila Hicks pushed the limits of textile-based forms, significantly impacting the field soon to be recognized as fiber art. But within institutions, it tended to be the younger generation, both students and faculty, who became the driving force behind restructuring curricula. Some colleges witnessed the mutation of home economics into a much broader approach known as environmental design, which encompassed architecture, landscape design, and environmental issues, as well as textile and clothing design. Others embraced a multimedia approach to art making that included textiles. Pratt Institute was an example of the latter. Located in the gentrifying Brooklyn neighborhood of Clinton Hill, its dynamic environment was instrumental in the emergence of the art-to-wear movement. While visiting Pratt students in 1970, the English fashion designer Zandra Rhodes found an atmo-

1

sphere that "was positively electric and in the end it was a visit which had a significant influence on my work."[2] (Inspiration worked both ways: Janet Lipkin recalls visiting New York's Henri Bendel, where in 1969 Rhodes had a boutique "filled with her creative silk-screened garments, as well as matching fabric on the couch and pillows and wallpaper. Very inspirational to me.")[3] Lipkin, Jean Cacicedo, and Marika Contompasis were roommates at Pratt (fig. 1), and with their friends opted to take up crochet as a means of expression in their differing class assignments. Contompasis, in the industrial design department, crocheted a vacuum cleaner. Cacicedo recalled, "She would bring it in and they'd say, 'Oh, you know, it is an art school, so you can crochet a vacuum cleaner!'"[4]

Similarly inventive approaches were emerging elsewhere, not least at the University of California, Berkeley, where Ed Rossbach had been breaking barriers since receiving his MFA in ceramics and weaving at Cranbook in 1947 and joining the Berkeley faculty in 1950. Affectionately called "the dean of American contemporary textiles,"[5] Rossbach kept a keen eye on exhibitions in his field and observed that California and New York were centers of disproportional influence in the creation of textiles arts. Commenting on a 1983 exhibition developed by Fiberworks for the San Francisco airport, showing the work of fiber artists who had won National Endowment for the Arts grants in the past two years, he noted that "half of them came from California and New York and the other half from all the other 48 states." As a result, Rossbach concluded that "the fiber movement was an urban movement contrary to what people might expect and that it is connected with art centers."[6]

Later observers would suggest that it was more dispersed, but there is little doubt that a handful of urbanites contributed to the early formation of the art-to-wear movement's identity. In New York, Paul J. Smith, director of the Museum of Contemporary Crafts (renamed the American Craft Museum in 1979) from 1963 to 1987, together with the American Craft Council (the museum's parent organization), sowed the seeds for a national exploration of materials, techniques, and concepts.

A key respondent to Smith's vision was Julie Schafler Dale (fig. 2). As Dale recounts in her contribution to this volume, after viewing hundreds of works in the slide library at the American Craft Council in 1972, she set out on a journey, visiting artists' studios

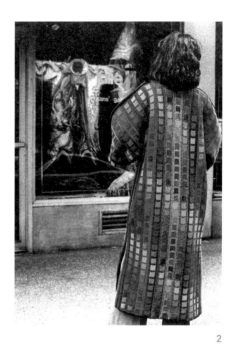

2

1 Clockwise from top left: Sharron Hedges, Marika Contompasis, Janet Lipkin, and Jean Cacicedo in the kitchen of the apartment Lipkin, Cacicedo, and Contompasis shared in Brooklyn in 1969. Photo courtesy Sharron Hedges

2 Julie Shafler Dale in front of her gallery in New York, c. 1980. Photo: Bill Cunningham. Julie Schafler Dale Archive

from New York to California. That same year, she founded Julie: Artisans' Gallery, operating first from her New York apartment, and, from September 1973, at a space on Madison Avenue. Dale was owner, patron, collector, and cultivator, and her gallery became the preeminent venue presenting one-of-a-kind wearable works by American artists. Her rotating window displays captured the imaginations of passersby as well as an impressive list of clients, many of whom became long-term patrons and collectors.[7] Over the years she contributed to the growing number of specialist magazines and exhibition catalogs, and her book *Art to Wear* (1986) became the movement's seminal publication, providing in-depth profiles of the leading artists of the day accompanied by stunning images by the Brazilian fashion photographer Otto Stupakoff. Although her gallery closed in 2013, the promised gift of some forty-eight pieces from her private collection to the Philadelphia Museum of Art celebrates the diversity of the art-to-wear movement and ensures that many significant works remain available to the public.[8]

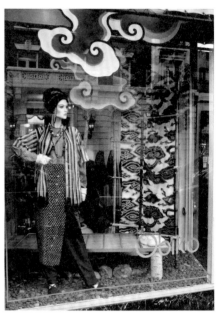

3

The most influential gallery on the West Coast was Obiko, founded in San Francisco by Sandra Sakata, initially collaborating with Kaisik Wong, Alex Maté, and Lee Brooks. Like Dale, Sakata was already representing artists prior to opening Obiko in 1972 (fig. 3). Closing with Sakata's death in 1997, Obiko was renowned for its flair for presentation and styling. Its themed fashion shows, often charity fundraisers, became anticipated events in the Bay Area. Sakata's boutique in New York's Bergdorf Goodman in the early 1980s was also instrumental in disseminating the concept of limited-edition art to wear.

Important galleries were not limited to the coasts. New Mexico's Santa Fe Weaving Gallery, a mid-1970s collective turned 1980s boutique—owned by Jill Heppenheimer and Barbara Lanning from 1992 to 2014 and thereafter by Elise Nye and Richard Holliday—has become known for representing premier small-studio artists and designers from around the world. Jacqueline Lippitz's Gallery of Art to Wear in Glencoe, Illinois, was a combination art gallery and boutique that by the late 1990s represented nearly two hundred artists.

The 1970s saw a burgeoning interest in the Japanese kimono form as a template for American artists. This paralleled a vogue for furniture and other objects imported by retailers such as Asiatica. Founded by Elizabeth Wilson and Fifi White in Kansas

3 Obiko window display,
San Francisco, 1990s.
Obiko Archive, Textile
Arts Council, Fine
Arts Museums of San
Francisco

City, Kansas, in 1977, Asiatica is known for its imaginative use of old and new Asian fabrics in one-of-a-kind clothing, as well as its collection of antique and vintage kimonos. In its structural simplicity, the kimono, revered in Japan as an art form, provided American artists with a pattern for work that could either be worn or hung on the wall like a canvas and thus represented a break with the principles of fashionable Western dress. Jane Kosminsky, one artist who sought such separation, stated in 1988: "I feel that one of the criteria for wearable art is that it can stand on its artistic value alone—as an art piece. This is what distinguishes it from 'fashion' or 'hand-made' clothing."[9] Other artists, in contrast, concur with Marian Clayden, who went from making dyed wall hangings and sculpture to creating art to wear and believed that, "if my wearables are not worn but hung as decoration, then they speak to the world only half of the conversation intended."[10]

 Such individual interpretations typify the world of art to wear, which, until the 1990s, reflected unique artistic principles rather than fashion trends. Thereafter, these two approaches merged and cross-pollinated, with multiple definitions of art to wear supported by the resulting mélange of craft fairs, trunk shows, high-style boutiques, art galleries, museum exhibitions, and—critically—dot-com enterprises. The launch of the BlackBerry and other "smartphones" in the late 1990s ushered in the easily accessible virtual world, changing the way artists present their work to the public. As Linda J. Mendelson noted in 2018 of her own life as an artist: "From 1975 to 2013 I had the privilege of being represented by Julie: Artisans' Gallery on Madison Avenue.... The work was there to be seen, touched and worn. The future has arrived. There is no longer a physical gallery. So, I am now presenting my work in cyberspace."[11] The internet has replaced many of the person-to-person connections that had nurtured and sustained artists for thirty years. Nevertheless, despite the rapidly shifting cultural landscape, these first-generation artists—and their successors—have continued to grow, following their individual interests in a variety of media.

The development of wearable art during the late 1960s and early 1970s collided with established textile and fine art practice. As the boundaries broke down, artists felt liberated to explore new approaches in all media, experimenting with a wide range of materials, techniques, and forms. Although fiber art can be linked to American tapestry weavers' efforts in the 1950s and 1960s to free their work from the limitations imposed by a fixed loom, it was not uniformly accepted in the United States. Nor was it welcomed by European tapestry weavers, who were in a period of transition, with the Gobelin and Aubusson pictorial tradition competing with the innovative, expressive works of artist-weavers such as Poland's Magdalena Abakanowicz. Her free-hanging *Red Abakan* broke new ground in 1969 when it was shown at the *Fourth International Tapestry Biennial* in Lausanne, Switzerland. A handful of young artists living in New York encountered innovative contemporary tapestries and textiles, which, along with broad shifts in the cultural landscape, induced them to follow a self-determined path. The result was an independent phenomenon that came to be known as art to wear.

broken threads

In 1957 the Museum of Contemporary Crafts in New York presented *Wall Hangings and Rugs*, featuring fifteen artist-craftspeople from the United States and Europe.[1] The seventy-nine works on display ranged from traditional tapestries to experimental weavings and modern appliqué. One of the most poetic and powerful works was Lenore Tawney's *Bound Man* (fig. 4), which featured an isolated male figure who, according to the artist, symbolized Christ on the cross and, by extension, all human suffering. Tawney "released" the image from the plane of the woven structure by suspending it between loosely bound wefts, allowing it to appear almost three-dimensional.

By 1963 wall hangings had evolved into two- and three-dimensional forms. The exhibition *Woven Forms* at the Museum of Contemporary Crafts featured five artists making sculptures in fiber: Alice Adams, Sheila Hicks, Lenore Tawney, Dorian Zachai, and Claire Zeisler.[2] As museum director Paul J. Smith noted, these works combined personal expression with the influences of historical tapestry-weaving techniques and ancient Peruvian textile traditions, which were being rediscovered and adapted to modern weaving.

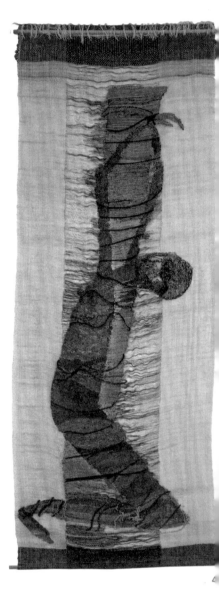

Some works incorporated more contemporary approaches to art making such as assemblage, which had been the subject of a 1961 exhibition at the Museum of Modern Art.[3] Zachai's *Woman Emancipated* (figs. 5, 6), for example, was noteworthy not only for its provocative title and enigmatic form but also for its use of nontraditional materials such as aluminum foil, wire, and bamboo.

Tawney's 1957 weaving and Zachai's work from 1960 both foreshadow the use of the human figure as a three-dimensional sculptural form in fiber art—seen, for example, in Barbara Shawcroft's colorful larger-than-life figures from 1967—as well as the use of the physical body as armature and participant in wearable art.[4]

Perhaps no exhibition did more to establish fiber art as a recognized form than *Wall Hangings* at the Museum of Modern Art in 1969. Organized by curator Mildred Constantine and textile designer Jack Lenor Larsen, who subsequently coauthored two books on what they defined as "art fabric,"[5] *Wall Hangings* viewed

4 Lenore Tawney (American, 1907–2007). **Bound Man**, 1957. Wool, silk, linen, and goat hair; discontinuous weft brocade, woven; 91 × 36 in. (91.4 × 231.1 cm). Museum of Arts and Design, New York. Purchased by the American Craft Council, 1958.2

5 Dorian (Dohrn) Zachai (American, 1932–2015). **Woman Emancipated**, 1960. Aluminum foil, synthetic cord, thread, wool, gold tinsel-like material, synthetic wool, and metal dowels; woven; 120 × 48 in. (304.8 × 121.9 cm). Museum of Arts and Design, New York. Gift of the Estate of Dorian Zachai, 2017.11.2

6 Installation view of Dorian Zachai's **Woman Emancipated** and other works in *Woven Forms*, Museum of Contemporary Crafts, New York, 1963. Photo courtesy American Craft Council Library & Archives

5

fiber art within the context of twentieth-century art and not as craft or design for industry. Twenty-eight artists from eight countries were represented, and the thirty-nine works on display were mounted flat, hung from the ceiling, or shown freestanding. The latter included Sheila Hicks's *Evolving Tapestry: He/She* (1967–68), a stacked construction of three thousand modular thread "pony tails," which was positioned on a turntable near the entrance so visitors could see the work from all sides. The pioneering fiber artist Ed Rossbach presented two hangings made with the nontraditional materials for which he was known, including one of twine interwoven with transparent polyethylene stuffed with crushed newspaper.

Rossbach, who has been described as "the spiritual and technical leader of the new movement in America in the textile arts in the '60s,"[6] taught in the design depart-

ment at the University of California, Berkeley, from 1950 to 1979, where he mentored many young artists. Fiber artist and educator Walter Nottingham praised Rossbach for his "phenomenal insight into where

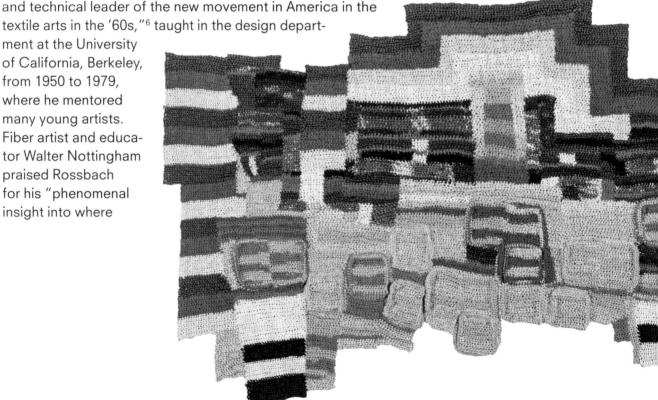

contemporary weaving was going." Rossbach and other textile artists looked especially to pre-Columbian textile designs and techniques for inspiration (figs. 7–9). According to Nottingham, Rossbach "understood the traditions of the textile arts" and was able, through his words, his work, and his teaching, "to take something from the past, a magnificent object or technique, and through manipulation of contemporary ideas and imagery bring it to the present."[7]

Thanks to Rossbach, Lillian Elliott, and others, the atmosphere in Berkeley's design department at the time was electric, as students were encouraged to take direction of their own work. Among these students was Debra Rapoport, who earned a master of fine arts in environmental design there in 1969. Rossbach encouraged Rapoport to experiment with structures and nontraditional materials, introducing her

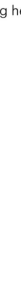

8

9

7 Anni Albers (American, b. Germany, 1899–1994). **South of the Border Pictorial Weaving**, 1958. Cotton and wool, 4⅛ × 15¼ in. (10.5 × 38.7 cm). Baltimore Museum of Art. Decorative Arts Fund and Contemporary Crafts Fund, BMA 1959.91

8 Ed Rossbach (American, 1914–2002). **Disintegration of the Bauhaus**, 1967. Jute; looping; 42 × 70 in. (106.7 × 177.8 cm). Philadelphia Museum of Art. Purchased with funds contributed by The Women's Committee and the Craft Show Committee of the Philadelphia Museum of Art, 1998-10-1

9 James Bassler (American, b. 1933). **I Weave Softwear**, 2000. Wool; tapestry weave. The Julie Schafler Dale Collection

collisionscollisionscollisionscollisionscollisionscollisionscollisionscollisionscollisionscollisionscollisionscollisionscollisionscol

and other students to indigenous basketry and off-loom textile techniques, often using the Phoebe A. Hearst Museum collection of Central and South American baskets and textiles. Like many other artists and students, Rapoport was familiar with Raoul d'Harcourt's seminal *Textiles anciennes du Perou et leurs techniques* (Textiles of ancient Peru and their techniques). Originally published in French in 1924, it was first translated into English for the *Ciba Review* in 1960 and then issued in an expanded edition by the University of Washington Press in 1962.[8] In addition, ancient and modern Central and South American textiles were eagerly collected by many artists during their travels, especially to Mexico and Guatemala, and became a hands-on resource, inspiring inventive designs and structures.

Rapoport's experiments with off-loom techniques in the eight works submitted for her thesis, "Constructed Textiles Related

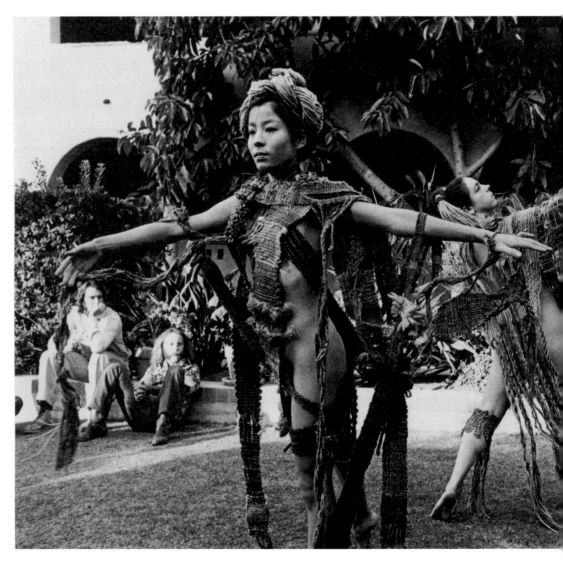

10 Debra Rapoport's **Fibrous Raiments** (1969) worn by members of the San Francisco Dance Troupe in a fashion show presented in Eugenia Butler's garden, November 1970. Courtesy of the artist

11 Mimi Smith (American, b. 1942). **Steel Wool Peignoir**, 1966. Steel wool, nylon, and lace. Spencer Museum of Art, Lawrence, Kansas. Museum Purchase, Helen Foresman Spencer Art Acquisition Fund, 2000.0071

to the Body,"[9] drew on her studies of indigenous weavings and incorporated traditional materials as well as modern "every day throwaways" such as green plastic bags and rubber tubing (fig. 10). Rapoport regarded these not as static structures or clothing, but rather as "personal environments" that found their form as the body moved. Her work provided the theoretical beginnings of American art to wear in the same way that Mimi Smith's 1966 master's project "Clothing as a Form" (fig. 11), influenced by the Fluxus and conceptual artists then teaching at Rutgers University, later gave an intellectual framework to conceptual clothing, or the so-called "Empty Dress,"[10] as a contemporary art form in the 1990s.

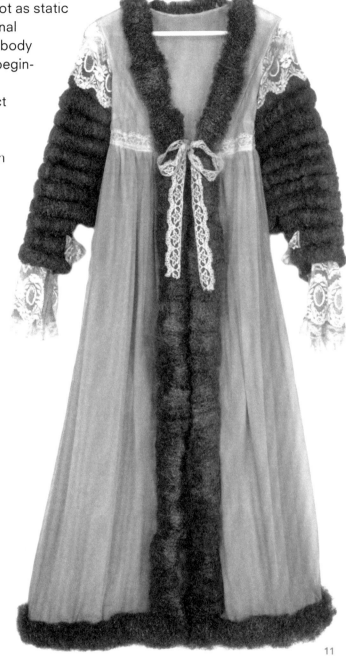

11

10

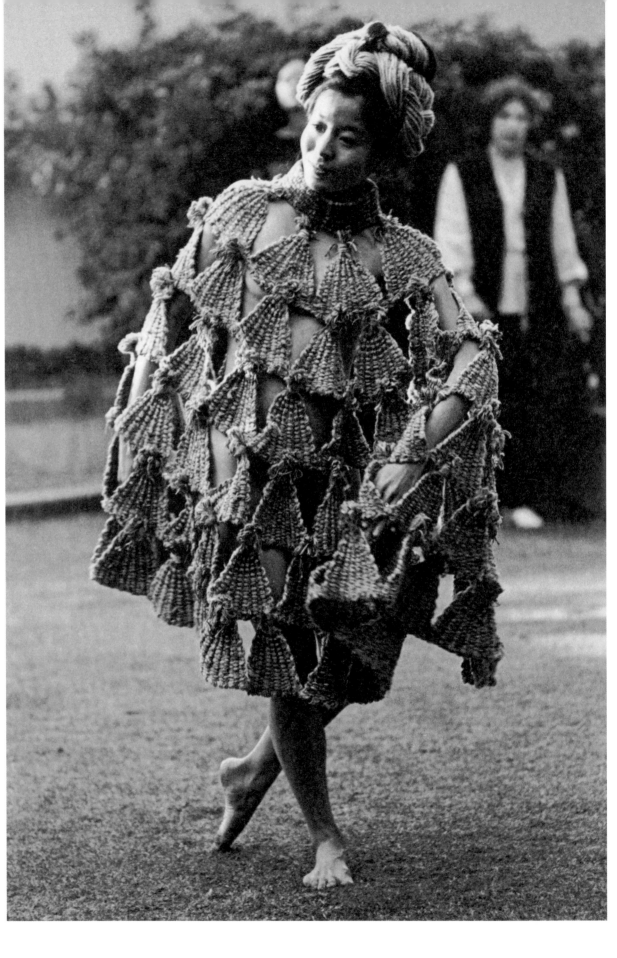

Rapoport presented her master's project in a "fashion show" staged in the garden of the Los Angeles art dealer Eugenia Butler's home in November 1970. Designed to be worn over the naked body, her creations were modeled by members of the San Francisco Dance Troupe, who were then appearing in the nude theatrical review *Oh! Calcutta!* The following week, the works were shown at Butler's gallery on La Cienega Boulevard, which from 1969 to 1971 introduced conceptual and performance artists to the Los Angeles art scene. Rapoport's thesis collection included a large tubular garment for two or three people, a cut-suede cape, a garment made of strips of macramé and net that could be worn multiple ways, a completely open netted garment that revealed the entire body, another made from crocheted videotape, and one constructed in mixed yarns from modular woven triangles joined to form positive and negative spaces (fig. 12). This last "garment" was reminiscent of Paco Rabanne's coat from 1966 constructed with leather triangles riveted onto a knitted leather base (fig. 13).[11] In an interview with the *Los Angeles Times* during the Butler event, Rapoport remarked: "I think of clothes as an art form. They are environments and I expect the woman to involve herself and participate with the clothes.... I want the woman to feel, to smell, to participate with fashion."[12]

In 1971, Rapoport was invited to participate in the *Fifth International Tapestry Biennial* at Lausanne.[13] Of the ten Americans showing that year, four exhibited traditional woven tapestries while the other six, including Rapoport, presented works in a mix of techniques and materials. Rapoport's *Fibrous Raiment with Conical Appendages* (fig. 16) was the most controversial submission. According to Jack Lenor

12 One of Rapoport's **Fibrous Raiments** (1969) worn by a member of the San Francisco Dance Troupe, November 1970. Courtesy of the artist

13 Paco Rabanne's **Leather Coat** and **Chin Strap Helmet** (1966). The coat is made of natural leather riveted onto a knit base. Photo: Keystone Press

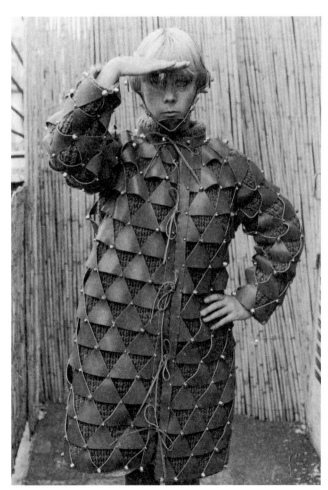

13

Larsen, who reviewed the event for *Craft Horizons*: "We thought we'd adore it but damnit she wore it, and the first is probably the last of the Biennale gowns."[14] Like the works for her master's project, it was constructed so that the textile could be manipulated as the body moved. For Larsen, the most compelling work shown was the Romanian-born artists Ritzi Jacobi and Peter Jacobi's poignant *Armoire* (fig. 14), a large metal coat stand hung with half-jackets woven to shape and sewn together, symbolizing the artists' status as new immigrants in West Germany. This conceptual installation contrasted with Rapoport's "tapisserie vivant" (living tapestry) and had echoes of Joseph Beuys's *Felt Suit* (fig. 15), which the German artist wore in his antiwar performance *Action the Dead Mouse / Isolation Unit* the same year and later reproduced in an edition of 100. When asked how the suit should be displayed, Beuys replied: "I don't give a damn. You can nail this suit to the wall. You can also hang it on a hanger, ad labium! But you can also wear it or throw it into a chest."[15] While offering the possibility, Beuys also acknowledged the impracticality of wearing a suit that wouldn't hold its shape. What mattered was that it was art; the "wearable" component was expendable.

14 Installation of Ritzi Jacobi and Peter Jacobi's **Armoire** at the *Fifth International Tapestry Biennial*, 1971. Photo: Lausanne Biennale Archives

15 Joseph Beuys (German, 1921–1986). **Felt Suit**, 1970. Felt; with hanger: 6 ft. 3½ in. × 27½ in. × 6½ in. (191.8 × 69.9 × 16.5 cm). Philadelphia Museum of Art. Gift of the Friends of the Philadelphia Museum of Art, 1971-41-9a,b

16 Rapoport wearing **Fibrous Raiment with Conical Appendages** at the *Fifth International Tapestry Biennial*, Lausanne, Switzerland, 1971. Photo: Lausanne Biennale Archives

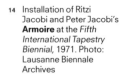

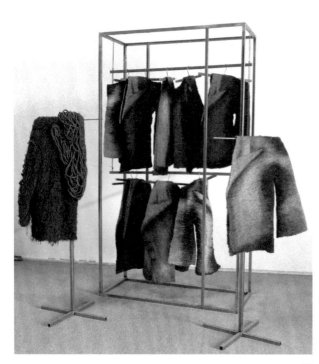

14

15

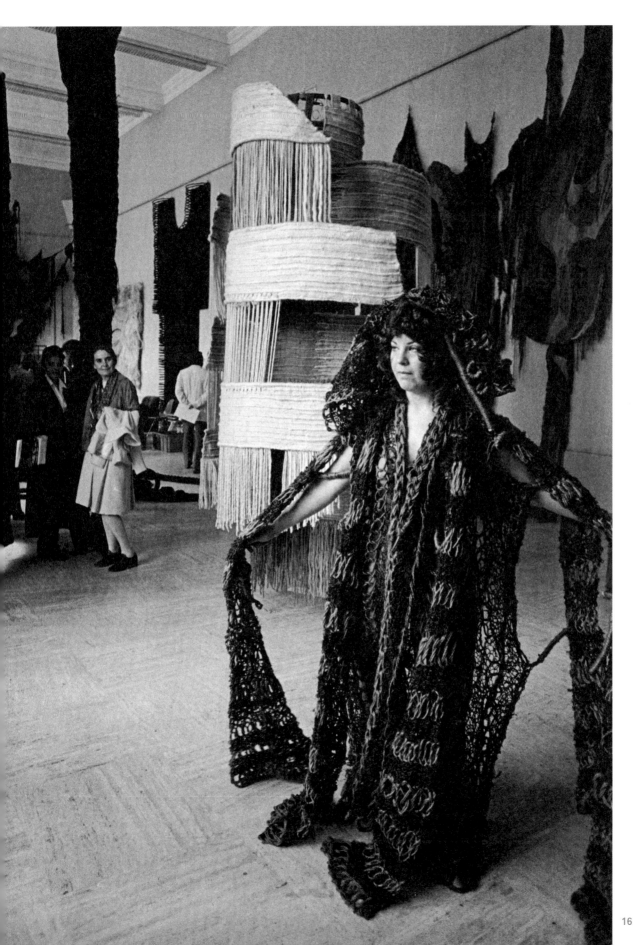

in the loop

When the Museum of Modern Art mounted its *Wall Hangings* exhibition in 1969, the sculptor Louise Bourgeois, who as a young woman had assisted in her family's tapestry restoration workshop in France, was asked to review the exhibition for *Craft Horizons*. Although she found the works "interesting" and "engaging" as objects, she believed that they did not demand enough of the viewer. "If they must be classified," she wrote, "they would fall somewhere between fine and applied art." She did, however, single out two crocheted works—Walter Nottingham's *Celibacy* (fig. 17)[16] and Ewa Jaroszynska's *Cocoons I and II* (1967)—as the most compelling. Bourgeois noted that "the crochet method can lead to great expanses of imagination, whereas the loom is a very rigid tool."[17] In this, the sculptor was prescient, as it was the mastery of free-form crochet by a group of students at Pratt Institute in Brooklyn that launched wearable sculpture, a cornerstone of the art-to-wear movement.

FREE-FORM CROCHET

The political and social issues that had been simmering during the 1960s ignited in 1968, a year marked by antiwar protests at the Democratic National Convention in Chicago, the assassinations of Martin Luther King Jr. and Robert Kennedy, and student strikes worldwide. At Pratt, striking students in the architecture and art departments denounced the teaching methods and curriculum as too traditional and conservative and demanded a greater voice in their education. As a result, the programs were redesigned to focus on individual creativity, encouraging students to push the boundaries of art making.

In the midst of this upheaval and change, five Pratt students—Janet Lipkin, Dina Knapp, Jean Cacicedo, Marika Contompasis, and Sharron Hedges—reveled in the potential of free-form crochet, creating randomly generated forms whose unrestrained exuberance laid the groundwork for what would soon become the art-to-wear movement. Lipkin, class of 1970 (fig. 18), later recalled the atmosphere on campus: "We were in prime time: 1968 through 1970. That was when everything was exploding.

18

17

17 Walter Nottingham (American, 1930–2012). **Celibacy**, 1968. Wool; crocheted; 72 × 30 × 12 in. (182.9 × 76.2 × 30.5 cm). Milwaukee Art Museum. Gift of Friends of Art, M1996.423

18 Janet Lipkin (American, b. 1948). **African Mask**, 1970. Wool, leather; crocheted. The Metropolitan Museum of Art, New York. Gift of Muriel Kallis Newman, 2003.79.13a–e

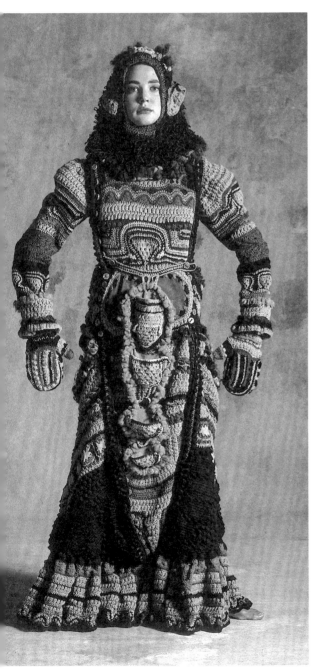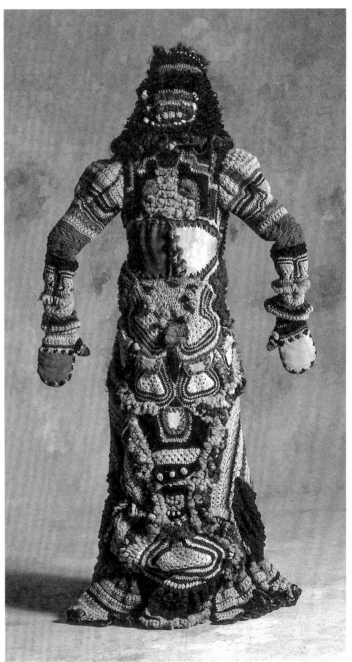

1ssionscollisionscollisionscollisionscollisionscollisionscollisionscollisionscollisionscollisionscollisionscollisionscollisionscollisionscollisionscollisionscollisionscollisionscollisionscollisionscoll

19

Discovering yourself was the most important thing in the universe, and we were at art school. So anything that was unusual, new, or inventive was supported. We had the perfect support—even though the teachers did try to structure us a lot."[18] Knapp credited Lipkin with influencing her work and that of their peers, recalling a "living" crazy quilt that Lipkin encrusted with found materials: "We were doing formal drawings of eggs, eggs slanted different ways, pointillism, cross hatching—and here was Janet doing something absolutely nuts, absolutely off the wall, and it really appealed to me."[19]

Lipkin's former roommate Cacicedo recently reflected: "Pratt was a mecca for exploration in so many ways. The counterculture of this era was embedded in our philosophy, our attitudes, our dress and our enthusiasm to be 'different' in our art making...it informed us, and thus, we became that culture....If it weren't for the dramatic atmosphere at Pratt and of the times, I wonder if I would have made wearables at all."[20]

19

Cacicedo learned to crochet from a friend's mother during the summer of 1968, and over the Christmas holidays she taught the technique to Lipkin and their other roommate, Contompasis. Their friends Hedges and Knapp taught themselves. Although the five classmates were studying different media—painting, sculpture, multimedia, graphic design, and industrial design—they were equally enthusiastic about using crochet in their work. Lipkin was intrigued by its flexibility and pushed the limits of the technique, combining it with other media such as papier-mâché, plaster, paint, and ceramics to make wall hangings, small freestanding sculptures, and wearable art. As Cacicedo recalls, the five young artists discovered that "clothing could be moving sculpture and as an art fashioned for the body, not 'fashionable' art."[21] Although Pratt had a fashion department (fig. 19), it was not a major any of the friends would "dare to acknowledge" or think of pursuing, despite the fact that they were crocheting garments.[22]

The Pratt group connected with other textile enthusiasts at Studio Del, located in the East Village off St. Mark's Place, home at the time to small boutiques where clients from the Upper East Side could shop "for something different, or amusing, or cheap."[23]

19 Pratt Institute 1968
Student Fashion Show.
Photo: Pratt Archives

Founded in 1965 by the sculptor Del Pitt Feldman, Studio Del was one of the area's quirky clothing boutiques, with decor its owner described as "Early Gypsy Tearoom." When the Pratt students discovered the studio in the late 1960s, it had expanded beyond clothing (including Feldman's own knit and crochet fashions) to include a yarn store and workshop and had become a meeting place for those interested in the textile arts. Lipkin started selling crocheted bags and hats there. The students also befriended two young women who were exploring crochet and would later teach classes at the studio. One was Arlene Stimmel, a California native and graduate of the San Francisco Art Institute who taught herself to crochet as a way of passing the time while waiting for the automobile spray paint she used for her abstract paintings to dry between coats. The other was Nicki Hitz Edson, who had moved to New York in the early 1960s from Colorado, where she had studied art, art history, and photography. Her interest in crochet sprang from her encounter with Nottingham's *Celibacy* at the Museum of Modern Art's *Wall Hangings* exhibition. "I couldn't believe it!" she later wrote. "I knew then that anything could be crocheted."[24] She promptly learned the technique from her mother during a visit home in 1969 and began applying it to her art. For Edson and her like-minded friends, crochet offered endless possibilities, limited only by their imaginations.

 Although the Pratt five headed in different directions after graduating in 1970, the friendships continued and even strengthened, as they encouraged one another and sometimes collaborated. Contompasis and Cacicedo relocated to California; in 1972 Cacicedo left for Wyoming, where she remained until to 1980. Hedges and Knapp stayed in New York, with Knapp eventually settling in Florida in 1977. Lipkin, who married in the summer of 1970, first moved to Toronto as a protest to the Vietnam War, and then in 1971 to San Francisco, where she shared an apartment with Contompasis. The following year, she moved back East to serve as the first textile artist-in-residence at the Peters Valley School of Craft in New Jersey. During this period, she added to her growing vocabulary of textile techniques by enrolling in intensive workshops with leading fiber artists. She studied weaving with Adela Akers and vegetable dyeing with Katherine Mahoney at North Carolina's Penland School of Craft; knotless netting with Barbara Shawcroft at the Yarn Depot in San Francisco; knitting with Mary Walker Phillips at Peters Valley; macramé with Virginia Harvey in New York; and spinning,

tie-dyeing, batik, and stitchery at the San Francisco YWCA. In 1974 she relocated to California before taking up a Fulbright fellowship in West Africa two years later.

By the early 1970s free-form crochet had made its mark in fiber art. Clinton Mackenzie, a Cranbrook-trained weaver who was introduced to the technique by Nottingham, commented in *New Design in Crochet* (1972) that it was now "a vital part of today's renaissance in the textile arts" and used for "art fabrics" such as wall hangings, sculpture, and "personal art forms," including clothing, jewelry, and body ornaments.[25] Del Pitt Feldman published *Crochet Discovery and Design* the same year and also recognized Nottingham's pioneering contributions in her last chapter, "Art and Crochet." Her book, subtitled "An innovative craftswoman shows you how to design and create new fashion artistically—without patterns," suggested that her readers approach free-form crochet as painting in yarn or as three-dimensional sculpture: "Let forms suggest other forms as you go along. Keep in mind shape that can enhance the body."[26] Although much of the book is illustrated with examples of her own work, Feldman also included wearable designs by Stimmel, Hedges, Edson, Cacicedo, and others.[27]

The following year, Edson and Stimmel published their own how-to book, *Creative Crochet* (fig. 20), a step-by-step guide to basic stitches, creative techniques, and works to wear. The pair had been conducting workshops throughout New York, and their introduction lists a vast array of objects they and their friends had crocheted, none of which bore the slightest resemblance to the ubiquitous crocheted granny squares made into "hippie"-inspired skirts, dresses, vests, capes, and afghans: "all kinds of wearing apparel—vests, hats, dresses, a pair of chaps, shirts, fantasy costume; animals real and imagined—frogs, turtles, horses, swans, dragons, and an 18-foot turkey; planets, stars, clouds, flowers, mushrooms, a forest, houses, masks, giant dolls and tiny dolls, puppets; and even a steak dinner, complete with potatoes, salad, and a cup of coffee."[28] The book was a communal effort, reflecting the close friendships that nurtured the creative spirit among these young artists. Edson acted as the book's photographer and contributed the fancy-stitch diagrams; Stimmel provided clothing diagrams, Hedges, additional line drawings, and Lipkin, moral support and inspiration. Julie Schafler (Dale) modeled for

20 Cover of *Creative Crochet* by Nicki Hitz Edson and Arlene Stimmel (Watson Guptill, 1973)

21 Sharron Hedges (American, b. 1948). **Rubelle's Owl Vest**, 1973. Wool; crocheted. Courtesy of The Julie Schafler Dale Collection

22

many of the photographs. Schafler, who had been selling one-of-a-kind works by some of the artists in the book out of her apartment since 1971, opened Julie: Artisans' Gallery on Madison Avenue the same year *Creative Crochet* was published. Over the next forty years, Julie and her eponymous gallery would be instrumental in defining the American art-to-wear movement.

Edson and Stimmel's book featured their own work and that of their friends Hedges, Lipkin, Knapp, Feldman, and other artists such as Susanna Lewis and Norma Minkowitz. Lewis, who had employed Lipkin, Hedges, and Contompasis as babysitters when they were students, had recently discovered the knitting machine but was still crocheting small wearable items such as vests. Minkowitz learned to crochet as a child but hadn't thought about making art to wear until she came across Edson's and Hedges's work at Julie: Artisans' Gallery in 1973 (fig. 21). With Schafler's encouragement, she began to create finely crocheted wearables that were the antithesis of the heavy, free-form crocheted coats and jackets made by other artists. Her interest in the female form developed around this time, and in 1975 she completed *Come Fly with Me* (fig. 22), which combined a wearable sculptural form with small figurative sculptures. This remarkable cape was knitted with the finest needles (size zero) in mercerized cotton and features a yoke covered with ninety-one one-inch cro-cheted, stuffed, and en-twined female figures. Its pale color palette

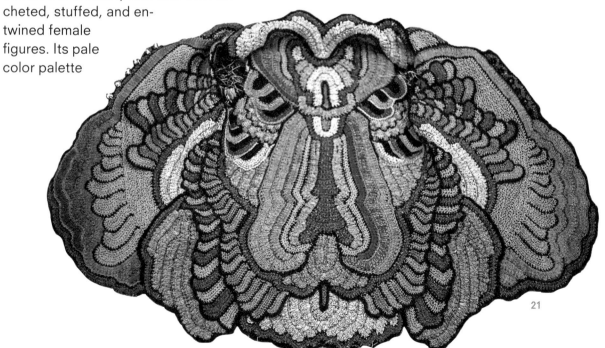

21

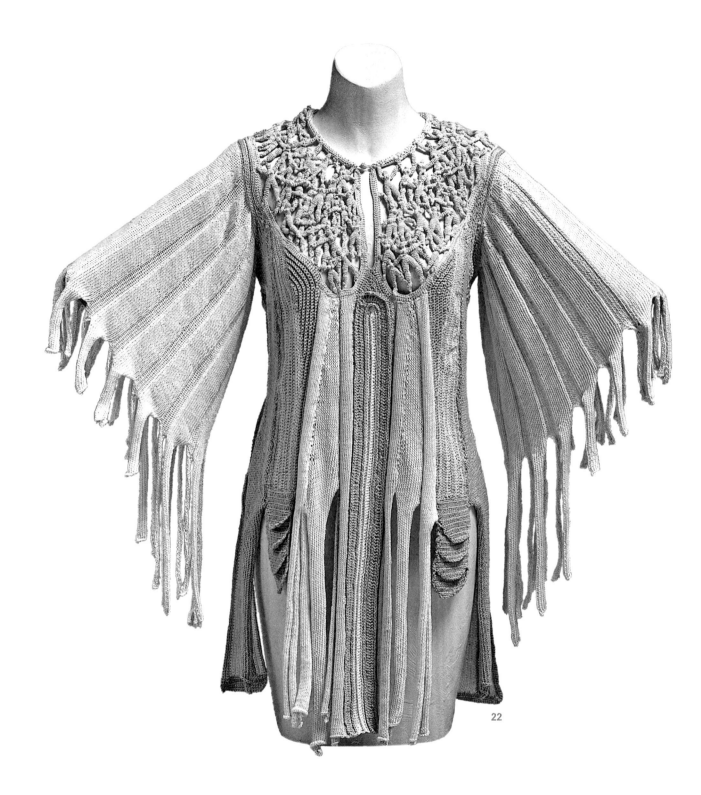

22

and subtle textures together with the cape's "feathered wing" sleeves contribute to the overall feeling of fragility and flight. Minkowitz continued to create wearable "fantasies" until the mid-1980s, when her evolving interest in the female form shifted toward large, finely crocheted abstract sculptures (fig. 23).

The art-to-wear movement emerged at a time when the search for personal growth and well-being could be pursued through a wide range of options, from EST seminars, encounter sessions, and consciousness-raising groups to New Age spirituality incorporating aspects of non-Western traditions such as yoga. Artists and clients often spoke of art to wear as performing a similar function as it engaged the body, mind, and spirit of both the maker and the wearer. Masks provided one way of engaging in transformation and realizing change. The Museum of Contemporary Crafts exhibition *Face Coverings* in 1970 displayed masks and helmets from around the world alongside work by contemporary artists and craftspeople. Edson's first mask was created for a Halloween party at Lipkin's house in 1971, and over the next several years she used her crochet hook to sculpt and draw elaborate fantasy characters, including a Russian czar whose head is crowned with towers, a menagerie of animal heads (fig. 24), and mythological figures such as an autobiographical Medusa, reflective of the artist's feelings during her divorce (see fig. 149).

For Lipkin, making art to wear was itself a deeply personal and spiritual experience. Her *African Mask* of 1970 (see fig. 18), created while she was living in Toronto, uses yarns she hand spun from vegetable-dyed fleece and crocheted around leather elements.[29]

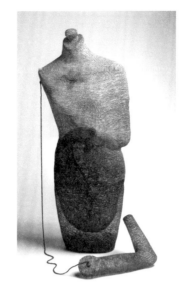

23

22 Norma Minkowitz (American, b. 1937). **Come Fly with Me**, 1975. Cotton; crocheted. The Metropolitan Museum of Art, New York. Gift of Norma Minkowitz, in memory of Fania Chigrinsky, 1980.49

23 Norma Minkowitz. **Miss Fit**, 1996. Knotted fiber coated with resin and pigment with applied fibers and resin; resin-coated, fabric-covered ball chain; h. (body): 39¾ in. (101 cm). Philadelphia Museum of Art. Gift of Elissa Cahn in memory of her parents, 2004-124-1

24 Nicki Hitz Edson (American, b. 1941). **Dragon Mask**, 1973. Wool; crocheted. Courtesy of the artist

24

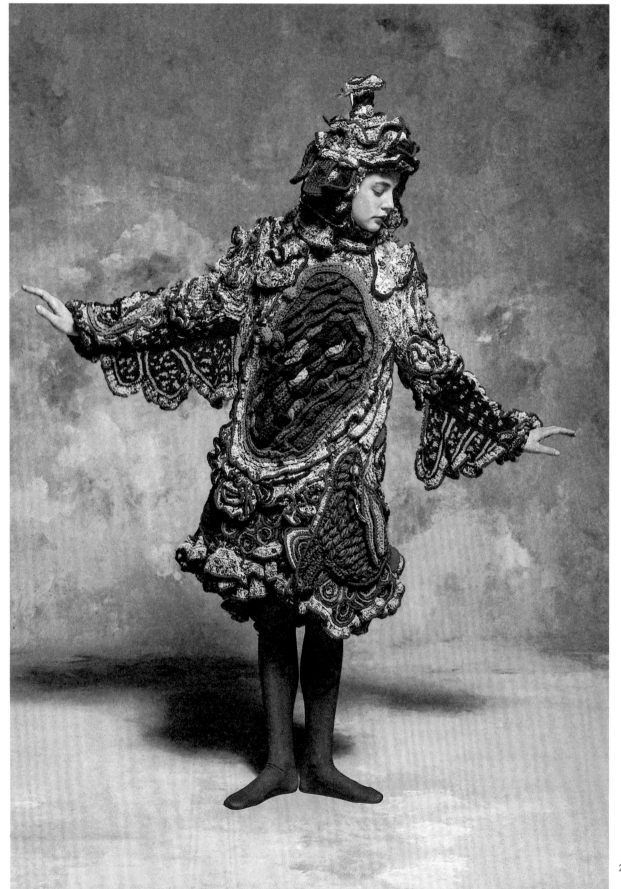

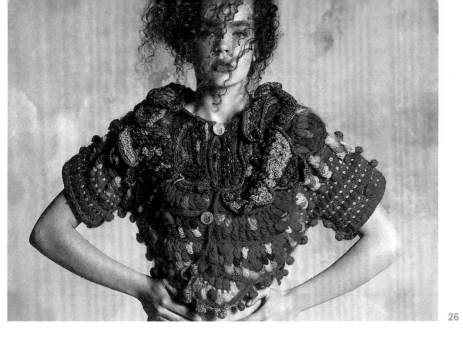

26

The coat, face mask, and mittens completely cover the body and include removable front pockets for holding spiritual symbols or objects. "I was very interested in spiritual dress, clothing that was used for ritual purposes. Rituals and festivals where the garment was work that spoke to the spirits," she recently recalled. "I always felt that each fiber artist was reborn from another culture, and mine was Africa."[30] In 1976, she received a Fulbright fellowship to study in Ghana, where she enrolled in classes in textile silk screening and the history of African sculpture at the University of Art and Technology in Kumasi. "The moment I got off the plane I knew I had come home," she said. "It was so familiar to me it could only have come from my soul."[31]

Lipkin's early wearable sculptures addressed the idea of transformation, including changing into a bird (fig. 25) or a luscious piece of fruit (fig. 26). The expression "bag of bones" becomes an oversize shoulder bag (fig. 27). In each work, the smallest details are magnified and reintegrated into the overall composition, creating a surreal image that questions the relationship of the wearer to the original form.

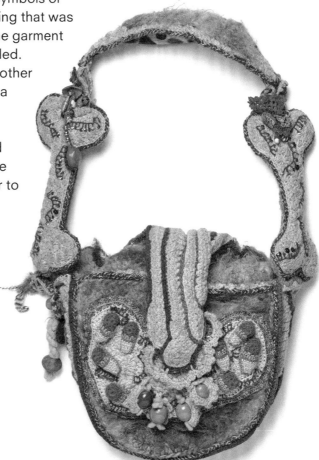

Many artists found the physicality of free-form crochet seductive, from the production of yarns—carding, spinning, and dyeing—to building forms loop by loop. Dina Knapp's wearable sculptures grew naturally as she worked, and their organic spontaneity belies the careful planning and drawing that went into their making. Knapp's hands-on approach to color and materials included carding fleece, spinning, and dyeing her own yarn, all of which contributed to the intensely personal and immersive quality of her creative efforts. *Whole Earth Tapestry*, her first major work, evolved over two and a half years and reflected "the progression of a chunk of lifetime."[32] The imagery drawn from "primitive" art includes stick-like figures, archaic birds, and fish that dance, swim, and fly across the densely patterned surface. In her most sculptural work, *Fungus Jacket* (figs. 29, 30), stuffed tubes of crochet undulate and wrap around the body like roots, evoking the dark earthiness of the forest floor, punctuated with colorful flowers and plants. With Knapp's move to Florida in 1977, the heavy crocheted garments of the New York years were replaced with lighter shapes embellished with a collage of materials, techniques, and images, some of which spoke to the violence of Miami's drug wars and the plight of Haitian refugees (fig. 28).

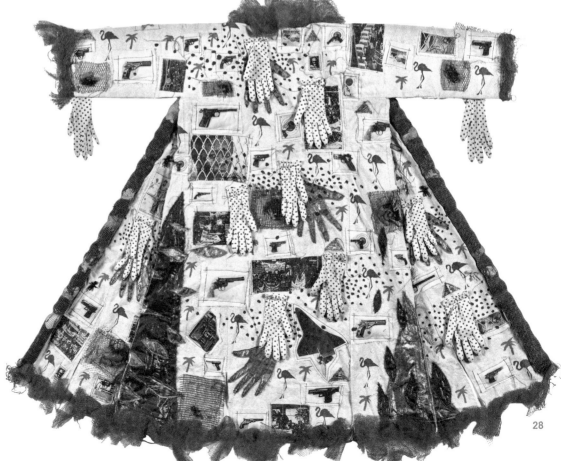

28

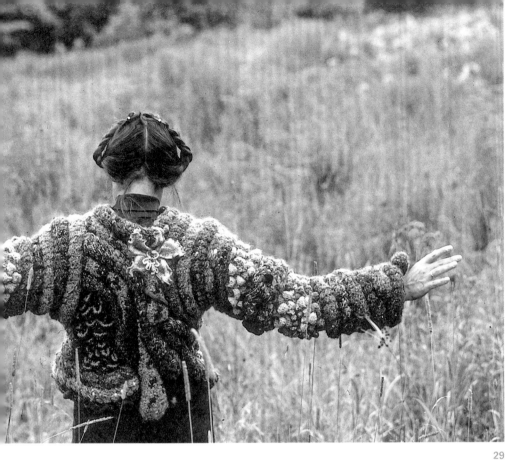

28 Dina Knapp (Israeli, active
United States, 1947–2016)
**See It Like a Native:
History Kimono #1**, 1982.
Cotton, polyester, plastic,
and paper: painted,
appliquéd, Xerox-
transferred, assembled.
Philadelphia Museum
of Art. Promised gift of
The Julie Schafler Dale
Collection

29 Dina Knapp wearing
her **Fungus Jacket**, 1974.
Photo: Jeffrey Knapp

30 Dina Knapp. **Fungus
Jacket**, 1974. Wool
tweeds, wool yarn, and
fiberfill stuffing; crocheted,
stuffed, sewn. Mobile
Museum of Art, Alabama

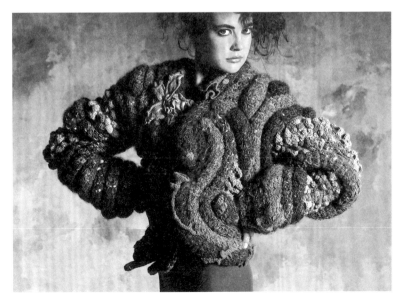

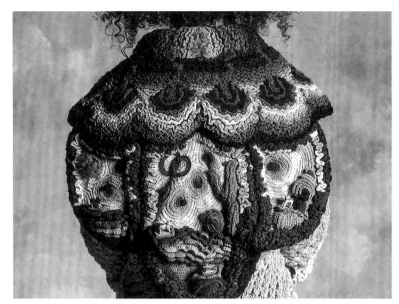

31

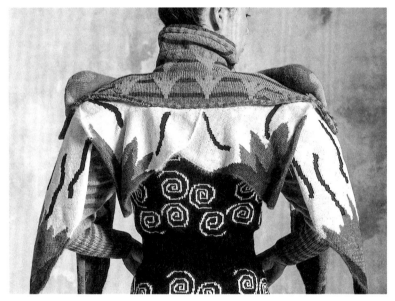

32

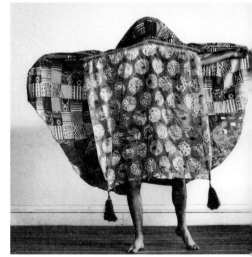

3

HAND TO MACHINE

While artists continued to work with free-form crochet and hand knitting, they also began experimenting with newer creative tools such as the home knitting machine (fig. 34). Widely used in the United Kingdom, Europe, and Japan, it was just being discovered by American knitters and would not achieve the same popularity among them until the late 1970s. Machine knitting was faster than hand knitting, but it was difficult to master and took considerable experimentation to use creatively. For some artists the organic nature of free-form crochet had become too emotionally draining and physically demanding, and increasingly the technique overwhelmed both form and image. Machine knitting, with its flat surface, offered more control and worked well with both bold, large-scale patterns and more intricate details (figs. 31, 32).

The transition from "hand" to "machine" coincided with the Pattern and Decoration (or P&D) movement in contemporary American art (1975–85), which emerged as a reaction to the dominance of Minimalism and Conceptualism. P&D artists embraced the wider visual history of world art and culture and looked to ornament as its unifying vision. With New York's Holly Solomon Gallery as its hub, the roster of such artists included Miriam Schapiro, Robert Kushner, Kim MacConnel, Robert Zakanitch, and Joyce Kozloff. Kushner and Schapiro referenced non-Western clothing forms in their work, with Kushner incorporating varied cultural references in his performance pieces (fig. 33), while Schapiro adapted the kimono shape and similar silhouettes for her "femmage" paintings (fig. 35).

Of the five former Pratt students, Contompasis was the first to acquire a knitting machine, in 1971, soon after moving to Berkeley from New York. As a former student of industrial design, she found machine knitting a natural transition from free-form crochet, but it was not until 1973 that she realized the "pictures" she was building using crochet and knitting could be translated into larger graphic images. Her first machine knits

34

31 Marika Contompasis (American, b. 1948). Detail of **Garden Triptych Coat**, 1975 (see fig. 104)

32 Janet Lipkin. Detail of **Flamingo**, 1982 (see fig. 43)

33 Robert Kushner (American, b. 1949). **Persian Line II, Leonard Street Loft**, 1975. Photo: Harry Shunk © J. Paul Getty Trust, Getty Research Institute, Los Angeles

34 Woman using a Brother knitting machine with a prepunched pattern card, 1975. *Sun Times* photo by Jim Klepitsch

35 Miriam Schapiro (Canadian, 1923–2015). **Kimono**, 1984. Colored markers on kimono-shaped paper. Pennsylvania Academy of the Fine Arts, Philadelphia. Gift of the Estate of Miriam Schapiro, 2015.25.60

31

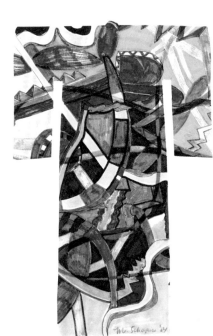

35

were assembled from small units using a Knitking machine. In 1977 she knitted *Trout-Magnolia Kimono* (fig. 36; see also fig. 57) for *The Art and Romance of Peasant Clothes* (1977–78), a traveling exhibition based on ethnic garment patterns by the California-based company Folkwear. The modular construction of the Japanese kimono was ideally suited to machine knitting, and Contompasis modeled her version on Folkwear's pattern 113, constructing it from twenty four-inch rectangular sections. Although the surface design has a pronounced Japanese sensibility, the inspiration was closer to home: trout fishing in the Rocky Mountains and the magnolia trees outside her studio.

Phoenix-Maze Coat (fig. 37), the most complex of her works, combines machine knitting and crochet. The different fibers and yarns produce a maze-like effect reminiscent of Sonia Delaunay's 1923 *Simultaneous* ensemble for Gloria Swanson (fig. 38). As Contompasis worked, her crochet took the form of a Coptic cross, which in turn inspired her to machine knit two Egyptian phoenixes for the front panels. The coat buttons at the sides and under the arms, but when unbuttoned and laid flat it can be hung on the wall. By 1985 Contompasis had moved beyond art to wear and launched a line of high-end knitwear known for its unique color sensibility.

Susanna Lewis and Linda J. Mendelson were also among the first to experiment with machine knitting. The technical guides each wrote, Mendelson in 1979 and Lewis in 1986, became essential handbooks for anyone interested in exploring the creative potential of home knitting machines.[33] Although they worked with similar machines, they differed in their individual approaches to design and construction.

Lewis's lush, complex, and intricately detailed images reflect her background in fine art, music, and biology and her love of American history. She learned to sew and crochet from her grandmother but was self-taught in other textile and needlework techniques, from hand spinning and natural dyeing to lace making. Lewis's machine knits incorporated a variety of yarns, including metallics, and she frequently combined knitting with other textile techniques such as appliqué, quilting, and stuffing. After seeing Mary Walker Phillips's hand-knitted

36 Marika Contompasis. **Trout-Magnolia Kimono**, 1977. Wool; machine knitted. Philadelphia Museum of Art. Promised gift of The Julie Schafler Dale Collection

37 Marika Contompasis. **Phoenix-Maze Coat**, 1979. Wool and silk; crocheted, knitted. Collection of Daniel and Hilary Goldstine

38 Sonia Delaunay (b. Ukraine, active France, 1885–1979). **Simultaneous Dresses (Three Women, Forms, Colors)**, 1925. Oil on canvas, 57½ × 44 ⅞ in. (146 × 114 cm). Museo Nacional Thyssen-Bornemisza, Madrid, inv. no. 519 (1981.30)

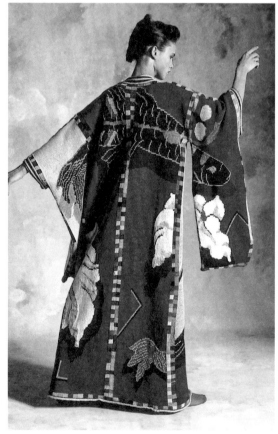

36

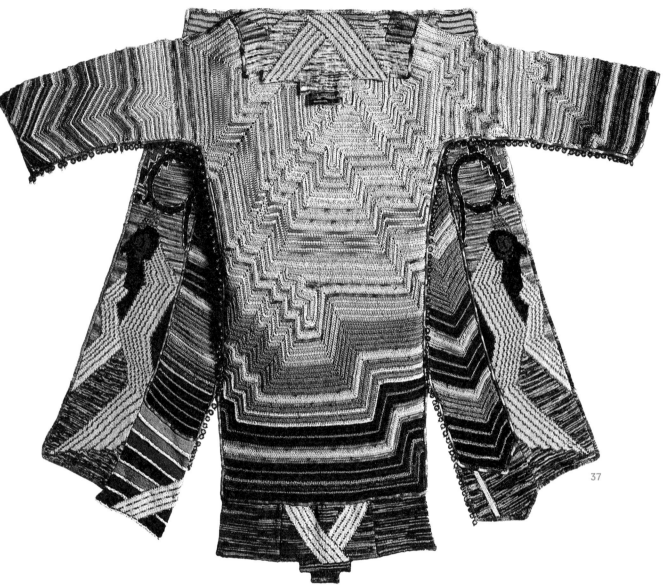

37

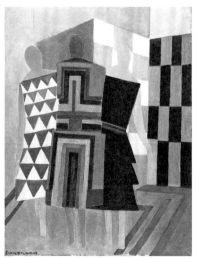

38

39

wall
hangings at
the Museum of
Modern Art in 1969,
Lewis started to knit her
own. In 1971 she spotted a
knitting machine in a Fifth Avenue store
window and, intrigued by the patterned samples in the display,
immediately realized that she could knit on the machine what she had
been doing by hand:

> I could make tapestries with it. I could put designs in the fabric and
> could also design the fabric. I could make fabric and design meld
> and blend to convey a larger message. I could work in two dimen-
> sions or three dimensions. I could work large scale or small scale.
> I could still use my beloved yarns, and feel, build, and enjoy my
> fabric. It would be a fabric unlike any I had ever before produced.[34]

The following day she purchased a Passap Duomatic 5, a
double-bed machine first introduced in 1961. Popularly known as the
"Pinky" for its color, this machine allowed the home knitter to knit
more than two colors in a row and used a punch card to create
rib jacquards and extra backing rows, making the fabric reversible.
Although jacquard patterns were available on prepunched cards,
inventive knitters came up with their own, blocking out the designs

39 Susanna Lewis
(American, b. 1938).
The Hunt: AD 1605,
1980. Wool and chenille;
machine-knitted couching
embroidery, crocheted
edge, knotting. Private
collection

40 Susanna Lewis. **Off
We Go into the Wild Blue
Yonder**, 1977. Wool,
metallic, rayon, and
angora yarns, satin and
lamé; machine knitted,
appliquéd. Private
collection

on graph paper and transferring them to punch cards. It took Lewis more than three years to knit her first group of tapestries. In 1976 she approached Julie Schafler, who encouraged her to make work that could be worn. Not used to thinking in three dimensions, at first she found it difficult to master the knitting machine for clothing. Eventually she came up with poncho and cape forms that worked both on the body and as tapestries (figs. 39, 40). Lewis's *Machine Knitter's Guide to Creating Fabrics*, written with Julia Weissman, focused on the concepts and techniques behind the various knitted structures using single- and double-bed machines. Her study of historical objects and textile techniques was reflected in her imagery—from the complex patterns found on nineteenth-century American overshot coverlets, to the death's heads and cherubs carved on early Anglo-American gravestones, to World War II airplanes. She often added embroidery, fabric appliqué, and small found objects to her finished work. As a volunteer in the Brooklyn Museum's costume and textile department between 1974 and 1980, she worked with many collections and in 1977

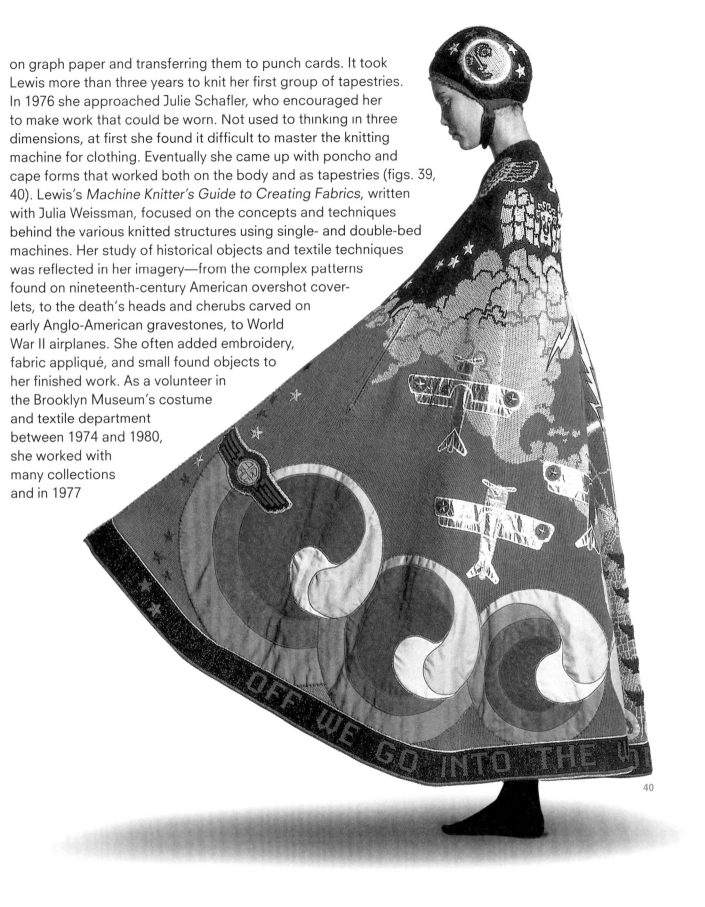

40

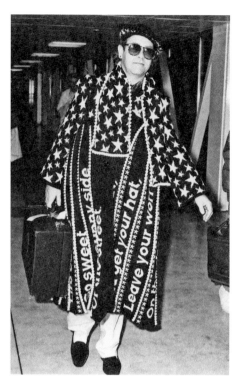

c
o
l
l
i
s
i
o
n
s
c
o
l
l
i
s
i
o
n
s
c
o
l
l
i
s
i
o
n
s
c
o
l
l
i
s
i
o
n
s
c
o
l
l

41

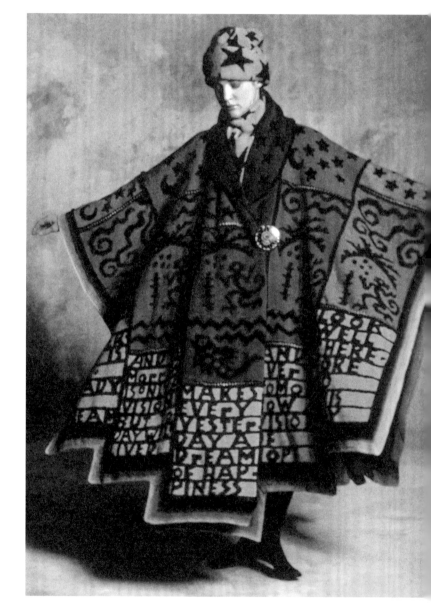

co-curated the exhibition *Lace: An Ornamental Art* with Elizabeth Ann Coleman. One of the exhibited works, a large Renaissance needle lace cover, was the inspiration behind Lewis's cape *The Hunt: AD 1605* (see fig. 39).

Mendelson uses color progressions and typography to create images that incorporate her favorite poems and other literary works, song lyrics, and radio programs remembered from childhood. She acquired her first knitting machine in 1973 and began constructing T-shaped garments from narrow knitted rectangles, which she crocheted together to form larger panels.[35] She worked exclusively in wool, using the simplest knitting stitch, the stockinette, for its smooth surface. Over the years her forms evolved from T-shaped garments to looser styles with dressmaker-like details such as set-in sleeves, gathers, and pleats, achieved by stretching and manipulating the knitted fabric panels into the desired effect. Her first coat, an homage to the poet E. E. Cummings, was exhibited at Julie: Artisans' Gallery in 1975. It was knitted on a single-bed knitting machine and, in order to give the appearance of a different pattern on each side, was constructed from two knitted coats sewn together, which also served to conceal the loose threads on the back. The first home knitting machines were limited to a twelve-stitch-wide repeat, requiring Mendelson to crochet many strips together to create a T-shaped form. She punched her own pattern cards from colored working sketches previously blocked out onto graph paper, and with the double-bed machine could produce knits with a different pattern on each side (fig. 41). Later knitting machines offered more options for larger design repeats (22 to 32 inches), and wider fabrics (50 to 60 inches) could be produced by manipulating the stitches. Mendelson later switched from the Passap Duomatic 80—which required her to lay out her designs on a grid stitch by stitch—to the Superba, on which she could electronically scan her designs from freehand drawings using a felt-tip pen, giving her the option of creating more fluid calligraphic patterns (fig. 42).

Lipkin turned to the knitting machine in 1978 after returning to Berkeley from Ghana.[36] Contompasis had given her a few lessons in the early 1970s, but it was not until the early 1980s that she became seriously interested in machine knitting as a means

41 Elton John wearing Linda J. Mendelson's **Sunny Side of the Street**, 1981. Photo: Dennis Stone

42 Linda J. Mendelson (American, b. 1940). **Christine's Poncho**, 1985. Wool; machine knitted, crocheted. Private collection

38

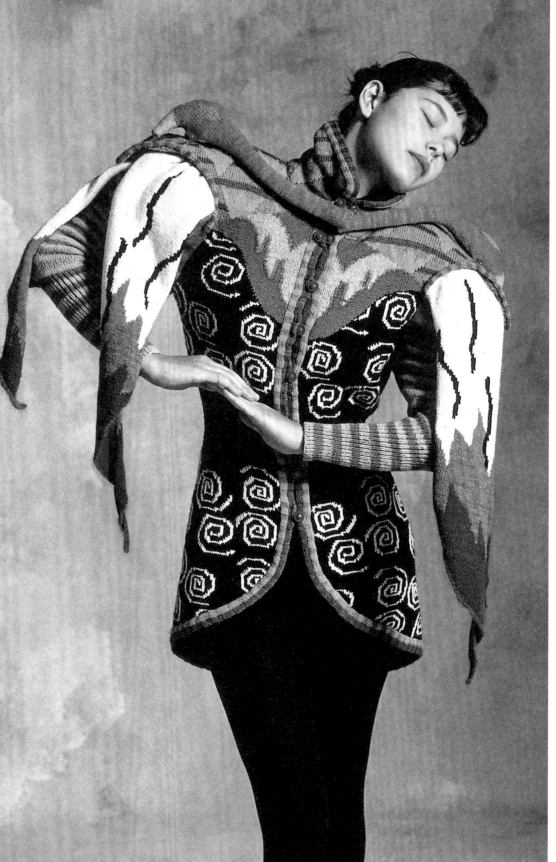

of creating a flat graphic surface. One of Lipkin's earliest machine-knit works, *Flamingo* (fig. 43), bridged three-dimensional form with surface design.

Lipkin readily admits to not being a "technician" and says she "did not have the temperament to follow the patterns" she designed.

> I had two or three fabulous knitters that I would work with. They made my images come alive. I would design a piece, work with a pattern maker, figure out the gauge, dye the yarn, design the cards, and make a booklet of instructions that could be followed to knit the pieces. When I got the pieces back, I would sew them together, line them (if necessary), and block them. . . . I did a small production line, 10–20 pieces in the same style, all hand dyed.[37]

Through trial and error she learned to adjust her designs to work on the body.[38] She discovered that layering and draping machine-knitted fabrics offered infinite possibilities for patterning, which led her during the 1980s to think of her work as clothing, not just wall hangings or paintings.[39] Lipkin developed a unique color palette, using separate baths to dip-dye black and white knits, which, when overlaid, looked like watercolors. She used this technique for a series of travel-inspired coats during the late 1980s in which she satisfied her wanderlust by researching her "destination"—Guate-mala, Mexico, Tibet, Indonesia—until the images coalesced into a larger design. In the late 1980s and early 1990s, she worked with the new computerized knitting machine, which allowed her to design using the entire bed of the machine. "Once you figured out the gauge of your yarn, you could draw the image onto paper and photograph it so it could be read by the machine. The knitter must control the knitting process, the computer will pick up the image and allow the machine to push the necessary needles forward."[40] As with the earlier pieces, Lipkin usually employed outside knitters to translate her designs. Two works designed for this machine, *Nudes* and *Transforming Woman* (fig. 44), were knitted by Lotus Baker.

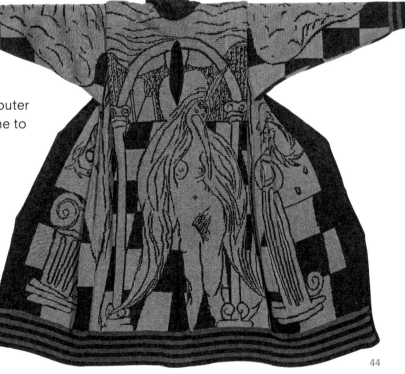

43 Janet Lipkin. **Flamingo**, 1982. Wool and angora; hand dyed, machine knitted, stuffed. Philadelphia Museum of Art. Promised gift of The Julie Schafler Dale Collection

44 Janet Lipkin. **Transforming Woman**, 1992. Wool; machine knitted. Collection of the artist

44

Nicki Edson moved from crocheted fantasy masks to machine knitting, with several years in between consulting for the commercial knitwear industry. By the mid-1980s she was creating machine-knitted works, including a series of striking *Landscape Kimonos* (1986–87) representing the four seasons (figs. 45–48), which are reminiscent of the Arts and Crafts stained glass designed by the California architectural firm Greene and Greene in the early twentieth century. In a 1988 interview, Edson reflected on the challenges faced by wearable art during this time:

> My "kimonos" are not particularly wearable. My main interest is not whether they are wearable, but in the surface and the techniques of the work itself. In the 60's, I think we all hoped that people would begin to wear wonderful clothes to express themselves. However, most people are too conservative to draw that kind of attention on themselves (myself included). For the prices I have to put on my pieces, I think it would be easier to hang (them) on a wall. It makes sense to me to free myself of the problems confined in the idea of wearables and open up new possibilities in design, color, and shape, and make tapestries. I like the idea of wearable art but I don't think it sells well.[41]

As the 1990s dawned, many artists working with machine knitting had moved on. The technique had been usurped by the fashion industry, making it difficult for one-of-a-kind works to compete with mass production. Contompasis, whose background was in industrial design, had been working commercially since 1985. Edson went on to create knitted wall hangings until the mid-1990s. Lipkin devoted more time to teaching art and turned to painting, while Lewis began designing knitting patterns for Sasha dolls. An exception was Mendelson, who continued to machine knit one-of-a-kind coats and cardigans, as well as multiples such as scarves and bags, which she sold exclusively through Julie: Artisans' Gallery until its closure in 2013.

45–48 Nicki Hitz Edson. **Landscape Kimonos**: **Winter**, **Spring**, **Summer**, and **Fall**, 1986–88. Wool; machine knitted. *Winter, Summer, Fall*, Philadelphia Museum of Art, promised gift of The Julie Schafler Dale Collection; *Spring*, private collection

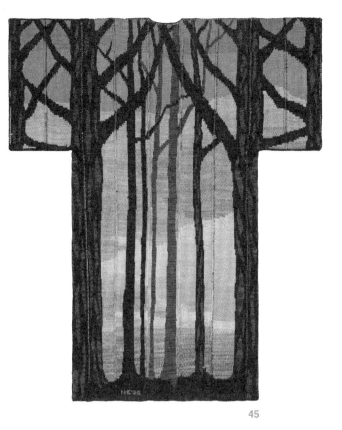

45

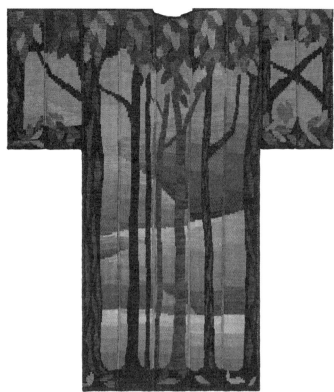

46

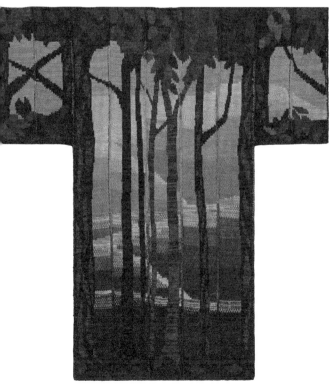

47

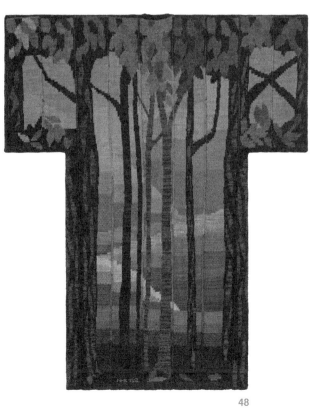

48

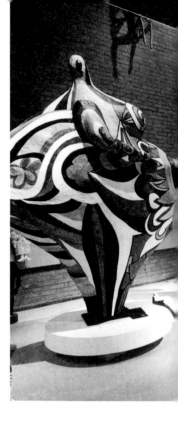

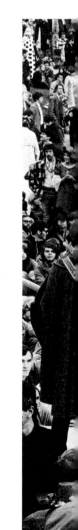

Between 1965 and 1972, under the direction of Paul J. Smith, the Museum of Contemporary Crafts in New York organized a series of themed exhibitions that both captured the Zeitgeist and expanded the audience for nontraditional art forms, including fiber and wearable art, contemporary design and crafts, and performance art. Among these were *Fabric Collage* (1965), *People Figures* (1967; fig. 49), *Body Covering* (1968), *Feel It* (1969), *Contemplation Environments* (1970), *Face Coverings* (1970–71), *Furs and Feathers* (1971), *Acts I, II, III* (1971), and *Fabric Vibrations* (1972). Each in different ways highlighted the connections between the body, its coverings, and its place in contemporary art and culture. Two galleries on opposite sides of the country—San Francisco's Obiko (1972–97) and New York's Julie: Artisans' Gallery (1973–2013)—further defined art to wear as body-essential forms unique for their exceptional quality and craftsmanship.

Over a decade later, sociologist Bryan Turner in *The Body and Society* would write: "The Body is at once the most solid, the most elusive, illusory, concrete, metaphorical, ever-present and ever-distant thing—a site, an instrument, an environment, a singularity, and a multiplicity. The body is the most proximate and immediate feature of my social self."[1] By the time this was written, the art-to-wear movement had established the notion of the body as an armature for art forms that at times were expressive of personal identities as well as social and political views.

body cultures

The Summer of Love in 1967 (fig. 50) gave way to the assassinations, protests, and riots of 1968, "the year the dream died,"[2] and the beginning of "the long 1970s," the cultural, social, and political shift that historian Bruce J. Shulman sees as beginning in January 1968 with the Tet offensive and ending with Ronald Reagan's reelection in 1984.[3] Traditional hierarchies and narratives were upended, disassembled, and reassembled into new forms. Collage and assemblage were the new metaphors connecting art and life, symbolizing the way we lived, what we wore, how we made art and music, and how we interacted with our peers and the greater world.

Young people found refuge in real and imagined cultures and histories as a way to assuage the anxiety and uncertainty over the future. The period gave us Renaissance fairs and living-history groups

44

49 Installation view of *People Figures*, Museum of Contemporary Crafts, New York, 1967, with side view at left of *Gwendolyn* by Niki de Saint Phalle. Photo courtesy American Craft Council Library & Archives

50 Easter Sunday "Love-In," Elysian Park, Los Angeles, March 26, 1967. During the late 1960s and 1970s, *Ojo de Dios* (Eye of God) weavings made by the Huichol of Mexico (top center) were acquired by travelers and became popular do-it-yourself craft projects. Photo courtesy Michael Ochs Archives / Getty Images

49

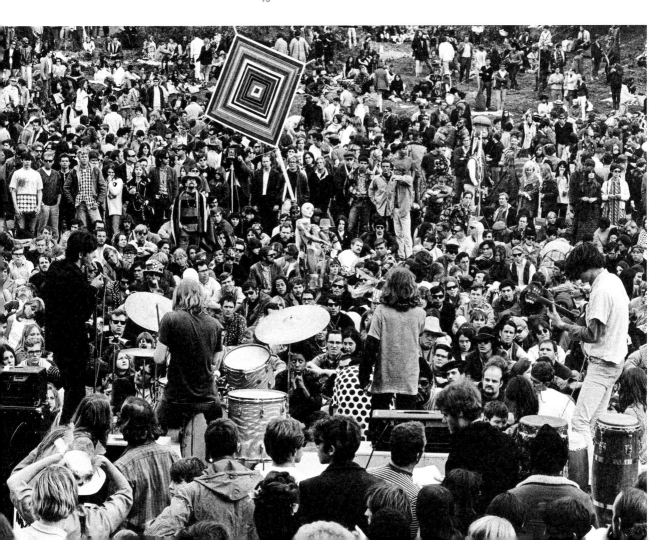

50

such as the Society for Creative Anachronism, whose members prided themselves on the historical accuracy of their medieval personas and costumes.

At the same time, vintage and handcrafted clothing allowed counterculture youth and fashionable wannabes to assemble unique personal looks in real life. For some this represented a step toward self-realization, while for others it reflected the tenets of the *Whole Earth* catalogues—self-sufficiency, recycling, and environmentalism.[4] While San Franciscans and Angelenos combed local vintage shops and boutiques for Victorian "granny" dresses and Mexican embroidered felt jackets, New Yorkers looked to the East Village and second-hand emporiums such as Limbo on Saint Mark's Place for surplus military uniforms and 1920s and 1930s dresses. Echoing across the nation, this trend continued well into the 1970s, prompting Carol Troy's *Cheap Chic: Hundreds of Money Saving Hints to Create Your Own Great Look* (1975), a guide that helped young shoppers navigate the many options from antique clothing to ethnic dress to work clothes.

According to fashion columnist Eugenia Sheppard, 1970 was a watershed year for personal adornment, as clothes became costumes and costumes became clothes.[5] Even feminist artists Miriam Schapiro and Nancy Youdelman embraced role play, collecting and dressing up in Victorian clothing as part of a class exercise in Judy Chicago's first feminist art class in 1970–71, at Fresno State College (now California State University, Fresno), which explored female identity, behavior, and sexual roles.

With nearly every historical period, culture, and ethnicity offering sartorial options, the politics of appropriation and exploitation were as much an undercurrent then as they are today. Fashion's newest darling, Giorgio di Sant'Angelo, found inspiration in Romany (1969) and Native American (1970) cultures (fig. 51)—and was singled out by folksinger Buffy Sainte-Marie, a member of the Cree First Nation, for appropriating the heritage of disenfranchised minorities while ignoring their needs.[6]

For Ben Compton, making clothes during the early 1970s was both business venture and spiritual journey. A graduate of Yale, where he studied costume design, Compton met Marion Holmes, a Fashion Institute of Technology graduate, while designing stage costumes for the Negro Ensemble Company.[7] Together they formed Best of Three Worlds, an anti–Seventh Avenue ready-to-wear company that from 1969 to

46

51 Giorgio di Sant'Angelo (American, b. Argentina, 1933–1989). **Dress from the Native American Collection**, Fall 1970. Rayon velvet, cotton cording, and ostrich feathers; pieced, appliquéd. Philadelphia Museum of Art. Gift of the Metropolitan Museum of Art, 2007-87-29

52 Marion Holmes (top center) and Ben Compton with models at Henri Bendel, New York, from *New York Magazine*, April 20, 1970. Photo © Susan Wood

53 Marion Holmes (American, b. 1949). **Ensemble for Best of Three Worlds**, c. 1970. Faille; appliquéd, machine embroidered. The Julie Schafler Dale Collection

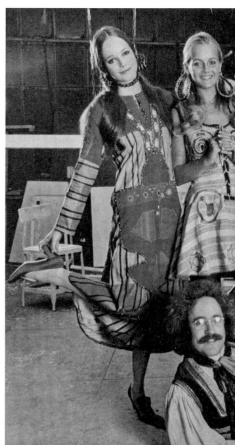

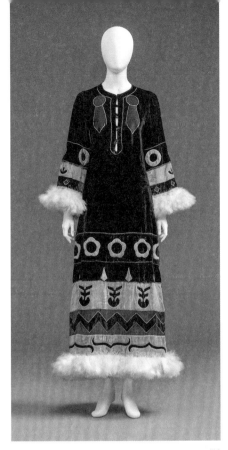

51

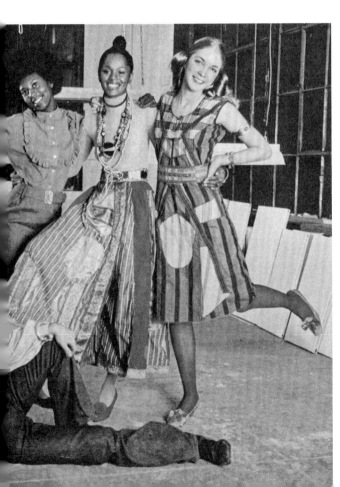

52

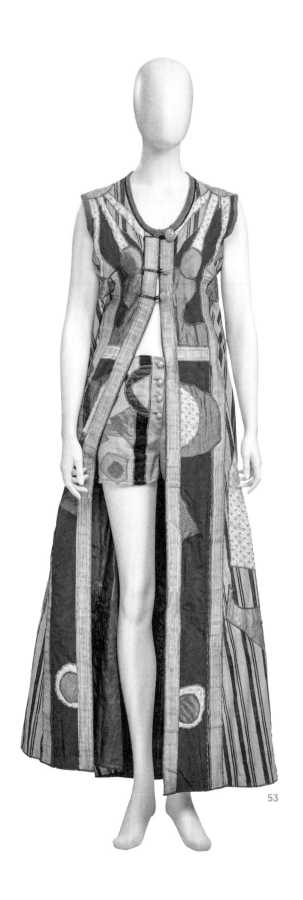

53

1973 looked to "the Old, the New and the Third World," as their label stated, for one-of-a-kind "ethnic"-inspired designs. Made from a patchwork of Indian and African fabrics, they were sold to small specialty shops such as Knobkerry, Inside Outlet, and Henri Bendel (figs. 52, 53). In 1969 Compton had also begun collaborating with Marian Clayden, whose theatrical experience included producing all the textiles for the nine near-simultaneous regional productions of the 1968 Broadway musical *Hair*. Clayden gradually turned to limited-edition garment production, and by 1974 Compton had returned to one-of-a-kind work, retaining his collaborative approach with Clayden and other California-based textile artists such as K. Lee Manuel and Nicki Marx. One writer described Compton's fantastic outfits as "idiosyncratic, painstakingly brilliant, and totally unclassifiable" and as "soul mirrors" that, like a full-length mask, "possess the particular identity of the woman for whom they are made."[8]

Compton's dresses reflected his theatrical roots and paid homage to many greats of fashion history—Paul Poiret, Madeleine Vionnet, Cristobal Balenciaga, and Charles James. His clients included women in music, film, and theater, and his dresses appeared on album covers and were worn onstage and to film premieres. In 1974 he conceived a trio of "gypsy" dresses that, like his earlier work with Marion Holmes, collaged recycled and new materials, including denim, hand-blocked Indian cottons, and silk organza. Two of them were worn by pop singer Kiki Dee: *Gypsy Dancer from a Long Forgotten Operetta* (fig. 54), made of silk organza and hand-screened Indian rayon georgette, was fold-dyed and its color then partially removed and embellished with beaded butterflies; and *Denim Gypsy*, an elaborate patchwork of lace and bleached and over-dyed denim recycled from blue jeans. *Ivory Gypsy* (fig. 55), the last of the series, was the most theatrical: with a hem circumference of thirty-two yards, it was reworked from an antique crocheted bedspread Compton had found years earlier in a San Francisco junk shop and was drawn to for "the incredible texture, and the color, including the stains and discolorations."[9] Anne Byrne Hoffman, then the wife of the actor Dustin Hoffman, acquired the dress from Julie: Artisans' Gallery and wore it to the premiere of *Lenny*, a biopic about comedian Lenny Bruce starring her husband.

54 Ben Compton's **Gypsy Dancer from a Long Forgotten Operetta** worn by singer Kiki Dee in a promotional poster for MCA Records, 1974

55 Ben Compton (American, 1938–1986). **Ivory Gypsy**, 1974. Cotton Kota-weave, batiste, crochet lace, ball fringe, and nylon braid; hand block-printed, partially bleached and over-dyed, tie-dyed, appliquéd, hand and machine sewn. Philadelphia Museum of Art. Gift of Anne Byrne Kronenfeld, 2016-104-1a,b

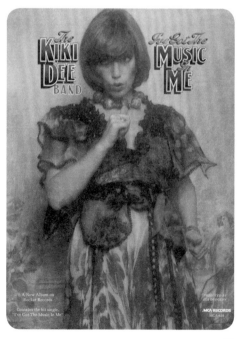

54

The artist Alexandra Jacopetti Hart reflected in *Native Funk and Flash: An Emerging Folk Art* (1974) on why Americans looked to other cultures for fashion inspiration: "Many of us have hungered for a cultural identity strong enough to produce our own versions of the native costumes of Afghanistan or Guatemala, for a community life rich enough for us to need our own totems comparable to African or Native American masks and ritual objects."[10] Following the book's publication, Jacopetti and two friends, Barbara Garvey and Ann Wainwright, launched Folkwear, a company offering patterns copied from ethnic and vintage clothing the three women had collected during their travels. Artists created their own versions using the patterns as basic templates. Ben Compton reimagined pattern #101, "Gaza Dress," in a patchwork of vintage fabrics and trimmings made for Julie Dale (fig. 56); Marika Contompasis's machine-knitted *Trout-Magnolia Kimono* (fig. 57) was based on pattern #113, "Japanese Kimono," and toured coast to coast with the *Folkwear* fashion show in 1977. "Peasant chic" played out as well, in the sewing patterns offered by *Butterick*, *McCalls*, *Simplicity*, and *Vogue* and the plethora of how-to books illustrated with works by art to wear's first generation of artists. These artists in turn were inspired by two recent publications, Dorothy K. Burnham's *Cut My Cote* (1973), based on the Royal Ontario Museum's collection, and the reissue of Max Tilke's *Costume Patterns and Designs* (1974), one of a series of books on folk dress from around the world originally published in Germany in the early 1920s.[11] Both books provided diagrams and layouts for untailored clothing constructed from cloth taken straight from the loom.

For many young people the search for authenticity and meaning translated into travel abroad and volunteering for the Peace Corps. Discounted fares aimed at students and youth-oriented guides such as the *Let's Go* series compiled by Harvard University students helped young travelers navigate work, study, and travel to Europe and beyond. Hitchhiking, backpacking, hanging out in

56

56 Ben Compton. **Gaza Wedding Dress**, c. 1977. Cotton twill and plain weave; resist-dyed, mirror embroidery, synthetic edging, upholstery trim, puff paint. The Julie Schafler Dale Collection

57 Marika Contompasis. **Trout-Magnolia Kimono**, 1977. Wool; machine knitted. Philadelphia Museum of Art. Promised gift of The Julie Schafler Dale Collection

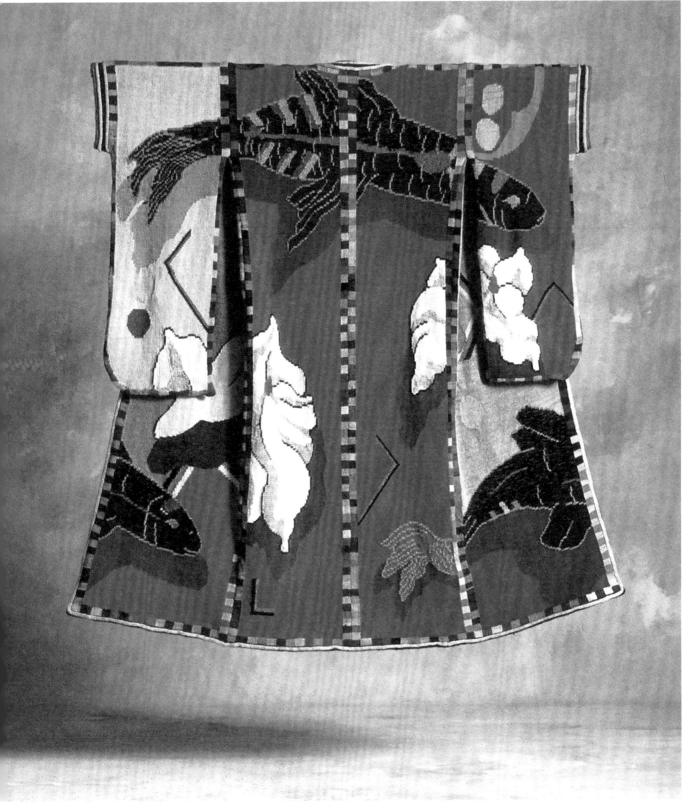

Amsterdam, London, and Paris, or venturing further afield to Afghanistan, India, and Nepal were rites of passage for many recent college graduates.

While traveling in Mexico in 1971 for "a summer of leather-craft, fabric design, and jewelry coupled with Mexican sunshine and brilliant outdoor markets,"[12] Anna VA Polesny embroidered a butterfly over a hole in her denim shorts (fig. 58). She continued to embellish them with personal images over the next two years, as her journey took her to sixteen countries in four continents. After returning from her travels in 1973, she submitted the shorts to the Levi's Denim Art Contest, where they won one of the fourth-place prizes.[13]

At the time, embellished denim was being feted as the new American folk art. Embroidered, studded, and painted denim jeans, overalls, jackets, and skirts stood out as unique expressions of individuality while also indicating allegiance to the broader youth culture. Polesny's shorts were one of five denim garments she decorated with embroidery between 1969 and 1976. They "evolved

52

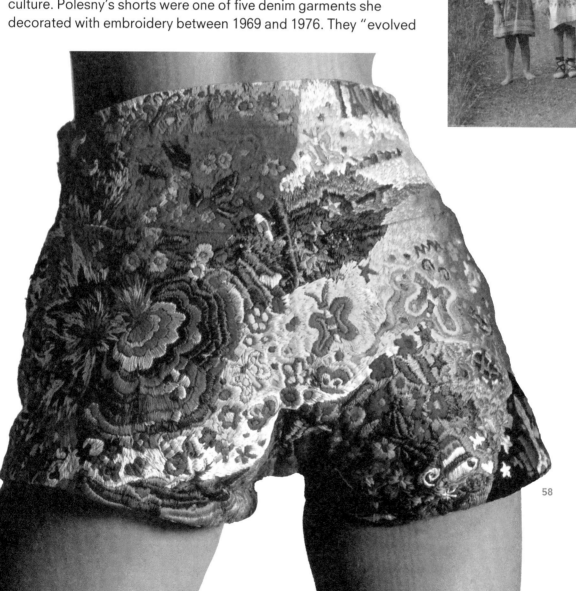

59

58

and took on a life of their own as I worked my way over the surface of each denim garment recording ideas, events, symbols, thoughts and attaching for posterity precious bits and pieces of my life."[14] The shorts' bright colors, she is quick to point out, reflected her study of the color spectrum and were not intended as an expression of the "hippie psychedelic palette." The embroidered letters IANNA combined her name with that of her boyfriend, Ian. Polesny's works drew on the Czech needlework traditions remembered from her childhood, especially *kroje*, the elaborately decorated ensembles worn on feast days that identified wearers with their villages (fig. 59). She learned to embroider at age six while attending a convent boarding school in the Himalayan Mountains of West Pakistan; by the time she entered high school in the United States she had attended eight schools on three continents.

Mary Ann Schildknecht (fig. 60) was also taught to embroider by nuns—in her case, while serving a two-year jail sentence in Milan for smuggling hashish. Her first large piece, a shirt, was made

from torn sections of her prison bedsheet she covered with satin stitch in psychedelic colors. While Polesny's embroidered shorts recorded her life experiences, Schildknecht's shirt explored tropes of hippie iconography through an Oz-like fantasy landscape with sun, forest, and road. One sleeve was embroidered with a castle (for parties), while the other featured a small circular opening or "port hole" in case, as the artist explained, she needed a blood transfusion.[15]

For some artists, exposure to other cultures challenged their preconceptions about what is or is not art.

58 Anna VA Polesny (American, b. Czechoslovakia, 1944). **International Levi's**, 1973. Cotton denim and cotton thread; hand embroidered. Philadelphia Museum of Art. Promised gift of The Julie Schafler Dale Collection

59 Sisters Anna Věra Alena, Máří Magdalena Naomi, and Zuzanka Polesná in their garden in Mlada Boleslav, Czechoslovakia. Photo by Alena Privazniková Polesná, MD, courtesy Anna VA Polesny

60 Mary Ann Schildknecht (American, b. 1947). **Embroidered Top and Skirt**, c. 1972. Cotton and velvet; embroidered. Collection of the artist

53

60

While a graduate student in painting at Yale, Ken Tisa was intrigued by the Haitian beaded and sequined banners in the exhibition *African and Afro-American Art* (1969), curated by Yale professor Robert Farris Thompson at the University Art Gallery. Soon after, while on a road trip to California, he be-came entranced by the Native American beaded vests he encountered on the reservations and felt a spiritual kinship with the art form. He began to embellish his favorite piece of clothing, a 1940s waistcoat, with beads, sequins, and pearl buttons. *Vest* (fig. 61), completed in 1974, had evolved organically over the previous five years, a process that fed his desire "to create without having creation separate from your life." He explains: "That's what wearable art is about. The pieces happen to be clothes, but they are conceived as art. Art can be anything, if it is done with passion and vision—with a certain abstract force. It is the obsession."[16] As he beaded the process came to reflect his own spiritual search, with the left image grounded in the materiality of the earth and the right in the otherworldly.[17]

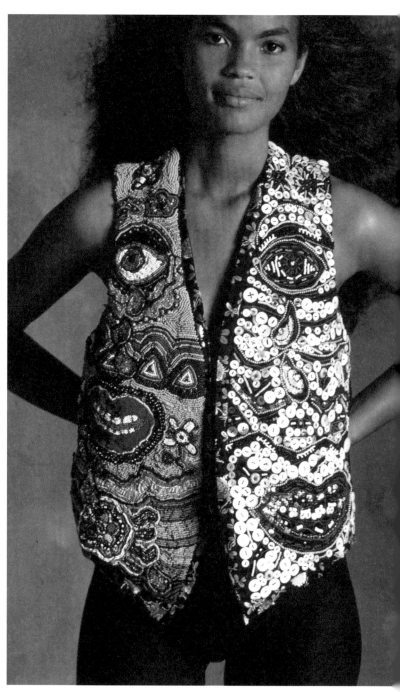

61 Ken Tisa (American,
b. 1945). **Vest**, 1974.
Glass beads, sequins,
and pearl buttons;
hand beaded, stitched.
Private collection

artful bodies

The notion of the body as canvas has long been explored in relation to tattooing and body painting as subcultural expressions with deeply rooted symbolic functions.[18] In the 1960s, the latter was initially associated with youth rebellion but by 1967 had become mainstream fashion as "young swingers" and "with-it girls" decorated themselves with Coty's Body Paints and Revlon's leg-art coloring kits. During Provincetown's Body Festival in 1968, artist Yayoi Kusama painted polka dots on naked bodies (fig. 62). At the psychedelic discotheque Electric Circus in New York's East Village, patrons were invited to have stars and flowers painted on their foreheads, cheeks, hands, and knees. Fashion photographers captured the German model Veruschka von Lehndorff's body decorated with a Pucci print and the British model Twiggy's "flower-power" eye for *Vogue* and *Harper's Bazaar*.[19] New York–based multimedia artist Mario Rivoli painted psychedelic bodies for the cover of the album *Don Sebesky and the Jazz-Rock Syndrome* (fig. 63). A corollary to this trend was the painted clothing by

62

63

62 Yayoi Kusama body painting, 1967. Photo by Seymour Wally / NY Daily News via Getty Images

63 Album cover for *Don Sebesky and the Jazz-Rock Syndrome*, 1968, featuring costumes and body painting by Mario Rivoli

Bay Area artists Candace Kling and Fred Kling (fig. 64) and K. Lee Manuel (fig. 65).

San Francisco's Jamie Summers made a name for herself as a tattoo artist while also pursuing painting, sculpture, ceramics, and textiles.[20] A protégé of the preeminent tattoo artist Don Ed Hardy, she worked under the nom de plume "La Palma" and was noted for creating abstract, subtly shaded animal-like markings (fig. 66). In a television interview Summers described her approach to body adornment: "I don't feel it's just an image placed on top of your body. I feel it's really part of you and coming to the surface.... Any image that I create for a person, that goes on a person permanently, should be about themselves, their psyche, their past, their present, and future, so I try to work with the person."[21]

Art and fashion connected through body jewelry. This new art form was influenced in part by "tribal" jewelry collected during travels, which had become a feature of counterculture dress, and original assemblages by artists such as Alex Maté and Lee Brooks, whose work was sold by Julie Schafler (Dale) and through the San Francisco gallery/boutique Obiko. By 1973 body jewelry had become part of the lexicon of artist craftsmen worldwide, including the Americans Arline Fisch and Marjorie Schick. Its forms had grown exponentially and were reaching garment-like proportions. Crafts author Donald J. Willcox observed: "Many of us are trying to bridge the gap between a piece of jewelry and a garment.... Not only are we seeking to master our own medium, but we are poking our noses out again, into the sanctuary of the fashion designer. We have served our apprenticeship, mastered it well, and matured in our medium. We no longer feel confined by limited definitions in how we express ourselves."[22]

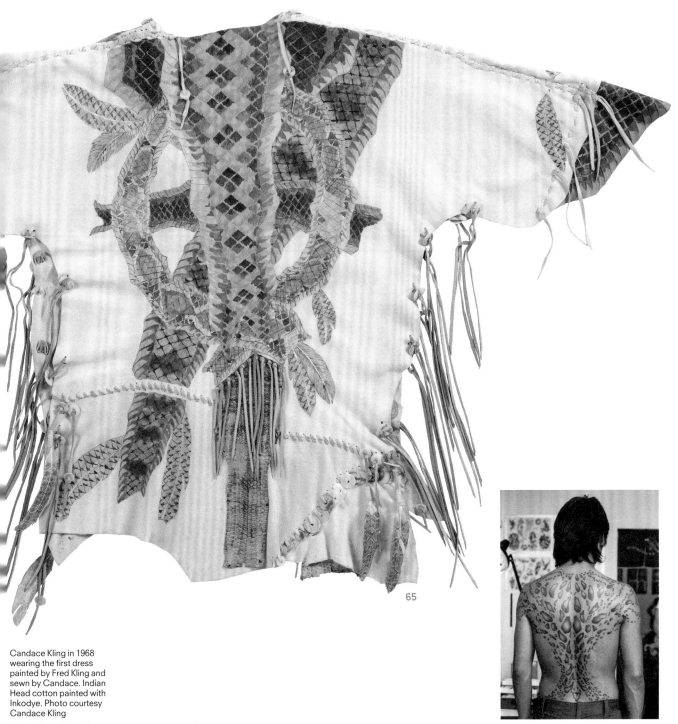

65

66

Candace Kling in 1968
wearing the first dress
painted by Fred Kling and
sewn by Candace. Indian
Head cotton painted with
Inkodye. Photo courtesy
Candace Kling

K. Lee Manuel (American,
1936–2003). **"Energy"
Poncho** (back view),
1975. Chamois leather,
snakeskin, horn,
mother-of-pearl discs,
and feathers; painted.
Courtesy Harrie George
Schloss

Tattoo by Jamie Summers,
also known as La
Palma. Photo courtesy
Julie Schafler Dale

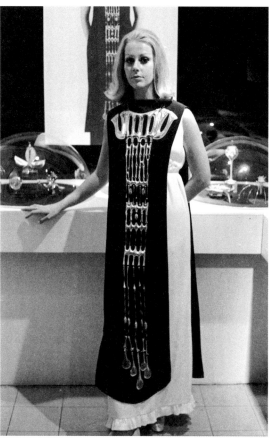

67

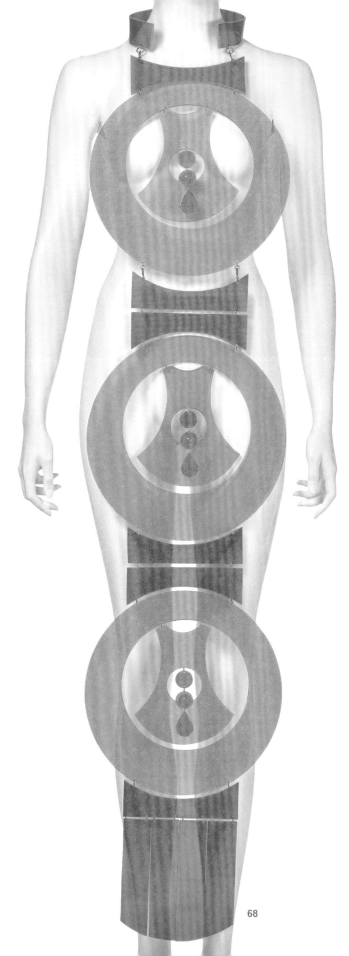

Artists arrived at body jewelry from many directions. For Schick it was a publication on the sculptor David Smith she read in 1966 while completing her graduate studies in jewelry at Indiana University, which led her to imagine experiencing his sculpture by inserting her head or arm through one of its holes. The realization that she could become part of a work instead of viewing it on a pedestal inspired her to create sculptures that could be worn or hung on the wall. The experience led her "to question what constitutes jewelry, but also how the wearer navigates life's spaces and what adornment truly means."[23] In contrast, Fisch was inspired by the pre-Columbian body jewelry she encountered in South America in 1965. In response she began to conceive forms as a kind of "body armor" and in 1966 applied oversize modernist silver ornaments to the front and back of a long black tabard open at the sides (fig. 67). Both artists became known for challenging accepted approaches. Over her influential fifty-year career Schick tested the boundaries of scale and materials, adopting painted wood and papier-mâché for her colorful oversize body sculptures and jewelry, while Fisch in the 1970s adapted the textile techniques of weaving, crochet, and knitting to metal for contemporary jewelry.[24]

Carolyn Kriegman's signature material was the acrylic plastic known as Plexiglas, made available in North America in the 1950s.[25] She used it to create her kinetic neckpieces, which by 1971 had become floor-length pectorals in transparent shocking pink and hot orange (fig. 68). When not worn, the oversize geometric shapes unhooked into shorter units that could hang on a pedestal or on the wall. Kriegman's designs were in keeping with the period's large-scale dress and furnishing prints, such as those by the Finnish company Marimekko, and mirrored

69

67 Guest wearing Arline Fisch's **Body Ornament** (1966) at the opening of *Jewelry by Arline Fisch* at the Museum of Contemporary Crafts, New York, 1968. Photo courtesy American Craft Council Library & Archives

68 Carolyn Kriegman (American, 1933–1999). **Plexi Pectoral**, c. 1971. Plexiglas and metal. Philadelphia Museum of Art. Promised gift of The Julie Schafler Dale Collection

69 Stephen Burrows (American, b. 1943). **Woman's Dress**, c. 1973. Wool blend knit. The Julie Schafler Dale Collection

59

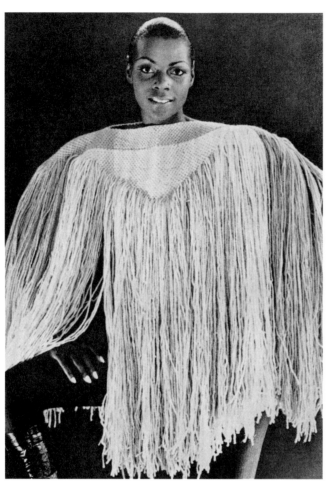

70

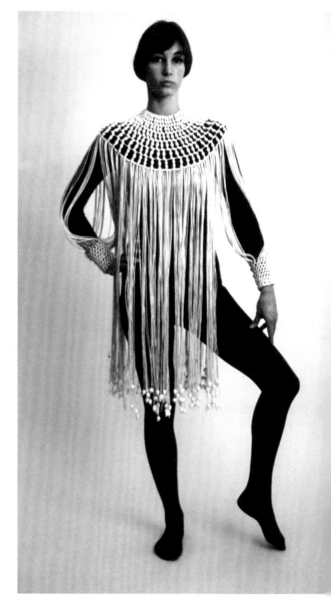

7

the cutouts in fashion newcomer Stephen Burrows's body-revealing knits sold through Henri Bendel (fig. 69).

Other artists experimented with macramé for body, face, and head coverings.[26] The technique was used by American fiber artists such as Claire Zeisler and Sheila Hicks to create striking sculptures in the early 1960s. Zeisler also used it in 1970–71 for two ponchos, one wearable (fig. 70) and one "symbolic." In less than ten years macramé was seen everywhere, with hobbyists adopting it for unimaginative wall hangings, plant holders, vests, and neckpieces.[27] Others deployed the technique more creatively. Louise Todd (Cope), for example, used knotted nylon fishing line strung with stoneware or porcelain beads and fiber-optic filaments that assumed a life of their own when the wearer's body moved (fig. 71). Macramé also briefly resonated in American fashion, as in Bill Smith's full-length pearl coat for the costume jeweler Richelieu (fig. 72) and Tzaims Luksus's tongue-in-cheek trompe l'oeil silk screen print for his eponymous fashion label (fig. 73).

In the hands of masters such as Raoul Spiegel and Paul Johnson, macramé reached its greatest heights when knotting was combined with other materials. For *Ptah Coat*, inspired by the Tutankhamun exhibition at the Metropolitan Museum of Art in 1978–79, Spiegel constructed a "soft body sculpture" from knotted leather thongs, feathers, and beads (fig. 74). Johnson sought to emulate "patterns left by melting snow, growths in cave formations, and crags and forms left by the tides."[28] His dramatic halter juxtaposes knotted linen, rock crystal, glass beads, shells, stones, and feathers (fig. 75).

70 Claire Zeisler (American, 1903–1991). **Macramé Poncho**, 1970, designed for a macramé exhibition at the Sherbeyn Gallery, Chicago. Photo from *Ebony*, July 1970

71 Louise Todd Cope (American, b. 1930). **Dress**, c. 1968. Fisherman's string and porcelain beads; macramé. Exhibited in *Body Coverings*, Museum of Contemporary Crafts, New York, 1968. Photo courtesy American Craft Council Library & Archives

72 Bill Smith (American, b. 1936). **Coat for Richelieu**, 1969. Faux pearls, brass metal chain, and ivory rayon cord tassels. Philadelphia Museum of Art. Purchased with the Costume and Textiles Revolving Fund, 2014-74-2

73 Tzaims Luksus (American, b. 1931). **Woman's Dress and Textile Design**, c. 1968. Printed silk satin, black satin ribbon. Philadelphia Museum of Art. Gift of Valla Amsterdam, 1996-101-2

61

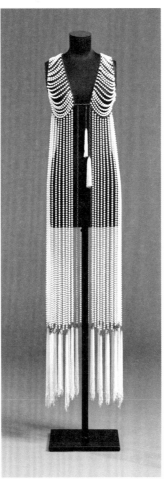

72

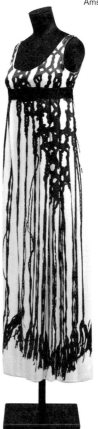

73

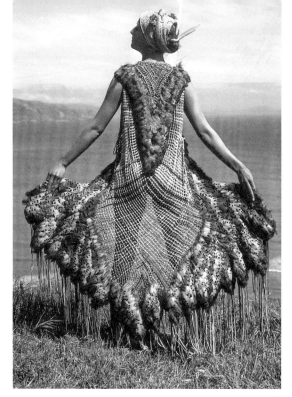

74

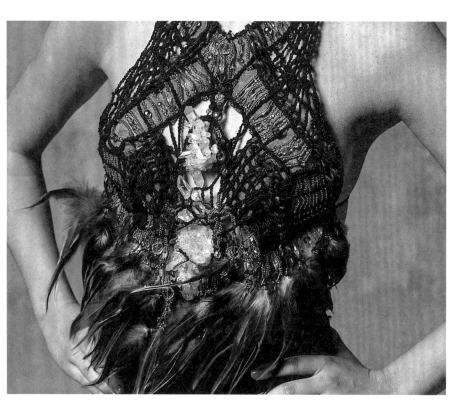

75

74 Raoul Spiegel (American, b. Germany, 1946). **Ptah Coat**, 1978. Leather, feathers, and beads; macramé. Collection of the artist

75 Paul Johnson (American). **Black Linen Rock Crystal Halter #239**, 1978. Waxed linen, rock crystal, crystal and glass beads, feathers, and ultrasuede; macramé, braided. Collection of Bonnie Ward Simon

76 Robert Rauschenberg (American, 1925–2008). **Bed**, 1955. Oil and pencil on pillow, quilt, and sheet, on wooden supports; 75¼ × 31½ × 8 in. (191.1 × 80 × 20.3 cm). The Museum of Modern Art, New York. Gift of Leo Castelli in honor of Alfred H. Barr Jr., RRF 55.004

77 Marilyn Pappas (American, b. 1931). **Opera Coat**, 1968. Satin, linen, fur, yarn, and synthetic fibers. Museum of Arts and Design, New York. Gift of the Johnson Wax Company, through the American Craft Council, 1977.2.68

assembled bodies

In 1961 the Museum of Modern Art presented *The Art of Assemblage*, a sweeping survey that traced the use of unorthodox materials in fine art from Pablo Picasso's first collage in 1912 to Robert Rauschenberg's then-recent combine paintings and other works by contemporary artists. By the late 1960s collage and assemblage had been deeply integrated into art education, where they were even incorporated into life-drawing classes. The Museum of Contemporary Crafts spotlighted the two approaches in its 1965 exhibition *Fabric Collage*, in which three-dimensional work by five contemporary women artists was shown alongside two smaller exhibitions of traditional women's work: one of American patchwork quilts, and the other featuring the reverse appliqué techniques of traditional *molas* made by the Kuna people of Panama and Colombia.[29] Lucy Lippard, a champion of feminist art, later reflected on collage as "a particularly female medium, not only because it offers a way of knitting the fragments of our lives together but also because it potentially leaves nothing out."[30]

Lippard's observation is demonstrated in the work of Alma Lesch and Marilyn Pappas, who bridged art, craft, folk art, and feminism by incorporating recycled clothing. Lesch's "portraits" of her Kentucky friends and family layered personal memorabilia such as eyeglasses and shirts into framed images that connected with American folk art traditions. Pappas's *Chest of Drawers*, an assemblage of socks, drawer pull, cotton, and embroidery, reflected the contemporary influence of Rauschenberg's combines (fig. 76). Pappas's assemblage *Opera Coat* (fig. 77) was later included in the landmark traveling

76

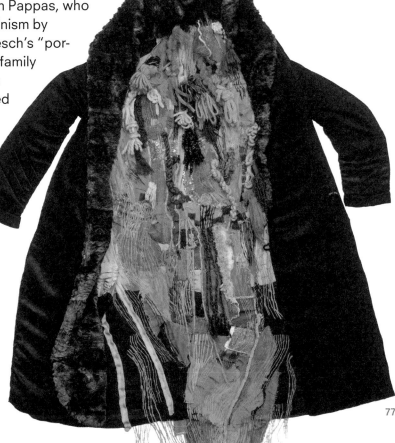

77

64

78 Mario Rivoli (American,
 b. 1943). **Overdone
 Jacket**, 1973. Found
 objects, silk, and cotton.
 Philadelphia Museum
 of Art. Promised gift of
 The Julie Schafler Dale
 Collection

79 Mario Rivoli in his
 apartment at
 175 MacDougal Street,
 New York, c. 1967.
 Photo: Frank Kolleogy

80 Mark A. Mahall
 (American, 1949–1978).
 Safety-Pin Jacket,
 1978. Brass, plastic,
 and synthetic. The
 Metropolitan Museum of
 Art, New York. Gift of
 Arthur and Joan Mahall
 and family, 1979 (1979.50)

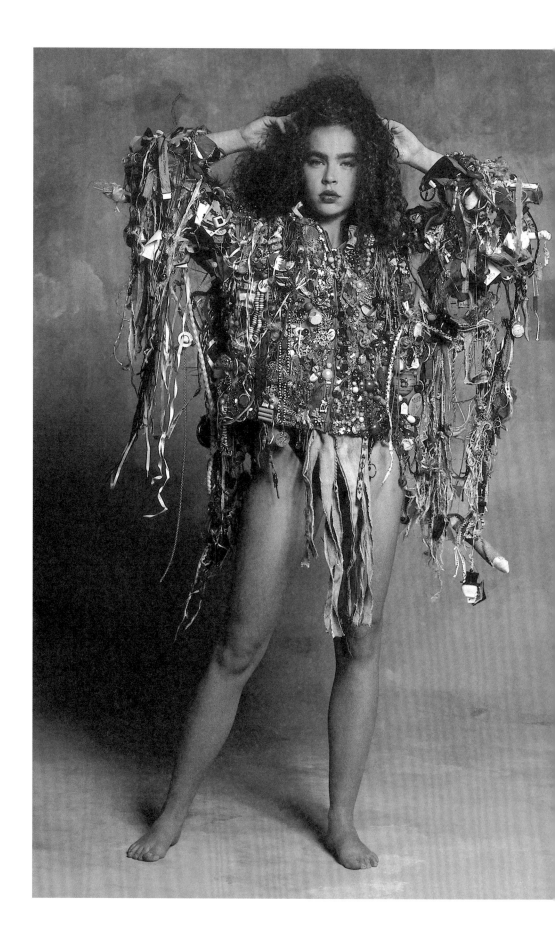

exhibition *Objects: USA*, which circulated in the United States and Europe in 1969–72. That piece and her *Army Shirt #3* (1970) spill out of the frame, paving the way for her work using collage and embroidery.

Artists such as Mario Rivoli saw assemblage as a way to erase the boundaries between art and life (fig. 79). Of his life in Greenwich Village during the 1960s he recalled: "I was my own assemblage when I was young— I mean really being a work of art. I wanted to include 'art' in very aspect of my life. I wanted to make 'art' as food, 'art' as clothing, 'art' as surroundings, because whatever 'art' was, I wanted to decorate it or rearrange it into a piece."[31] Over the years he illustrated children's books; made one-of-a-kind embellished leather coats, vests, and bags; painted bodies; designed theater sets; and, in 1977, when he moved to Denver, created restaurant murals, quirky six-foot-tall doll sculptures from found objects, and extravagant floral arrangements using glass beads. During his world travels, Rivoli filled his pockets with metal bottle caps, candy wrappers, and other throwaways, some of which ended up on the *Overdone Jacket* (fig. 78), started in re-

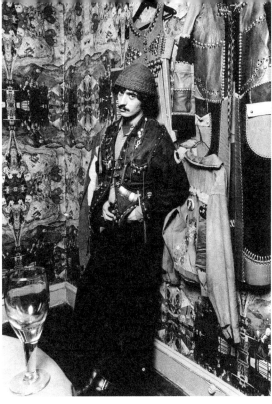

79

sponse to Levi's Denim Art Contest in 1973 but never submitted. Rivoli described it as shining like "a little faceted jewel" from a distance,[32] a comment that could apply equally to Mark Mahall's 1978 faux-leather jacket covered with thousands of small brass safety pins (fig. 80). For

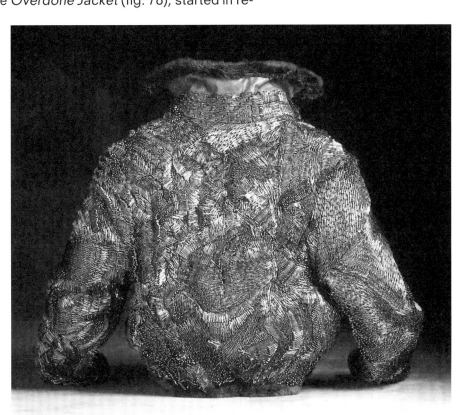

80

66

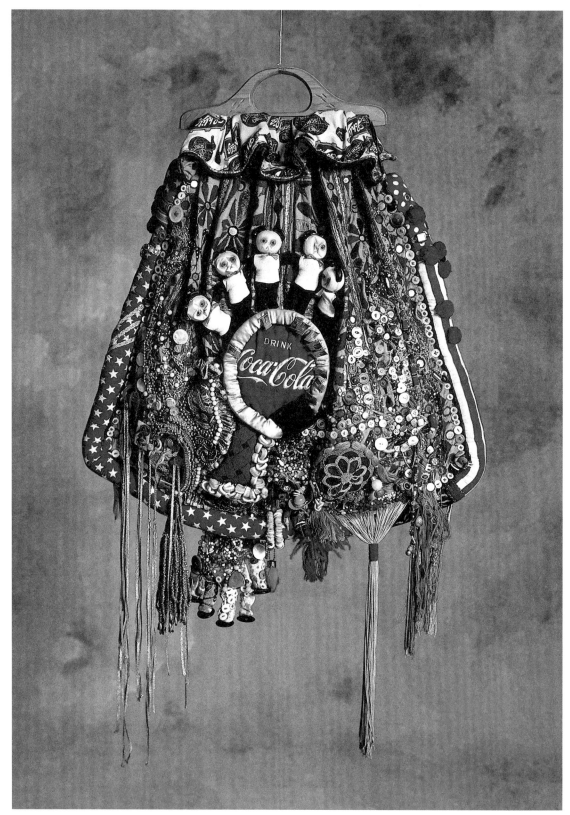

81 Mario Rivoli. **Bicentennial Bag**, 1975. Found objects, silk, and cotton; embroidered, assembled. Philadelphia Museum of Art. Promised gift of The Julie Schafler Dale Collection

82 Debra Rapoport (American, b. 1945). **Hoop Hat with Beaded Flowers**, 1993. Nineteenth-century hoop skirt, vintage beaded flowers, millinery foliage, tinsel cording, and metallic fabric. Philadelphia Museum of Art. Gift of Helen Williams Drutt English in honor of the artist, 2000-142-3

83 Yoshiko Wada (Japanese, active United States, b. 1944). **Coca-Cola Kimono**, 1975. Cotton and silk; warp-predominant plain weave, weft-resist dyed (ikat). Fine Arts Museums of San Francisco. Gift of Yoshiko I. Wada, 2005.28

Rivoli's oversize *Bicentennial Bag* (fig. 81), he embellished an Indian Rajasthani mirror-work textile with found objects, including a large red patch embroidered with the Coca-Cola logo, an image he used as a tongue-in-cheek symbol of global unity.[33] Many other artists during these years responded to this image, from Andy Warhol to textile artist Yoshiko Wada, whose *Coca-Cola Kimono* (fig. 83) ironically re-created the brand name using traditional Japanese resist-dyeing.

Of the first-generation art-to-wear artists, Debra Rapoport is unique in the seamless way she has integrated her life and art. As Jo Ann Stabb observed:

> She is uninterested in producing things for sale . . . things for any specific use, or purpose, truly only interested in creating an experience and experiencing creativity. . . . She responds directly to the potential of any range of materials— no matter how humble or unexpected—and she can suddenly arrange something completely out of context to become something to wear—on her head, her body, her feet—without precedent. Her body is her armature—and her materials— increasingly—are recycled from cultural "left overs."[34]

Rapoport's hoop hat from 1993 (fig. 82) is one such example; it was upcycled from a nineteenth-century hooped skirt and trimmed with extravagant beaded flowers she also made.

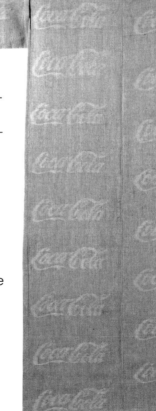

performing bodies

By the 1970s performance art had become a central fixture of the art scene, especially in the Bay Area, Los Angeles, and New York. Costumed performances took many forms, from purely art based events to confrontational protests addressing cultural and social issues of the day. In some performances, individual or multiple bodies assumed sculptural forms. Others involved role-playing and were informally scripted or choreographed, while some evolved as spontaneous events involving audience participation.

In 1971 the Museum of Contemporary Crafts presented *ACTS: A Series of Participatory Exhibitions / Events for Total Involve-*

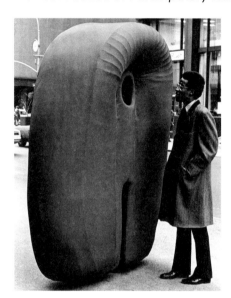

84

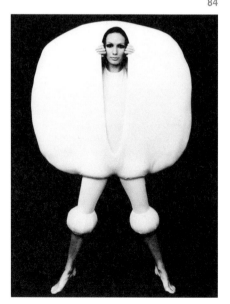

85

ment, a three-part exhibition focusing on performance. The show included two types of oversize inflatable sculptures by the Swiss artists Carl Bucher and Heidi Bucher, which the couple wore on the streets of New York; *Phosphorescent Inflatables* of soft vinyl glowed in the dark and were meant to be worn, while the *Apparel Sculptures* functioned as objects (figs. 84, 85).[35] The third act of the exhibition, *Costume Statements*, was an interactive event in the galleries in which five artists made and wore a variety of body coverings, wearable sculptures, and costumes for improvised performances. June Ekman and Burt Supree worked with visitors creating costumes out of newspapers, Debra Rapoport made "Fibrous Raiments" for

84 Carl Bucher (Swiss, 1935–2015) and Heidi Bucher (Swiss, 1926–1993). **Apparel Sculpture**, 1971. Photo courtesy American Craft Council Library & Archives

85 Carl Bucher and Heidi Bucher. **Phosphorescent Inflatable**, 1971. Photo courtesy American Craft Council Library & Archives

86 Performance artist Pat Oleszko (American, b. 1947) as **New Yuck Women: Fishwoman**, 1971. Presented in *ACT III: Costume Statements*, *ACTS*, Museum of Contemporary Crafts, 1971. Photo courtesy American Craft Council Library & Archives

87 Robert Kushner (American, b. 1949). **New York Hat Line: Pink Serenade**, 1974. Photo: Kathy Landman

the public to try on, and Evelyn Roth guided participants in recycling old garments and cloth into new sculptural wearables. Pat Oleszko used her own body as "an art playground" to create "visual editorials" of types of people inspired by Bernard Rudofsky's recently published *The Unfashionable Human Body* (1971). Oleszko, whose interest in costumed performances was encouraged by visiting artists Claes Oldenburg and Andy Warhol while she was a student at the University of Michigan in the late 1960s, used satire and exaggeration in her performances. For *New Yuck Women*, a solo exhibition presented the same year at the Museum of Contemporary Crafts, she re-created six stereotypes from the city's neighborhoods—Fishwoman (fig. 86), Playboy Bunny, Secretary, Old Woman, Woman's Lib, and Upper East Side Matron.

Robert Kushner constructed many of his early performance pieces as fashion shows. In 1972, while living in California, he presented *Costumes Constructed and Eaten*, a performance of edible attire. His interest in clothing was further fueled when he returned to New York and encountered the legendary exhibitions curated by Diana Vreeland at the Metropolitan Museum of Art's Costume Institute from 1972 to 1989. Between 1973 and 1976 Kushner presented a series of performances, including *The New York Hat Line* (fig. 87), which consisted of six hats for a tourist's day on the town, first performed in 1975 and later reprised at the Museum of Modern Art in 1978. By 1981

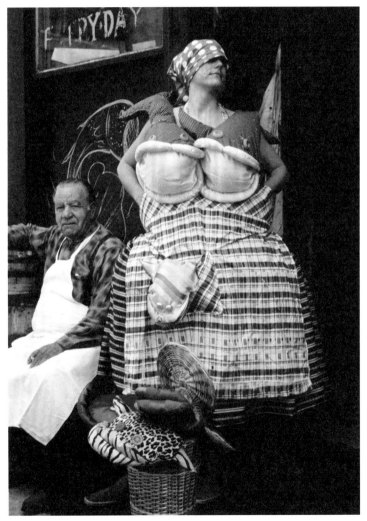

86

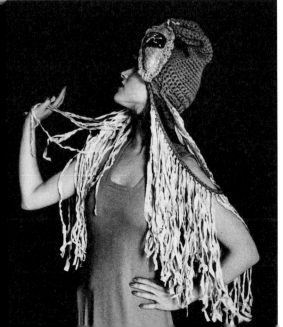

87

nsconnectionsconnectionsconnectionsconnectionsconnectionsconnectionsconnectionsconnectionsconnectionsconnectionsconnectionsconnectionsconnectionsconnectionsconnectionsconnectionsconnection

69

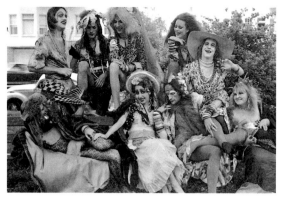

88

he was fully committed to the Pattern and Decoration movement, which resonated with the decorative and graphic elements of art to wear.

San Francisco was home to the gender-bending theater group The Cockettes (1969–72; fig. 88) and its offshoot Angels of Light, which were among the "radical" character-based costume performance ensembles. Their female personas, both on and off the stage, wore outrageous outfits reworked from stage costumes, vintage clothing, and anything else they could find.[36] Soon after the Cockettes disbanded, Kaisik Wong took center stage with a different kind of street presence based on fantasy.[37] He was unique in his ability to bridge performance, wearable art, and ready-to-wear fashion over his two-decade career (fig. 89). Wong attended Parsons School of Design in New York for less than a year and briefly worked for the American fashion designer Adele Simpson before returning to San Francisco in 1971. By 1973 he had joined Sandra Sakata's boutique/gallery Obiko as artistic director and creative designer, continuing as a consultant until his death in 1990. His most dramatic work, *The Seven Rays*, was commissioned by his friend Salvador Dalí in 1974 for the opening of the Dalí Theatre-Museum in Figueres, Spain. In 1976 he started designing on his own for private clients, including movie and music celebrities such as Tina Turner and Elton John. Wong's enigmatic work mixed and layered colors, fabrics, forms, and images from nature, as well as the myths and legends of Asian, South American, and Central American cultures.

In New York, multimedia artists Stephen Varble (fig. 90) and John Eric Broaddus (fig. 91) took their provocative performances to the city's streets

88 The Cockettes in the Panhandle, San Francisco, 1971. Photo: Fayette Hauser

89 Kaisik Wong with model Merle Bulatao, wearing Wong's **Red Ray** from the series **The Seven Rays** (now in the Fine Arts Museums of San Francisco), Spain, summer 1974. Photo: Steven Arnold

90 Performance artist Stephen Varble poses in one of his handmade outfits, 1975. Photo: Jack Mitchell / Getty Images

91 Performance artist John Eric Broaddus on the cover of *Fiberarts*, September/October 1984. Photo: Richard Toglia

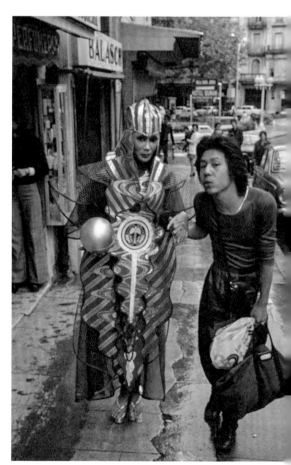

90

91

in the 1970s. Both assembled one-of-a-kind costumes from found objects, street trash, and even food. Varble, whose works challenged gender norms, led one-person Costume Tours of New York in 1975–76, visiting banks, museums, galleries, and boutiques to protest the establishment. Broaddus, who initially worked with Varble, assembled men's clothing that he wore to festivals and clubs such as Studio 54 and Xenon. Broaddus described his work as "appearances," distinguishing it from Varble's, which he identified as performance. As he explained, "An appearance is someone stepping out as himself, not someone who dresses up and takes on another's identity."[38] In the late 1970s Broaddus created the costume series *Endangered Species* to address the degradation of the environment.

In Seattle, the Friends of the Rag, a loosely allied group of some forty fiber artists, fashion designers, and theater costumers, tapped their professional skills to present forty-two public performances as well as numerous invitation-only appearances between

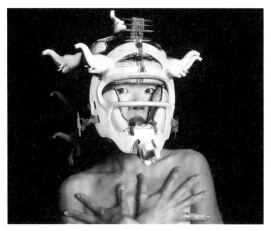

92

connectionsconnectionsconnectionsconnectionsconnectionsconnectionsconnectionsconnection

92 Susan Nininger
(American, b. 1952).
Untitled Mask, late
1970s. Clay, fabric, and
plastic. The Julie Schafler
Dale Collection

93 Susan Nininger. **Duck:
Hunting**, 1979. Cotton
flannel, corduroy, chintz,
bamboo, rafia, and paper;
stitched, assembled,
cast. Photo: Jim Cummins

1972 and 1980. In 1978 they performed *Traveling Modes and Devices: The Traveling Show* at the Renwick Gallery in Washington, DC. Member and multimedia artist Susan Nininger told stories using costume, body objects, and costume sculpture, each of which she regarded as a distinct form. Costume and body objects were designed specifically for the body and worn for performances (figs. 92, 93), while costume sculptures were conceptual works using costume and clothing forms to imply a human presence. Nininger's *Untitled Mask*, a costume sculpture from the late 1970s, combines sculpted ceramics (she trained as a ceramicist), fiber, wood, and plastic into a bizarre fantasy image resembling an elephant with two trunks. The story is left to the viewer's imagination. By 1981 Nininger was well on her way to establishing herself as a costume designer and stylist for film, stage, music videos, commercials, and print, and also became a faculty member of the Film and TV Costume Design Program at the Fashion Institute of Design and Merchandising (FIDM) in Los Angeles.

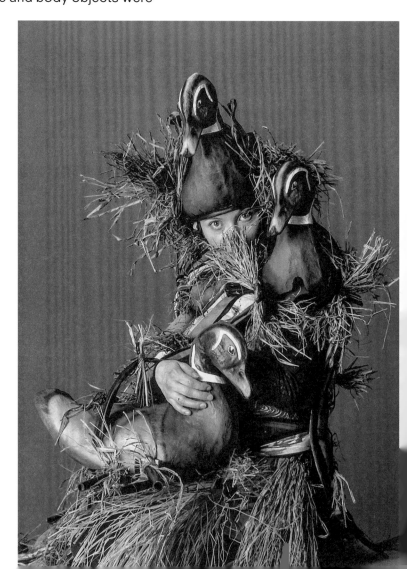

nature's bodies

Nature has always been a rich source of imagery for artists, and during the period under consideration here it inspired new forms such as site-specific Earth Art, which emerged in the late 1960s along with the modern environmental movement. The publication of Rachel Carson's *Silent Spring* in 1962 had focused attention on the dangers of DDT and other pesticides, but it was not until January 28, 1969, that the long-term implications of manmade disasters were brought home. The oil blowout at Platform A off the coast of Santa Barbara, California, was an environmental crisis with repercussions never before imagined. Three million gallons of crude oil were released into the ocean, coating 35 miles of beach and killing more than 3,600 seabirds and countless fish, dolphins, seals, and sea lions. The oil industry and the community were completely unprepared for such a calamity. Citizens rallied, organizing the all-volunteer Get Oil Out and establishing an Environmental Rights Day on the first anniversary of the blowout. The first Earth Day was celebrated on April 22, 1970, and universities began setting up ecology centers and offering environmental studies as a major.

For many artists, these events and others to follow were life changing and became the central focus of their work. For Canadian performance artist Evelyn Roth, who worked on both sides of the border, it meant committing herself full-time to environmental issues. She recycled fabrics, leather, fur, feathers, newspaper, and television videotape, crocheting, knitting, and knotting them into new forms. These were employed in outdoor performances by the Evelyn Roth Moving Sculpture Company (1973–c. 1990) aimed at drawing attention to human beings' connections with nature, especially coastline beaches and marine life. Roth had been introduced to videotape as a material by Debra Rapoport in 1971 at the Museum of Contemporary Crafts, and she began to crochet it into clothing and accessories such as a "cozy" for her car (fig. 94). She reworked yarn from unraveled sweaters into a shared family sweater for four, a garment that recalled James Lee Byars's *Plural Dress* shown in the 1968 *Body Coverings* exhibition (fig. 95).

94

94 Evelyn Roth (Canadian, b. 1936). **Video Tape Car Cozy**, 1971. Photo courtesy Centre for Contemporary Canadian Art

95 James Lee Byars (American, 1932–1997). **Plural Dress**, 1967. Photo courtesy American Craft Council Library & Archives

95

74

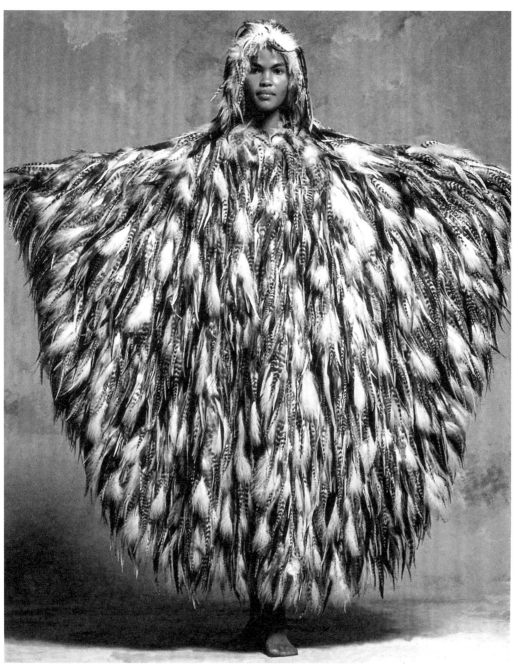

96

96 Joan Ann Jablow
(American, b. 1941). **Big
Bird**, 1977. Feathers,
wool knit, and silk
polyester; glued, stitched.
Courtesy Harrie George
Schloss

97 Bill Cunningham
(American, 1929–2016).
Griffin Mask, 1963.
Feathers, sparterie, wire,
jersey, and velour;
molded, stitched, glued.
Philadelphia Museum of
Art. Promised gift of
The Julie Schafler Dale
Collection

98 Jamie Summers
(American, 1948–1983).
**Crustaceans and
Venomous Marine Life
Converging on Hair
Tide (Lobster Jacket)**,
1977. Velvet, silk, human
hair, and clay; quilted,
stitched, appliquéd,
painted, crocheted.
Philadelphia Museum of
Art. Promised gift of
The Julie Schafler Dale
Collection

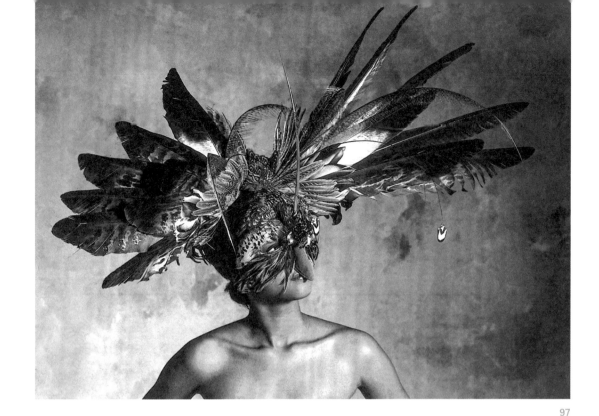

In 1975, she published *The Evelyn Roth Recycling Book*, a how-to guide on creating art from everyday materials.

The organic character of free-form crochet and assemblages of found materials such as fur and feathers easily translated into art to wear that evoked images and forms from nature. Susanna Lewis's interest in biology translated into a cape illustrating the life cycle of the monarch butterfly (see fig. 156). Joan Ann Jablow (fig. 96), Bill Cunningham (fig. 97), and K. Lee Manuel gave new life to feathers, forming them into masks, capes, and, in Manuel's case, decorated collars with painted images (see fig. 102). Jamie Summers explored her spiritual connection to the oceans and the universe in embellished surfaces (fig. 98; see also fig. 142). Nicki Hitz Edson's series of machine-knitted kimonos focused on the changing colors of the seasons (see figs. 45–48). Tim Harding rendered painterly impressions of seascapes, koi ponds, fields, mountains, and gardens using his own technique of reverse appliqué to capture light and movement (see fig. 171). Risë Nagin captured the essence of road travel and its fleeting images in transparent, layered fabrics (fig. 99).

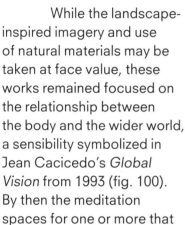

99

While the landscape-inspired imagery and use of natural materials may be taken at face value, these works remained focused on the relationship between the body and the wider world, a sensibility symbolized in Jean Cacicedo's *Global Vision* from 1993 (fig. 100). By then the meditation spaces for one or more that had been explored by many artists during the late 1960s and 1970s—from individual "tents" conceived by Marian Clayden to the shared spaces of Byars's *Plural Dress* and Roth's *Family Sweater*—had intersected with wearable art. The body as framework could be present or absent, the work might be worn or hung on a wall, but the human (and humanitarian) cognitive content was firmly implied. On the world stage, this boundary-breaking American approach had been first articulated at the World Crafts Council's 1980 conference in Vienna, where Katherine Westphal led a group presentation by artist-educators then working in Northern California, a region whose impact on the national and global art-to-wear movement is explored in the next chapter.

99 Risë Nagin (American, b. 1950). **Road Goliaths**, 1985. Silk, cotton, polyester, and acrylic paint; stained, layered, appliquéd, pieced, hand sewn. Museum of Arts and Design, New York. Gift of the artist, 1995.56

100 Jean Williams Cacicedo (American, b. 1948). **Global Vision: Save Earth**, 1993. Wool; felted, dyed, reverse appliquéd. Philadelphia Museum of Art. Promised gift of The Julie Schafler Dale Collection

100

"Good Vibrations," the Beach Boys' single released on October 10, 1966, is widely acknowledged as the seminal composition of the nascent psychedelic-rock movement and an anthem for the 1960s counterculture. It also provides insight into the underlying focus of the West Coast's emerging art-to-wear movement. With a title derived from composer Brian Wilson's fascination with cosmic vibrations, the song suggested extrasensory perception and, in doing so, aligned itself with the Flower Power movement. More telling, however, was the statement by publicist Derek Taylor, who had worked with the Beatles and would help organize the Monterey Pop Festival in June 1967: "Wilson's instinctive talents for mixing sounds could most nearly equate to those of the old painters whose special secret was in the blending of their oils. And what is most amazing about all outstanding creative artists is that they are using only those basic materials which are freely available to everyone else."[1]

"excitations" and exhibitions

"Those basic materials" equally might refer to the textiles and garments that emerged as part of the youth culture associated especially with San Francisco, which attracted some 100,000 people under twenty-five during 1967's Summer of Love. Much of what was worn on the streets, then and later, was homemade or adapted, often from secondhand clothing. So central to this look were the classic Levi denim jeans—I too cut open the lower side seams to insert flares of paisley-printed fabric—that this San Francisco–based firm experienced record-breaking expansion; between 1964 and 1974 its US manufacturing facilities increased from sixteen to sixty-three and twenty-three new overseas units were opened. Capitalizing on this phenomenon, the Levi's Denim Art Contest was launched in 1973 by Richard M. Owens, publicist for the firm.[2] More than two thousand entries from every US state except Alaska, as well as Canada and the Bahamas, were judged by a panel that included Los Angeles–based fashion designer Rudi Gernreich and three San Franciscans: influential modernist photographer Imogen Cunningham, M. H. de Young Memorial Museum curator of painting and sculpture Lanier Graham, and *San Francisco Chronicle* art critic Tom Albright. The panel reviewed 10,000 slides and selected 25 winners and 25 honorable mentions.

Denim Art, the resulting exhibition, premiered in the spring of 1974 at the Museum of Contemporary Crafts, New York, and then

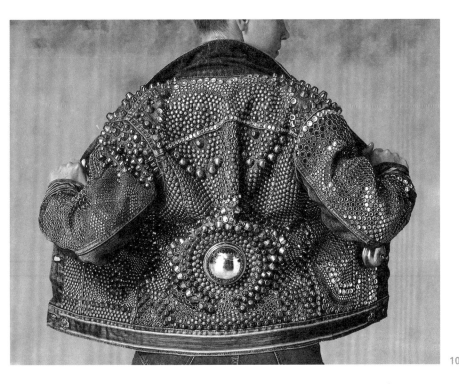
101

101 Billy Shire (American,
b. 1951). **"Anonymous"
Jacket**, 1973. Cotton
denim twill, metal,
rhinestones, and ribbons.
Collection of the artist,
courtesy La Luz de Jesus
Gallery, Los Angeles

102 K. Lee Manuel. **Maat's
Collar**, 1990. Painted
feathers and braided cord.
Philadelphia Museum
of Art. Promised gift
of The Julie Schafler Dale
Collection

toured for over a year, with stops in its spiritual San Francisco home, the de Young; the Los Angeles Municipal Art Gallery; the Madison Art Center in Wisconsin; and Arizona State University, Tempe. The winning garment was a metal-studded jacket by Billy Shire (fig. 101), whose business, Ducks Deluxe, made similarly studded leather belts for musicians in Los Angeles. While Shire's jacket resonated with the look of the Hell's Angels, who had acted as peacekeepers during the Summer of Love, the entries were "by and large less 1950s biker tough and more psychedelically whimsical."[3] As a result, Bay Area artists were increasingly associated with "hippy," and not as a compliment. Californian textile artist Ana Lisa Hedstrom still recalls when the term was later disdainfully hurled at Gaza Bowen in New York. "The prejudice was really strong," she said, adding: "There was a hippy aspect then, but, boy, the craftsmanship was superb."[4]

Bodywear, orchestrated by the Oakland Art Center in 1974, told a very different story from the *Denim Art* show, and one that underscores Hedstrom's remarks. Many of the thirty-one Californian artists

102

82

included in the group-planned exhibition provided statements for the typescript catalogue, and these reveal a nuanced blend of interests in materials and quality, but also in "excitations." Among those who touched upon the spiritual dimension of their work were Jean Ray Laury—who in the same year co-authored *Creating Body Covering* with Joyce Aiken—and Lynne Streeter, whose intent was to "materialize or recreate myself . . . to crochet my aura."[5] K. Lee Manuel (fig. 102) documented her aim as "creating a visual energy space using the body as armature for art," while Kaethe Kliot, a master of bobbin lace, pushed for "more than pleasing the eye," stating that "the sharing of the spirit is the final objective."[6] Candace Crockett asserted that "fibers are an inspiration to the visionary and fantastic," adding: "Spontaneity and freedom are very important . . . to transcend space, to create another world—a special and magical world which has strength and life."[7]

103

Similar links between textiles and personal expression had previously been brought to the fore by *Fabric Vibrations*, a 1972 exhibition of tie- and fold-dye wall hangings and environments at the Museum of Contemporary Crafts. Director Paul J. Smith's accompanying statement noted: "During the last few years there has been a revival of this art, particularly among young people. There is fascination with the spontaneity and mystery of the process; the end result, vibrations of color and pattern, relate directly to the youth culture today—their music, their interest in the mystical, and their life style."[8] Among the eight invited artists was Marian Clayden, who from California contributed six works, including *Meditation Tent* and *Ceremonial Enclosure* (fig. 103).

Bodywear was one of several regional shows scheduled to coincide with "Convergence," the second National Conference of the Handweavers Guild of America, founded in 1969. The choice of San Francisco and Oakland as venues for the conference reflected three factors, two localized and one with international ramifications. The first was the existence, by 1974, of twenty-five guilds of the Conference of Northern California Handweavers. The second factor was the burgeoning number of workshops within an hour's drive of the Bay Area, a topic to which we shall return. The third was *Deliberate Entanglements*, an exhibition at the UCLA Art Galleries that had opened late in 1971. Curated by Bernard Kester, head of UCLA's fiber program,

the exhibition was accompanied by the week-long conference "Fiber as Medium," which is credited with giving rise to the term "fiber art," notwithstanding the groundbreaking *Wall Hangings* exhibition at MoMA in 1969. *Deliberate Entanglements* toured to Portland, Oregon, and Salt Lake City before ending up at the Palace of the Legion of Honor in San Francisco in September 1972.

Although the art-to-wear movement would soon be regarded as a distinct entity, throughout the Western United States its origins owed much to the freewheeling exchange between those making and promoting fiber sculptures, others "upcycling" and inventing artistic clothing, and new arrivals to the Bay Area such as Clayden (from England via Australia), Yoshiko Wada (from Japan via Colorado), and, from Pratt, Janet Lipkin and Marika Contompasis (fig. 104). Contompasis, who taught crochet along with Lipkin at San Francisco State in the early 1970s, observed, "Fine artists who have become disenchanted with the white canvas because of its distance from everyday life, are taking on these 'warmer' arts of the craftsman. We try to put fine art into everyday life by wearing it, sitting on it, sleeping under it."[9] Kester, though more interested in sculptural and architectural outcomes, agreed: "Artists are designer-craftsmen who execute their own work, and intimate involvement with the material brings out the unity of materials, concept and form."[10] Of the thirteen works he selected for *Deliberate Entanglements*, five had originated in Europe, one in Colombia, and seven in the United States; of the latter, two were by UCLA graduates Neda Al Hilali and Françoise Grossen, and another was by Kay Sekimachi, who lived in Berkeley.

Thus, by 1974, the exhibition catalogue for *Bodywear* could state with confidence that "California is particularly rich

103 Marian Clayden (British, active United States, 1937–2015). **First Ceremonial Enclosure**, 1971. Silk; folded, multistage stitch-resist dyed and discharged. Museum of Arts and Design, New York. Gift of the artist, through the American Craft Council, 1989.4

104 Marika Contompasis. **Garden Triptych Coat**, 1975. Wool, yarn, and wood; crocheted. Collection of Jerri Sherman

105 K. Lee Manuel. **Conflicts/ Contrasts**, 1982. Chamois and feathers; painted. Location unknown

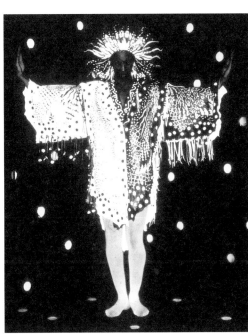

in both [the] number of its textile artists and the quality of their work."[11] This is entirely borne out by the seminal exhibition held nine years later at the American Craft Museum (as the Museum of Contemporary Crafts had been renamed in 1979). Eleven of the twenty-five artists shown in *Art to Wear: New Handmade Clothing* were based in Northern California—Jean Cacicedo (who moved to Berkeley in 1980), Marian Clayden, Judith Content, Danielle Cuvillier, Lea Ditson, Ana Lisa Hedstrom, Ina Kozel, Janet Lipkin, K. Lee Manuel (fig. 105), Gloria Walsh, and Katherine Westphal—while a twelfth, Marika Contompasis, had moved to Los Angeles. Together this was twice the number of New York artists represented. In addition, Ellen Hauptli, a Californian who lived in Brooklyn from late 1979 into mid-1984, tipped the balance of exhibitors to a majority with a California ethos. Since this ethos involved responding to a "freer" lifestyle—as well as a more temperate climate that encouraged the use of lighter, more fragile, and more fluid materials—it was natural that so many Californian artists met the exhibition criteria, which insisted that garments "be truly wearable…a three-dimensional form in motion."[12]

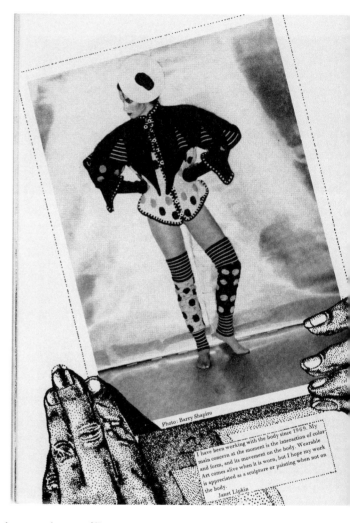

Photo: Barry Shapiro

I have been working with the body since 1969. My main concern at the moment is the interaction of color and form, and its movement on the body. Wearable Art comes alive when it is worn, but I hope my work is appreciated as a sculpture or painting when not on the body.
Janet Lipkin

Also mounted in 1983, ten miles north of Oakland at the Richmond Art Center, was *Poetry for the Body: Clothing for the Spirit*, curated by Jo Ann C. Stabb, an influential member of the design faculty at the University of California, Davis. Of the forty-four participants in this national invitational show, twenty-seven were from California, with the remainder (including nine from New York City and environs) selected with input from Julie Schafler Dale. Its catalogue (fig. 106) captures the boundary-breaking attitudes of those involved in what Stabb called "intimate, body-scale art developed as an outgrowth of the declaration of individuality of the 1960s." Of that new direction, Clayden wrote: "Everything is possible—even garments which are associated with function and commerce, can speak to the spirit." In contrast, Pat Hickman (fig. 107) was excited by

"clothing as image and idea ... especially when it is not necessarily 'wearable' but momentarily caught between being functional and being totally non-wearable," adding the caveat that "this temporary, often fragile state, when time has apparently stopped, allows me to wonder about the meaning of clothing as art." Debra Rapoport (fig. 108) described her art in a free-verse poem that included the lines "Its form is packaging. I want to speak of contemporary life.... I want to appreciate and respect the mundane.... What I DO documents this energy."[13] Candace Kling, who showed one of her complex, head-encasing creations (fig. 109), referenced the Yoruba belief that the head contains the essence of personality and spirit. She later recalled this exhibition as "a benchmark," adding: "I went all over the world because of that show and meeting all those others involved."[14]

A decade and a half after the Summer of Love, the art-to-wear movement had reached maturity. The years ahead would see an expansion in the opportunities to show work, largely driven by the phenomenal growth of craft fairs. Major museum exhibitions still tended to focus on fiber as objects or wall

106 Janet Lipkin's 1983 machine-knitted ensemble as shown in the exhibition catalogue for *Poetry for the Body: Clothing for the Spirit* (Richmond Art Center). Graphics: Frances Butler; photo: Barry Shapiro

107 Pat Hickman (American, b. 1941). **One Size Fits All**, 1999. Garment pattern piece; stamped, stitched. Courtesy of the artist

108 Debra Rapoport. **Three-Part Necklace with Lotus Blossoms**, 1984. Embroidery, plastic, wire, copper tubing, paper cord, paint, rag, ribbon, and lotus blossoms (silk). Courtesy of the artist

109 Candace Kling (American, b. 1948). **Church and Steeple**, 1983. Persian lamb, satin, buckram, organdy, and metallic nylon. Courtesy of the artist

85

107

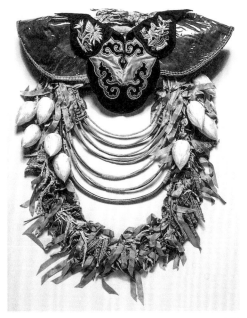

108

109

hangings: Lia Cook at the Oakland Museum (1995) and the Renwick Gallery in Washington, DC (1996); Ed Rossbach at the Renwick Gallery (1997); and Gaza Bowen at the Museum of Art and History, Santa Cruz, California (1997), the latter having turned from making shoes to mixed-media sculpture two years earlier.[15] Of an exhibition devoted to African American improvisational quiltmaker Rosie Lee Tompkins at the UC Berkeley Art Museum (1997), one critic wrote: "The exhibit says the critical barriers that once stood between art and craft, between popular and elite sensibility, between European and pan-cultural aesthetics, are down. It would appear that, having moved away from the decorative arts, and successfully survived the dichotomizations of 'craft versus art' discussions, fiber art, is now to be seen simply as art."[16] However, Hedstrom, speaking as a founding member of the art-to-wear movement, stresses that "fiber art had become separate from wearables, and except for the always-conceptual Debra Rapoport, we didn't get invited."[17] Nevertheless, as we shall see, the Bay Area art-to-wear movement had international repercussions.

material matters

The influence of climate on the West Coast aesthetic aside, Rapoport in her 1974 *Bodywear* statement highlighted another key element of the California ethos, namely a focus on "the spontaneity of fibrous materials—i.e. raw fiber, cordage, papers, plastics, wire, etc....I see and sense a form (these forms I experience visually in other media) but I need to make my statement through fiber."[18] Seven years earlier, an even more extensive list of materials had appeared in her Berkeley master's thesis: linen, raw silk, wool, cotton, rayon, mixed yarns, green plastic strawberry baskets, green polyvinyl strips, plastic raffia, cotton batting, bed pads, silk-screened rags, towels, feathers, plastic bags, Haitian cotton, rubber amber tubing, and plastic electrician's wire.[19] Such a lengthy list reflects the impact of her studies under Ed Rossbach and Lillian Elliott, who were known for their wide-ranging exploration of materials and techniques. This celebration of materials—on their own and in finished textiles of all sorts—extended to Rossbach's wife and fellow inveterate traveler,

Katherine Westphal (fig. 110), who in 1966 had begun to teach in the newly formed design department at Berkeley's "sister" university in Davis. Pat Hickman, who studied at UC Berkeley during this period, described Elliot's approach to teaching in a way that captured the behavior of many instructors around the Bay Area and in Davis, some sixty miles to the northeast:

> She arrived for class carrying bags bulging with textiles from her own collection. One by one, she'd bring them out—a raw silk shirt from Turkey, a sock from Yugoslavia, a Coptic tapestry fragment from Egypt, a plaited palm-frond puppet from Indonesia, a North African tie-dyed cloth—to illustrate a technique, a crazy, unexpected juxtaposition of color, a thread gone wild. Lillian looked at these as surprises, giving permission to her and us to play and break the rules. The level of excitement and enthusiasm with all the suggested possibilities was like a small town revival meeting—over cloth.[20]

The adoption of varied materials and approaches by West Coast artists also reflected wider trends in textile art. Milton Sonday, then curator of textiles at the Cooper-Hewitt Museum in New York, observed, in relation to tie-dyeing, that, "today, plastic bags may

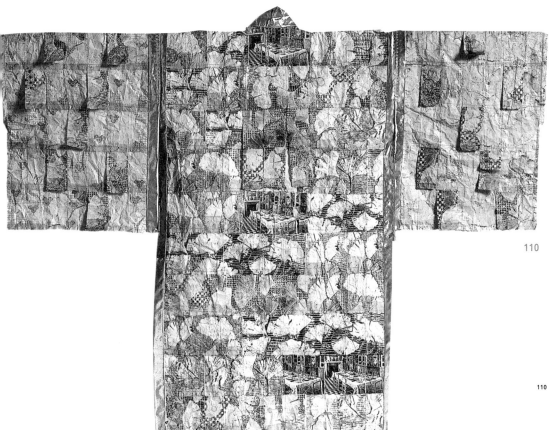

110

110 Katherine Westphal (American, 1919–2018). **Giverny IV**, 1984. Handmade paper, color Xerox, and gold lamé; dyed, stamped, batched. Courtesy Harrie George Schloss

SEW WHAT, BABE?

SEW WHAT. DESIGNERS' WORKROOM
LITTLE DAISY BANCROFT & BOWDITCH
SERENE?...SALACIOUS OR JUST SWEET & SIMPLE. WITH LOVE AND CARE
AND EXPERT CRAFTSMANSHIP, A CREATION JUST FOR YOU, WHOEVER YOU ARE.

111

eplace bamboo sheaths, rubber bands—raffia, and metal clamps—
yarn bindings for boards and blocks." He also noted the important
and often-overlooked point that, "technically speaking, the great
break-through for contemporary craftsmen is synthetic dyes which are
quick-setting and ensure accurate color planning."[21] The ready avail-
ability of cotton dyes that developed in the sun was essential for Fred
Kling, who for a decade or so from 1968 painted some five hundred
garments with a fiber-reactive dye now known as Inkodye. The cutting,
sewing, and filling-in of solid colors was done by his then-wife,
Candace Kling. By 1971, their garments were being sold at Sew What
(fig. 111), run by Marna Clark (fig. 112), daughter of San Francisco
art gallery owner Ruth Braunstein of Braunstein/Quay.[22] Sew What
was just one of many relatively short-lived but influential Bay Area
boutiques supporting fiber and textile artists.

More enduring, and also a key resource for materials, was
Straw into Gold, which was founded in Oakland in 1971 and moved
to Berkeley ten years later. The store initially carried spinning
fibers, natural dyes, and acid dyes for wool (as opposed to finished
yarns). Founding partner Susan Druding Jones, a former Rossbach
student, taught more than fifteen hundred people to spin and dye
before Straw into Gold turned to wholesale-only in 2001.[23] Another
important resource was the Yarn Depot in San Francisco, co-founded
about 1960 by Susan Pope, known for introducing West Coast fiber
artists such as Dominic Di Mare to Paul Smith at the Museum of
Contemporary Crafts. Kay Sekimachi remembers Yarn Depot as a
place where everyone "hung out," including Cacicedo, who worked
there in 1970, prior to her departure for Wyoming. Lacis, established
in Berkeley in 1965 by Kaethe Kliot, became known for more than
lace; it was also the place to get buttons, ribbons, trims, hard-to-find
Japanese threads, and rare books, as well as home to the Museum
of Lace and Textiles.

Such resources were critical as the movement matured, and
many artists turned their focus to extracting from and responding to
the essence—or spirit—of their materials. Candace Kling, for example,
after spending six months at Parsons School of Design in New York

111 Poster for Sew What,
 1971–72, advertising
 garments by Fred and
 Candace Kling. Photo
 courtesy Candace Kling

112 Fred Kling (American,
 b. 1944) and Candace
 Kling. **Marna Clark's
 Wedding Dress**, 1973.
 Cotton; painted with
 fiber-reactive dyes. Photo
 courtesy Candace Kling

112

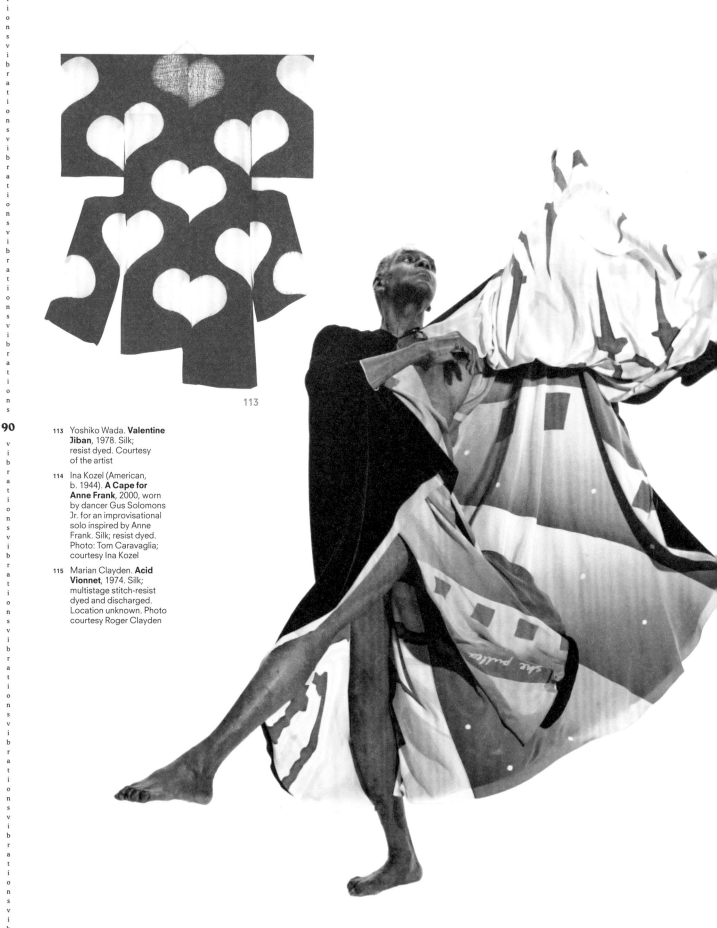

113

90

113 Yoshiko Wada. **Valentine Jiban**, 1978. Silk; resist dyed. Courtesy of the artist

114 Ina Kozel (American, b. 1944). **A Cape for Anne Frank**, 2000, worn by dancer Gus Solomons Jr. for an improvisational solo inspired by Anne Frank. Silk; resist dyed. Photo: Tom Caravaglia; courtesy Ina Kozel

115 Marian Clayden. **Acid Vionnet**, 1974. Silk; multistage stitch-resist dyed and discharged. Location unknown. Photo courtesy Roger Clayden

and finding it too rigid, elected to complete her BFA at the California College of Arts and Crafts (CCAC; now the California College of the Arts) in 1978 and began her exploration of ribbons. By 1980 she was creating richly detailed textile sculptures, primarily in the form of helmets and headdresses (see fig. 109), which sold to clients as diverse as Elton John and the Duchess of Devonshire.

Another influence on the nascent West Coast art-to-wear movement derived from the Pacific Rim rapprochement epitomized by Yoshiko Wada (fig. 113), who in the early 1970s moved to California but maintained close contacts with her native Japan. Seeking to share her knowledge of Japanese textile techniques and kimonos, in 1975 she co-founded Kasuri Dyeworks, a gallery and shop in Berkeley. Jack Lenor Larsen wrote, "Perhaps more than anyone else, Wada caused the evolution of fiber focus from cloth structure to the dye patterning that we now recognize as surface design."[24] Her consistent engagement with Japanese silk throwsters and weavers also ensured the availability of distinctive cloths created to respond to physical resists, or shibori.

115

Other West Coast artists responded to materials and techniques originating in Asia (figs. 114–18). The renowned dyer Marian Clayden, who would later spend time in Japan, was praised for her choice of materials, which Wada described as "always astute, taking into account the opacity, reflectivity, and transparency of various fabric surfaces affected by the colors and light."[25] Ina Kozel, a fellow exhibitor in the Museum of Contemporary Crafts' 1976–77 show *The Dyer's Art: Ikat, Batik, and Plangi*, had become enchanted with vividly dyed silks in 1969–70, while living and traveling in Southeast Asia and India. She recalls being "deeply moved by the beauty of the fabrics of the region—all fabrics, not just batik. The thrill of looking at luxurious color saturation on a piece of silk started next to a Thai dye vat and still thrills me today." Then a recent graduate of the Cleveland Institute of Art, she contrasted these techniques with her more austere training, which consisted of "a loom, a silkscreen and a dull Scandinavian aesthetic."[26] Back home Kozel taught herself wax resist techniques, and in 1976 she went to Kyoto to learn *rōketsuzome*, or wax painting. She has continued to innovate using these and other dyeing techniques.

Ana Lisa Hedstrom studied ceramics at Kyoto Art College in Japan after completing her BA at Mills College in Oakland in 1965. It was not until 1975, when she completed a workshop in shibori taught by Wada at Berkeley's Fiberworks Center for the Textile Arts, that Hedstrom was entranced by the process, and her primary media soon became Kanebo silk marocain (a repp-type weave) and other fine silks. In 1983 she returned to Japan, this time to research shibori and collect textile samples.[27] Another artist who visited Japan and adopted the kimono form prior to the late 1970s was Katherine Westphal, who also learned shibori techniques from Wada. Judith Content was introduced to shibori in a surface-design class she took with Candace Crockett while studying textiles at San Francisco State University in 1978–79. "Candace invited Ana Lisa Hedstrom to visit our class to do a dye demonstration," she recalls. "It was then that I fell in love with Arashi shibori dyeing. I went right home to practice using broom handles because I didn't have PVC pipe! I kept playing and experimenting, and after graduation in 1979, I took dye classes at Straw into Gold in Oakland, Fiberworks and Pacific Basin in Berkeley, and...De Anza College in Cupertino, where I studied with Maggie Brosnan."[28] Content likens her work to Japanese haiku, meant to depict the essence of a specific moment in time, while the kimono evokes reverence as a timeless and valued form.

For many American artists, the kimono form exemplified an alternative to the values espoused by Western fashion. In her statement for the 1974 *Bodywear*

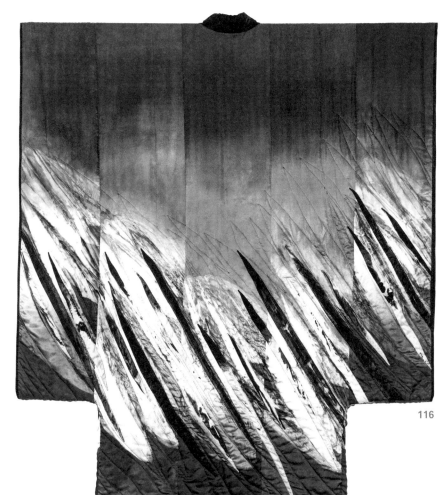

116

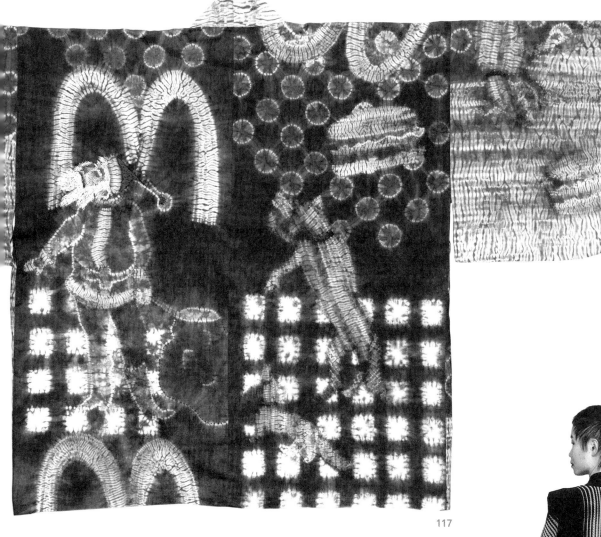

117

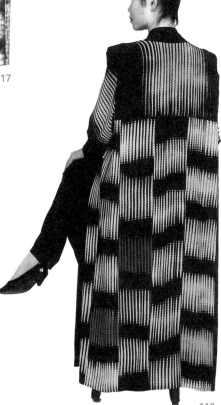

118

Judith Content
(American, b. 1957).
"Sweltering Sky"
Kimono, 1992. Silk; resist
dyed, pieced, appliquéd,
quilted. Fine Arts
Museums of San
Francisco. Museum
purchase, Textile Arts
Council Endowment
Fund and Judith Content,
2001.130

Katherine Westphal.
A Fantasy Meeting of
Santa Claus with
Big Julie and Tyrone at
McDonalds, 1979.
Cotton; shibori-dyed in
indigo, with supplemental
embroidery. San Jose
Museum of Quilts and
Textiles, 2010.427.002

Ana Lisa Hedstrom
(American, b. 1943).
Coat, 1988. Silk crepe;
resist-dyed, pieced.
Courtesy of the artist

catalogue, Yvonne Porcella wrote: "The concept of mass produced clothing is planned obsolescence. I strive to make an incredibly beautiful item which will endure."[29] Kozel stresses tradition, ritual, sensuality, and beauty, sensibilities derived from her study of kimono.[30] Hedstrom is both adamant and articulate about the potent force of mastery, as understood in Japan: "Beauty is not a bad word in Japan. Beauty is also a concept; it starts a narrative, a catalyst to 'what if' and 'who' and all those things that a garment can conjure up." Regarding the broader social changes of the period, she speaks for the "quiet" Californians such as Carol Lee Shanks (fig. 119), whose work is abstract, laden with haptic rather than overt messages. As Hedstrom notes: "Our work doesn't need slogans, words, or feminist images; we embraced it instead of commenting on it."[31]

119

That these values took hold in Northern California is due in part to the influence of the region's sizeable Japanese community, as well as a taste for Japanese and Chinese rugs, porcelains, silks, bronzes, and jades, which were sold by Gump's in San Francisco beginning around 1908.[32] Some influences were more

tangential. Cacicedo (fig. 120) was inspired to integrate reverse appliqué into her work by the *molas* of Panama's Kuna women, artifacts widely admired and collected largely due to *Mola Art from the San Blas Islands*, a 1972 publication by Kit S. Kapp, whose interest in ethnographic textiles had begun with an appreciation of Ainu culture when he was stationed in Japan just after World War II.[33]

More broadly "Pacific" was the integration of Native American and Latin American cultural, spiritual, and technical influences, as well as those of Korea, Indonesia, the Pacific Islands, and China. Stabb, following a trip to Peru in 1974, began making fragile poncho forms that suggest both spiritual and votive uses (fig. 121).[34] Lipkin, using her Knit King model 901 machine, developed imagery incorporating Mexican and Southwest American

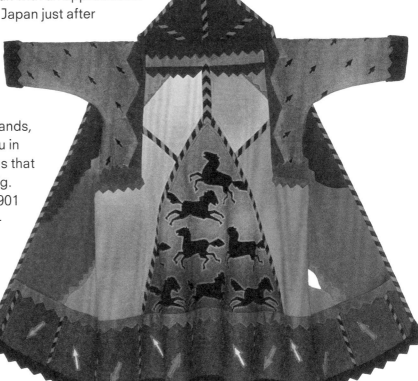

120

119 Carol Lee Shanks (American, b. 1957). **Imprint Silhouette Ensemble**, 2008. Silk; hand-stitched resist (*nui shibori*), clamp resist (*itajime*), piercing. Courtesy of the artist

120 Jean Williams Cacicedo. **Tee Pee Coat**, 1988. Wool cloth; shrunk, pieced, dyed. Philadelphia Museum of Art. Promised gift of The Julie Schafler Dale Collection

121 Jo Ann C. Stabb (American, b. 1942). **Faux Peruvian Gauze Poncho**, 1977. Photo-silkscreen images of Peruvian gauze textiles printed on silk organza. Courtesy of the artist

121

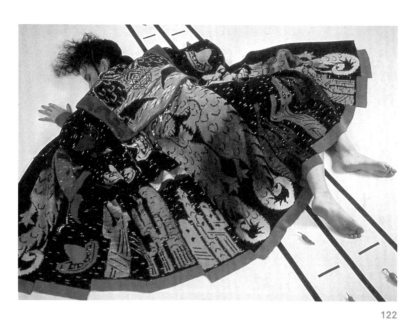

122

122 Janet Lipkin. **Mexico in Midday**, 1987. Wool, including hand shibori-resist dip-dyed yarns; intarsia machine knitted. Promised gift of The Julie Schafler Dale Collection

123 Ellen Hauptli (American, b. 1941). **Skirt, Top, Cocoon with Scalloped Edges**, 1984 and in limited editions until 2000. Mushroom-pleated polyester; purl edges sewn on a Merrow Serger; necklace by Leslie Correll. Courtesy of the artist

sensibilities (fig. 122); like Cacicedo, she also became an expert dyer, dip-dyeing black-and-white patterns (some reflecting her time spent in Africa) and space-dyeing her yarns so that these ikat elements overcame the color limitations of her electronic machine.

Such influences were not limited to the Bay Area, but were perhaps more concentrated there. Uniquely, Hauptli (fig. 123) developed her signature pleated polyester garments while an MFA student at Fiberworks. For her 1977 graduate show, she recalls, "One of the things I did was a dress—a plain piece of fabric, a rectangle—but I had a way of folding in the corners and pleating it, and then when the sleeves popped out they looked like sleeves. Then Miyake was doing that later."[35] The Pacific influences went both ways as well. Japanese fashions aside, in the 1980s and 1990s, when artistic interest in identity, types, and cultural idioms was often satirical, curator Stephanie Barron notes, such "open-armed receptivity to various visual vocabularies was relatively free of ironic positioning, and it enriched and complicated the handicraft revival in the West Coast with pronounced international influences."[36]

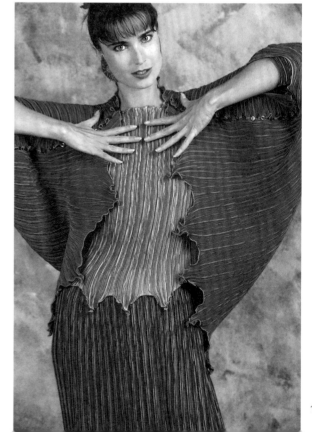

123

collegiate influences

Interviewing Ed Rossbach in 1983, Harriet Nathan observed that Rossbach's leadership "was instrumental in making the Bay Area a major center for fiber arts. He attracted talented students to his numerous classes at Berkeley, and stimulated their creativity and interest in both historical and contemporary expressions of fiber art. He joined his students and other mature fiber artists in the activities of the fiber art centers, schools, and galleries that clustered in the Bay Area and served to attract increasing numbers of artists and students."[37] The self-effacing Rossbach would have shied away from taking such individual credit. When asked, in the same interview, if the element of proximity contributed to a shared energy among artists, he replied:

> I think it does. I think it makes a great difference. I wonder how these people in relative isolation, in small communities, where they don't have a large support group of people also interested in fiber, how they manage to do such interesting work, as they sometimes do. I think in this area, for instance, we enjoy such a richness of all this fiber activity. I think recently it has been astounding, the number of lectures on various phases of fiber art, and exhibits, the number of invitations to exhibits and openings that are floating around. You can't believe that all this is happening. . . . I don't think it's been like this before. I think it's extremely lively right now.[38]

The activity in and around the Bay Area was supported by a good number of teaching institutions, including San Francisco City College, College of Marin, Mendocino College, San Francisco State, Chico State, and San Jose State. A consistent influence was Oakland's California College of Arts and Crafts (CCAC), founded in 1907, and the Berkeley Adult School, founded in 1922. The esteemed fiber artist Kay Sekimachi studied first at the latter and then, in 1955, at CCAC, later returning at times to teach at the Adult School, where one of her students was Lillian Elliott. Nance O'Banion, a graduate of Cal (as UC Berkeley is known locally), joined the CCAC staff in 1974 and, aside from teaching globally, remained associated with the school until her death in 2018, offering courses that reflected her multimedia, interdisciplinary, and collaborative approach. Such complex interweaving of experiences came to typify the Bay Area.

By the 1970s many recent graduates were also teaching in Berkeley at new enterprises such as Pacific Basin Center of Textile Arts, founded in 1972 by CCAC graduates Inger Jensen and Pat Violette

McGaw to offer non-degree courses, a three-year certificate, and "a sense of community."[39] Fiberworks Center for the Textile Arts was founded the following year by a group consisting primarily of Cal graduates; Gyöngy Laky was director until 1977, after which she joined the faculty at UC Davis. Both centers were inspired to some extent by the small scale of Trude Guermonprez's and Lia Cook's CCAC courses and the gradual dissolution between 1968 and 1972 of the dedicated design department at Cal. Ellen Hauptli recalls how many active artists continued to take classes and teach at both centers, which as a result became "additional focal points for the fiber art movement in the 1970s and 1980s."[40] Hauptli herself had a BA from UC Davis and was teaching ethnic dress at Fiberworks when she enrolled in its newly established MFA program in 1975. For some fifteen years, these centers not only provided courses to artists in the Berkeley area, but also exhibition spaces.[41] And, of course, only eight miles north was the Richmond Art Center, which also offered classes and workshops.

12

Much of the energy in the Bay Area had been shared with Davis. In early 1968, Westphal had been joined by Stabb in the emerging design department. A Northern Californian who trained at the Tobé-Coburn School in New York and earned a masters in fashion design from UCLA, Stabb recalls the joy of finding kinship in the Bay Area, with its network of friends and fellow "textile junkies": "Rather than exchanging criticism and generating feelings of competition, we shared the joy of creativity and self-expression. It was fun! From this I learned that greater growth and development can be accomplished in a positive, supportive, exploratory atmosphere—rather than a critical, perfectionist-oriented one. That is not to say that we did not continue to strive for improvement and growth—but we worked from an attitude of aspiration."[42] As early as 1970 Davis students were creating garments from materials as diverse as bonded Tyvek and pleated paper (fig. 124). Debra Rapoport, a member of the faculty 1970–78, taught costume design and personal adornment, and memorably sometimes appeared without notice in one of her looped or netted wearable "environments." Many other former Cal students were offered positions as teaching assistants and garnered the appellation "freeway flyers," as they raced from CCAC or Berkeley Adult School to Richmond Art Center or Davis. As Pat Hickman recalled, "So much was going on and NOT under one institutional roof."[43]

From the outset the approach in these departments was exploratory. Rapoport drew on her experience with a broad range of

techniques: plain weaving on a frame loom, double cloth, tapestry, rya knotting, and card weaving, as well as the off-loom methods of macramé, twining, binding, monk's-belt threading, knitting, stitching, crochet, and knotless netting, not to mention dyeing. Westphal experimented with photocopying onto cloth, collage, dyeing, and heat-transfer printing, and was a driving force until her retirement in 1979. Graduating from Davis between 1972 and 1979 were Lois Hadfield, Hauptli, and Carol Lee Shanks, who in 1983 began making unstructured shapes of layered silk habutai, toying artfully with wrinkles, folds, and subtle fabric juxtapositions. In a recent interview, Hauptli and Shanks shared similar memories of Westphal: "She really put her thumb down and said, 'You've got to do better, this is not good enough.'... She wanted you at the highest level possible. And she wanted you to break rules."[44]

In 1980 Westphal led a delegation of Davis faculty members—Stabb, Rapoport, and Dolph Gotelli, whose expertise was visual presentation—to the World Crafts Council in Vienna, where they gave lectures and workshops on "Wearable Art from North America." The invitation had been engineered by Jack Lenor Larsen, a former student of Westphal's husband, Rossbach, and the moment represented a breakthrough for both the American Craft Council and for art to wear on the global stage. Speaking to some fifteen hundred assembled international delegates, Westphal emphasized the high standards of the work: "The boundaries are loose but the integrity, the clean discipline of the artist, is solid. The artists break barriers of rigid craft disciplines. They form their own parameters for their work."[45] The American Craft Museum's subsequent *Art to Wear* exhibition (fig. 125)—which, as noted above, prominently featured Bay Area artists—toured to many Southeast Asian venues in 1983–84, more evidence that the global emergence of art to wear was highly indebted to the explosion of creativity on the West Coast in the previous decades.[46]

124 Display of student work made for the Textiles and Clothing 170 course, UC Davis, 1970, using bonded Tyvek, a nonwoven material composed of flashspun, high-density polyethylene fibers, made available commercially by DuPont in 1967. Photo courtesy Jo Ann C. Stabb

125 Katherine Westphal. **Kyogen II**, 1983. Handmade paper, indigo cotton, and color Xerox; dyed, stamped, patched. Private collection

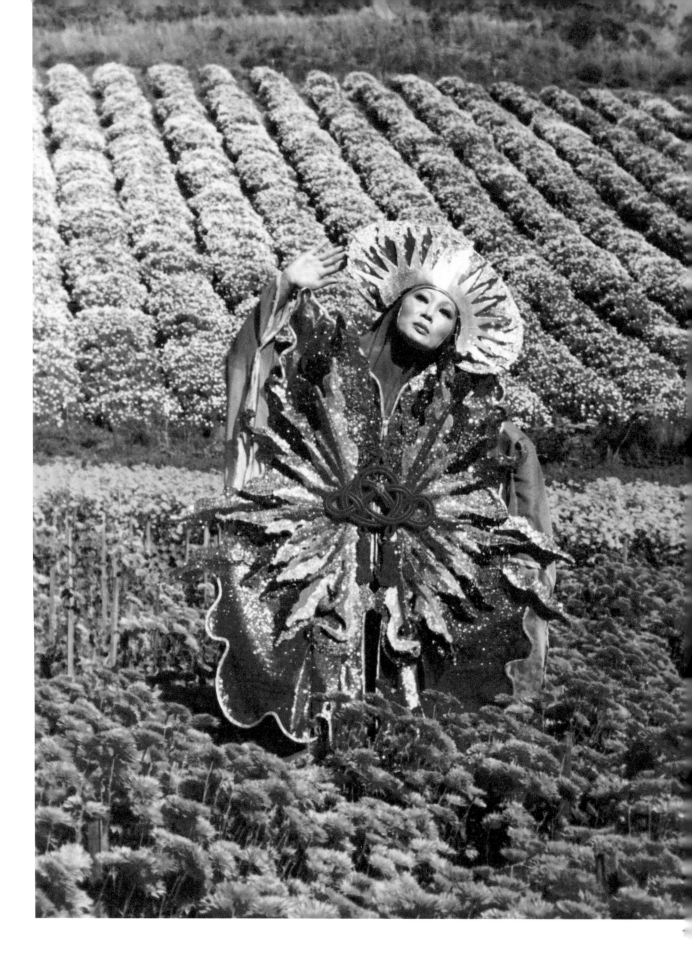

generous spirits

Collaboration underpinned the creative energy of the Bay Area art-to-wear scene from the outset. Central to this spirit was Sandra Sakata, who after traveling the world as flight cabin crew took a painting class at CCAC while also managing Great Eastern Trading Company. At Great Eastern she developed a client base of artists making both garments and jewelry; when it closed in 1971, she continued to operate from the home of the jewelry designers Alex Maté and Lee Brooks (known as Alex & Lee). By 1972 Sakata had opened her own gallery, Obiko, where Alex & Lee continued to exhibit and the window displays were created by the locally renowned artist Kaisik Wong (fig. 126). Sakata later recalled: "I turned to painting with clothes rather than canvas. Many of my window and shop displays were based on Chinese, Japanese and south east Asian cultures. We created environments which united clothing, jewelry, furniture, and colors. There was an urgent, beautiful force at work."[47] Obiko enjoyed immediate success, and by the end of 1983 she also had a concession in New York's Bergdorf Goodman.[48] Ultimately, Obiko represented more than a hundred artists, 80 percent of them from the Bay Area. Among these were Cacicedo, Clayden (fig. 127) , Ditson, Hauptli, Hedstrom, Janet Kaneko, Candace and Fred Kling, Kozel, Lipkin, Manuel, Shanks, Carter Smith (fig. 128), and Fumiko Ukai.[49] From Japan came work by Jun'ichi Arai, Yasu Akano, and Yoshiko Jinzenji.

Sakata is remembered as a motivator. Cacicedo, who began showing at Obiko in 1982, recalls:

> She would come into my studio and SCREAM. I will never forget her high-pitched scream of enthusiasm. She'd encourage, bringing some scraps of [Jun'ichi] Arai fabrics to work with, or she'd say, "If you can do one, you can do ten dresses." So both Ana Lisa [Hedstrom] and I can credit her for a total transformation, going from one-of-a-kind to limited production. And she knew how to retail. That really intimidated me, but she opened up the doors to us to make us feel comfortable because we

128

101

126 Kaisik Wong (American, 1950–1990). **Harvest from I Ching**, c. 1976, worn by Merle Bulatao. Photo by Kaisik Wong. Fine Arts Museums of San Francisco. Museum Purchase, Gift of Alma Kay Wont, the Textile Arts Council Endowment Fund, Marian Clayden, Peggy Gordon, Pamela Ransom, Santa Fe Weaving Gallery, Mr. and Mrs. Alfred S. Wilsey, Susan York and Various Donors, 1998.181.24

127 Marian Clayden. **Florentine Dress**, 1976. Striped silk with chenille; clamp-resist discharged and dyed. From an edition of four dresses, one exhibited in *Art to Wear: New Handmade Clothing*, American Crafts Museum, New York, 1983. Photo courtesy Roger Clayden

128 Carter Smith (American, b. 1946). **"Amazon Jungle" Scarf Coat**, c. 2001. Silk crepe; tie-dyed. Philadelphia Museum of Art. Promised gift of The Julie Schafler Dale Collection

127

had her saying, "Let's work together." She'd do spectacular themed shows—Tibetan carpets or whatever—and it was very interesting how she brought out in us something, I don't want to say the word commercial but, in a sense, it was.[50]

Hedstrom concurs, saying, "When I look back, I'm not sure I would have become focused on clothing if I had not met Sandra."[51] Shanks, who was introduced to Sakata in 1991 by Cacicedo, said: "My life as a clothing designer and maker was forever changed. There are few people that I can credit for recognizing something within me, seeing that potential and encouraging me to explore and develop. Sandra was one of those people. She gave me the opportunity to become a part of her vision. The expectations she held up for me pushed my creativity to a new place."[52]

Sakata was adept at creating collaborations of many sorts. For one show, she "paired Ditson with Ana Lisa Hedstrom, who was dyeing scarves. The two made a collaborative collection. Jean Cacicedo and K. Lee Manuel produced embellished wool coats as a result of Sakata's urgings and when she introduced silk painter Ina Kozel to the Oregon-based husband-and-wife design team of Judith and Lin (Linwood) Lundell, the sum of talent was sublime."[53] Kozel, who returned to San Francisco from Japan around 1978, was quickly embraced at Obiko and was one of several artists Sakata included in the 1979 San Francisco Museum of Modern Art exhibition *Art for Wearing*. However, Sakata was equally vocal regarding the personal impact of the "spirited reality" of the artists she worked with: "They create beauty out of nothing. My artists introduced me to a new way of thinking. They begin with an empty canvas—no assumptions, no rigid frameworks. They let the energy flow through them. Before I opened Obiko I was very structured. . . . The beauty of their work strengthens my commitment to share it with others."[54] Importantly, to ensure their success, Sakata also encouraged several artists to seek professional partners such as the pattern makers and graders who worked with Cacicedo, Lipkin, and Hauptli as a result of Obiko's support. Lipkin, whose patterns were made by Toshiko Sugiyama, recalls the process: "She helped me develop my garments by brainstorming with me about my ideas and drawings and then created amazing patterns, for the knitter, Lotus Baker, to follow."[55]

Such collaborations were not new. Clayden and Manuel had worked with New Yorker Ben Compton for Best of Three Worlds, the business he ran with Marion Holmes between 1969 and 1973.

102

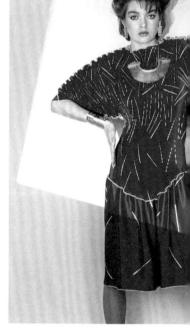

129

129 Ellen Hauptli and Lois Hadfield. **Drop-Waist Dress**, 1986. Crystal pleated polyester; painted by Hadfield with pigments including metallics, set in heat of Hauptli's industrial pleating process, purl edges sewn on a Merrow Serger; jewelry by Leslie Correll. Courtesy Ellen Hauptli

130 Members of Group 9: (top, from left) Jean Cacicedo, Janet Lipkin, Ana Lisa Hedstrom, and Gaza Bowen; (bottom, from left) K. Lee Manuel, Candace Kling, and Marian Clayden. Not pictured: Ina Kozel and Marika Contompasis. Photo courtesy Jean Williams Cacicedo

131 Ellen Hauptli's scrapbook pictures of **Progressive Piece**, 1992–93, a collaboration with Lois Hadfield, Gaza Bowen, Susan Wick, Elke Kuhn, Carol Sarkisian, Debra Rapoport, and Marcia Donahue. Photo courtesy Ellen Hauptli

During the 1980s Hauptli worked with Hadfield, who used pigments (including metallics) rather than dyes, set in the heat of Hauptli's industrial pleating process to create prints that "accentuate the hide-and-seek, shrink-and-grow nature of the pleated fabric" (fig. 129).[56] Nor were these associations limited to the creation of wearables. Mary Winder Baker, Debra Rapoport, and Susan Wick created "remarkable textile-oriented performances and installations that inspired and ex-panded the definition of creativity in San Francisco," including one documented in a 1977 video.[57] Often, such collaborations were informal, as was the case with Group 9 (fig. 130), formed in 1991 and consisting of Bowen, Cacicedo, Clayden, Contompasis, Hedstrom, Kling, Kozel, Lipkin, and Manuel (until her death in 2003). For more than a decade, Cacicedo notes, the group's "camaraderie provided ideas, support and discussions for furthering our careers as a woman."[58] A more short-lived grouping initiated by Hauptli resulted in a "progressive piece" (fig. 131) exhibited at The Hand and The Spirit Gallery in Phoenix, Arizona, in October 1993. It grew as it passed from hand to hand: from Hauptli to Hadfield, to Bowen in Santa Cruz, Wick (now in Denver), Elke Kuhn (Moore) in Brooklyn, Carol Sarkisian in Santa Fe, Rapoport in New York, Marcia Donahue in Berkeley, and finally back to Hauptli for completion. For these people, as well as the majority of art-to-wear practitioners, the "good vibrations" of camaraderie were an essential component of artistic life.

130

131

culations

For millennia textiles and clothing have served as a means of communication. The words *textiles* and *text* even share a common linguistic root in the Latin *textere,* to weave. This "language of threads" survives today in idiomatic expressions such as "web of words" and "to spin a yarn." By the middle of the twentieth century, American textile artists were looking beyond traditional European hand weaving to pre-Columbian and Andean indigenous textiles for a new visual language. In 1959 the weaver Anni Albers (see fig. 7) expressed her desire to break from Bauhaus tradition and separate form from function: "To let threads be articulate again and find a form for themselves to no other end than their own orchestration, not to be sat in, walked on, only to be looked at, is the raison d'être of my pictorial weavings."[1] In their search for more expressive forms, many textile artists looked beyond the "pliable plane" to three-dimensional fiber sculptures. With art to wear, sculptural practice expanded to include the human body, adding another voice to the conversation.

imaginary worlds

Fantasy literature and science fiction during the 1960s and early 1970s offered an escape from the period's upheavals. One of the most widely read English-language books of the time was J. R. R. Tolkien's *Lord of the Rings.* Originally published in England in 1955, it took ten years for the trilogy to reach the American mass market. When the three-volume paperback edition was launched in 1965, it immediately connected with young readers, selling nearly half a million copies the first year. College students read it as an allegory and parable of the present time, despite Tolkien's insistence that the work carried no inner meaning or message. One mother, purchasing the trilogy for her freshman daughter in 1966, quipped that "going to college without Tolkien is like going without sneakers."[2]

The book's influence on popular culture extended to include *Gandalf for President* bumper stickers, *Frodo Lives* graffiti, and the lyrics of Led Zeppelin, Black Sabbath, Genesis, and Pink Floyd.

Jean Williams Cacicedo and Nina Vivian Huryn were among the many young people drawn to *Lord of the Rings*. After graduating from Pratt in 1970, Cacicedo moved to the Bay Area, and relocated two years later to rural Wyoming. It was here, she says, that she "learned to focus my ideas, to find my inner strengths and beliefs. It was the most prolific period of my life. I minimized external influences and concentrated on invention, development, experiment." One such experimental work was a three-dimensional wall hanging of Tolkien's beloved *Treebeard* (fig. 132). Completed in 1973, just weeks before the author passed away, it combined sculptural form and narrative into a lively portrait of the troll-like character described in *The Two Towers*, book 3, chapter 4.[3]

For Huryn, Tolkien was the catalyst that led her to create her own fantasy world. While a freshman at Cleveland Institute of Art in 1971 majoring in textile design, she painted and silk-screened a leather jacket with images borrowed from *Lord of the Rings* (fig. 133). At first she wore the jacket as a kind of talisman, but as the Tolkien

132 Jean Williams Cacicedo.
Treebeard, 1973. Wool, leather and/or vinyl, suede/ultrasuede; knitted, crocheted, tufted, wrapped, stuffed. The Julie Schafler Dale Collection

133 Nina Vivian Huryn (American, b. 1952). **Painted Leather Jacket** (1971) and **Les Enfants Terribles** (1974?), 1975. Photo: Rebecca A. McBride. The Julie Schafler Dale Collection

107

articulationsarticulationsarticulationsarticulationsarticulationsa

132

133

108

connections faded it became a much-loved part of her everyday wardrobe.[4] Huryn's early work, including the fantasy clothes she designed for local rock musicians while still in college, expressed a quirky romantic vision of medieval and Renaissance dress that her sister, photographer Rebecca A. McBride, captured in a series of images of the artist and her friends (see fig. 133). Huryn's *Tree Outfit* (fig. 134), made for Julie: Artisans' Gallery in 1976, the year following her graduation, is an idiosyncratic evocation of medieval fashions featuring flowing pants, a loose shirt, and a tooled leather and suede jerkin painted with foliage, large and small figures, and birds chasing one another through a forest. By this time Huryn was composing her own tales filled with pixies, ghosts, witches, and happy adventurous skeletons. The latter were inspired by the "ghoulies" and "ghosties" illustrating "A Cornish Litany," a favorite postcard she had owned since childhood. Huryn's "skellies" searched for the Holy Grail, fished in a swamp contaminated by nuclear waste, and even participated in a rodeo after they encountered a billboard of the Marlboro Man. In *Mr. Bones II* (fig. 135),[5] a work inspired by the skeleton dance from her favorite children's television program, *The Little Rascals*, the wearer becomes a "skellie" ready to embark on escapades of her own.

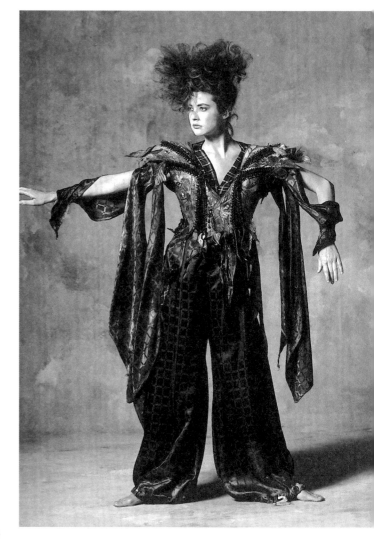

134

While Huryn's phantom spirits were happy and hopeful, Arlene Stimmel embraced the world of sorcery and black magic expressed in the heavy metal sounds of bands like Black Sabbath for a work unique in her oeuvre, *Snake Jacket* (fig. 136). Stimmel, who was a painter, fell in love with textiles and saw crochet as a technique that could capture their "lusciousness" and "incredible gradations of color."[6] With her sculptural jacket she countered beauty with a work that was "dark and evil"; the back shows two writhing serpents with menacing red bead eyes flanking a skull surrounded by a pentagram. The sleeves and accompanying helmet are covered with snake scales.

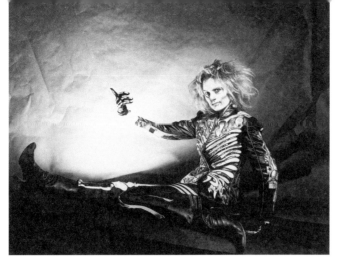

134 Nina Vivian Huryn. **Tree Outfit**, 1976. Leather, suede, antique shoe buttons, and satin; tooled, painted, laced, stitched. Philadelphia Museum of Art. Promised gift of The Julie Schafler Dale Collection

135 Nina Huryn wearing **Mr. Bones II**, 1979. Photo: Rebecca A. McBride. The Julie Schafler Dale Collection

136 Arlene Stimmel (American, b. 1945). **Snake Jacket**, 1974. Wool and metallic yarns; crocheted, stuffed. Philadelphia Museum of Art. Promised gift of The Julie Schafler Dale Collection

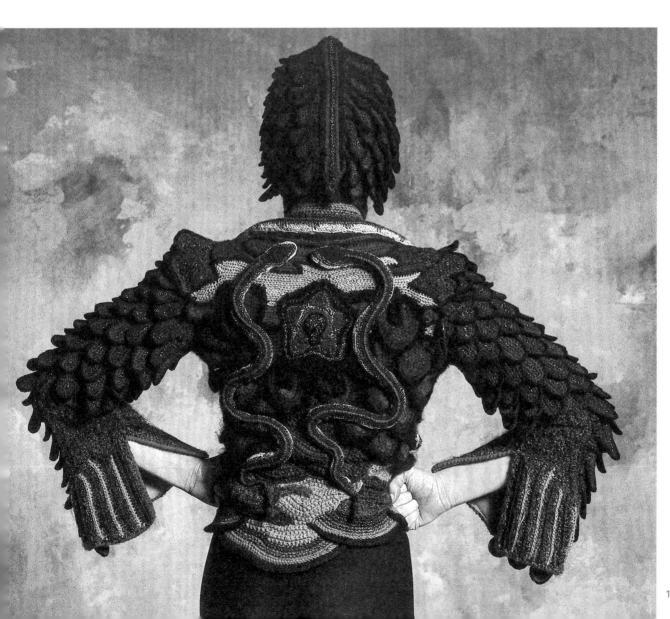

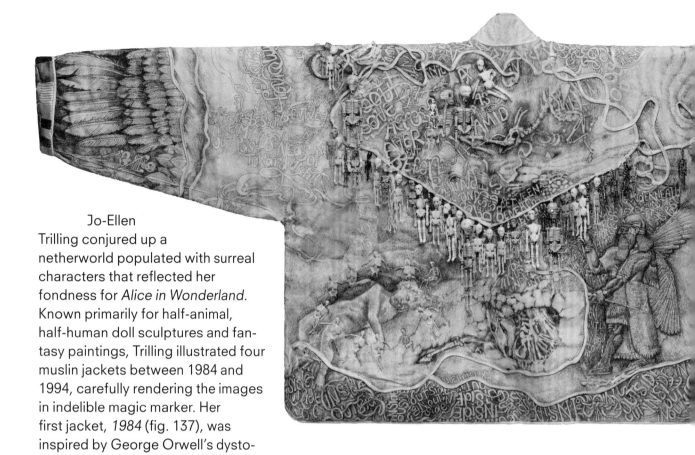

Jo-Ellen Trilling conjured up a netherworld populated with surreal characters that reflected her fondness for *Alice in Wonderland*. Known primarily for half-animal, half-human doll sculptures and fantasy paintings, Trilling illustrated four muslin jackets between 1984 and 1994, carefully rendering the images in indelible magic marker. Her first jacket, *1984* (fig. 137), was inspired by George Orwell's dystopian novel in response to an invitation from Julie Schafler Dale to participate in her gallery's tenth-anniversary exhibition. Trilling had read Orwell as a teenager and was filled with dread as the year in the title approached. She found release by drawing an anthropomorphic fantasy world populated by rats, including a large human-like rodent modeled on Jean-Auguste-Dominique Ingres's famous pencil study in the Metropolitan Museum of Art for the portrait of the French writer, art collector, and pro-Royalist *Monsieur Bertin* at the Louvre. With *Preposition Jacket* (fig. 138), *Rain Jacket* (c. 1990), and *Billy Jacket* (c. 1990),

110

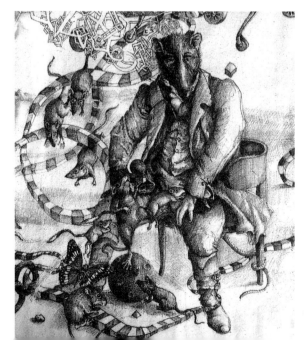

137

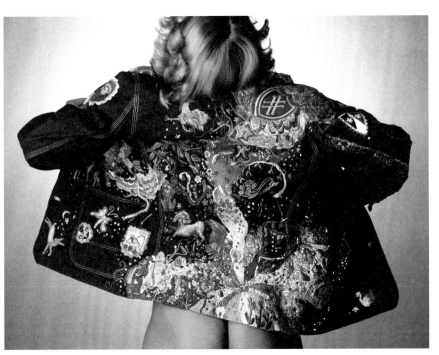

Trilling juxtaposes words and drawings to engage the viewer in a kind of visual wordplay. The Western-style *Preposition Jacket*, for example, features a fringe of articulated plastic skeletons, while their illustrated counterparts lie exposed in a graveyard of prepositions—*in*, *out*, *under*, and *over*, among others—together with two of the Metropolitan Museum of Art's most famous ancient sculptures: the "winged genie" from an Assyrian relief panel, and the Hellenic sculpture of the sleeping child Eros.

For other artists, stories remembered from childhood or read as young adults left an indelible impression. Anna VA Polesny's fascination with fables, legends, and folk tales is reflected in her choice of embroidered images for *Fancy Jacket* (fig. 139), taken from Ilse Bischoff's woodcuts in *Tricks of Women and Other Albanian Tales* and C. E. Brock's illustrations for a book of Romanian legends.[7] Susanna Lewis humorously reimagined one of her favorite films, *The Wizard of Oz* (1939), as a pair of thigh-high machine-knitted stockings incorporating Dorothy's iconic ruby slippers for *The Great American Foot* exhibition at the Museum of Contemporary Crafts in 1978 (fig. 140). The right leg represented Kansas, the left, the Emerald

137 Jo-Ellen Trilling (American, b. 1947). **1984 Jacket** (detail of back), 1983. Cotton; drawn, stitched. Philadelphia Museum of Art. Promised gift of The Julie Schafler Dale Collection

138 Jo-Ellen Trilling. **Preposition Jacket**, 1989. Cotton canvas, silk, plastic, metal, and ink; tinted, drawn, pieced, appliquéd. Philadelphia Museum of Art. Promised gift of The Julie Schafler Dale Collection

139 Anna VA Polesny. **Fancy Jacket**, 1974. Cotton-denim twill, cotton embroidery in satin, stem, and chain stitches, metal studs, appliquéd patches, glass beads, and plastic sequins. Collection of the artist

139

City, while garters read "Somewhere over the rainbow" and "We're off to see the Wizard." Lewis's *Oz Socks* coincided with the release of the film version of the musical *The Wiz,* based on the original L. Frank Baum novel published in 1900.

Norma Minkowitz embraced the magic and spirit of William Henry Hudson's popular novel *Green Mansions: A Romance of the Tropical Forest* (1904) in a finely crocheted and knitted dress (fig. 141) whose layered textures and subtle palette evoke the lush jungle of southeastern Venezuela and capture the innocence of the forest-dwelling girl Rina discovered by the novel's traveler narrator.

Jamie Summers's fictions were complex and multilayered assemblages of materials, techniques, and found objects that like her art in other media referenced deeply held spiritual beliefs and environmental concerns. The lining of *Harmony in the Evolution of a Spiral Galaxy* (fig. 142) features a handwritten inscription in free-form verse reading in part:

> The Earthbound Man lies within the main disc of the milkyway and its spiral arms. Starfields, clusters, clouds of gasses and dust compose the galaxy which his solar system moves. Earthbound man is acquainted with only one stratum held together by the all powerful gravitational force—Suspended in space—

By donning the jacket, the wearer situates herself within the cosmography of the universe. Whatever the impetus for Summers's piece, it had good company in popular music in 1979, from Jimmy Briscoe and the Beavers' disco hit "Into the Milky Way" to the mellow sounds of the Japanese City Pop group The Milky Way. The connection to Japanese pop culture and the world of manga and anime is reinforced by Summers's use of souvenir fabric patches printed with Japanese superheroes and robots.

140

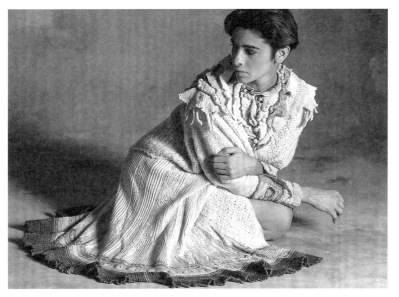

141

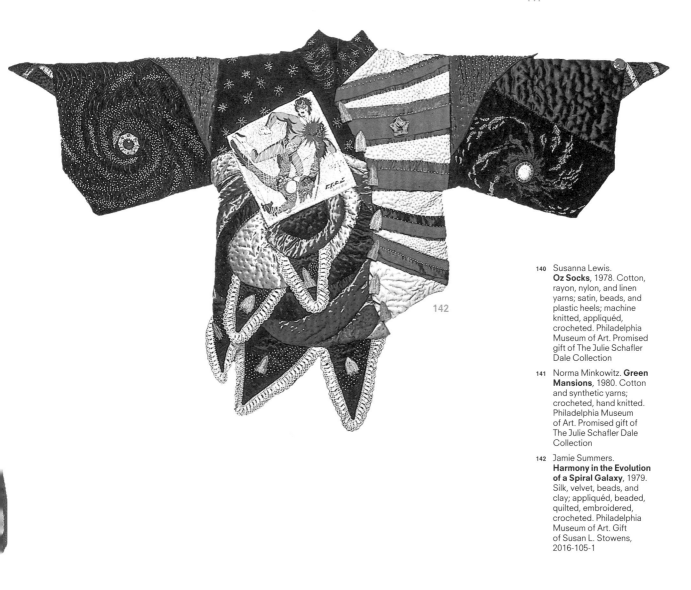

142

140　Susanna Lewis.
Oz Socks, 1978. Cotton,
rayon, nylon, and linen
yarns; satin, beads, and
plastic heels; machine
knitted, appliquéd,
crocheted. Philadelphia
Museum of Art. Promised
gift of The Julie Schafler
Dale Collection

141　Norma Minkowitz. **Green
Mansions**, 1980. Cotton
and synthetic yarns;
crocheted, hand knitted.
Philadelphia Museum
of Art. Promised gift of
The Julie Schafler Dale
Collection

142　Jamie Summers.
**Harmony in the Evolution
of a Spiral Galaxy**, 1979.
Silk, velvet, beads, and
clay; appliquéd, beaded,
quilted, embroidered,
crocheted. Philadelphia
Museum of Art. Gift
of Susan L. Stowens,
2016-105-1

life journeys

Art to wear responded to events in the lives of its makers and those around them. It commemorated the past or marked critical turning points; it exorcized traumatic events, confronted mortality, or acted as a "soul mirror" uniting the maker and the wearer.[8]

At times such connections were only recognized retrospectively. Lipkin, for example, sees her three works with bird images—*Bird Coat* (see fig. 25), *Flamingo* (see fig. 43), and *Transforming Woman* (see fig. 44)—as symbols of freedom that reflect her personal journey, marked in ten-year intervals, as she searched for new directions in her art and life.[9]

Louise Todd Cope's *Walking Quilt* (fig. 143) was made for Helen Drutt to wear to the 1974 opening of her eponymous craft gallery in Philadelphia. The patchwork of vintage fabrics was a tribute to one of Drutt's most cherished heirlooms, a crazy quilt her grandmother made from family textiles. Cope's homage, which could also hang on the wall, included many of the owner's personal mementos: her mother's wedding belt, Drutt's first tie-dye fabric, pieces of the dress she wore to her sister's wedding, and her grandmother's shawl.

Joan Steiner, a self-taught artist/illustrator who had majored in philosophy in college, reimagined the world around her in miniature using fabric and found objects. Her first works were soft sculptures such as a muff in the form of a toaster, but she soon found herself drawn to tiny things. Memories of her childhood home in New Jersey during the 1950s inspired a group of three vests in 1977—kitchen, bathroom, and basement, each rendered down to the smallest details, such as an oven door that

143

Louise Todd Cope.
Walking Quilt, 1973–74.
Silk, cotton, metallic
novelty fabric, wool, and
pearls; pieced.
Philadelphia Museum of
Art. Gift of Helen Williams
Drutt English, created for
the occasion of the
inaugural exhibition of the
Helen Drutt Gallery,
Philadelphia, 2010-213-1

Joan Steiner (American,
1943–2010). **Kitchen Vest**,
1977. Cotton, synthetics,
various trims, and found
objects; quilted, printed,
appliquéd, embroidered.
Philadelphia Museum
of Art. Gift of Mrs. Robert
L. McNeil, Jr., 1994-92-5

Joan Steiner. **Bathroom
Vest**, 1977. Cotton,
synthetics, and found
objects; appliquéd, quilted,
embroidered. Location
unknown

Joan Steiner. **Basement
Vest**, 1977. Cotton,
synthetics, and found
objects; appliquéd, quilted,
embroidered. Philadelphia
Museum of Art. Promised
gift of The Julie Schafler
Dale Collection

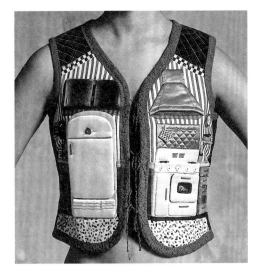
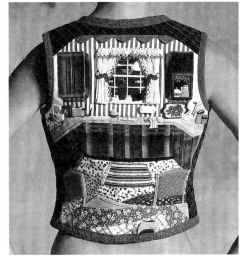

144

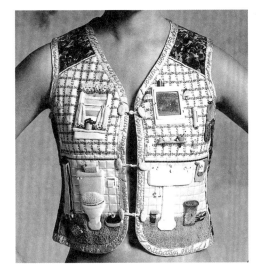
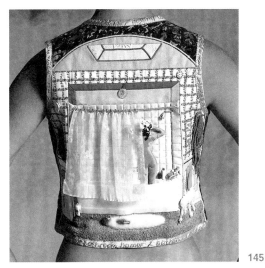

145

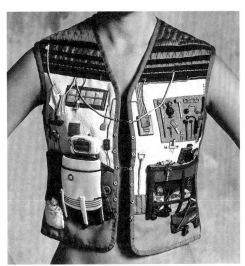
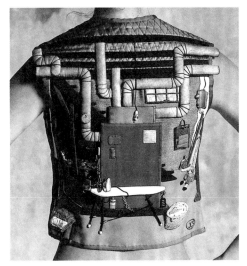

146

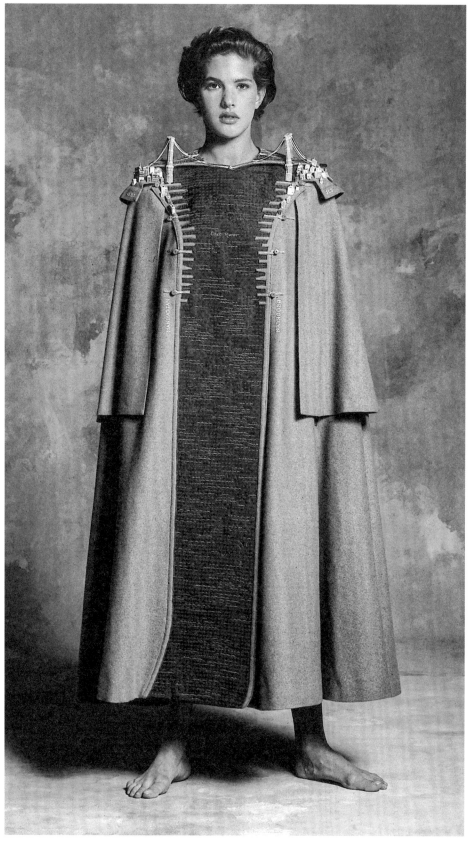

147 Joan Steiner. **Brooklyn Bridge Cape**, 1985. Silk, cotton, polyfoam, and cashmere; embroidered, appliquéd, quilted. Collection of Joanna S. Rose

148 Sheila Perez Ghidini (American, b. 1950). **Combat Vest**, c. 1985. Cotton and molded plastic figures; quilted. Philadelphia Museum of Art. Promised gift of The Julie Schafler Dale Collection

149 Nicki Hitz Edson. **Medusa Mask**, 1975. Wool; crocheted. Philadelphia Museum of Art. Promised gift of The Julie Schafler Dale Collection

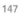

opens to reveal a turkey (figs. 144–46). In 1980 she made hats in the form of a fishing boat, a highway, an iron, and a blender. She mined the urban landscape: Manhattan from Fifty-Ninth Street to Battery Park was transformed into a collar (1979) and the Brooklyn Bridge was re-created on the shoulders of a cape (fig. 147) from the original blueprints.[10] Making wearable art was secondary to Steiner's need to create pictures and sculptures, and she expanded her miniature world to include award-winning illustrated puzzles and children's books in which objects were not what they seem but made from look-alikes.

For many artists the creative process helped artists manage trauma in their lives. Sheila Perez Ghidini's *Combat Vest* (fig. 148) covered with toy plastic soldiers channeled the artist's anger over her divorce, while Nicki Hitz Edson's *Medusa Mask* (fig. 149) expressed the volatile emotions

148

149

surrounding the breakup of her marriage. Ben Compton celebrated survival in the *Phoenix Coat* (fig. 150), using singed fabric salvaged from a fire that destroyed his studio.

The large butterflies dominating Cacicedo's exuberantly crocheted and knitted coat *Transformations* (fig. 151) also symbolize a turning point. The images mark her recovery after being injured in a fire, and also express Cacicedo's artistic rebirth as she changed the way she designed and constructed her coats and how she saw color. By the time Cacicedo returned to California in 1980 after eight years in Wyoming and Colorado, she had made the leap from free-form crochet to felting and hand-dyeing wool fabrics for coats and wall hangings. Her images were often drawn from life on the Western frontier,

118

150 Ben Compton. **Phoenix Coat**, 1975. Wool-nylon blend and rayon; cut, stitched, dip-dyed, machine appliquéd. Philadelphia Museum of Art. Promised gift of The Julie Schafler Dale Collection

151 Jean Williams Cacicedo. **Transformations**, 1977. Wool and suede; crocheted, hand knitted. Courtesy Harrie George Schloss

150

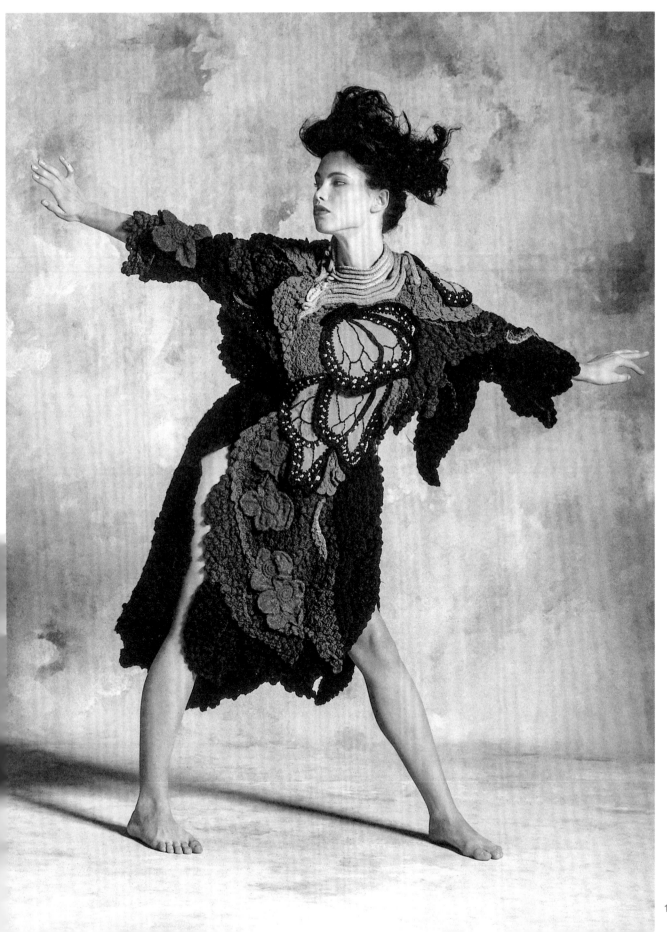

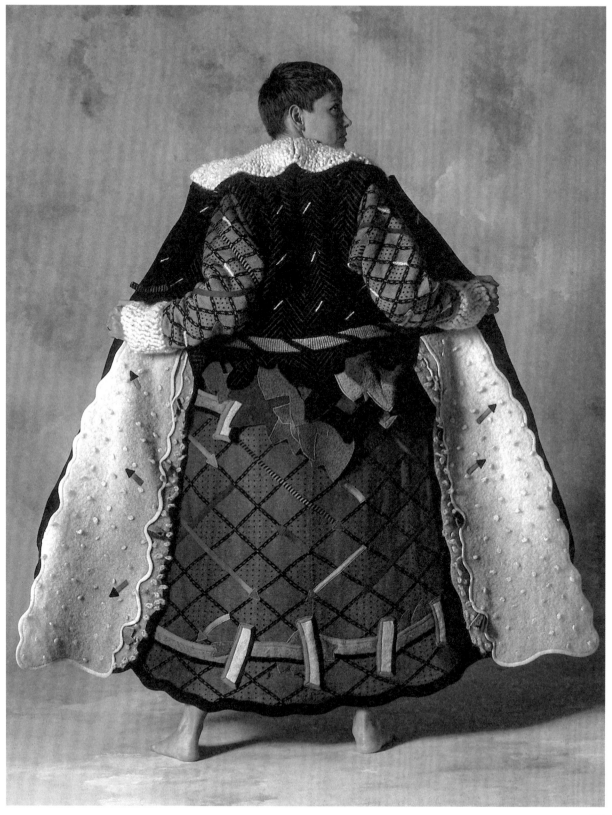

153–55

as in *Chaps: A Cowboy Dedication* (fig. 152) and *Tee Pee Coat* (see fig. 120). The process of creation was slow and involved many steps over several years, as evidenced by comments in one of her sketchbooks of the 1980s (figs. 153–55):

> Drawing is one episode to the total production of a wearable piece I wish to create. The process of constructing my wearable work takes so much time that the making of drawings is actually separate physically and often conceptually different from the final wearable. Drawings give me the freedom to work out color and composition in many ways. In each piece that I create there is a story and a character which eventually evolves as the narrative, often made possible by creating drawings first. I see my drawings and my craft as the means to convey my art through fabric, sewing, and dye.[11]

Butterflies and rainbows, among the most readily identifiable counterculture images of the 1960s and 1970s, are often dismissed as period clichés. In the hands of Susanna Lewis, Ben Compton, Marian Clayden, and Sharron Hedges, they transcend such categorization. Susanna Lewis's entomologically correct *Life Cycle of the Monarch Butterfly* (fig. 156) and *Moth Cape* (fig. 157) were both

152 Jean Williams Cacicedo. **Chaps: A Cowboy Dedication**, 1983. Wool and Dacron; knitted, crocheted, felted, hand dyed. Philadelphia Museum of Art. Promised gift of The Julie Schafler Dale Collection

153–55 Jean Williams Cacicedo. Preparatory sketches for *Chaps: A Cowboy Dedication*. Courtesy of the artist

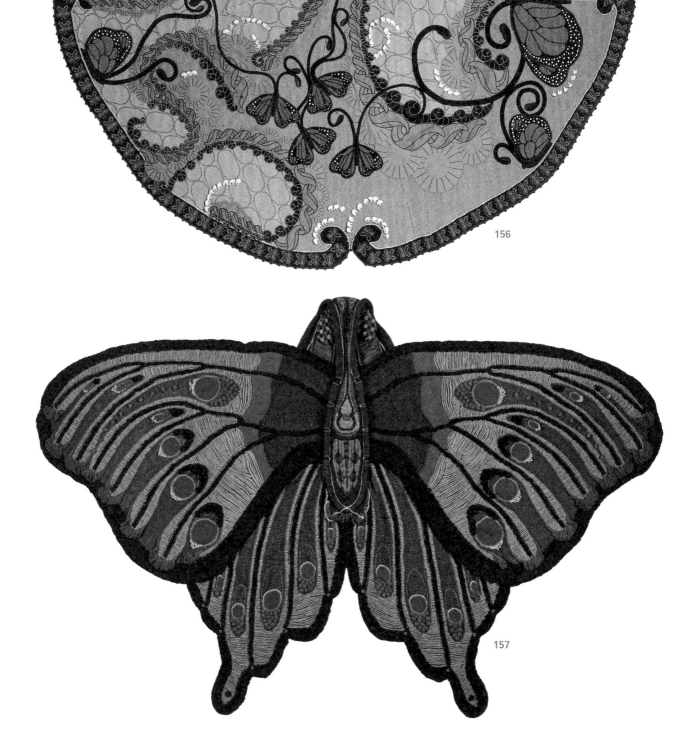

156

157

informed by her background in biology yet represent two completely different visions. *Life Cycle* was conceived as an illustration tracing the process of metamorphosis, while *Moth Cape* stands alone as an object. The moth image came from a dream: "The moth represents death; it was a huge creature, very big and heavy. When I saw it in the dream, it was not flat, but was alive and active. I saw it first from the underside, because it came down toward me—although it was brilliant, just like the cape, And when it came, it folded its wings around me—as the cape itself would around your body. . . . When I felt it on me in the dream I had to struggle to make it release me."[12]

Like Lewis's *Moth Cape*, Compton and Clayden's collaborative *Nocturnal Moth* cape was devised as an object, a "living sculpture" using the moving body as its armature (figs. 158, 159). Made for the Oakland Museum's 1974 *Bodywear* exhibition, it was shown with *Acid Vionnet* (see fig. 115), a work Compton described as a trippy combination of fashion icons Madame Vionnet and Charles James as well as Clayden and himself. *Nocturnal Moth* was an homage to the scene in Federico Fellini's film *La Dolce Vita* (1960) of a mass procession at dawn. Its genesis involved Compton shipping

156 Susanna Lewis. **Life Cycle of the Monarch Butterfly**, 1978. Wool, metallic, and nylon yarns; beads, studs, and tassels; machine knitted, appliquéd. Private collection

157 Susanna Lewis. **Moth Cape**, 1979. Wool, nylon, metallic, and chenille yarns; machine knitted, crocheted, stuffed, quilted. Philadelphia Museum of Art. Promised gift of The Julie Schafler Dale Collection

158 Ben Compton and Marian Clayden. **Nocturnal Moth**, 1974. Silk super organza, steel corset stays, nylon "horsehair" braid, silk veiling, cotton lace, and elasticized harness; dyed, clamped, discharged, dipped, burned, cut, pieced, embroidered. The Julie Schafler Dale Collection / collection of Roger Clayden

159 Ben Compton wearing **Nocturnal Moth**, 1974. The Julie Schafler Dale Collection

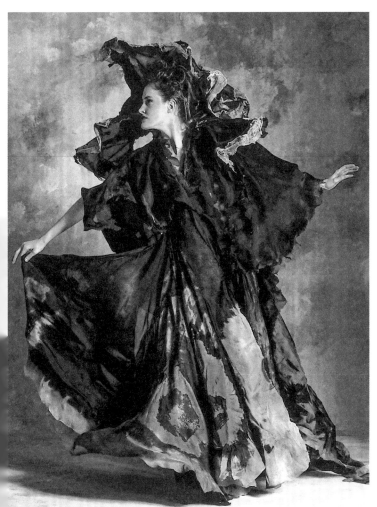

158

159

the partly assembled cape from New York to California, where it was dyed, clamped, discharged, dipped, burned, and cut by Clayden, returned to Compton in New York for completion, and finally sent to Oakland for the exhibition. One of Compton's last works, *Madame Butterfly* (fig. 160), is both a theatrical conceit and a wearable sculpture. This kimono-like garment of silk brocade and cotton lace streaked with red is a haunting evocation of Cio-Cio San's suicide attempt in Puccini's opera.[13]

In *Morpho* (fig. 161), Hedges captures the iridescence of a large tropical butterfly using fifty colors of yarn for its layered wing-like forms. This, the last of what Dale has described as Hedges's "great coats" made between 1975 and 1984, is more object-like than its four predecessors, which Dale sees as abstractions of individual clients' personalities. Although each coat is a unique display of bold color and form, when seen side-by-side they illuminate Hedges's changing aesthetics, from free-form images to more organized forms.

The creative process for these artists was a long and complicated journey. Leather artist Joe Barth said he found it difficult to disassociate himself from the finished work: "The piece is a part of me. I forever tell people that. People who buy my work say to me, this is 'my' bag"; but I answer, no, *my* initials are the only ones on there. You may have it on permanent lend-lease, but it is *my* bag."[14] For others such as Hedges, the immersion in the physicality of the crochet technique was a "way to get my own insides out there, to release myself."[15] Upon completing her last coat, *Morpho*, its title prescient, Hedges left art to wear to become a designer of commercial knitwear and, later, textile prints.

124

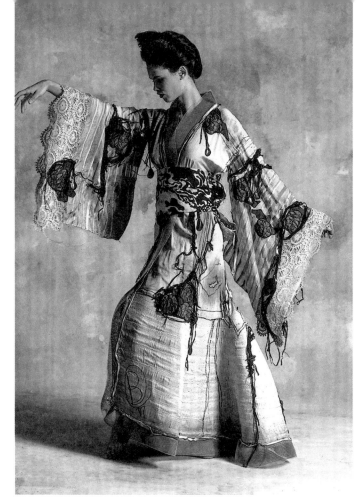

160

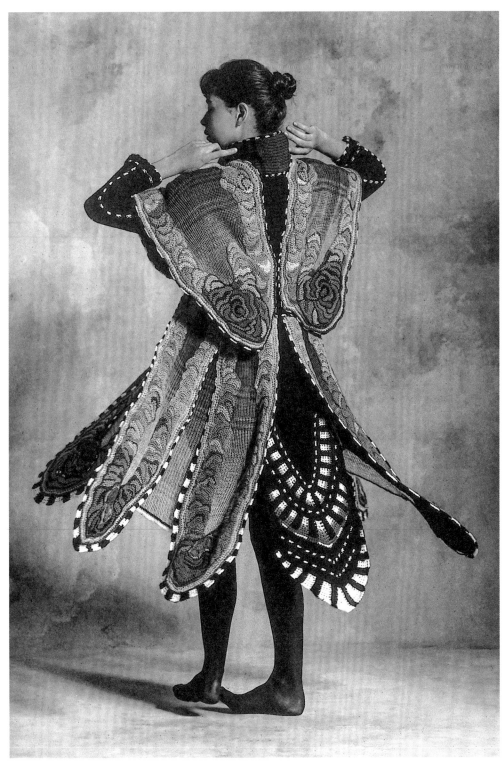

161

160 Ben Compton. **Madame Butterfly**, 1977. Silk, nylon "horsehair" braid, lacquered mussel shells, cotton, lace, and silk brocade; embroidered, pieced, appliquéd. Philadelphia Museum of Art. Promised gift of The Julie Schafler Dale Collection

161 Sharron Hedges. **Morpho**, 1984. Wool; crocheted, hand knitted. Philadelphia Museum of Art. Promised gift of The Julie Schafler Dale Collection

color and text

Color theory classes were an essential component of the new art education of the late 1960s and 1970s, spurred on by the emergence of color-field painting in contemporary art and the publication of the two cornerstones of Bauhaus color theory— Johannes Itten's *The Art of Color* (1961) and Josef Albers's *Interaction of Color* (1963)—as well as Charles Smith's *Student Handbook of Color* (1965), often used as a text in studio classes, where students carried out exercises using silk-screened Color Aid papers.

The period was defined by the rainbow color spectrum, which was tie-dyed, painted, embroidered, knitted, and crocheted; it graced rock album covers, and united "alternative" lifestyles such as the Rainbow Family of Living Light. Its meaning and significance were celebrated in 1975 throughout the San Francisco Bay Area and in *The Rainbow Show* at the M. H. de Young Memorial Museum, an exhibition that featured work by contemporary California artists using the image and the spectrum as its focal point (fig. 162). According to the sprawling catalogue, the wide-ranging survey celebrated light and color, the different kinds of environments that explore color, and the emotional rhythms associated with the rainbow symbol. Janet Lipkin and Marika Contompasis collaborated on *Primordial Swamp*, a woven, dyed, airbrushed, and patchworked installation described in *Craft*

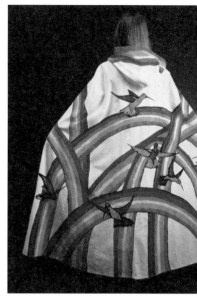

163 (back)

Horizons as having "quilted walls, colossal stuffed-fabric serpents, fabric pyramids, and glowing neon configurations,"[16] installed under an enormous heliographic rainbow by Lloyd Cross. Simultaneously, Marian Clayden was exhibiting *Ribbons, Ropes and Rainbows* at Palo Alto's Syntax Gallery.

Linda J. Mendelson's reversible *I Made My Song a Coat* (fig. 163), also known as *Rainbow Coat*, incorporates color progression inside and outside in combination with lines from William Butler Yeats's poem of the same name running along each shoulder and sleeve. The artist's machine knits incorporate an array of texts, from the poetry of E. E. Cummings and Emily Dickinson to lyrics from popular music and the introductory words of the long-running radio series *Grand Central Station* (fig. 164) to quotes from the twentieth-century inventor and visionary R. Buckminster Fuller. Like Mendelson's other works, it offered a platform for conversations uniting color, text, and the body. Her use of typography as a decorative form

162 Fred Kling and Candace Kling. **Painted Cape**, 1975. Cotton velveteen; painted with Inkodye. Location unknown. Photo courtesy Candace Kling

163 Linda J. Mendelson. **I Made My Song a Coat**, 1976. Wool; machine knitted. The Metropolitan Museum of Art, New York. Gift of Linda Mendelson, 1981 (1981.309a,b)

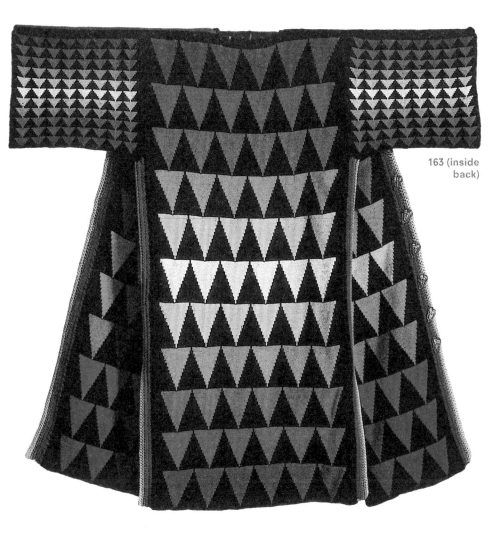

163 (inside back)

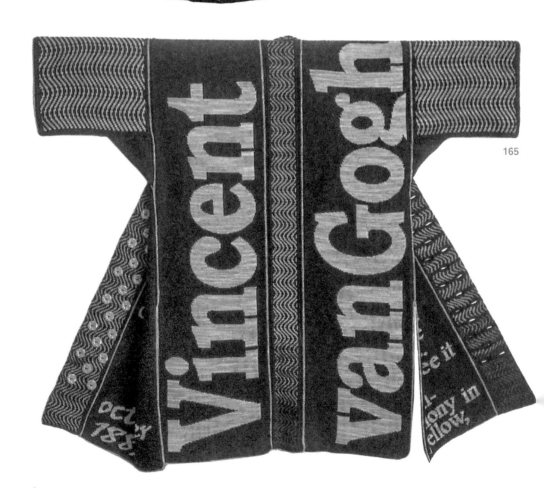

164 Linda J. Mendelson.
Grand Central Coat,
2003. Wool; machine
knitted. Philadelphia
Museum of Art. Gift of
Henry Benning Spencer,
2016-103-1a,b

165 Linda J. Mendelson.
Van Gogh Kimono, 1999.
Wool; machine knitted.
Private collection

166 Illustration from "Name
of the Game," *Life*,
September 13, 1968, 71,
featuring designs by
Rudi Gernreich, Adolfo,
and W. H. Wragge,
with props for the
upcoming movie *Recess*.
Photo: Bill Bell

167 Linda J. Mendelson. **Big
Red**, 1995. Wool; machine
knitted. The Julie Schafler
Dale Collection

164

165

followed in the footsteps of other modernist designers, from Alexander Girard's typographic patterns on sheer drapery fabric (1956) to Rudi Gernreich's use of typeface on a knitted dress with tights in 1968 (fig. 166). Typography and calligraphy were integral to Mendelson's designs: "Most people think of printed words as totally utilitarian, whereas I think they are intrinsically so beautiful. I love the idea of type and that communication can be so beautiful and also be understood by an enormous number of people."[17]

Mendelson's most playful works create a resonance between color, text, and typography. With the *Van Gogh Kimono* (fig. 165), the painter's signature yellow is combined with a well-known quotation on the color from a letter he wrote to his brother Theo. In another work (fig. 167), the word *RED* is pulled through red's various hues to blue, mirroring Josef Albers's observations on the afterimage and how colors influence one another when placed side by side.

166

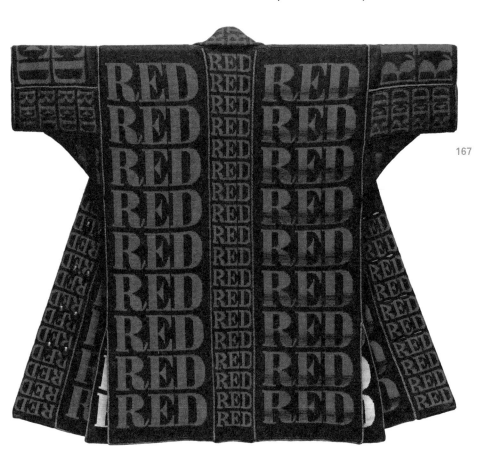

167

Mendelson usually experimented with six to ten color combinations and six or seven patterns for each garment until she found those that worked. Her one-of-kind commissions (she made only one or two a year) stimulated other production pieces. Mendelson's background in fine arts and later experience as a chart and graph maker, calligrapher, and draftsperson led her to develop a system for the knitting machine where she would graph out numerical relationships and transpose them into color and shape. The effect of changes in machine-knitting technology on her designs is evident in two works that quote from the same Haiku poem, "Kyo-Ah" (Bird of Time), first used in the late 1970s on a semicircular cape constructed from narrow knitted strips, and then in 2015 for a coat in which graduated disc-shaped forms recall traditional Japanese roof tiles known as *onigawara* (figs. 168, 169).

For weavers trained in the Bauhaus tradition such as Anni Albers, color and the woven structure were the foundation of a formal

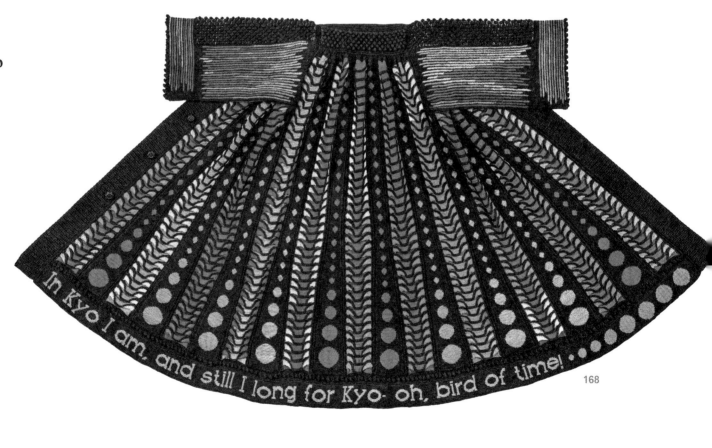

168

anguage of threads. For Randall Darwall (fig. 170), whose background was in painting, color was also a visceral, sensual, and spiritual experience. He was fascinated by the way color interacted with complex weave structures, and this became the prime motivator in his work as he orchestrated these elements into subtle yet startling conversations.[18] Ann Whiston Spirn, a professor of landscape architecture and planning at the Massachusetts Institute of Technology (MIT), said of Darwall's use of color: "The finished fabric of my shawl shimmers, not alone from the silk threaded through, but from the play of hues; threads transforming color, brown at one end, slipping

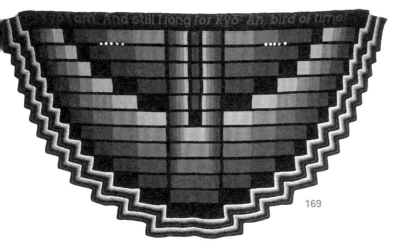

169

168 Linda J. Mendelson.
In Kyo–Kawara Coat,
2015. Wool and plastic
buttons; machine knitted.
Philadelphia Museum
of Art. Promised gift
of The Julie Schafler Dale
Collection

169 Linda J. Mendelson.
In Kyo Cape, 1979. Wool;
machine knitted. Private
collection

170 Detail of shawls by
Randall Darwall
(American, 1948–2017)
in various colorways
and weaving techniques,
c. 1985. Artist files,
Costume and Textiles
Department, Philadelphia
Museum of Art

170

through to green, to purple at the other end, many stories or one story line with many phases; the shawl ends in a palette of knotted twists."[19]

The images Minnesota artist Tim Harding creates for his kimono-shaped garments and wall hangings are reminiscent of those revealed in Impressionist brush strokes (fig. 171) but are created by violating and destroying the "preciousness" of fabric using a technique he invented in 1979 that builds up the textile surface through dyeing, layering, quilting, slashing, and fraying coarsely woven cottons to reveal color, images, and pattern.

132

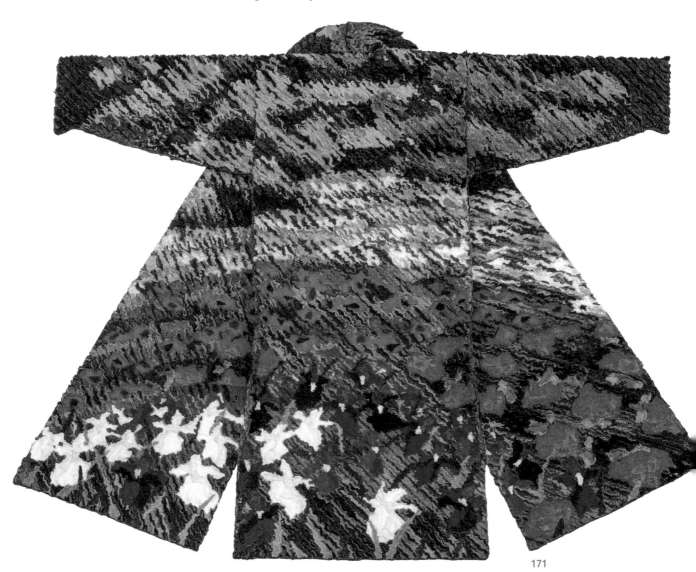

171

empty clothes

When creating his first assemblage in 1959, Jim Dine used his own clothes, painting over his green corduroy suit, adding a painted cardboard shirt and tie, and slashing the trousers into a "skirt." The gender ambiguity of Dine's paint-covered "suit," presented as a three-dimensional form, marks the beginning of a new art form, conceptual clothing, which explored identity and power through the absent wearer. Mimi Smith's MFA thesis at Rutgers on "Clothing as a Form" (1966) expanded the concept, reflecting the influence of the Fluxus artists on faculty at the time. According to Smith, the word "feminism" was not part of her vocabulary during these years, though she was interested in translating women's life experiences into a new sculptural art form. Since women's clothing was easily identified with the female experience, she decided that clothing forms could represent her life—as a bride, a married woman, and a mother—and by using household materials she could create work that bridged illusion and reality. *Girdle* (1966) is made from rubber bathmats, elastic, and ribbon; a nylon-and-lace peignoir is trimmed with steel wool (*Steel Wool Peignoir*, 1966; see fig. 11); and a wearable maternity dress of marbleized vinyl fabric (the type used for kitchen chairs) includes a clear plastic dome positioned over the belly (fig. 172).

Few first-generation art-to-wear artists confronted feminist issues directly, though feminism was a major rallying cry during the late 1960s and early 1970s. Looking back, however, a number of artists now see their choice to use crochet and knitting in their college art work as a feminist statement in the male-dominated contemporary art scene. Gaza Bowen, who during the 1970s and 1980s made beautifully crafted one-of-a-kind shoes, in 1986 began to explore the social and political issues surrounding gender and feminism through shoe sculptures. She transformed the housewife's arsenal of household cleaning "tools" into ironic unwearable fashion accessories in works

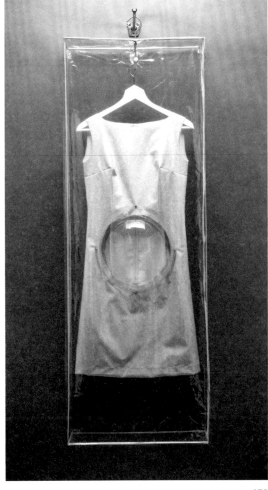

171 Tim Harding (American, b. 1950). **Garden: Field of Flowers**, 1991. Cotton; quilted, layered, slashed, frayed. Museum of Arts and Design, New York. Gift of Mr. and Mrs. Edmund A. Hajim, 1991.56

172 Mimi Smith. **Maternity Dress**, 1966. Plastic, vinyl, zipper, screws. Rhode Island School of Design Museum, Providence. Helen M. Danforth Acquisition Fund, 2007.8

172

173

such as *The American Dream* (fig. 173), made with sponges and plastic clothes pins, and *The Little Woman's Night Out* (fig. 174), which features copper pot scrubbers.

The Fabric Workshop, founded in Philadelphia in 1977, had as its goal "to teach artists from many different media the technical skills needed to create a new form of American art"[20] using hand textile printing with an emphasis on experimentation and breaking down barriers in art. During its early years the workshop created limited-edition prints, sculptural works, installation pieces, non-functional objects, and experimental clothing. One of the projects initiated during the workshop's first year was Judith Shea's *Semaphore Shirts* (fig. 175), silk-screened in primary colors red, yellow, and blue. Shea had studied fashion at Parson's School of Design, graduating in 1975. After a summer residency at Artpark in Lewiston, New York, in 1974, she began to make clothing forms based on the paper pattern pieces used for garment construction, which in turn influenced the series of shirt forms she created with the workshop. In 1978 Louise Todd Cope's *Poetry Shirt* (fig. 176)—a wearable shirt printed with seventeen original poems by Donald J. Willcox—was conceived as an alternative to a book of poetry. The British weaver Peter Collingwood was so taken with the idea that he sent Cope a description of his imaginary trip to the public library, where he attempted to borrow a size 38 shirt of poems but discovered that all the 38s were checked out.[21]

Between 1977 and 1979, Marian Schoettle assisted the Fabric Workshop's visiting artists in translating their ideas into three dimensions. The experience was formative to her approach to clothing as a conceptual art form. Among those in residence at the time was environmental artist Jody Pinto, known today for integrating

175

176

173 Gaza Bowen (American, 1944–2005). **The American Dream**, 1990. Found objects, sponge, plastic clothespins, kidskin, neoprene, plywood, and press board. Fine Arts Museums of San Francisco. Museum purchase, Textile Arts Council Endowment Fund, 1994.47a-e

174 Gaza Bowen. **The Little Woman's Night Out**, 1987, from the series **Shoes for the Little Woman**. Mixed media. Fine Arts Museums of San Francisco. Museum purchase, Barbara Donohue Jostes Bequest Fund, 1999.143

175 Judith Shea at the Fabric Workshop, 1977. On the wall are her **Semaphore Shirts** (top) and paper jacket and pants for **Four Continents**. Photo courtesy Fabric Workshop, Philadelphia

176 Louise Todd Cope. **The Poetry Shirt**, 1978. Cotton; embroidery. The Julie Schafler Dale Collection

136

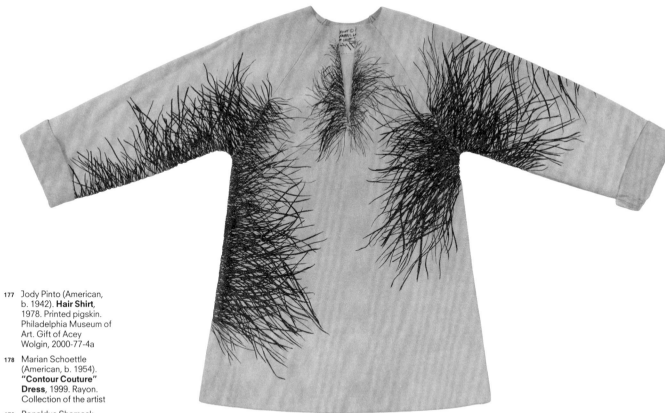

177 Jody Pinto (American,
b. 1942). **Hair Shirt**,
1978. Printed pigskin.
Philadelphia Museum of
Art. Gift of Acey
Wolgin, 2000-77-4a

178 Marian Schoettle
(American, b. 1954).
**"Contour Couture"
Dress**, 1999. Rayon.
Collection of the artist

179 Ronaldus Shamask
(American, b. Netherlands,
1945). **Sketch of Pleated
Dress**, 1979. Graphite
pencil on graph paper,
67 × 43 inches (170.2 ×
109.2 cm). Philadelphia
Museum of Art. Gift of
Sara Albrecht, 2012-116-1

180 Marian Schoettle. **No
Fixed Address**, 2014.
Printed Tyvek. Collection
of the artist

177

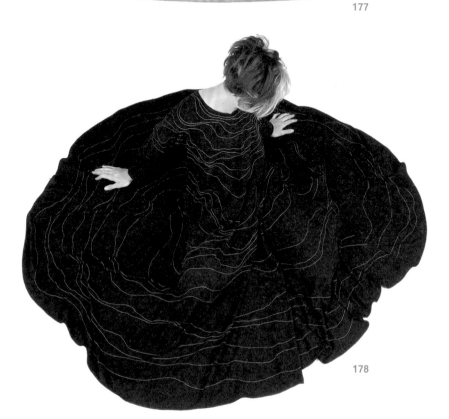

178

art into architecture and landscape. The body-as-landscape metaphor Pinto visualized as *Hair Shirt* (fig. 177) referenced her own drawings. Schoettle responded to the landscape as well in a series of limited-edition *Cartography* dresses (fig. 178) in which a single thread winds its way around the bodice and the circular skirt to mark its "topography."

The shared concepts that unite contemporary architecture and fashion were presented in the 1982 exhibition *Intimate Architecture* at the Hayden Gallery at MIT. Among the eight fashion designers included in the exhibition was Ronaldus Shamask,[22] who worked out his clothing ideas in the form of precisely rendered architectural drafts on graph paper (fig. 179). In 2007, Schoettle's tongue-in-cheek acknowledgment of this shared conceptual history led her to launch Post Industrial Folk Wear (fig. 180), a lifestyle line made from printed Tyvek wrappings used for building construction. Her conceptual approach to clothing resonates in the descriptions she gives her garments: Hurricane Floyd dresses, graffiti dresses, photographically processed dresses, narrative clothing, and tautological clothing.

Schoettle's collaboration with British artist Fran Cottell between 1984 and 1986 resulted in the co-curated exhibition *Conceptual Clothing*, one of the first explorations of the subject, and led Schoettle to name her own business "Mau-Conceptual Clothing." The exhibition presented twenty-three artists working across a variety of media, including performance, and traveled to eight venues throughout the United Kingdom in 1986–88, and then toured in the United States and Europe in 1989–92. The

179

180

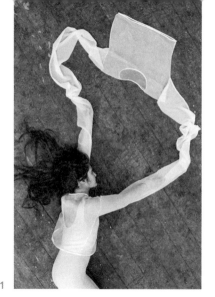

181

starting point for the work Schoettle exhibited, dresses and shirts that could be manipulated from their conceptual forms into wearable garments (fig. 181), was a quotation from the British anthropologist Marilyn Strathern: "The art of concealment is related to the concept of bringing things outside."[23]

By 1990 conceptual clothing was increasingly adopted as a sculptural form by artists. Clothing forms presented separately from the body became metaphors for power and identity, among other ideas, and were the focus of numerous museum and gallery exhibitions, including *Empty Dress: Clothing as Surrogate in Recent Art* (1990), curated by Nina Felshin, and *Art on the Edge of Fashion* (1997), curated by Heather Sealy Lineberry. Among the first generation of art-to-wear artists, Norma Minkowitz was one of the first to explore the idea of clothing and the body as an empty vessel, in, for example, her unwearable shoe sculptures of the early 1980s, filled with crocheted "worms" and "tacks." Jean Williams Cacicedo expanded on this concept in *My Father's House* (fig. 182), where her grief over her father's death was channeled into a "spirit house" that celebrated his life. She incorporated words from Psalm 104:2 into "a shear open matrix of thread so that one could fill the inside of the coat as a vessel for housing the soul of the departed." Displayed originally on an armature, the coat was also wearable and thus closed the circle by giving life to the empty form.[24]

181 Marian Schoettle. **Double Shirt**, 2014, from the series **Clothing Enigma**. Silk mousseline; sewn. Courtesy of the artist

182 Jean Williams Cacicedo. **My Father's House**, 1994. Wool; felted, dyed, knitted. Courtesy Harrie George Schloss

182 (fror

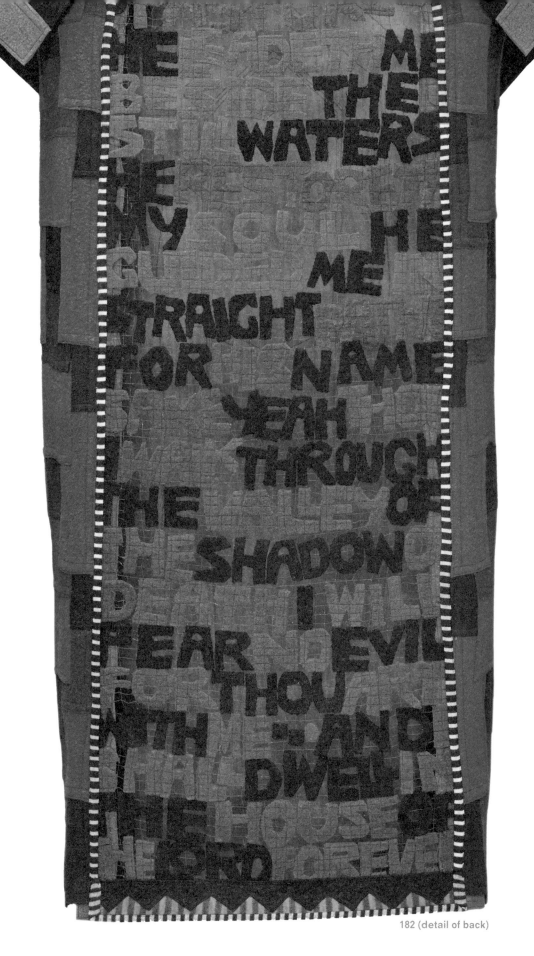

182 (detail of back)

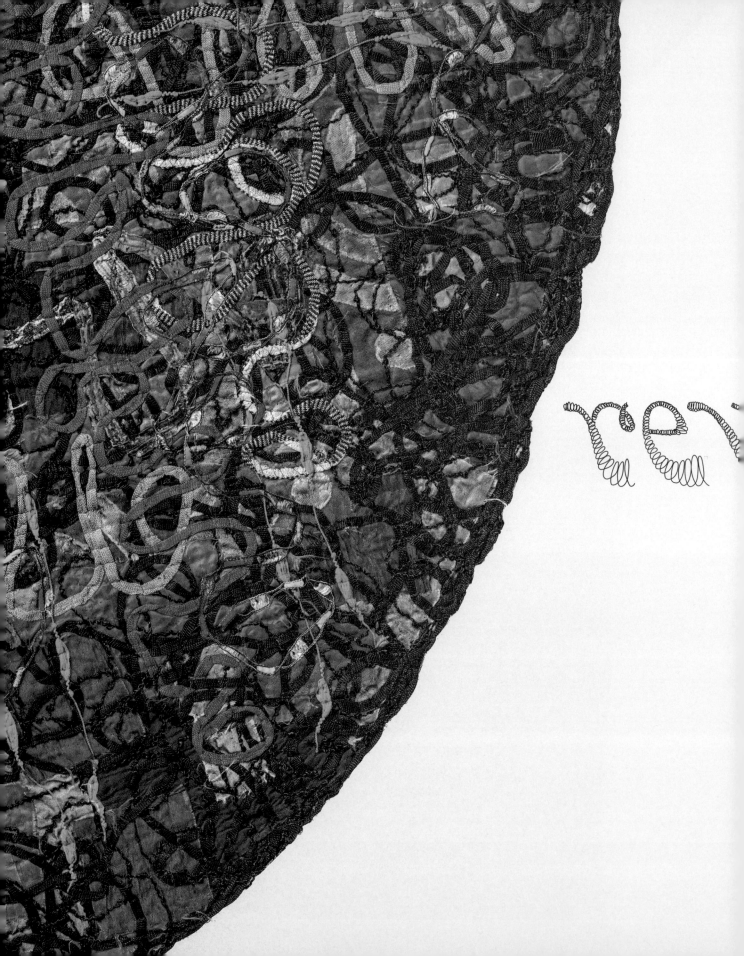

rberations

The story of art to wear from 1967 to 1997 is one of singularity followed by assimilation. This trajectory is paralleled by the fate of denim jeans, which by the 1970s, as fashion historian Valerie Steele notes, "were no longer really the mark of the worker, the rebel, or the hippy, because everyone wore them. Yet even as jeans became 'co-opted' by the fashion system, their signifying value grew more powerful.... As the counterculture was being swallowed up by consumer society, 'real'-life' denim became 'life-style denim.'"[1] As sportswear increasingly dominated casual attire, associated generational and demographic factors caught up with Levi's sales in 1997. The previous year, the company had made record sales of $7.1 billion; the following year, its sales shrunk by 15 percent and nearly six thousand North American employees were laid off.[2]

No figures exist to document the consumption of art to wear, but just as designer jeans propelled the globalization of fashion empires such as Versace, Armani, and Calvin Klein, the artists making wearables had inspired a response among individuals and clothing companies alike, resulting in offerings that echoed—but never achieved—the creative manipulation of materials, finishes, and imagery so rightly associated with art to wear. No longer a solely American phenomenon, the movement became both more diverse and more dispersed. However, some first-generation American participants remain at work (fig. 184), and it is their activity and influence that form the basis of this chapter.

why 1997?

Aside from being a turning point in the trajectory of Levi's sales, 1997 was a pivotal year in the United States and the world of the sort that had happened some thirty years earlier during the Summer of Love. "That sense of displacement, of a center that no longer held," prevalent at the inception of the art-to-wear movement,[3] could equally be applied to 1997, a year that saw the deaths of Gianni Versace, Princess Diana, and—of great significance in the world of art to wear—Sandra Sakata, owner of the Obiko gallery in San Francisco, who succumbed to cancer at fifty-seven. Carol Lee Shanks (fig. 183) recalled that "*everything*

183

183 Carol Lee Shanks. **Illuminated Warrior**, 2006. Cotton, Burmese bast fiber netting, and ostrich-eggshell beads; indigo-dyed, shibori-dyed, pieced, machine and hand stitched. Courtesy of the artist

184 Debra Rapoport. **Epaulets and Hood**, 2016. Cardboard, used teabags, egg cartons, and paper. Photo: Denton Taylor. Collection of the artist

142

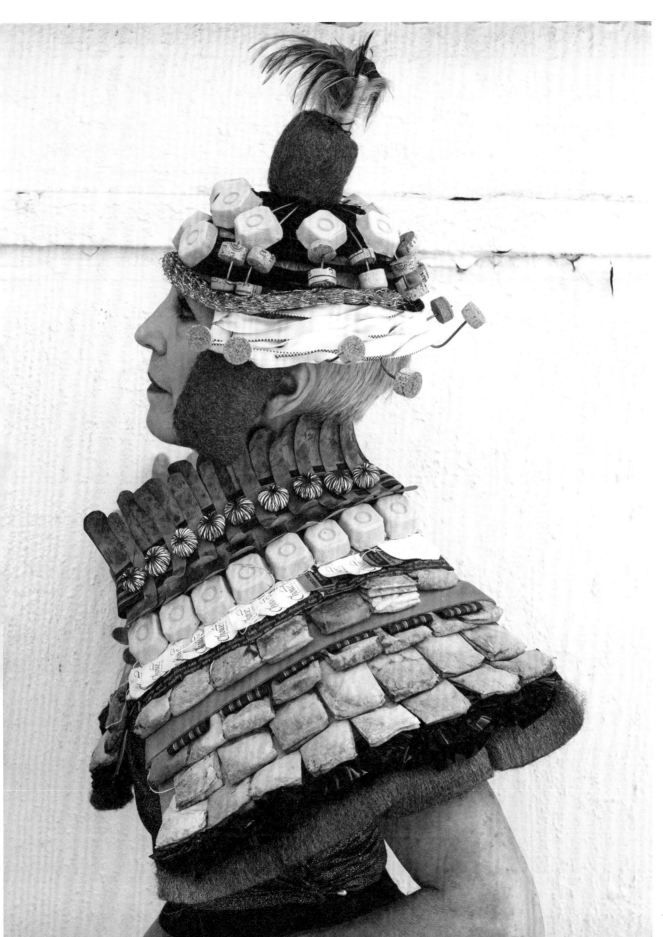

changed; Sandra's death took the wind out from under my wings....She had allowed me to soar." Shanks and Ellen Hauptli agreed that while some people tried to continue that legacy, "it didn't work. It was so much HER. Her vision. You just couldn't match that one!"[4] Within a few years, Jacqueline Lippitz's Gallery of Art to Wear in Glencoe, Illinois, had also closed. This meant that two of the four most influential art-to-wear galleries—the others being the Santa Fe Weaving Gallery and Julie: Artisans' Gallery—were gone.

Until its closure in 2013, Julie Schafler Dale's gallery retained its unique approach of offering one-of-a-kind works of art that just happened to be wearable. Dale presented new entrants to this field as late as 2007, when she began to show Diana Prekup's garments composed of densely stitched water-soluble stabilizer (fig. 185).[5] For those making art to wear in limited editions, other options remained, including second-generation boutique-concept galleries such as Dream Weaver (Sarasota, Florida, and Martha's Vineyard, Massachusetts), Northern Possessions (Chicago), Turtledove (Philadelphia; fig. 186), Bazaar Del Mundo (San Diego), Jackie Chalkley (Washington, DC), and Bellagio (Asheville, North Carolina).Traveling art-to-wear "trunk shows" have been orchestrated by the likes of Pat Henderson, a former Bergdorf Goodman buyer who since 1988 has operated her business out of Santa Cruz, California, showing what she describes as "the work of top clothing artisans from the U.S., Europe, and Japan." Susan Summa (fig. 187), already known for her knitwear, opened Atelier in 2002, a New York gallery initially focusing on three shows a year for the wholesale trade and now offering

185 Diane Prekup (American, b. 1956). **Stained Glass Opera Coat**, 2013. Silk or synthetic overlapping plain weave, fancy yarns, and knit binding; appliquéd with synthetic monofilament. Philadelphia Museum of Art Promised gift of The Julie Schafler Dale Collection

186 Harriet T. Abroms (American, b. 1937). **Woman's Duster Coat**, c. 1988. Cotton; silk-screened. Philadelphia Museum of Art. Gift of Harriet T. Abroms from her Turtledove Collection, 2007-70-10

187 Susan Summa (American, b. 1948). **Woman's Vest**, c. 1995. Cotton; machine knit. Philadelphia Museum of Art. Gift of Harriet T. Abroms from her Turtledove Collection, 2007-70-16

186

185

187

avant-garde fashions from around the world. Commenting on the state of art to wear at that time, Summa wrote:

> Changes in our market place were reflected by the growing demand by patrons to make pieces that fit! Not everyone wanted to collect garments that were shapeless and voluminous body-canvases. Our collectors and galleries began asking for sized garments instead of accepting the one-size-fits-many concept. During the 1990s, as the marketplace for artwear became increasingly savvy, many galleries also began requesting colors that more closely followed fashion trends, more sophisticated silhouettes, fine finishing details and construction, and more refined embellishment.... Many of us began to question our choices. None of us regretted our decisions to make art, but we entered a period of reevaluation. Some no longer wanted to make production work and began to make one-of-a-kind work again. Some decided to teach in order to be able to experiment with new techniques and nurture the next generation of fiber designers. Some chose to move further into creation of well-designed, fashion-oriented collections.[6]

Also in 2002, Marika Contompasis established MA+CH with her brother, Charles, who also attended Pratt Institute. Based in upstate New York, this studio is unusual in its comprehensive approach to everything from design and dye/print processes through to finishing, warehousing, and shipping, supported by Charles's patents and trademarks.

And other forces were afoot. Minimalist fashions had begun to take hold of the runways; after the conspicuous consumption of the 1980s, the "less is more" ethos gained ground as the 1990s progressed. It was in the late 1990s, for example, that Calvin Klein introduced its take on American minimalism with several clean, simple monochrome collections. This was not a new component of fashion; what *was* new was the adoption of a minimalist aesthetic, sometimes called "clothing neutral," that aimed to blend in with an increasingly aggressive urban society through what was essentially a form of camouflage, disguising wealth and elite sensibilities.

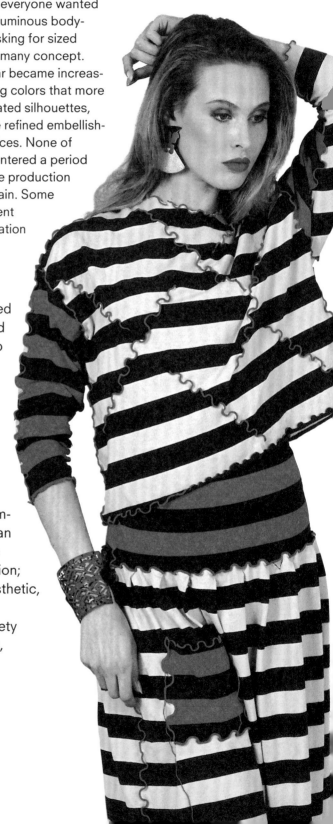

the shifting artistic landscape

In 1994 the perceptive educator, curator, and artist Jo Ann C. Stabb was already considering the impact of those who had transformed art to wear into "a kind of American couture." Aware that many of the established artists had evolved during the mid- to late 1970s "from pioneers in one-of-a-kind garments to business men and women who create limited production lines" (fig. 188), she described their merging of personal style and technical ability with skills in managing production teams and sales strategies as a success that "established wearable art as a legitimate, almost mainstream endeavor rather than a marginalized hobby."[7]

Stabb might well have been speaking of Marian Clayden, who, having made scarves and wraps for Julie: Artisans' Gallery and garments sold elsewhere (including at Obiko) since the late 1970s, in 1981 established her fashion business. Clayden Inc. initially produced one collection per year, famously using a sandwich toaster to clamp-resist patterns in the mid-1980s (fig. 189).[8] In response to keen and widening demand, by 1988 she was making four collections a year. Some garments, such as *Viennese Bias Dress* (1991), remained in her line for more than a decade. Stars who appreciated Clayden's elegant artistry included Meryl Streep, Sigourney Weaver, and Oprah Winfrey. Produced in a wide range of fabric designs and colors, the most admired Clayden creations were composed of jacquard-woven silk/rayon cut velvet, ombré-dyed and discharged. She had first obtained this fabric—undyed—from a European mill in about 1986, but soon began to design her own velvet patterns (fig. 190). Such was her impact that these loom-patterned velvets appear to have inspired the revival of devoré, a far cheaper process in which velvet is printed with an etching medium that removes pile to imitate cut velvet.[9] At the apex of her career she

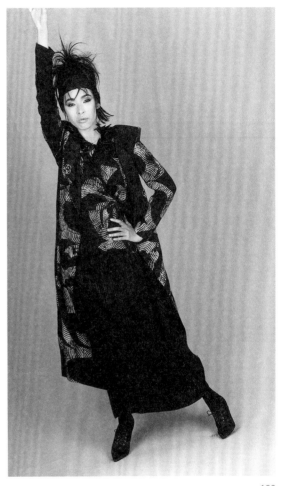

189

188 Ellen Hauptli. **Riffle Top and Skirt**, c.1994. Cotton/Lycra jersey; seams and ruffles stitched with purl edge serger; jewelry by Leslie Correll. Courtesy of the artist

189 Marian Clayden. **Toaster Print Garment**, 1987. Wide-wale cotton corduroy; pigment-printed, scorched pattern transferred to screen and masked to create a variant design; jewelry by Leslie Correll. Courtesy of the artist

participated in the 1998 and 1999 "7th on Sixth" shows, annual runway events for New York's fashion industry. By then her work was carried by luxury department stores Henri Bendel, Saks Fifth Avenue, and Bergdorf Goodman; at the latter, her ranges were the most profitable per square foot among designer boutiques. Downsizing within a few years (and retiring in 2005), she was the last of the first-generation art-to-wear artists to sustain a business on this scale, with sales of more than $1 million in the mid-1990s. Despite this commercial success, she was adamant about her motivations: "The real thrill of clothing design was making a successful combination of all the elements— body style, fabric, drape, dyeing, and how it moves when worn—so as to create a garment that makes the wearer feel she is enclosed in something as valuable to her as a work of art."[10]

148

Clayden's imitators, especially the numerous suppliers of devoré accessories and garments, exemplify the diffusion of garments that *appeared* handmade but used simpler techniques and less-detailed finishing. While the American Craft Museum's 1983 *Art to Wear* exhibition emphasized the wearability of its selection, that very feature had led some critics to conclude that the garments were not art but "pleasing collectibles," or that they were becoming conservative—in line with fashion—and even nostalgic.[11] Embroidery designer, needlewoman, and author Erica Wilson, on the other hand, saw "craftsmanship, sophistication and practicality…weaving their way into creations that are still unique works of art, yet eminently wearable," and noted, presciently, that "this blend of art and craftsmanship is reaching new heights and is undoubtedly going to have a great influence on fashion designers everywhere."[12]

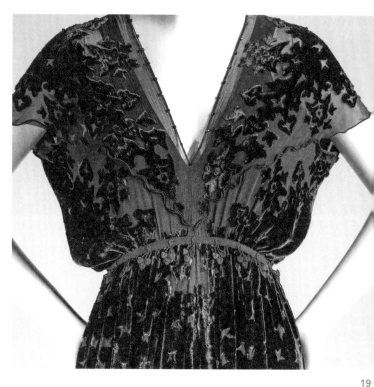

19

Computer-aided design, applied first to knitting machines in 1979 by the German manufacturer H. Stoll & Co., was already leading the way. The world's first electronically controlled flat knitting machine was followed in 1987 by Stoll's CMS 400, which could simultaneously produce exchanges in colored yarns (intarsia) and fully fashioned garments. Janet Lipkin, Susanna Lewis, and Linda J. Mendelson were among those who took advantage of these possibilities as they disseminated through the makers of hand-operated machines. With these technological advances, Mendelson found that her "output has become increasingly complex, due to both an evolving artistic sensibility and the technological progress in the loom-knitting field," adding: "My connection to modern art movements such as Constructivism and Color Field Painting becomes more apparent with the passage of time."[13] But when industrial machines were able by 1997 to combine several gauges, and were soon providing woven and ikat-like effects, there was little difference, save artistic intention, between mass-produced and hand-knitted garments.

Computer-aided weaving followed a similar trajectory, becoming user-friendly in the mid-1980s and achieving a comparable level of sophistication in the hands of skilled designers in the 1990s. Digitally printed cloths began to challenge existing figuration methods, starting in the late 1980s as a substitute for screen printing. The dye-sublimation (or heat-transfer) printer, developed in the early 1990s, was soon joined by what is essentially an ink-jet (direct) printer. Since 1997, Ana Lisa Hedstrom (fig. 191) has skillfully explored the potential of digitally printing fabrics, but cautions that the many fashion designers now using scans of quick, casually made pieces of shibori have diluted the appreciation of masterful dyeing.[14] Finally, the finessing of microfiber production during the

190 Marian Clayden.
Fragments Gown, 1998.
Jacquard-woven silk/
rayon cut velvet. The
Metropolitan Museum of
Art, New York. Gift of
Marian Clayden–Artist
Designer, 2003.200a,b

191 Ana Lisa Hedstrom.
Untitled, 2004. Polyester
organza; digital dye
sublimation print from
scanned shibori fabric.
Courtesy of the artist

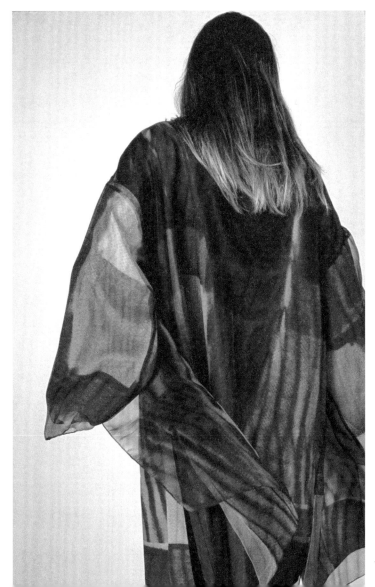

1990s made shimmering, subtly patterned, digitally printed synthetic fabrics a common feature of fashion by about 2000. Eventually, even London's *Financial Times* noticed:

> Think of it as luxury polyester. And imagine a microfibre with a sheen reminiscent of washed silk rather than plastic, and the substance of a thickly woven quality cloth rather than the scratchiness of its rough forebears, without any unnecessary weight. No wonder Japanese avant-garde fashion houses such as Comme des Garçons and Issey Miyake, which have used polyester in designs for the last two or more decades, are now being followed not by high-street chains (with which the old polyester is more readily associated) but by high fashion names such as Nina Ricci and Narciso Rodriguez. Meanwhile at Louis Vuitton, designer Marc Jacobs created polyester skirts and knitwear, and at Lanvin almost half of the new women's wear collection was made from the material.[15]

It seems no surprise that by the time this was written, in 2008, Hauptli had ceased making pleated, hand-painted, overlock-edged polyester garments, and by 2001 was working with ralli (fig. 192).[16]

In addition, makers of art to wear now had authentic and often exquisite "ethnographic" competitors. Import shops and specialty stores had existed since the 1960s; Pier 1, founded in San Mateo, California, in 1962, was frequented by many Bay Area artists, including Stabb, Ed Rossbach, and Katherine Westphal, who ultimately donated some of their textile purchases to the design collection housed at the University of California, Davis.[17] Pier 1 is now headquartered in Texas and has more than a thousand stores nationwide. Its provision of interesting imports ceased to be an unusual feature after 1997, when the World Trade Organization's 1994 Agreement on Textiles and Clothing (ATC) began a ten-year program phasing out quotas and reducing tariffs, rapidly increasing clothing imports from China, Hong Kong, Taiwan, Japan, and South Korea, as well as the Indian subcontinent, Africa, and Latin America, and shrinking the domestic clothing sector in the United States and other developed countries.[18] The North American Free Trade Agreement (NAFTA), also enacted in 1994, made more clothing manufactured in Mexico available to American consumers. All of these changes also allowed agencies as diverse as Oxfam and the World Bank, together with small-scale cooperative ventures,

to market indigenous dress from cultures where hand-production still predominated. For the art-to-wear movement, this meant that the once relatively rare and inspirational artisanal garments, whether Miao or Peruvian, Bengali or Oaxacan, became readily available in the US market.

Finally, with the first digital paper-printing presses becoming available in 1993, a profusion of how-to books, ethnographic textile studies, and special-interest magazines such as *Fiberarts* (first issued in 1976)*, Surface Design Journal* (1976), and *Ornament* (1978) included full-color, high-quality images by the end of the 1990s. Once-prized full-color volumes such as Julie Schafler Dale's 1986 *Art to Wear* or smaller practical books such as Yvonne Porcella's *Pieced Clothing* (issued in1980 and revised in 1987) ceased to be the exceptions. The world's wearables—both literally and virtually—were at everyone's fingertips. Soon Stabb could observe: "The highly original and unique processes and hand techniques [artists had] developed are now more widely accessible with many publications, classes, and workshops offering information similar to what was previously individualized and exclusive."[19] Stabb might well have added audiovisual media, since she had served as executive producer for *Wearable Art*

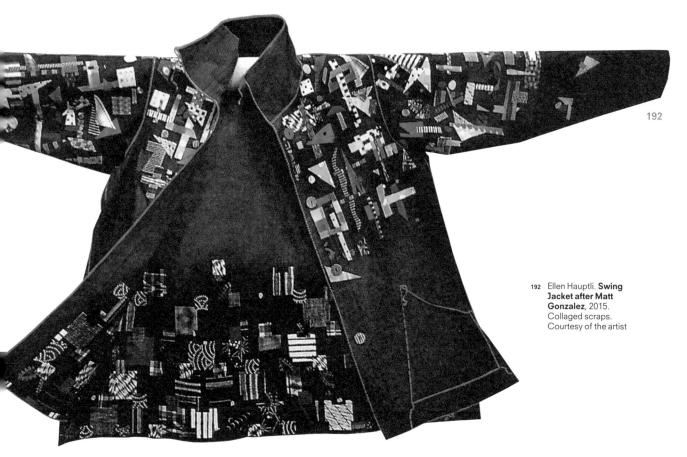

192

192 Ellen Hauptli. **Swing Jacket after Matt Gonzalez**, 2015. Collaged scraps. Courtesy of the artist

from California (1985–86), a series of five half-hour educational video programs on Jean Cacicedo, Gaza Bowen, Candace Kling and Ellen Hauptli, K. Lee Manuel, and Katherine Westphal.[20]

Alongside the increased availability of "real" ethnographic clothing and its parallel, foreign-made garments that shadowed key approaches to materiality developed through American art to wear, came the foregrounding of nonwearable art that referenced the body (fig. 193). Nina Felshin noted that the early 1990s had "witnessed a rather extraordinary proliferation of art in which clothing is abstracted from the human body."[21] As Polly Ulrich explained in 1999 to readers of *Fiberarts*, this was the culmination of a decades-long process: "Since the 1960s, philosophy and art have begun to redeem the body, repositioning it as an important aesthetic subject." Ulrich provided a compelling reason for this postmodernist embodiment of ideas, noting that "this salvage of the body comes in the midst of, and perhaps because of, the rapid digitalization and dematerialization occurring in our media- and technology-driven society."[22] By 2010, platforms such as Pinterest and Instagram were disseminating millions of virtual images, often without acknowledgment of the maker, date, or materials, removing that sense of significance so critical to art of any kind.

One project of postmodernism has been to diminish the distinctions between, for example, "high" and "low" art. In the world of art to wear, this has played out in a blurring of the line between wearable art and fashion. This change is captured, for example, in the publisher's description of Shirley Friedland and Leslie Piña's 1999 book *Wearable Art, 1900–2000*: "From one-of-a-kind hand made fashion to commercially made highly decorative apparel, wearable art has become an important category for both collectors of vintage costume and of unique contemporary fashion."[23] This trend garnered a headline in *Women's Wear Daily* in 2002, when Barneys New York featured one hundred vintage art-to-wear garments drawn from the collection of Cameron Silver, owner of the Los Angeles–based vintage store Decades.[24] That same year, Tim Harding (fig. 194) offered a more nuanced appraisal of the state of play:

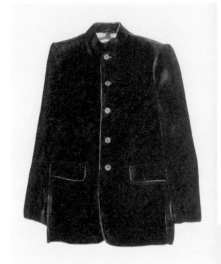

193

Today, one might say that the now-fragmented movement is larger, much more diverse, and more closely associated with fashion than art. It numbers more artist/designers, more craft fairs, more retailers, and more collectors. The new work synthesizes early inspirations, the new marketplace, fashion, the craft world, the art world, pop culture, and the current social and political climate. To many creators of art-to-wear, it matters little whether their work is labeled as fine art, decorative art, or applied art, as long as they are able to pursue their vision and form of expression. The ongoing democratization of fashion, the melding of high-brow and lowbrow culture, and the cross-fertilization of previously distinct fields have all influenced the popularization of art-to-wear. In some ways, the goals of the early populist movement have been realized.[25]

193 Waverly Liu (Chinese, b. 1974). **Family Portrait 47, Dad's Zhongshan Suit**, c. 2012. Watercolor on paper, 36 × 28 in. (91.4 × 71.1 cm) Courtesy of the artist

194 Tim Harding. **Koi**, 1991. Bias-cut Dupioni silk; layered, slashed, frayed. Minnesota Museum of American Art, St. Paul. Purchase, Funds from Twin Cities Mazda Dealers, Elizabeth and Robert Gunderson, Mona Meyer, McGrath and Gavin, Cray Research Incorporated, and an anonymous donor, 92.16.1

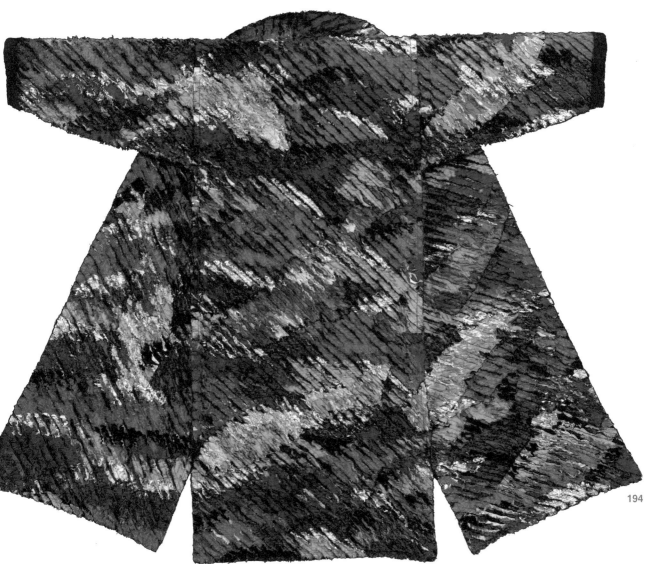

194

the wider world

From her base in Berkeley, Yoshiko Wada had led annual tours to Japan beginning in the 1980s, providing Americans access to shibori masters. She also sponsored in-person visits to America by Japanese textile artists, including Jun'ichi Arai, whose daring textiles became synonymous with Issey Miyake's avant-garde fashions, and curated numerous exhibitions featuring shibori-based processes, including one in Japan in 1984–85 in collaboration with Ana Lisa Hedstrom. Meanwhile, the annual shibori festival established by Kahei Takeda (from a family of shibori specialists in Arimatsu, Japan) had become such a major global attraction that in 1992 Arimatsu artisans organized the first International Shibori Symposium (ISS) in Nagoya. Their intention was "to redefine shibori, exploring its possibilities for manipulating two-dimensional fabric into three-dimensional forms."[26] As a result, Takeda and Wada founded the World Shibori Network (WSN), which, with Wada as a principal force, has led to the ISS being hosted not only in Japan, but also India, Chile, the United Kingdom, Mexico (fig. 195), Australia, France, Hong Kong, and China. Through the WSN, as well as through numerous workshops around the world, Wada has become known as the pioneer of "neo-shibori," now a worldwide textile phenomenon. Not limited to inspiring art to wear, the WSN and ISS initiatives were nevertheless among the collaborative developments that made the 1990s "a point when those within the field gained a self-awareness that allowed, eventually, for less concern about outside opinions."[27]

195

The Lausanne International Tapestry Biennial had, since its foundation in 1962, been a significant indicator of the state of textile art.[28] Although wearable art had not been part of the biennial since Debra Rapoport shocked its organizers by *wearing* her entry in 1971, its cessation in 1995 seemed to symbolize an uncertainty felt around the world, especially to those dealing with entities for whom "outside opinions" still mattered. Articulating the mood in the Americas was Yosi Anaya (fig. 196), a Mexican textile artist and authority on indigenous textiles of Latin America. Noting concerns that universities were also closing their textile departments, she wrote of these "moments in which the historic yet hushed thread of activity—mainly relegated to women—had to reaffirm the validity of the artistic intent in the creative production of textiles despite the fact that the hierarchic currents of artists' thought bounced it back to the home and as a pastime, in an era in which art moved and continues to move in new conceptual and theatrical levels." She questioned how to "vindicate and restore the creative process implicit in the handling of materials, forms, techniques, colors, spaces and history, while textile activity diversifies in so many manifestations that it becomes almost unclassifiable."[29] The reply came in 1997, when

195 Christina Kim (South Korean, b. 1957). **Bandhani Flags**, 2010. Installation for the 10th International Shibori Symposium, Museo Textil de Oaxaca, Mexico

196 Yosi Anaya (Mexican). **Shadow Women**, 2015. Miniature printed silk huipiles cover each small, individual cutout and lacquered figure in an installation for the artist's exhibition *Continuity Re-Inscribed* at the Cork Institute of Technology's Wandesford Quay Gallery, Cork, Ireland. Photo courtesy CIT Crawford College of Art and Design, Cork

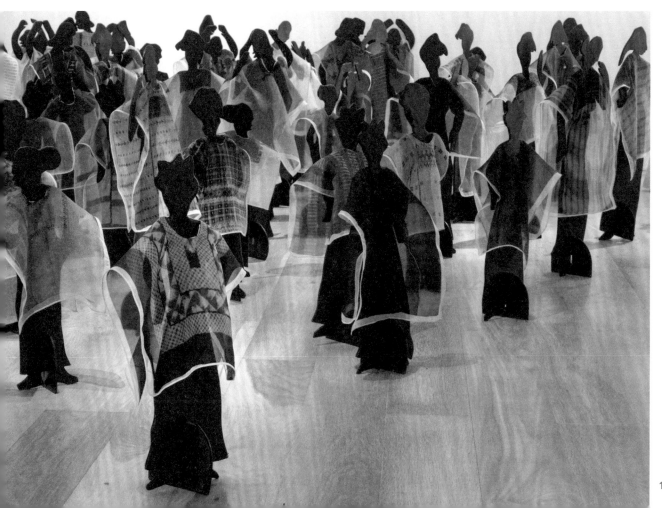

the Colombian textile artist Pilar Tobón formed the World Textile Art (WTA) organization with the support of the Latin American Art Museum in Miami. The WTA has organized biennials in Miami, Latin America (fig. 197), and, after 2007, in Europe; unlike the Lausanne shows, the WTA embraces all forms of textile art, including art to wear.

As Julie Schafler Dale has observed, "Dissemination of the movement abroad produced new players and new aesthetics reflective of foreign cultures. Korea, Japan, the Netherlands, Belgium, Germany, and, of course, the United Kingdom made invaluable contributions in pushing forward the story of art clothing."[30] Artists from the United Kingdom were especially visible in the United States, whether through Julie's presentations of Carole Waller's hand-painted garments or features such as the 1999 coverage in *Fiberarts* of the work of empty-dress artist Caroline Broadhead and hat-maker extraordinaire Jo Gordon.[31]

It was in New Zealand, however, that art to wear found its most forceful advocate outside the Americas. Launched by Suzie (now Dame) Moncrieff in 1987, the World of WearableArt (WOW) event was started in the coastal city of Nelson as a small show combining wearable art, theater, and dance. In 2005 it was moved to a much larger venue in Wellington and stepped into the international spotlight. Inspired by art to wear, "WOW takes art off the wall and onto the human form."[32] Far more radical is the fact that participants come from a broad range of backgrounds and visualize concepts as diverse as "entrapment and blindness, eroticism and fetish, Pacifica, fantasy and flight."[33] Entries from more than forty countries compete in categories such as "Creative Excellence: Architecture," "Performance Art," and "Bizarre Bras." The annual three-week theatrical spectacle now draws some sixty thousand visitors. Among its 2018 awards were several garnered by entrants from the United States, including Dawn Mostow and Ben Gould of Seattle, who were overall winners in the International category with *Foreign Bodies* (fig. 198) developed for the "Under the Microscope" section. The pair, who both graduated from Pratt in 2008, had won the Wearable Technology Award the previous year and went on to found Dawnamatrix, specializing in handcrafted latex couture that "merges fine art with high style as a vision for the future of fashion."[34]

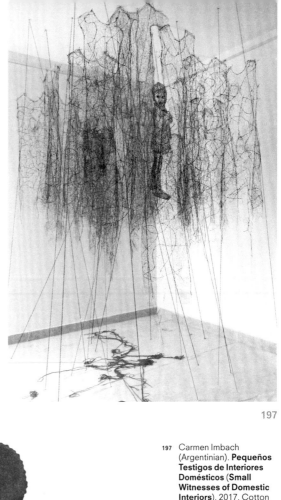

197

197 Carmen Imbach
(Argentinian). **Pequeños
Testigos de Interiores
Domésticos** (**Small
Witnesses of Domestic
Interiors**), 2017. Cotton
and wool; macramé.
Courtesy of the artist

198 Dawn Mostow
(American, b. 1979) and
Benjamin Gould
(American, b. 1985).
Foreign Bodies, 2018.
Latex, EVA foam, and
inflation valves;
solvent-based adhesive
construction. Image
courtesy World
of Wearable Art Ltd.

198

old issues, new solutions

None of these developments would have surprised Katherine Westphal. When she led the delegation of UC Davis staff to the World Crafts Council gathering in Vienna in 1980, her lecture had presented not one concept, but many. "Wearable art can tell a story like a comic strip or like a bas relief on an ancient wall," she said. "The story can be encyclopedic, poetic, narrative or journalistic or it can have no story at all." Suggesting the importance of play—on ideas, words, forms, materials, or play itself—she continued: "It is art moved out of the gallery onto the street. It moves the man or woman into a painting. This painting performance becomes the changing, moving, growing art in the street. . . . There is a new audience, an audience exposed to art without going into the citadel of the elite, the gallery or museum. It is for all to enjoy or reject. It is there."[35] Nor would they surprise Jo Ann Stabb, who as curator included an excerpt from Westphal's lecture in the catalogue of her seminal *Poetry for the Body* show of 1983. Stabb stressed the visualization of anti-establishment values, the intense dialogue between creator and materials, and the fact that "the work itself is the performance . . . half of Wearable Art is the *wearer*."[36]

Debra Rapoport would feel equally at home with at least some of the WOW winners. Since her return to New York in 1978 she has taught consistently, including workshops at Eileen Fisher and the Lower Eastside Girls Club, encouraging young women to explore their creativity and individual styles.[37] The Fisher workshops, dubbed "Green Eileen," used recycled clothes, an exercise for which Rapoport—along with other New Yorkers in Ari Seth Cohen's now-famous Advanced Style group[38]—is renowned. Often featured on the internet, she specializes in creating unlikely combinations of upcycled garments and accessories (fig. 199) as well as making hats and jewelry from paper towels and their cardboard tubes. Instead of "lasting objects to sell," Rapoport is now interested in creating "visual moments." As Stabb explains, "Her authentic form of self-invention is an artistry aimed toward uncommodifying the culture."[39]

Rapoport's life-long fondness for finding artistry in "stuff" now has an official proponent in WOW, for which "the garments are constructed from an extraordinary array of materials—car parts, wood shavings, zips, silk, potato chip packets, seaweed, slices

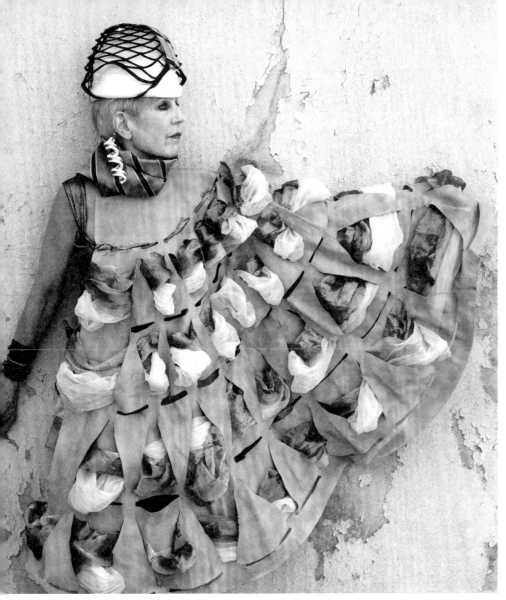

199 Debra Rapoport.
**Reinvented Cape with
Hat, Scarf, and Earring**,
2016. Cape: suede,
spray paint, added fabric.
Photo: Denton Taylor.
Courtesy Debra Rapoport

199

of toast, old telephone posts, paper clips, corrugated iron, gloves, feathers—the list is endless."[40] The Christchurch sisters Natasha English and Tatyanna Meharry (the first two-time winners of the Supreme Award) won in 2018 with *WAR sTOrY*, a representation of the more than 120,000 New Zealand men and women who served in World War I that incorporates recycled objects, including old army and household blankets, salvaged rimu from demolished houses, plastic toy soldiers, crushed red bricks, and traded pieces of pounamu. "We wanted to include as many tangible memories as well, using recycled materials that have been either collected over the years, traded or salvaged to help imbue this art piece with

memories for past, current and future generations."[41] Grace DuVal, a Chicago-based designer who in 2017 won the WOW Sustainability Award (as well as being runner-up for the Supreme Award), machine stitched rubber salvaged from tires to create *Refuse Refuge* (fig. 200). One can hear echoes of Rapoport in her statement: "Materiality is really what drives me. I truly love nothing more than taking everyday objects and transforming them into garments that are beyond our imagination."[42]

Rapoport's upcycling, radical in 1967, is no longer so. Recycled vintage kimonos have become a mainstay at Asiatica, an import business cofounded by Elizabeth Wilson in Kansas City, Missouri, in 1977. Asiatica gradually amassed more than ten thousand examples; those inappropriate for the collection or museums have been disassembled, inspected, and meticulously repurposed. Beginning in the late 1980s, some were sold through the Obiko shop within Bergdorf Goodman (fig. 201); by the late 1990s, they were widely available through trunk shows in New York, Boston, Washington, San Francisco, Los Angeles, and elsewhere.[43]

Reflecting on the past twenty years, Rapoport notes that "there is more Fast Fashion than ever. People are shopping non-stop and there is more consumption. I see the boxes piling up in *every* NYC lobby. There are even more fashion seasons! But at the same time the fashion/art schools are focusing on sustainability. Students and the younger generation are embracing zero waste and taking it seriously." In November 2018 she co-presented a lecture titled "Loved Clothes Last: Reinventing Waste" to a sustainable fashion event at the University of Pennsylvania, orchestrated by the Post Landfill Action Network (PLAN), a student organization on many campuses that focuses on zero waste. "They call themselves 'waste nerds,'" said Rapoport.[44]

Other initiatives include that of the Textile Center of Minnesota (founded in 1994 and since 2001 based in Minneapolis), where a 2018 workshop on upcycling T-shirts was led by Candy Kuehn, an instructor and artist involved with the center for more than twenty years and "fondly referred to as 'the dye

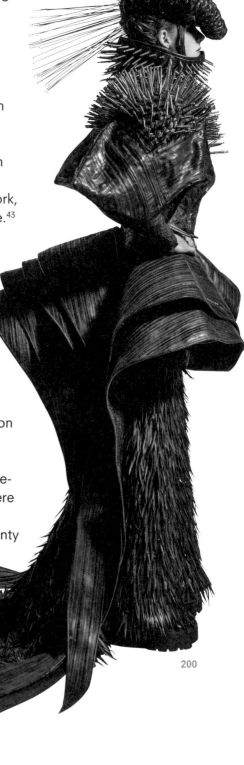

200

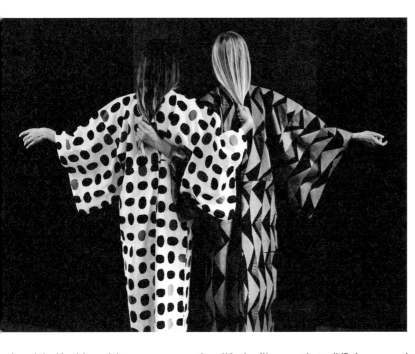

200 Grace DuVal (American, b. 1988). **Refuse Refuge**, 2017. Bicycle inner tubes, spokes, metal valves; hand and machine sewn. Image courtesy World of WearableArt Ltd.

201 Vintage kimonos. Photo courtesy Asiatica

201

ab midwife,' inspiring new creative life in fiber artists."[45] Among the members of the center's National Artist Advisory Council is Pat Hickman, known for her exploration of gut and other skin materials. A student of Ed Rossbach, for twenty-nine years Hickman taught in textile and fiber programs, including at UC Berkeley, UC Davis, San Francisco State University, the M. H. de Young Museum Art School, Berkeley's Pacific Basin School of Textile Arts, and Oakland's California College of the Arts—in other words, centers of exploration and collaboration that fueled so many alternative approaches to materials.[46]

Other first-generation art-to-wear pioneers who have engaged with sustainability include Marika Contompasis, whose MA+CH has since 2002 made its own water-based colors and dyes as needed, printing and dyeing whole garments so that no scraps are dyed. The company's patented Phly-Dye process not only limits waste of fabrics, dye, and energy, but also creates a distinctive range of colors.[47] At the other end of the spectrum (pun intended) are programs engaging with older colorants, such as the World Shibori Network: Natural Dye Workshop and its affiliate Slow Fiber Studios, established by Wada in 2008.[48] The latter was founded to promote multifaceted and holistic practices of textile making and

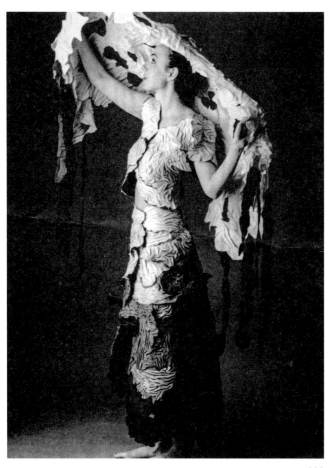

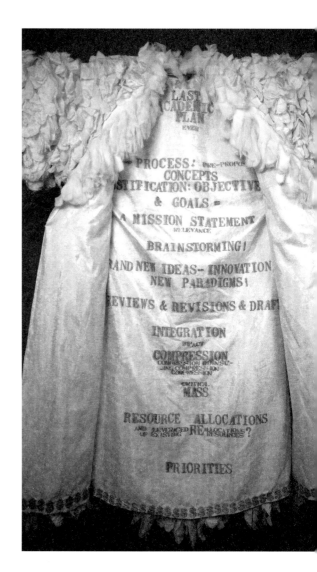

202

offer hands-on field-study programs. Individual expressions of environmental awareness abound, as exemplified by Hedstrom's *Terra Infirma* (Sick Earth), a series of works reflecting on the damages we have inflicted on nature, one of which (fig. 202) was featured in the WOW competition and fashion show in New Zealand in 2011. Another example is Anna VA Polesny's 2016 exhibition *Utopia to Paradise?*, which visualized significant influences and changes in people, community, food, and air quality in the city of Northampton, Massachusetts.[49]

Individual pieces employing recycled materials often represent personal responses to an artist's working environment, which typically houses all kinds of "bits" kept for the moment when they can be given new artistic life. Stabb's *Swan Song: My Last Academic Plan Ever!* (fig. 203), for example, features a lavishly feathered outer surface of recycled and reshaped industrial silk discards; inside is stamped a summary of the academic planning and replanning process together with a border of dollar signs, capturing her frustration with an educational system whose "outside opinions"—in this case, of administrators—care only about the bottom line. In November 2011, Jill Heppenheimer of the Santa Fe Weaving Gallery asked her coterie of artists to work with fragments and samples from earlier pieces; those contributing to *Metamorphosis: Breathing New Life into Artifacts* included Judith Content, who made "reimagined tassels" from thread spools (fig. 204). Hauptli, who since 2001 has created garments from repurposed ralli quilts, particularly from the semi-nomadic Saami tribe of Pakistan, first confirmed with an expert in the field that she was not destroying a limited supply of old textiles. Commenting on her scraps, which her research reveals were called "cabbage" by tailors since at least the seventeenth century, she says, "I have a very rich and colorful vegetarian diet.... Heaps of *cabbage* of all colors and fibers always lay about my studio. I use the bigger pieces to build new garments. I've even thrived on the coleslaw! Tidbits of Indian and Pakistani quilts snipped away from coats and jackets fill the bins under my tables—I call it 'salad.'"[50] In a further step, Hauptli has begun to deconstruct and rework all sorts of garments, including kimonos, sweaters, jeans, and men's shirts, and calls these "Continuation Clothing—making new from the old."[51]

202 Ana Lisa Hedstrom. **Amphitrite, Queen of the Sea, Cries Bitter Tears of Brown Oil**, 2011. Synthetic felt; stitched, manipulated, dye sublimation transfer. Collection of the artist

203 Jo Ann C. Stabb. **Swan Song: My Last Academic Plan Ever!**, 2002. Exterior "feathers" of recycled silk, polyester lining, diluted dye, and gold metallic thread; stitched, hand stamped, embroidered. Collection of the artist

204 Judith Content. **Tassels**, c. 2014. Silk, various fibers and threads, wooden thread spool, and buttons; hand-twisted, crocheted, arashi-shibori dyed and discharged, painted. Courtesy of the artist

back on the wall

Ellen Hauptli's "cabbaged" *Swing Jacket after Matt Gonzalez* (see fig. 192) was made for the 2015 Richmond Art Center exhibition *Body as Agent: Changing Fashion Art.* As the catalogue explains, this was "an exhibition honoring and responding to *Poetry for the Body: Clothing for the Spirit*...[and] demonstrates how wearable art has changed." Note that "body" appears in both titles, but "fashion" has replaced "clothing," a curatorial trend apparent in the exhibition held a decade earlier at the de Young Museum and entitled *Artwear: Fashion and Anti-fashion.* For the Richmond show, curator Inez Brooks-Myers "deliberately chose to include the word 'fashion'...because the word has grown, in contemporary usage, to stand not only for those things that we wear—apparel—but it references style, *how* clothing and accessories are worn, *how* an individual presents him/herself to the street on a daily basis."[52] The exhibition showcased this breadth of concept, including portraits of articles of clothing, garment shapes as metaphors, and examples of street wear by the documentary photographer Raymond Holbert (fig. 205), as well as upcycling, art to wear, and—pushing the conceptual boundaries of the show the furthest—textile art on the wall.

And so the movement has come full circle. Jean Cacicedo, Judith Content, Ana Lisa Hedstrom, and Janet Lipkin, among the first-generation artists featured in *Body as Agent,* have been showing wall pieces for some two decades. While Cacicedo was prompted in part by her discontent with the three years she spent in garment production in Bali in the 1990s, Lipkin spent that decade painting, returning to textiles in 2000 and, after her husband's death in 2009, finding solace in the creation of portraits of dolls that express "the same passion I have for textiles and cultures in a new, but familiar medium" (fig. 206).[53] Content had also ceased making art to wear in the 1990s. "It was a gradual, hard decision," she recalls. "I had enjoyed having studio help and representation at a wonderful network of wearable galleries, but I wanted to work large—really large. I wanted to explore architectural works for the wall, and I realized my limitations as a clothing designer. Ironically, my wall pieces now often consist of the kimono form" (fig. 207).[54] Tim Harding had also created kimono-shaped wall pieces early

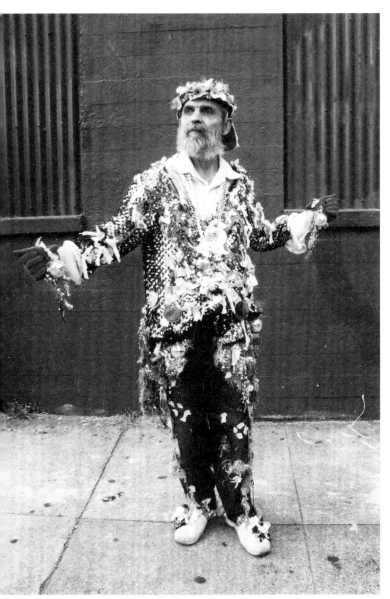

205

205 Raymond Holbert
(American, b. 1945). **Man
in Fashion**, 2016. Digital
photograph. Courtesy of
the artist

206 Janet Lipkin.
Scandinavian Dolls,
2015. Acrylics, lace, and
pompons; painted,
collaged; 45½ × 27½ in.
(115.6 × 69. 9 cm).
Courtesy of the artist

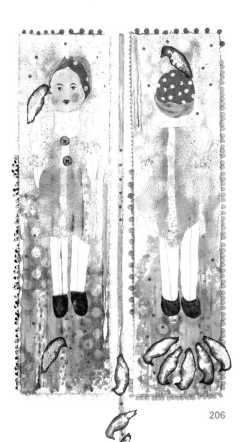

206

in his career, but for thirty years focused
on art to wear as a means of blurring
the lines between applied art, decorative
art, and fine art. Working in collaboration
with his late wife, Kathleen, who had
talents in garment design and marketing,
he recalls: "From my own personal
perspective, the great recession of 2008
marked the end, or the beginning of
the end. By that time I had already shift-
ed into studio production much more
focused on wall pieces. Many galleries
and boutiques that carried our wearable
pieces went out of business or shifted
to a more production-fashion orientation. That coincided
with Kathleen's cancer diagnosis, after which she was
forced to retire." Like Content, Harding looked for a new
challenge in a change of scale: "It was jumping from a
basic unit of the width of a woman's shoulders to occupying a big
wall in a public space" (fig. 208).[55] Hauptli had changed her scale
too, but in the opposite direction, making "textile sculptures, like the
softballs and bats and bamboo and pencils that I am covering with
ralli and other quilted fabric, stitched scrolls, and small textile collages

208

using thread and scraps from previous projects."[56] Mendelson took a different trajectory; although long engaged with knitting, crochet, sewing, felting, and "whatever else is essential to the creation of a piece," her website now features embroidered panels she incorporates into large bags. She declares, "I used to knit, now I sew!"[57]

Many analysts of economic forces have accepted that the 2008 global financial crisis was the signal that postcapitalism, as Paul Mason calls it, has replaced postmodernism. Given that the American art-to-wear movement was an early manifestation of postmodernist art, this is of significance beyond the downturn in the market. The crash has also revived interest in Karl Marx's materialist philosophy as expressed in *Das Kapital* (1867).[58] Frank Harry Pitts, for example, considers Marx's analysis of the "power of our creations to enslave us," arguing that "the entire material and intellectual world we create resembles a double-edged sword whereby our labour realises our desires and designs but disappears into products and structures on which we then become dependent."[59] In other words, the art-to-wear movement was *too* successful, becoming so well absorbed into mainstream culture that it lost its anti-establishment edge, and with this, sales. For reasons of economy (or environmentalism), many former good customers now "shopped" in their own wardrobes, while younger potential customers often simply opted to get "the look" at a lower price. As Hedstrom puts it, "There was a paradigm shift. Textiles are always tied into the economy" (fig. 209).[60] Little wonder that many first-generation artists have moved on and their principal gallerist, Julie Schafler Dale, chose to retire, as did Jill Heppenheimer of the Santa Fe Weaving Gallery (though that enterprise continues under new owners Elise Nye and Richard Holliday).

Thus wearable art had lost its original gatekeepers—individual gallerists whose personal interest in their clients was essential—and its subtlety and complexity was ill-served by the simultaneous rise of impersonal internet sales vehicles. The latter favored simple keyword descriptions, as did more distanced gatekeepers.

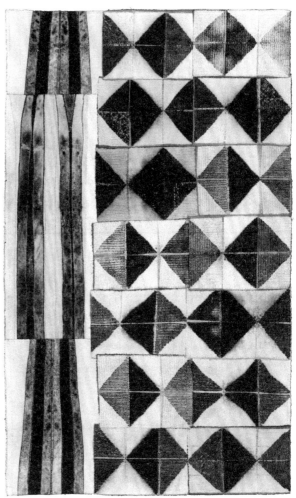

209

207 Judith Content. **Syncline**, 2016. Thai silk, organic cotton batting, raw silk backing; arashi-shibori discharged, dip-discharged, pieced, quilted. Courtesy of the artist

208 Tim Harding. **Enigma**, 2018, from the series **Collapse Quilt Montage**. Dye sublimation, printed synthetics; reverse appliqué. Courtesy of the artist

209 Ana Lisa Hedstrom. **Diamonds**, 2016. Silk; sewing-machine resist, hand dyed and pieced. Courtesy of the artist

As Stabb noted a year after the 2008 crash: "Curators and art historians like to use labels—categories—'boxes,' if you will—to group artists and artistic activity." Her own riposte to such restrictions was defiant: "Artists do not. True pioneers in any field reject the whole notion of thinking 'inside the box.' Rather, they question authority and intuitively seek something new and unprecedented, something personally meaningful and expressive, striking out on their own, finding their own voices, and often risking all—including their reputations and their futures."[61] Cacicedo concurs: "Whether on the body or off the body, my work investigates the transformative properties of cloth and provides a canvas where I can communicate ideas through the visceral language of color and texture" (fig. 210).[62]

Yet however much it changes, the art-to-wear movement continues to have an impact. Elsewhere I have argued that "since the 1970s, the freedom to move through three-dimensional space has increasingly provided opportunities for textile artists, who occupy a conceptual landscape in which they are at liberty to move in any direction within their textural domain"—an activity I call "textiles parkour."[63] Like the urban "freerunners" who leap from building to building, proponents of art-to-wear "duck and dive" amid a vast range of skillfully deployed techniques, materials, forms, and functions, ensuring their ability to reach new artistic destinations. For a moment it may have seemed that fashion had overtaken and submerged art to wear, but instead, the latter has emerged to provide an important model of artistic drive to the fashion industry, which has come under increasing pressure. Lidewij Edelkoort, one of the world's most respected trend forecasters, declared in November 2014 that "the fashion industry has reached breaking point." Her *Anti-Fashion Manifesto* highlights ten key challenges, including the cessation of "materialisation," or the loss of knowledge resulting in "a two dimensional world without the sensuality of texture, weight and drape." Expressing

210

despair with "an obsolete system managed by a tired group of individuals and agencies," she concluded: "If some higher organization of the fashion trade does not halt this hemorrhaging process, we will see the demise of the creative textile industries and with it the death of fashion as we know it."[64] Might one propose that the Peabody Essex Museum's 2017 showcase—in seemingly sedate Salem, Massachusetts—of thirty-two of WOW's "most unique, spectacular and outlandish wearable artworks...expertly crafted in a range of materials"[65] was an artistic antidote to Edelkoort's ailing "culture of clothes"?

The final word must go to Stabb, the consummate educator, artist, and chronicler of art to wear: "Art is not about progress. Art is about self-expression, and the legacy of the pioneers of the 1960s and 1970s is alive and well."[66] Evidence of this creativity is plentiful, but a singular example was the 2018 UC Davis summer session (fig. 211) led by Adele Zhang, one of Stabb's former students and herself a maker of art to wear. To inspire her students, Zhang borrowed ethnographic clothing and textiles from former American Craft Museum director Paul J. Smith.[67] Smith's generosity to Zhang and her young students reflects his close association with Rossbach and Westphal—as well as his behind-the-scenes support of Westphal, Dolph Gotelli, Stabb, and Rapoport when they made their seminal presentations to the World Crafts Council in 1980. The spirit of this first generation's open-handed sensibilities lives on, enriching an artistic landscape negotiable by those who embrace conceptual parkour.

210 Jean Williams Cacicedo. **Drawing in Wool: Transformations Hand Bag**, 1999. Wool, polymer, and reed; stitched, fulled. Courtesy of the artist

211 Sharon Zhu and Sabrina Espiritu's UC Davis summer session project, 2018. Photo courtesy Jo Ann C. Stabb

169

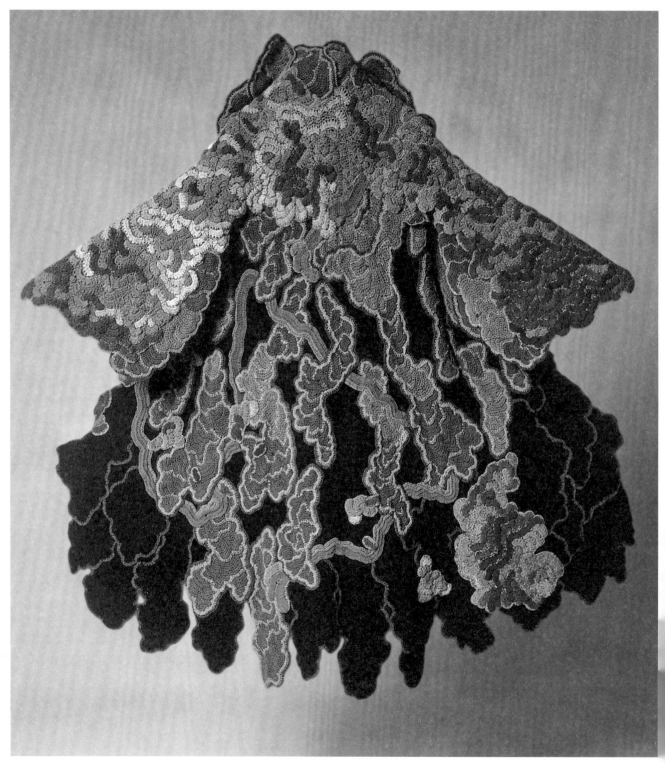

off the wall: a reflection

Julie Schafler Dale

To create without having the creation separate from your life, that's what wearable art is about. The pieces happen to be clothes, but they are conceived as art. Art can be anything if it is done with passion and vision with a certain abstract force. It is the obsession. —KEN TISA[1]

Art to wear is kaleidoscopic in its visual range: a rich collage of color, form, texture, and media; a rainbow coalition of human stories—poignant, celebratory, intimate, heartbreaking, joyous, fantastical, always intensely personal—reflecting the internal and external landscape of a generation that came of age in the 1960s.

The works are as varied and unpredictable as the individuals who conceived them. Their language can be narrative or abstract, their silhouettes rigid or amorphic, their surfaces organic or silky smooth, transparent or opaque. At times they are encrusted with life's detritus, assemblages of found objects. Or, like visual puzzles, they are collages of meticulously collected or created increments interfacing to tell a story or send a message. Always, they are the physical embodiment of private worlds and intuitive symbols— unabashedly autobiographical.

Whether structured or free-form, the pieces represent personal, sometimes cathartic journeys, the creative process driven, as K. Lee Manuel put it, by an ancient drum, "an inside sound and vibration that starts quietly and then gets huge," until, finally, the work reveals itself, the story complete—a chunk of lifetime lived, transformed into a physical entity.[2]

212 Sharron Hedges. **Julie's Coat (Midnight Sky)**, 1977. Wool; crocheted. Philadelphia Museum of Art. Promised gift of The Julie Schafler Dale Collection

These artists paid tribute to the past through their adoption of traditional, even ancient techniques and silhouettes, but also heralded the future by virtue of their innovation and personal iconography. A rich sensuality, voluptuous physicality, and love of fiber permeates the field, as epitomized by the early crochet work of artists such as Jean Williams Cacicedo, Janet Lipkin, Sharron Hedges, Dina Knapp, and Marika Contompasis, in which luxuriant texture seems to have seduced the maker as surely as it engulfs the wearer—whose presence and participation are always acknowledged through form.

Ultimately, art to wear is characterized by a standard of excellence—painstaking and compulsive—that derives from an unwavering commitment to creative integrity, a concern with process, and a stringent lack of compromise. Rarely have the roles of artist, designer, and craftsperson been so fully assumed by an individual in control of the creation from conception to completion.

213 **Julie's Coat** on display in the New York City apartment of Julie and Jim Dale. Photo courtesy Julie Schafler Dale

These defining characteristics of art to wear are rooted in the tumultuous 1960s. No longer bound by the discipline of wartime asceticism, free of the drive of their upwardly mobile parents for security and status, free of the pressure to conform to a traditionally structured society, the "baby boomers" claimed their place in the world, redefining moral values, expectations, and lifestyle choices. Self-expression was a driving force, the catalyst for pushing through new frontiers, fueled by a sense of empowerment and the realization that individual stories were unique, relevant, and worth telling. "It was like back to the truth, back to the most important, honest thing at the moment," recalled Lipkin. "If you could get there, then you could start over and perhaps create a new society, which would be a better place. I just felt like we could make a difference."[3]

While the sense of entitlement, self-importance, and idealism that accompanied this generation's coming of age was not new, its intensity, fervor, and reach were unique to these times. When faced with the cultural sterility, restrictions, and contradictions of the

Eisenhower era, and followed by the trauma and moral ambiguity of war and civil upheaval, youth culture instinctively responded by challenging authority and reassessing establishment values on multiple fronts.

Broadly speaking, art to wear falls under the umbrella of the twentieth-century American Craft Revival. At the same time, it shares a purpose and a mandate with the earlier British Arts and Crafts movement, as well as related developments such as Japonisme, Art Nouveau, and the Vienna Secession, all of which united art and craft, artist and craftsperson. The teachings of William Morris and John Ruskin, under which the British Arts and Crafts movement flourished, reached the United States in part through Oscar Wilde's 1882 lecture tour of the country. Charles Robert Ashbee, architect-designer, social reformer, and founder of the Guild of Handicraft (1888), also made several influential tours of the United States, starting in 1896. British ideals were further disseminated through books, newspaper articles, and journals such as *The Studio*.[4]

By 1903, rural utopian communities including Byrdcliffe Arts Colony on Overlook Mountain near Woodstock, New York, and Maverick Art Colony in Glenford, New York, had sprung up in the eastern Catskills, later home to the iconic Woodstock Festival. In the early twentieth century, Austria's Wiener Werkstätte (Vienna Workshops, founded 1903 and with a shop in New York 1922–32) and Germany's Bauhaus (1919–33) extended the emphasis on excellence of design, rigorous process, training in multiple disciplines, and integrity of object and lifestyle.

The movement was further reinforced by the immigration of Bauhaus artists such as Anni Albers, who taught at Black Mountain College in North Carolina from 1933 until the closure of the weaving department in 1959, when she became the first textile designer to be given a one-person show at the Museum of Modern Art in New York. Her two books—*On Designing* (1959) and *On Weaving* (1965)—enjoyed multiple editions and ensured her impact on textile arts.[5] From Germany by way of Holland came Trude Guermonprez, who taught at Black Mountain from 1944 to 1948 before moving to the Pond Farm Workshops in Guerneville, California, and later, from 1960 until her death in 1976, chaired the craft department at the California College of Arts and Crafts in San Francisco. Albers and Guermonprez were among the handful of educator/weavers who profoundly impacted the emerging studio fiber movement in the

United States, influencing a new generation of students and creating the philosophical framework within which art to wear would later thrive.

Meanwhile, art and industry were being united through technology in the innovative textile designs of Jack Lenor Larsen, Marianne Strengell, Dorothy Liebes, and others. However, the breakthrough within the American Craft Revival occurred in the 1960s, when form and aesthetic consumed function.[6] The "artist-craftsman" took the spotlight, redefining the complexion of American craft. Traditional media were subjected to innovation, driven by artistic standards and approaches to form, color, and texture. The one-of-a kind object emerged as "an extension of individual personality." In his 1970 book *Objects: USA*, Lee Nordness states: "The passion put into the object was transferred to the owner: tactility became a new alertness. Following the visual and tactile response came a deeper emotional-intellectual involvement: the one-of-a-kind object is inherently personal, the rapport intimate."[7]

The stage was set for art to wear. The merger of artistic discipline with the introspective, rebellious, and idealistic attitudes of the 1960s is key to understanding this movement and its place within the tumultuous social, political, and artistic world into which it was born. What emerged on a national scale in the 1970s was a body of work that reflects its time through the expression and sharing of personal stories and narratives, expanding the limits and definition of art forms.

That these forms were both functional and wearable—demanding participation by definition—speaks to the larger drive in the artistic community at that time to get art "off the wall," out of galleries and museums and onto the street, integrating it more fully into daily life, where participation and interaction could enrich lives and further expand consciousness.

In a radical thrust forward, wearable works were often conceived both flat and three dimensionally, as living sculptures on a body, expressive of both artist and wearer, a quintessential merger of art and life. Increasingly, artists began applying principles of color, design, dimension, and composition to textiles—in effect, sculpting or painting with fibers and dyes—and then animating their work, giving it volume and form by placing it on the body.[8] As Lipkin puts it, "It's something that happens when it goes on the body. It becomes real, it's able to move, it's able to be alive and it's meant to be alive."[9]

It would be incorrect to perceive art to wear as part of a neat forward progression, a linear evolution of ideas. Rather, its vitality and uniqueness is best understood as the confluence of multiple streams, each adding dimension, flavor, and complexity. Change was in the air. Happenings, "be-ins," performance art, conceptual art, environmental and site-specific works—all of these cultural and artistic trends lent themselves to the emerging notion of clothing as a vehicle to animate and display visual imagery.

From East to West coasts, hotbeds of creativity and cross-fertilization reflected the new culture on all levels of life. New York's Greenwich Village and East Village saw the shift from beat to folk to rhythm and blues to rock, as well as the evolving parade of jazz forms. Bill Graham's Fillmore West and East became venues for the explosive music scene. San Francisco's iconic Summer of Love in 1967 triggered other similar gatherings across the country. The energy was reflected in coffeehouses and bars, lofts and boutiques, head shops and galleries. Students at Columbia University and the University of California, Berkeley, fomented radical thinking and free speech. Art colleges nationwide turned out students who reveled in their new-found freedom of self-expression.

In addition to these social changes within the country, traditions from outside the United States began to influence and define the emerging art-to-wear movement. Paramount to a generation driven by the desire to find one's self through experience and first-hand knowledge of the world was the *Wanderjahr*, which opened new aesthetic frontiers as young travelers were brought into close contact with other cultures with different expressions of spirituality, and with deeply rooted traditions of handwork. These artists returned home with a heightened awareness that life and art need not exist on separate planes, but could blend seamlessly in utilitarian objects that invite participation and elevate day-to-day existence.

Even those who did not travel were exposed to these ideas through exhibitions, objects, and books such as Dorothy K.

214

ä l l o f t h e w a l l o f f t h e w a l l o f f t h e w a l l o f f t h e w a l l o f f t h e w a l l a l l

175

o f f t h e w a l l o f f t h e w a l l o f f t h e w a l l o f f t h e w a l l o f f t h e w a l l o f f t h e w a l l o f f t h e w a l l o

Burnham's catalogue for the Royal Ontario Museum's *Cut My Cote* exhibition in 1973.[10] This publication, along with the availability of Folkwear patterns, dramatically impacted the look of the young movement by breaking down traditional ethnic patterns of dress into their modular components. The simple silhouettes offered canvas-like surfaces on which to work, respected the integrity of the cloth itself, bestowed a timeless, universal quality to the pieces, and distanced them from the fashion world.

In tandem came the awareness that these universal art forms could house and convey deep-seated expressions of spirituality. This vibrant core of tribal adornment—"ceremonial ornament or regalia, that are at once works of art and living conduits to the spirit world"[11]—is reflected in many of the pieces that best define art to wear, revealing them as contemporary talismans. They are personal totems, environments within which intimate, private worlds and convictions are played out and enhanced through physical realization. They speak of freedom and flight, containment and escape, dream worlds and personal mythology, resurrection and transformation, cycles of life and death. They address feminism; divorce and confrontation; the environment, health, and beauty of our planet; heritage; tradition; and innovation. They reflect pop culture and pay tribute to other cultures through form and technique. They connect to primal ritual and ceremony and embrace a notion of process as a partner to self-revelation and an expression of character. Ultimately, the creative experience is handed over to the wearer, who in turn is transformed by being enveloped in the unique expression of another human life.

Art to wear is eloquent and innovative, the product of merciless devotion and commitment to "getting it right," to prioritizing the needs and "wholeness" of a piece over all else, no matter what physical toll it exacts or hours it consumes. Deeply embedded in their historical moment, these pieces are rich, sensual, layered, and visionary. In them, timely attitudes and freedoms converge with personal content to reveal something unique and complex, a blending of old and new into a deeply poignant form that embraces the body as metaphor and structure to express our human story as it is lived.

As a gallerist, I inhabited the world of art to wear as facilitator, mentor, participant, and collector. From 1973 to 2013, Julie: Artisans' Gallery was my "wizard" world, a space where creativity and self-expression thrived in an atmosphere where the ever-

seductive lure of participation was a constant source of vitality. It was the crossroads where diverse threads of my life wove together to create a vibrant tapestry. My days were a kaleidoscope of color, texture, creativity, innovation, surprise, and wonder. There was an endless parade of diverse personalities and memorable encounters. The opportunity to teach and encourage others was accompanied by the constantly renewable gift of learning that comes from navigating uncharted territory in pursuit of a life-changing adventure.

The gallery was as much a creative vehicle for me as the works themselves were extensions of their makers. It was my assemblage—an ever-changing family of pieces and people, serendipitous and amorphic in its configuration, that coalesced as a statement about creativity, innovation, and excellence. And because this ensemble instinctively reflected my vision and aesthetics, it evolved over the years, as I did.

The mandate was simple, the priority clear. I sought and encouraged pieces conceived by and for the artists, not for the commercial public. "Make the piece you always wanted to create." What emerged was wondrous, honing my eye and instinct to respond to the pieces that glowed with life and vibrated with an inner heartbeat. Perhaps it was the lack of compromise, the pursuit of innovation, the exhilaration that comes with embracing the unknown coupled with my own gut response. All that diversity of media, color, shape, texture, and purpose, joined together and resonating with a single voice.

Coming from a background in art history, I instinctively revered the creative process and perceived the makers as artists, their creations as artworks. I loved the quirks and idiosyncrasies that found expression in unanticipated forms. That I could participate in the process through encouragement and support, and by linking these artists to the public, was a powerful elixir. That I could also express my own identity by enveloping myself in these art works was indisputably seductive.

In retracing the path that led to the opening of Julie: Artisans' Gallery, I recognize a pivotal moment that caused me to take the proverbial "fork in the road." Sitting in the library of the New York University Institute of Fine Arts, researching a paper on the charismatic circle surrounding Gertrude Stein in early twentieth-century Paris, I realized that seventy-five years hence, someone would be researching the 1970s, marveling at the

215 Poster for the *Tenth
 Anniversary Exhibition*,
 Julie: Artisans' Gallery,
 1984. Photo Archive,
 Julie: Artisans' Gallery

216 Window display for the
 *Twenty-Fifth Anniversary
 Exhibition*, Julie: Artisans'
 Gallery, 1999, featuring
 Linda J. Mendelson's **Van
 Gogh Kimono** (see fig.
 165). Photo Archive, Julie:
 Artisans' Gallery

richness, complexity, and relevance of our time and culture. At that
critical moment, I understood that I wanted to experience firsthand
the creative landscape of my generation. Furthermore, I wanted
to merge my forays into art history with a longstanding interest in
fashion as body adornment.

Inspired by a course in museum training, I volunteered at
the costume wing of the Museum of the City of New York. In
that environment, I discovered the richness of antique and vintage
garments, which revealed themselves as exquisite objects disclos-
ing personal stories and cultural information. Were contemporary
artists expressing themselves through works for the body?

I found the answer soon thereafter, in 1972, in the slide
library of the American Craft Council, where I had hoped to
discover unique, handmade wearable pieces by contemporary
artists. I combed through hundreds of slides. The Museum
of Contemporary Crafts had mounted the exhibitions *The Art of
Personal Adornment* (1965) and *Furs and Feathers* (1971), but I also
sifted through countless files on individual artists who were using
the body to animate their visual imagery through use of innovative,
unanticipated, and unorthodox forms and media.

It was inevitable that I expanded my research, leaving
the library to discover an astounding network of creativity around
the country. Traveling from studio to studio, from New
York to California, I was quickly immersed in a world of
feathered masks and headdresses, macramé and beaded
halters, capes woven with rainbows and clouds, densely
and voluptuously crocheted coats celebrating flora and
fauna, patched and stitched leather coats, shorts embroi-
dered with symbols of distant journeys, jackets encrusted
with found objects and life's detritus.

The pieces were vital, fresh, relevant, and
demanded participation. Many also had integrity as two-
dimensional canvases or as static sculptures. These were
personal diaries, voices clamoring to be heard, reflections
of a free-form generation nurtured on the idea of self-
expression. Here was the sensation of discovery that had
fueled my formative years—the breaking of new barriers
to reveal expressions of creativity for which there
were no clear preexisting categories. In a transition that
was exhilarating and life-changing, I recognized the

TENTH ANNIVERSARY
JULIE ARTISANS' GALLERY
JANUARY 6–FEBRUARY 2, 1984
EXHIBITION OF WEARABLE ART

Julie

JULIE ARTISANS' GALLERY, 687 MADISON AVE., NEW YORK, N.Y. 10021 PHONE 212/688-2345

scope of what had been set in motion by the radical civic, social, and political attitudes of the 1960s as they inextricably intertwined with and shaped the evolution of the twentieth-century American Craft Revival. Here was the gateway I had been seeking to participate in a contemporary art form that uniquely reflected my generation.

In September of 1973, Julie: Artisans' Gallery opened at 687 Madison Avenue, contextualizing these works among the best of New York's art and fashion worlds. I never wavered in my conviction that these extraordinary pieces would be a magnet for the general public. We began to showcase artists in the street-level windows. We scheduled group shows in the gallery space around themes such as *Circus*, *New York*, *Kimono*, and *The Mask*. In time, we mounted anniversary exhibitions to celebrate our ten, twenty, twenty-five, and thirty years of visibility on Madison Avenue. Many of the now iconic works that define the art-to-wear movement were conceived and created for these events.

We learned how to create unity from diversity by setting up dialogues between materials and ideas—responding to color, texture, and form. With the support of a caring and deeply dedicated staff, through trial and error, success and failure, we created the rules and formats for presenting clothing as an art form separate from fashion. The gallery became a network of creativity in real time, linking idiosyncratic personalities, artists, and collectors pulled in by their curiosity and appreciation of the innovative. Always there was the common desire to participate in the process, by doing, by wearing, by collecting, or simply by absorbing the energy.

In 1998 the gallery relocated three blocks north to 762 Madison Avenue, remaining in the epicenter of New York's art and fashion worlds. With nearly twice the square footage, we were able to reflect the now expanded, international scope of art to wear, showcasing works from the United Kingdom, France, Germany, the Czech Republic, South Korea, the Netherlands, and Japan. In addition, we were able to juxtapose the fiber movements with examples from the studio jewelry movement, thereby highlighting the universal and eclectic manifestations of body adornment as an art form.

216

179

A critical change had also occurred in 1983 with my acquisition of Whitney Kent's *Byzantine Coat*, created for our tenth anniversary exhibition. Hand-quilted from hand-dyed fabric, encrusted with carved, sanded, painted, and varnished wooden plaques or tesserae to reveal an abstracted landscape stacked in horizontal bands, it glowed with the sparkle and luminescence of Byzantine robes. I knew that I would not wear this piece, but felt a keen responsibility to acquire it for posterity. I had become a custodian. My perspective consciously shifted to one of a historian with a mission of preservation. A collection began to take shape.

The criteria for acquisition were nuanced, more instinctive than calculated. The lens through which I perceived this new art form had been shaped by a lifetime of cultural exposure. As a New Yorker who came of age in the 1960s, I was continually "looking." My art history education provided the intellectual grounding to reference, decode, and appreciate. I was well prepared to interact with the early examples of this newly emerging art form. In vetting the work that came through the gallery, as well as selecting pieces for the collection, I recognized a certain alchemy that occurs when form, content, process, and vision come together in harmony, expressing a resolution of purpose— signaling the collector to respond.

Fundamentally, the pieces I chose each succeeded in harnessing the body as a vehicle to animate visual imagery, abstract and narrative, thereby advancing the idea of clothing as an art form. These works embodied a harmony of process and vision that looked inward but communicated outward, reflecting a culture in flux, driven by individualism, social awareness, and rebellion.

In very personal terms, I was drawn to the powerful, irresistible, all-consuming creative urge that gave this movement life and validity. The artworks for which I have been custodian these many years represent completed journeys, each releasing the artist to address new challenges, rise to new pinnacles.

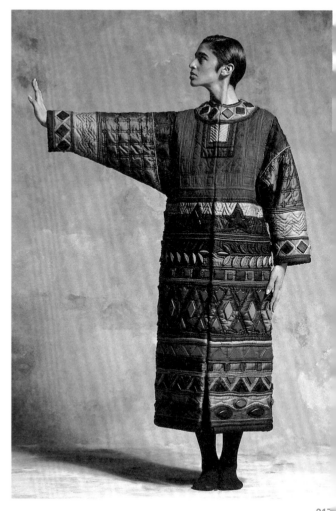

217

217 Whitney Kent (American, 1913–1999). **Byzantine Coat**, 1983. Pine, polished cotton; hand-quilted and chain stitched, dyed, carved, painted, varnished. Philadelphia Museum of Art. Promised gift of The Julie Schafler Dale Collection

218 Dina Knapp. **Frog Jacket**, 1975. Wool; crocheted. The Julie Schafler Dale Collection

As the artworks were displayed in the gallery on dowels, mannequins, and pedestals to break down the predisposition to view "wearable" as fashion, I expanded on this concept within the context of our home. The works were presented among an eclectic mix of fine arts, decorative arts, and folk and ethnographic material. The standards of excellence translated seamlessly from one field to the next. By juxtaposing period, form, and media, we sought to emphasize a commonality of aesthetic and vision that would trigger a dialogue, expanding established perspectives. Contextualizing these amazing works within a broader aesthetic arena has been a richly rewarding experience. It was my personal mandate over the years, as well as the professional conversation I fostered with Julie: Artisans' Gallery.

Upon reflection, I was in the right place at the right time. However, perspective now reveals that the pieces and the movement that seduced me spoke a language I understood. In an age that believed deeply in creativity, self-expression, excellence, and lack of compromise, I had found my voice. It was as natural for me to act out my identity through Julie: Artisans' Gallery as it was for the artists I was fortunate to encounter and befriend to express and share their private worlds by transforming the body into a vibrant and eloquent canvas—art to wear.

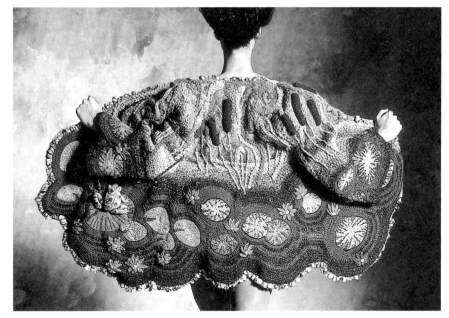

218

Introduction

1. Jean Cacicedo, interview with Mary Schoeser, July 25, 2018.

2. Zandra Rhodes and Anne Knight, *The Art of Zandra Rhodes*, 2nd ed. (London: Michael O'Mara, 1994), 53.

3. Janet Lipkin, correspondence with Dilys E. Blum, March 21, 2019.

4. Cacicedo, interview with Schoeser.

5. Carole Austin, "Ed Rossbach: MATRIX/BERKELEY 96," exh. brochure (Berkeley, CA: University Art Museum, 1986), 2.

6. "Charles Edmund Rossbach: Artist, Mentor, Professor, Writer," transcript of interview by Harriet Nathan in 1983 (Regional Oral History Office, Bancroft Library, University of California, Berkeley, 1987), 112, http://digitalassets.lib.berkeley.edu/rohoia/ucb/text/artistmentor00rossrich.pdf.

7. Julie's impressive list of clients included Candace Bergen, Peter Boyle, Charles Bronson, Ellen Burstyn, Cher, John Cleese, Glenn Close, Billy Crystal, Donovan, Carrie Fisher, Roberta Flack, Whoopi Goldberg, Larry Hagman, Valerie Harper, Jim Henson, Ann and Dustin Hoffman, Jill Ireland, Jeremy Irons, Elton John, Quincy Jones, Caroline Kennedy, Melissa Manchester, John Mellencamp, Liza Minnelli, Mary Tyler Moore, Paul Newman, Yoko Ono, Elaine Paige, Bernadette Peters, Diana Ross, Todd Rundgren, Siegfried and Roy, Carly Simon, Sylvester Stallone, Cat Stevens, James Taylor, Robin Williams, and Joanne Woodward.

8. Julie's relationship with the museum goes back at least to 1977, when she participated in the first Philadelphia Museum of Art Craft Show and wrote "What Is Art to Wear?" for the catalogue. This set a precedent for including art to wear in museum crafts shows.

9. Jane Kosminsky in *Finery*, exh. cat. (Raleigh: Visual Arts Program, North Carolina State University, 1988), 20.

10. Marian Clayden in *Finery*, 20.

11. Linda J. Mendelson, "Statement," *TAFA: The Textile and Fiber Artist List*, https://www.tafalist.com/profile/linda-j-mendelson/.

Collisions

1. See American Craft Council, *Wall Hangings and Rugs*, exh. cat. (New York: Museum of Contemporary Crafts, 1957).

2. See American Craft Council, *Woven Forms*, exh. cat. (New York: Museum of Contemporary Crafts, 1963).

3. See William C. Seitz, *The Art of Assemblage*, exh. cat. (New York: Museum of Modern Art, 1961).

4. The human figure was also the subject of the exhibition *People Figures* at the Museum of Contemporary Crafts in 1966, with three hundred works exploring the body in African art, American and international folk art, and by contemporary artists such as Niki de Saint Phalle.

5. Mildred Constantine and Jack Lenor Larsen, *Beyond Craft: The Art Fabric* (New York: Van Nostrand Reinhold, 1973), and *The Art Fabric: Mainstream* (New York: Van Nostrand Reinhold, 1981).

6. Oral history interview with Walter Nottingham, July 14–18, 2002, Archives of American Art, Smithsonian Institution, Washington, DC, https://www.aaa.si.edu/collections/interviews/oral-history-interview-walter-nottingham-12090#transcript.

7. Oral history interview with Nottingham.

8. Raoul d'Harcourt, "Peruvian Textile Techniques," *Ciba Review* 12, no. 36 (February 1960): 2–40. The *Ciba Review* was published 1937–71 by the textile company Ciba-Geigy and focused on the global history of textiles, with each monthly issue devoted to a specific theme. Raoul d'Harcourt, *Textiles of Ancient Peru and Their Techniques*, ed. Grace G. Denny and Carolyn M. Osborne, trans. Sadie Brown (Seattle: University of Washington Press, 1962). D'Harcourt's book was an indispensable resource for anyone working with fiber, from Anni Albers to Claire Zeisler. Sheila Hicks recalled coming across the French edition while studying pre-Inca textiles at Yale School of Art and was thrilled to discover that Albers had signed it out from the library years earlier.

9. Debra Ellen Rapoport, "Constructed Textiles Related to the Body" (master's thesis, University of California, Berkeley, 1969).

10. Nina Felshin, *Empty Dress: Clothing as Surrogate in Recent Art*, exh. cat. (New York: Independent Curators International, 1993).

11. Paco Rabanne designed another version of this coat for mass production; it was included in the 1967 exhibition *Body Coverings* at the Museum of Contemporary Crafts, New York.

12. Alan Cartnal, "Raiment in New Form," *Los Angeles Times*, November 5, 1970.

13. The *International Tapestry Biennial* was held in Lausanne 1962–95. For a history, see Giselle Eberhard Cotton and Magali Junet, *From Tapestry to Fiber Art: The Lausanne Biennials, 1962–1995* (Milan: Skira; Lausanne: Fondation Toms Pauli, 2017).

14. Jack Lenor Larsen, "Two Views of the Fifth Tapestry Biennial: The Greatest Craft Show on Earth . . . ," *Craft Horizons* 31 (October 1971): 23, 62.

15. Jörg Schellmann and Bernd Klüser, eds., *Joseph Beuys: Multiples; Catalogue Raisonné, Multiples and Prints, 1965–80*, 5th ed. (New York: New York University Press, 1980).

16. Nottingham's *Celibacy* was also exhibited at the *Fifth International Tapestry Biennial* in Lausanne in 1971.

17. Louise Bourgeois, "The Fabric of Construction," *Craft Horizons* 29, no. 2 (March–April 1969): 31–35. Bourgeois had worked in her family's tapestry restoration workshop as a *dessinteur*, redrawing the missing areas for reweaving.

18. Julie Schafler Dale, *Art to Wear* (New York: Abbeville, 1986), 45.

19. Dale, *Art to Wear*, 22.

20. Jean Cacicedo, correspondence with the author, August 29, 2018.

21. Cacicedo, correspondence with the author.

22. Janet Lipkin, correspondence with the author, August 29, 2018.

23. Angela Taylor, "Living—and Shopping—Easy in 'East Village' Boutiques," *New York Times*, December 8, 1965.

24. Nicki Hitz Edson and Arlene Stimmel, *Creative Crochet* (New York: Watson-Guptill, 1973), 8.

25. During the late 1960s MacKenzie taught weaving at Tyler School of Art in Philadelphia; at the time of his book's publication, he was a professor of art and design at California State University, Fullerton. Today he is known primarily as an abstract painter.

26. Del Pitt Feldman, *Crochet: Discovery and Design* (Garden City, NY: Doubleday, 1972), 79.

27. Del Pitt Feldman, *The Crocheter's Art: New Dimensions in Free-Form Crochet* (New York: Doubleday, 1974), looked at crochet as sculpture and featured the work of Janet Lipkin and Norma Minkowitz.

28. Edson and Stimmel, *Creative Crochet*, 8.

29. *African Mask* was sold by Julie: Artisans' Gallery to Muriel Kallis Newman, Chicago philanthropist and collector of Abstract Expressionism and other modern works as well as African sculpture, masks, and jewelry. It is now in the collection of the Metropolitan Museum of Art, New York, together with other works from Newman.

30. Janet Lipkin, correspondence with Mary Schoeser, October 9, 2018.

31. Douglas Bullis, "'Colors Have a Life of Their Own': Janet Lipkin's Clothing," *Ornament* 12, no. 3 (1989): 56.

32. Dale, *Art to Wear*, 23.

33. Linda Mendelson and Mark Dittrick, *Creative Machine Knitting* (New York: Dutton, 1979); Susanna E. Lewis and Julia Weissman, *A Machine Knitter's Guide to Creating Fabrics* (Asheville, NC: Lark, 1986).

34. Lewis and Weissman, *Machine Knitter's Guide*, xi.

35. Gauri Bhatia, "Profile: Linda Mendelson," *Macknit* (Fall–Winter 1985): 22.

36. Lipkin also continued to hand knit and crochet between 1979 and 1981, creating a company with partners Lori Hanson and Amy Rothberg that sold to Bergdorf Goodman, Saks Fifth Avenue, and Henri Bendel.

37. Lipkin, correspondence with Schoeser.

38. Jo Mancuso, "Janet Lipkin: West Coast Innovator," *Macknit* (Summer 1987): 70.

39. Bullis, "Colors Have a Life of Their Own," 57.

40. Lipkin, correspondence with Schoeser.

41. Visual Arts Program, North Carolina State University, *Finery* (September 9–November 6, 1988), 21. Interviews with participants of Finery were conducted in writing and telephone conversations during the spring of 1988.

Connections

1. Bryan S. Turner, *The Body and Society: Explorations in Social Theory* (Oxford: Basil Blackwell, 1984), 7–8.

2. See Jules Witcover, *The Year the Dream Died: Revisiting 1968 in America* (New York: Warner, 1997).

3. Bruce J. Schulman, *The Seventies: The Great Shift in American Culture, Society, and Politics* (New York: Da Capo, 2002), 4.

4. The first *Whole Earth Catalog* (Menlo Park, CA: Portola Institute) was published in fall 1968.

5. Eugenia Sheppard, "The Big Costume Party," *Harper's Bazaar* (October 1970): 204.

6. Judy Klemesrud, "Fighting a War in Behalf of Indians," *New York Times*, October 24, 1970. Sant'Angelo had received that year's American Fashion Critics award (known as the "Coty") for his Native American collection.

7. Trudy Owett, "Breaking in, Breaking Out," *New York Magazine*, April 20, 1970, 32–37.

8. Clara Pierre, *Looking Good: The Liberation of Fashion* (New York: Reader's Digest, 1976), 263–64.

9. Ben Compton, artist's statement, October 1974, Julie Dale Archives.

10. Alexandra Jacopetti Hart, *Native Funk and Flash: An Emerging Folk Art* (1974; reprint, Bloomington, IN: Trafford, 2013), 5.

11. Dorothy K. Burnham, *Cut My Cote*, exh. cat. (Toronto: Royal Ontario Museum, 1973); Max Tilke, *Costume Patterns and Designs: A Survey of Costume Patterns and Designs of All Periods and Nations from Antiquity to Modern Times* (New York: Hastings House, 1974).

12. Anna VA Polesny, correspondence with the author, July 31, 2018.

13. The winning entries were featured in Levi Strauss and Company, *Levi's Denim Art Contest: Catalog of Winners* (Mill Valley, CA: B. Wolman / Squarebooks, 1974), and Peter S. Beagle, *American Denim: A New Folk Art* (New York: Abrams, 1975).

14. Polesny, correspondence with the author.

15. Hart, *Native Funk and Flash*, 82.

16. Dale, *Art to Wear*, 199.

17. Dale, *Art to Wear*, 196.

18. The now widely accepted term "body as canvas" was proposed as one of many options for "body as object" by A. A. Bronson and Peggy Gale in their book *Performance by Artists* (Toronto: Art Metropole, 1979), 198.

19. Judy Klemesrud, "For Swingers and Their Grandmothers, Body Paint Is In," *New York Times*, August 3, 1967.

20. Summers moved from San Francisco to New York in 1982; on July 1, 1983, she was tragically killed in a bicycle accident.

21. Jamie Summers interview, Kinolibrary Archive, clip KR99, http://www.kinolibrary.com.

22. Donald J. Willcox, *Body Jewelry: International Perspectives* (Chicago: Henry Regnery, 1973), xiv.

23. Matt Lambert, "Who's Afraid of Marjorie Schick?" *Art Jewelry Forum*, April 14, 2016, artjewelryforum.org.

24. Arline Fisch, *Textile Techniques in Metal for Jewelers, Sculptors, and Textile Artists* (New York: Van Nostrand Reinhold, 1975).

25. The brand name Plexiglas was registered by Röhm & Haas in Darmstadt in 1933, but the material and its variants were not made available in North America for several decades.

26. Cope's work was included in the Museum of Contemporary Crafts exhibition *Body Coverings* (1968), a broad survey of approaches to modern clothing, from the new Apollo pressurized space suit to the high-fashion designs of Rudi Gernreich, Paco Rabanne, André Courrèges, and Bonnie Cashin, and later in *Face Coverings* (1971) together with Marjorie Schick and Arline Fisch.

27. Virginia I. Harvey, *Macramé: The Art of Creative Knotting* (New York: Van Nostrand Reinhold, 1967).

28. Paul Johnson, artist's statement, April 1, 1974, Julie Dale Archive.

29. Museum of Contemporary Crafts, *Fabric Collage: Contemporary Hangings, American Quilts, San Blas Appliqués*, exh. cat. (New York: Museum of Contemporary Crafts of the American Craftsmen's Council, 1965).

30. Lucy Lippard, "Sweeping Exchanges: The Contribution of Feminism to the Art of the 1970s," *Art Journal* 40, nos. 1–2 (Fall–Winter 1980): 365.

31. Dale, *Art to Wear*, 190. At the time, Rivoli indulged his passion in the Tunnel of Love, a vintage shop he owned during the mid-1960s, and as one of three partners in a cooperative gallery in the mid-1970s.

32. Dale, *Art to Wear*, 192.

33. The idea of Coca-Cola as a symbol of unity was originally put forth in the company's 1971 advertising campaign and jingle, "I'd Like to Buy the World a Coke," which was rerecorded (minus the Coca-Cola reference) by the New Seekers as the hit song "I'd Like to Teach the World to Sing (in Perfect Harmony)."

34. Jo Ann C. Stabb, email correspondence with the author, October 28, 2018.

35. The Buchers had been working on a series of wearable sculptures called *Landings to Wear* since 1967, and one of the works included in the exhibition had been featured on the cover of the German edition of *Harper's Bazaar* in January 1969. In 1972 the couple's first solo exhibition, *Body Shells*, was presented at the Los Angeles County Museum of Art.

36. Julia Bryan-Wilson, "Handmade Genders: Queer Costuming in San Francisco circa 1970," in *West of Center: Art and the Counterculture Experiment in America, 1965–1977*, ed. Elissa Auther and Adam Lerner (Minneapolis: University of Minnesota Press, 2012), 83.

37. See "The Wearable Art of Kaisik Wong," *Golden Haze*, May 10, 2012, http://goldenhaze.blogspot.com/2012/05/wearable-art-of-kaisik-wong.html.

38. I. M. Stackel, interview with John Eric Broaddus, *Fiberarts* 11, no. 5 (September / October 1984): 30.

Vibrations

1. Derek Taylor, "The Beach Boys," *Hit Parader* (October 5, 1966): 12.

2. Owens is a co-author, with Peter Beagle, Tony Lane, and Baron Wolman, of the book *American Denim: A New Folk Art* (New York: Harry N. Abrams, 1975).

3. Sarah Archer, "Levi's Denim Art Contest," *American Craft Inquiry* 2, no. 1 (June 2018): 70, https://craftcouncil.org/post/levis-denim-art-contest.

4. Ana Lisa Hedstrom, interview with the author, July 18, 2018.

5. Oakland Museum, *Bodywear: Clothing as an Art Form*, exh. cat. (Oakland: The Museum, 1974), 5–6, 9. Laury and Aiken taught textiles at California State University, Fresno, and ran Everywoman's Studio In Clovis, California, were they offered short courses in all aspects of textiles. Their book, published by Van Nostrand Reinhold, focused on recycling the old or individualizing new clothes.

6. *Bodywear*, 5, 7.

7. *Bodywear*, 3.

8. Paul J. Smith, in American Craft Council, *Fabric Vibrations: Tie and Fold-Dye Wall Hangings and Environments*, exh. cat. (New York: Museum of Contemporary Crafts, 1972), n.p.

9. *Bodywear*, 3.

10. UCLA Special Collections, Wight Gallery Records, series 665, box 53, cited in Emily Zaiden, "Deliberate Entanglements: The Impact of a Visionary Exhibition," *Textile Society of America Symposium Proceedings: New Directions: Examining the Past, Creating the Future*, Los Angeles, September 10–14, 2014, http://digital.commons.unl.edu/tsaconf/887.

11. *Bodywear*, 1.

12. Kathleen Nugent, in American Craft Museum, *Art to Wear: New Handmade Clothing*, exh. cat. (New York: The Museum, 1983), n.p.

13. Jo Ann Stabb, curator's introduction, and Marian Clayden, Pat Hickman, and Debra Rapoport, artists' statements, in *Poetry for the Body, Clothing for the Spirit*, exh. cat. (Richmond, CA: Richmond Art Center, 1983), n.p.

14. Candace Kling, interview with the author, July 19, 2018.

15. "Biography," on artist's website, http://www.gazabowen.com/bio.htm.

16. Kenneth Baker, "Diversity, Piece by Piece," *San Francisco Chronicle*, July 4, 1997, cited by Candace Crockett in documentation for the 1997 San Francisco State University Fine Arts Gallery exhibition *Fabric of Life: 150 Years of Northern California Fiber Art History*, https://gallery.sfsu.edu/events/1997/09/20/724-fabric-life-150-years-northern-california-fiber-art-history.

17. Hedstrom, interview with the author.

18. *Bodywear*, 8.

19. Debra Ellen Rapoport, "Constructed Textiles Related to the Body" (master's thesis, University of California, Berkeley, 1969).

20. See Pat Hickman, "Lillian Elliott," *Textile Society of America's Ninth Biennial Symposium*, Oakland, October 7–9, 2004, http://digitalcommons.unl.edu/tsaconf/451.

21. Milton Sonday, in *Fabric Vibrations*, n.p.

22. Braunstein/Quay, which operated from 1961 to 2011, was one of the nation's first "cross-over" galleries, exhibiting sculptural clay, fiber art, art furniture, and glass alongside paintings, drawings, and sculpture.

23. Straw into Gold is now called Crystal Palace Yarns and is based in Richmond, California. See "About Us," http://www.crystalpalaceyarns.biz/about/about.html.

24. Jack Lenor Larsen, foreword to *Memory on Cloth— Shibori Now*, by Yoshiko Iwamoto Wada (Bunkyō, Tokyo: Kodansha International, 2002), 7.

25. Wada, *Memory on Cloth*, 88. Clayden wrote the sections on resist dying in Jack Lenor Larsen's seminal book, *The Dyer's Art: Ikat, Batik, Plangi* (New York: Van Nostrand Reinhold, 1976).

26. "Designers: Ina Kozel," in *Obiko Art Wear Archive Project* (San Francisco: Textile Arts Council, Fine Arts Museums of San Francisco, 2014), http://www.textileartscouncil.org/obiko-archive/.

27. See "Ana Lisa Hedstrom," https://craftcouncil.org/recognition/ana-lisa-hedstrom. She recalls that silk marocain cost $32 a yard in 1980, and is not much made now. Hedstrom, interview with the author.

28. Judith Content, correspondence with the author, October 8, 2018.

29. *Bodywear*, 8.

30. See the artist's website, http://www.inakozel.com/fabric.html.

31. Hedstrom, interview with the author.

32. Gumps closed in 2018. See Gareth Lauren Esersky et al., *Gumps since 1861: A San Francisco Legend* (San Francisco: Chronicle, 1991).

33. See Elaine Dawson, "The Life and Work of Kit Kapp," *Old World Auctions Newsletter*, January 2015, https://us7.campaign-archive.com/?u=42ffef0375589a144048218&id=cad1747228.

34. *Feather Poncho*, for example, is distressed as if a grave garment; it was exhibited at the *Tenth Biennial Exhibition of Work by California Craftsmen*, E. B. Crocker Art Gallery, Sacramento, 1977.

35. Ellen Hauptli, interview with the author, July 23, 2018.

36. Stephanie Barron, Sheri Bernstein, and Ilene Susan Fort, *Made in California: Art, Image, and Identity, 1900–2000* (Berkeley: University of California Press, 2000), 261.

37. Harriet Nathan, notes from interview with Ed Rossbach (1986), "Artist, Mentor, Professor, Writer: With an Introduction by Jack Lenor Larsen: Oral History Transcript" (Berkeley: Bancroft Library, Regional Oral History Office, 1987), iv.

38. Rossbach, in interview with Nathan, 127–28.

39. Inger Jensen and Pat McGaw, *Pacific Basin School of Textile Art: The History, 1972–1986*, 5, https://issuu.com/ingerjensenpatmcgaw/docs/pacific_basin_school_of_textile_art.

40. Ellen Hauptli, "Asian Ideas," *American Craft* (February/March 2000): 87.

41. Fiberworks closed in 1987, while Pacific Basin Center became Pacific Textile Arts in 1990 on its move to Mendocino, some 150 miles to the north.

42. Jo Ann C. Stabb, "Philosophical Statements and Humorous Anecdotes," transcript of lecture given on the occasion of her receipt of the International Textile and Apparel Association's Hillestad Award in 2002, n.p., courtesy of the artist.

43. Hickman, "Lillian Elliott," 211.

o
f
f
t
h
e
w
a
l
l
o
f
f
t
h
e
w
a
l
l
o
f
f
t
h
e
w
a
l
l
a
l
l
o

44. Ellen Hauptli and Carol Lee Shanks, interview with the author, July 23, 2018.

45. Katherine Westphal, "Wearable Art," lecture presented to the World Crafts Council, Vienna, 1980, extract from Rebecca A. T. Stevens and Yoshiko I. Wada, *The Kimono Inspiration* (Bristol: Pomegranate, 1996), 77. See also Jo Ann Stabb, "Katherine Westphal and Wearable Art," *Textile Society of America Ninth Biennial Symposium* (2004), http://digitalcommons.unl.edu/tsaconf/452; and "Oral History Interview with Katherine Westphal, 2002 September 3–7," Smithsonian Institution, Archives of American Art, https://www.aaa.si.edu/collections/interviews/oral-history-interview-katherine-westphal-11788.

46. One result was the establishment of several organizations promoting art to wear in South Korea, including the Korea Fashion & Culture Association, established as the Korean Art to Wear Association in 1995. See "The Korea Fashion & Culture Association," http://fashionca.co.kr/01e.asp.

47. Douglas Bullis, "Sandra Sakata: A Generous Spirit," *Ornament* 15, no. 4 (1992): 65, 83.

48. See "Pat Henderson, Bergdorf Goodman," in *Obiko Art Wear Archive Project.*

49. Other artists in the Obiko roster included: Lucia Antonelli, Catherine Bacon, Holly Badgley, Pam Berry, Ariel Bloom, Margaret Burgess, Leslie Correll, Lea Ditson, Bettina Maria Fahlbusch, Keiki Fujita, Susan Green, Tim Harding, Lorraine Kempf, Kayla Kennington, John Marshall, Giselle Shepatin, and R.A.L. West (a.k.a. CUCA). See *Obiko Art Wear Archive Project*; see also "Obituary: Sandra Sakata," *SFGATE*, September 24, 1997, https://www.sfgate.com/news/article/OBITUARY-Sandra-Sakata-2805261.php.

50. Jean Cacicedo, interview with the author, July 25, 2018.

51. Hedstrom, interview with the author.

52. Carol Lee Shanks quoted in *Obiko Art Wear Archive Project.*

53. Chiori Santiago, "Sandra Sakata: Transcending Gravity," *Ornament* 21, no. 3 (1998): 42.

54. Sakata quoted in Bullis, "Sandra Sakata: A Generous Spirit," 63.

55. Janet Lipkin, correspondence with the author, October 28, 2018.

56. "Ellen Hauptli's Polyester Peats," *Threads* (June/July 1986): 48.

57. First Generation, "Baker/Rapoport/Wick," https://archive.org/details/cbpf_000115.

58. Cacicedo's notes for Bay Area Women Artists' Legacy Project, provided to the author July 25, 2018.

Articulations

1. Anni Albers, *Pictorial Weavings*, exh. cat. (Cambridge: The New Gallery, Charles Hayden Memorial Library, Massachusetts Institute of Technology, 1959), n.p.

2. "Hobbit Habit," *Time*, July 15, 1966, 51.

3. Tolkien describes Treebeard as a "large Man-like, almost Troll-like figure, at least fourteen foot high, very sturdy, with a tall head and hardly any neck. Whether it was clad in stuff like green and grey bark, or whether it was its hide, was difficult to say. At any rate the arms, at a short distance from the trunk, were not wrinkled but covered with a brown smooth skin. The large feet had seven toes each. The lower part of the long face was covered with a sweeping grey beard, bushy, almost twiggy at the roots, thin and mossy at the ends. But at the moment the hobbits noted little but the eyes. These deep eyes were now surveying them, slow and solemn, but very penetrating." J. R. R. Tolkien, *The Two Towers* (Boston: Houghton Mifflin, 1982), 66.

4. Dale, *Art to Wear*, 225.

5. Helen Cullinan, "Artist Rattles Creative World with Her Skeleton Designs," *Cleveland Plain Dealer*, January 1, 1969. Huryn's fascination with skeletons has continued into other media. In 1997, for example, she illustrated a book of Day of the Dead folktales (*Cuentos de el Día de los Muertos*) collected by Salvador González.

6. Dale, *Art to Wear*, 72.

7. *Tricks of Women and Other Albanian Tales*, trans. Paul Fenimore Cooper (New York: William Morrow, 1928); *Children's Stories from Rumanian Legends and Fairy Tales*, trans. M. Gaster (London: Raphael Tuck, c. 1930).

8. Clara Pierre, *Looking Good: The Liberation of Fashion* (New York: Reader's Digest Press, 1976), 262.

9. Janet Lipkin, correspondence with the author, March 22, 2019.

10. Both the collar and cape were worn by New York real estate developer Richard Rose and his wife to the Beaux Arts Ball of the Architectural League of New York in 1990.

11. Jean Williams Cacicedo, email to Julie Schafler Dale, May 23, 2017.

12. Dale, *Art to Wear*, 95.

13. In 1980 Compton abandoned art to wear in search of a life with more balance and peace, explaining that he no longer felt any "deep emotional pleasure in making clothes." Dale, *Art to Wear*, 285–86.

14. Dale, *Art to Wear*, 165.

15. Dale, *Art to Wear*, 61.

16. "Exhibitions," *Craft Horizons* 35, no. 4 (August 1975): 38.

17. Jo Ann Goldberg, "With a Wizard's Hand: Linda Mendelson," *Ornament* 11, no. 2 (1987): 46.

18. Randall Darwall, "Color Conversations," *Handwoven* (March/April 2000): 82.

19. Anne Whiston Spirn, *The Language of Landscape* (New Haven: Yale University Press, 1998), 209–10.

20. Michael A. Quigley, *Art Materialized: Selections from the Fabric Workshop*, exh. cat. (New York: Independent Curators Inc., 1982), 4.

21. John Michael Kohler Art Center, *Maximum Coverage: Wearables by Contemporary American Artists*, exh. cat. (Sheboygan, WI: The Center, 1980), 25.

22. The other designers in the exhibition were Giorgio Armani, Gianfranco Ferré, Krizia, Stephen Manniello, Issey Miyake, Claude Montana, and Yeohlee Teng.

23. Rasheed Araeen et al., *Conceptual Clothing*, exh. cat. (Birmingham, UK: Ikon Gallery, 1986), 35.

24. Jean Williams Cacicedo, email to the author, April 24, 2019.

6. Susan Summa, "A Personal Look at an Evolving Movement," in Katherine Duncan Aimone, *The Fiberarts Book of Wearable Art* (New York: Lark, 2002), 12–13.

7. Jo Ann C. Stabb, "A Time of Renewal: Update on Wearable Art," *Surface Design Journal* (Summer 1994): 8.

8. By 1987 such "toaster prints" were being screen-printed by Allen Grinberg of Zoo-Ink in San Francisco, with hand-painted blockout to produce blurred edges; Clayden also masked areas of the original to create variations. See Betsy Levine, "A Passion for Elegance: Master Dyer Marian Clayden Creates Clothing by Listening to the Fabric," *Threads*, no. 14 (December/January 1987–88): 36–41.

9. Devoré began appearing, for example, in Jasper Conran collections from 1989 on.

10. Mary Schoeser, *Marian Clayden: A Dyer's Journey through Art and Design*, gallery guide (London: Fashion and Textile Museum, 2014), n.p. By 1988 Clayden Inc. was fully staffed, with Roger Clayden as business manager and Barbara Schinners (now Barbara Hume) assisting Marian with garment design; clothing was produced in a facility near their home in Los Gatos, California. Clayden remained the creative force in her home-dyeing studio, where experiments were done. Once the season's patterns and colors were created, assistants Karen Livingstone and Lucina Ellis dyed to fill the orders. Clayden produced her last full collection in 2005, at age sixty-seven, and died in 2015.

11. See the reviews by Charles Talley, *Surface Design Journal* (Fall 1983): 18, and Linda Dyatt, *American Craft* (October/November 1983): 14–20.

12. Erica Wilson, "Art to Wear: New Handmade Clothing," syndicated review published in Texas, Pennsylvania, Louisiana, New York, and Massachusetts, August 21–27, 1983.

13. "Linda J. Mendelson," https://www.tafalist.com/profile/linda-j-mendelson/. "Loom knitting" became the preferred term for knitting machines among makers of wearable art, who felt that "machine knitting" implied high-speed, industrial production.

14. Ana Lisa Hedstrom, interview with the author, July 18, 2018.

15. Josh Sims, "Silk or Synthetic?" *Financial Times*, May 12, 2008.

16. Ralli quilts are made of recycled and hand-dyed cotton cloth in the Umerkot and Tharparkar districts of Sindh, Pakistan, as well as in the Indian states of Rajasthan and Gujarat. Traditionally for use by the family, some are now commercially produced.

17. The Jo Ann C. Stabb Design Collection includes Rossbach donations such as an Indian skirt (1985.01.36) and shirt (1986.04.17), as well as a Stabb donation of a Cost Plus imported tunic (2017.08.18).

18. See Ruth K. Shelton and Kathy Wachter, "Effects of Global Sourcing on Textiles and Apparel," *Journal of Fashion Marketing and Management* 9, no. 3 (2005): 318–29, https://doi.g/10.1108/13 612020510610444.

19. Jo Ann C. Stabb, "Tracking the Art-to-Wear Spirit in the 21st Century," *Surface Design Journal* (Spring 2012): 11.

20. Entitled *Wearable Art from California* (1985–86), these videos were distributed for many years by the University of California, the American Craft Council in New York, and the United States Information Agency throughout Europe, and are now available online.

21. Nina Felshin, "Clothing as Subject," *Art Journal* 54, no.1 (Spring 1995): 20.

22. Polly Ulrich, "Beyond Touch: The Body as Conceptual Tool," *Fiberarts* (Summer 1999): 43–44.

23. See Shirley Friedland and Leslie A. Piña, *Wearable Art 1900–2000* (Atglen, PA: Schiffer, 1999).

Reverberations

1. Valerie Steele, *Fifty Years of Fashion: New Look to Now* (New Haven: Yale University Press, 1997), 88–89.

2. Lou Taylor and Fiona Anderson, "Fashion for Women and Men in the Twentieth Century," in *The Cambridge History of Western Textiles II*, ed. David Jenkins (Cambridge: Cambridge University Press, 2003), 1073.

3. The years between 1961 and 1968 saw the deaths of Ernest Hemingway, Marilyn Monroe, President John F. Kennedy and his brother, Bobby, and Martin Luther King Jr. See Martin Filler, "Interior Landscapes and the Politics of Change," in *High Styles: Twentieth Century American Design*, ed. Lisa Phillips, exh. cat. (New York: Whitney Museum of American Art and Summit Books, 1985), 162.

4. Carol Lee Shanks and Ellen Hauptli, interview with the author, July 23, 2018.

5. Patricia Malarcher, "Diana Prekup's Wearable Webs," *Surface Design Journal* (Spring 2011): 30–33.

a
l
l
o
f
t
h
e
w
a
l
l
o
f
f
t
h
e
w
a
l
l
o
f
f
t
h
e
w
a
l
l
a
l
l

185

o
f
f
t
h
e
w
a
l
l
o
f
f
t
h
e
w
a
l
l
o
f
f
t
h
e
w
a
l
l
o
f
f
t
h
e
w
a
l
l
o
f
f
t
h
e
w
a
l
l
o
f
f
t
h
e
w
a
l
l
o
f
f
t
h
e
w
a
l
l
a
l
l
o

24. Anamaria Wilson, "Barneys Sells 'Art to Wear,' " *Women's Wear Daily*, August 30, 2002. The items on sale included tie-dyed caftans by Clayden, painted silks by Ina Kozel, Rasta Tam hats of the sort created for Bob Marley by Knapp, transfer-printed velveteen tunics by Westphal, and a cocoon coat by Wong, with price tags up to $6,000.

25. Tim Harding, "The Art-to-Wear Movement in America," in Aimone, *The Fiberarts Book of Wearable Art*, 10.

26. M. Griffiths, "Ancient and Modern: Arimatsu Shibori," https://www.researchgate.net/publication/293571695_Ancient_modern_Arimatsu_shibori.

27. Mary Schoeser, *Textiles: The Art of Mankind* (London: Thames and Hudson, 2012), 377.

28. Giselle Eberhard Cotton, "The Lausanne International Tapestry Biennials (1962–1995): The Pivotal Role of a Swiss City in the 'New Tapestry' Movement in Eastern Europe after World War II," *Textiles and Politics: Textile Society of America Thirteenth Biennial Symposium Proceedings*, Washington, DC, September 18–22, 2012, http://digitalcommons.unl.edu/tsaconf/670. In some respects the closure of the Lausanne event was a reflection of shifting centers of influence; in 1972, the first Łodz Triennial was held, accepting only Polish artists, but by 1975 it had become international and continues to this day.

29. Yosi Anaya, "Welcome to World Textile Art," http://www.wta-online.org, accessed November 27, 2011.

30. Julie Schafler Dale, correspondence with the author, October 23, 2018.

31. Pamela Johnson, "Seeing Things: Caroline Broadhead's Illusions," *Fiber Arts* (Summer 1999): 37–42; Susannah Handley, "Jo Gordon: An Allegory in a Hat Box," *Fiberarts* (January/February 1999): 31–35. Both artists had been short-listed for the prestigious Jerwood Prize for Applied Arts: Textiles, awarded by the Crafts Council's London gallery, which Broadhead won in 1997.

32. See Victoria Crocker, "The 2018 WOW Award Winners," https://www.worldofwearableart.com/2018/09/2018-award-winners/.

33. Publisher's description, Martin De Ruyter et al., *Off the Wall: The World of Wearable Art*, 3rd ed. (Nelson, NZ: Craig Potton Publishing, 2011), www.pottonandburton.co.nz.

34. See "Dawnamatrix: About," https://dawnamatrix.com/about/.

35. Katherine Westphal, "Wearable Art" (excerpt of the lecture), in Richmond Art Center, *Poetry for the Body: Clothing for the Spirit* (Richmond, CA: The Center, 1983), n.p.

36. Westphal, "Wearable Art," n.p.

37. See "Debra Rapoport: About Me," http://debrarapoport.com/about-me-2/.

38. See https://www.advanced.style/.

39. Jo Ann C. Stabb, "Tracking the Art-to-Wear Spirit in the 21st Century," *Surface Design Journal* (Spring 2012): 12.

40. See Crocker, "The 2018 WOW Award Winners."

41. Dionne Christian, "WOW! Sisters Make Art History at World of Wearable Arts," *New Zealand Herald*, September 29, 2018.

42. "World of Wearable Art: Grace DuVal," https://www.worldofwearableart.com/2018-competition/wow-designers/#grace.

43. See Susan Cannon, "Asiatica—40 Years and Counting," http://www.asiaticakc.com/blog/40-years-and-counting.

44. Debra Rapoport, correspondence with the author, October 16, 2018.

45. See "Textile Center: About Us," https://textilecentermn.org/history-of-textile-center-2/; see also "Candy Kuehn: Fiber Work," http://candykuehnstudio.com/gallery/fiber-work/.

46. See the artist's website, http://www.pathickman.com. Now professor emerita of art, University of Hawai'i at Manoa, Honolulu, Hickman headed the school's fiber program 1990–2006 and is now based in Garnerville, New York.

47. See "Phly-Dye + Eco," https://www.marikacharles.com/phly-dye-eco.

48. See NaturalDyeWorkshop.com and slowfiberstudios.com.

49. See Anna VA Polesny, "Utopia to Paradise?" https://www.annavapolesny.com/utopiatoparadise.

50. Ellen Hauptli, artist's statement in Inez Brooks-Myers, *Body as Agent: Changing Fashion Art*, exh. cat. (Richmond, CA: Richmond Art Center, 2015), 27.

51. Ellen Hauptli, correspondence with the author, October 29, 2018.

52. Inez Brooks-Myers, "Introduction," in *Body as Agent*, iv.

53. Janet Lipkin, artist's statement in Brooks-Myers, *Body as Agent*, 47.

54. Judith Content, correspondence with the author, October 9, 2018.

55. Tim Harding, correspondence with the author, October 20, 2018.

56. Ellen Hauptli, correspondence with the author, October 28, 2018.

57. See the artists' websites, www.ellenhauptli.com and www.lindajmendelson.com.

58. See Paul Mason, "Was Marx Right?" in *Postcapitalism: A Guide to the Future* (London: Penguin, 2016), 49–78.

59. Justin Reynolds, citing F. R. Pitts, in "Designing the Future: A Review of Economic Science Fictions," *New Socialist*, May 26, 2018, https://newsocialist.org.uk/designing-the-future.

60. Ana Lisa Hedstrom, conversation with the author, July 18, 2018.

61. Jo Ann C. Stabb, note from 2009, provided to the author July 20, 2018.

62. Jean Cacicedo, artist's statement in Brooks-Myers, *Body as Agent*, 11.

63. Schoeser, *Textiles*, 373.

64. Schoeser, *Textiles*, 373.

65. Peabody Essex Museum, exhibition description, https://www.pem.org/exhibitions/wow-world-of-wearableart.

66. Jo Ann C. Stabb, interview with the author, July 19, 2018.

67. Adele Zhang, correspondence with the author, October 30–31, 2018. The loan derived from items exhibited in *A Geographical Journey: The Paul J. Smith Textile Collection*, San Jose Museum of Quilts and Textiles, January 19 to April 15, 2018, curated by Amy DiPlacido. They were selected to complement the sizeable holdings in the Jo Ann C. Stabb Design Collection at UC Davis. Zhang said of this project, "As Jo Ann's student, I deeply believe that good designs are inspired by the past, serve the present and lead to future."

Off the Wall: A Reflection

1. Ken Tisa quoted in Julie Schafler Dale, *Art to Wear* (New York: Abbeville, 1986), 199.

2. K. Lee Manuel quoted in Dale, *Art to Wear*, 217.

3. Janet Lipkin quoted in Dale, *Art to Wear*, 49.

4. Monica Obniski, "The Arts and Crafts Movement in America," in *Heilbrunn Timeline of Art History* (New York: Metropolitan Museum of Art, 2000–), http://www.metmuseum.org/toah/hd/acam/hd_acam.htm (June 2008).

5. Anni Albers, *On Designing* (New Haven, CT: Pellango, 1959); subsequent editions were published by Wesleyan University Press in 1961, 1962, 1966, and 1971. Anni Albers, *On Weaving* (Middletown, CT: Wesleyan University Press, 1965); subsequent editions by Studio Vista (1974), Dover (2003), and Princeton University Press (2013).

6. Lee Nordness, *Objects: USA* (New York: Viking, 1970), 22.

7. Nordness, *Objects: USA*, 22.

8. See Julie Schafler Dale, "The Kimono in the Art-to-Wear Movement," in *The Kimono Inspiration: Art and Art-to-Wear in America*, exh. cat., ed. Rebecca A. T. Stevens and Yoshiko Iwamoto Wada (Washington, DC: Textile Museum; San Francisco: Pomegranate, 1996), 82.

9. Janet Lipkin quoted in Dale, *Art to Wear*, 52.

10. Dorothy K. Burnham, *Cut My Cote*, exh. cat. (Toronto: Royal Ontario Museum, 1973).

11. Patricia Leigh Brown, "Medicine in the Making," *New York Times*, September 11, 2017.

artist biographies

Anni Albers (1899–1994)
Berlin-born Anni (Fleischmann) Albers wanted to be an artist from a young age. She entered Bauhaus as a weaver (the only path then available for women) and eventually became workshop leader. Albers met her husband, Josef, at the Bauhaus; in 1933, the pair left Germany when he was offered a position at Black Mountain College in North Carolina.

Albers's innovative style gained her the distinction of being the first textile designer to have a solo show at the Museum of Modern Art in New York. She wrote extensively about weaving, and her book *On Weaving* (first published in 1965) is considered a seminal work. Albers sold her loom after creating her final weaving in 1968. She and Josef moved to California and Albers started making silkscreens, many with designs reminiscent of her woven work.

James Bassler (b. 1933)
James Bassler earned a BA in education and an MA in art, both from the University of California, Los Angeles (UCLA). He developed an early interest in fiber from observing the hooked rugs made by his father, a major league baseball player. In the 1950s, Bassler traveled with his father to Europe and Asia, where he first experienced weaving as a part of everyday life. Since then, Bassler has been a working weaver, continuing to include techniques from ancient cultures in his artistic process. In the 1980s, after exposure to Navajo wedge weaving and to the minimalist musical compositions of John Cage, Bassler took a more conceptual approach to his art.

Bassler has taught in the United States and Mexico, including in the Los Angeles Unified School District; the Mexican Arts and Culture program, Oaxaca; California State University, Long Beach; the Appalachian Center for Crafts, Smithville, Tennessee; and, from 1975 until retirement in 2000, at UCLA, where he is professor emeritus in design and media arts.

Bassler's work has been shown nationally and internationally and is represented in public collections such as the Art Institute of Chicago; the Cleveland Institute of Art; the Minneapolis Institute of Art; the Museum of Arts and Design, New York; and the Oakland Museum. He was also a participating artist in the PBS television series *Craft in America*.

Gaza Bowen (1944–2005)
Gaza Bowen was born in Memphis, Tennessee, and lived for many years in Santa Cruz, California. Trained as a shoemaker, Bowen spent nearly two decades focusing on the shoe structure, making sculptures that comment wryly on fashion and feminism. In the final decade of her life, Bowen turned to mixed-media pieces culminating in *Bibliotheca Memoria,* an installation of books and furniture built from salvaged materials.

Bowen's work is in many private and public collections, including the Los Angeles County Museum of Art; the Oakland Museum; the M. H. de Young Memorial Museum, San Francisco; the Powerhouse Museum, Sydney, Australia; and the Deutsches Schuhmuseum, Offenbach, Germany.

John Eric Broaddus (1943–1990)
A prominent figure in the New York art scene in the late 1970s and early 1980s, Broaddus expressed his creativity in a variety of media. He was a highly regarded set designer and equally well known for the elaborate costumes he constructed from found objects and wore for street performances and at clubs such as Studio 54. Broaddus was also a pioneer in the emerging field of book arts, skillfully incorporating cutouts, stencils, glitter, ink, tempera, and other materials into unique bound books.

His finely crafted works have been acquired by institutions such as the Victoria and Albert Museum, London; the Biblioteca Nacional de España, Madrid; and the Seibu Museum, Tokyo.

Jean Williams Cacicedo (b. 1948)
As an undergraduate sculpture major at Brooklyn's Pratt Institute, Jean Williams Cacicedo became interested in textile traditions, using crochet and nontraditional materials for her assignments. After earning her BFA in 1970, she moved to California and then to Wyoming, where from 1971 to 1978 she made textiles influenced by Native American symbols and the colors of the prairie landscape. After relocating to Berkeley, California, in 1980, she extended her practice to include techniques such as reverse appliqué and fulling resist paste to create patterns on lightweight wool gauze.

Cacicedo has received a National Endowment for the Arts Craftsman Fellowship Grant and was named Artist of the Year by the Oakland Museum, among other awards. Her works have been shown extensively and are included in the collections of the M.H. de Young Memorial Museum, San Francisco; the Oakland Museum the Museum of Arts and Design, New York; the Museum of Fine Arts, Boston; and the Tassenmuseum Hendrikje, Amsterdam.

Marian Clayden (1937–2015)
Marian Clayden was born in Preston, England, and trained as a teacher. She drew on skills from a textile coloring class to develop a tie-dyeing style she categorized as a type of *plangi.* After moving to San Francisco in 1967 and finding success selling her textile hangings, Clayden's career took off when she was hired to create sets and costumes for the musical *Hair.* By the late 1970s her hand-dyed textiles were widely available, and Clayden branched out into fashion design. By the mid-1990s, her garments were being carried by most high-end American retailers.

Clayden's work is in the collections of institutions such as the Metropolitan Museum of Art, New York; the M. H. de Young Memorial Museum, San Francisco; the Los Angeles County Museum of Art; and the Victoria and Albert Museum, London.

Ben Compton (1938–1986)

Born in Baltimore, Ben Compton earned a BA from Yale University and studied costume design at the Yale School of Drama. He worked as a theatrical costume designer for Broadway and Off-Broadway, regional and community theater, summer stock, and costume houses. In 1969, together with Marion Holmes, Compton formed Best of Three Worlds, a company that manufactured "anti–Seventh Avenue" ready-to-wear apparel.

His work was commissioned by Diana Ross, Syreeta (the former Mrs. Stevie Wonder), Melissa Manchester, and many others, and was shown at the Oakland Museum, the Helen Drutt Gallery in Philadelphia, and regularly at Julie: Artisans' Gallery in New York.

Judith Content (b. 1957)

Judith Content earned a BFA from San Francisco State University. A full-time studio artist for more than thirty-five years, she draws on her background in watercolor and passion for building to make her art quilts and other textiles.

Content hand-dyes silks, using a contemporary approach to shibori, a traditional Japanese dyeing technique. She then tears the silk into pieces, arranges and rearranges the fragments, and sews them together, often adding appliqué.

Her work has been exhibited widely and is included in numerous public and private collections. Publications include *Textiles: The Art of Mankind* by Mary Schoeser and *Memory on Cloth: Shibori Now* by Yoshiko I. Wada.

Content also works in pottery, jewelry, bookmaking, collage, and other artistic media.

Marika Contompasis (b. 1948)

Marika Contompasis earned a BA in industrial and product design from the Pratt Institute in Brooklyn. In 1970 she moved to Berkeley, California, and began teaching at San Francisco State. The following year, she acquired a knitting machine, enabling her to create detailed two-dimensional images in yarn.

She has exhibited at institutions such as the Smithsonian, the Museum of Modern Art, New York, and the Los Angeles County Museum of Art and is included in the Metropolitan Museum of Art's permanent costume collection. She was the recipient of a National Endowment for the Arts award. Her collections have been carried by retailers such as Barney's New York, Fred Segal, and Bergdorf Goodman.

Since 2002, Marika and her brother Charles have worked together as MA+CH, developing collections of women's art–focused fashion and textile art and design for decor.

Louise Todd Cope (b. 1930)

Louise Todd Cope is an American fiber artist and educator. She earned a BA from Syracuse University and an MA in Creative Spirituality from Holy Names University, Oakland.

From 1969 to 1973, Cope taught in the textiles department at Moore College of Art, Philadelphia. She has also taught in Maine, North Carolina, and California, and at the Canada Arts Council. In 1984, Cope co-founded Hands in Outreach, an educational sponsorship program for impoverished inner city girls in Nepal. From 1985 to 1990 she led textile tours in Thailand. In 1996, she founded Cloak the Earth, an interfaith project aimed at helping people make prayer shawls to express their care for the planet.

Cope is a recipient of the American Craft Council award, a North Carolina Museum History award, and a National Endowment for the Humanities grant.

Bill Cunningham (1929–2016)

At age nineteen Bill Cunningham left Boston for New York, where he landed an advertising job at the upscale retailer Bonwit Teller. He then opened a millinery store, William J., where he sold his own creations.

After two years of military service, Cunningham returned to New York and resumed his hat design business. He also began creating fantasy masks featuring feathers and winged shapes that were highly sought after by Bonwit Teller for their Fifth Avenue windows.

Through these early endeavors Cunningham found his life's work—as a society and fashion photographer and columnist for the *New York Times*. His story is told in *Fashion Climbing*, Cunningham's posthumously published memoir.

Randall Darwall (1948–2017)

Randall Darwall studied art history and painting at Harvard College. After graduating in 1970, he taught art at the Cambridge School in Weston, Massachusetts, and discovered weaving while unsuccessfully trying to generate interest in fiber art among his high-school students.

Darwall left teaching to attend the Rhode Island Institute of Design (RISD), where he earned his MA in art education. Initially, he studied painting at RISD, but soon found himself spending countless hours in the textile design studio. While interested in all aspects of weaving, Darwall was known as a master colorist. He once said, "Everything I do is oriented toward color as an active element." His specialty was weaving rectangles of cloth designed to be worn as clothing shawls and scarves, but also considered as works of art.

Darwall was married to Brian Murphy, a clothing designer who created one-of-a-kind vests, jackets, and ensembles from Darwall's unique textiles.

Renée DeMartin (b. 1946)

Renée DeMartin earned a BA in art education from Kent State University and an MFA in metals and jewelry from Southern Illinois University.

Following college, she worked as an arts and crafts instructor, layout and design artist, photography assistant, and teaching assistant. In the mid-1970s, DeMartin moved to Sydney, Australia, where she taught art and jewelry making and worked as an audiovisual assistant in a library. In the early 1980s, she completed

training in diving and underwater photography. Since 1979, DeMartin has been self-employed as a craftsperson, creating and selling one-of-a-kind items that utilize her skills in drawing, jewelry making, and animal photography.

Nicki Hitz Edson (b. 1941)

Nicki Hitz Edson is a fiber artist who makes masks and other wearables, tapestries, and animal portraits. She started out in crochet, then added knitting and felting to her creative skills.

Edson has taught workshops at Barnard College, Brooklyn Museum Art School, Colorado Mountain College, the New School for Social Research, and the Penland School of Crafts, among other places. She has exhibited extensively in the United States as well as in Lisbon and Tokyo.

Her work is featured in books such as *The Kimono Inspiration*, released in conjunction with the exhibition of the same name at the Textile Museum, Washington, DC. With Arlene Stimmel, Edson co-wrote *Creative Crochet* (1973), a chronicle of "free-form" crochet. Edson currently lives in Oakland.

Arline Fisch (b. 1931)

Arline Fisch first encountered jewelry as art in the Metropolitan Museum of Art's Egyptian collection. With those ornaments as inspiration, she developed a technique using thin wires to create forms resembling knitted or braided fabric.

She received a BS from Skidmore College in Saratoga Springs, New York, and an MA from the University of Illinois at Urbana-Champagne. She taught art for two years at Wheaton College in Norton, Massachusetts, then traveled to Copenhagen on a Fulbright Grant to study silversmithing. She also taught at Skidmore College and is professor of art (emerita) at San Diego State University.

Fisch has exhibited extensively for more than five decades. Her work is in prominent collections, including the Victoria and Albert Museum, London; the Musée des Arts Décoratifs, Montreal; the Museum of Fine Arts, Boston; and the Vatican Museum.

Sheila Perez Ghidini (b. 1950)

Sheila Perez Ghidini earned a BFA from the University of Hartford, Connecticut, and later studied at Cranbrook Academy of Art, Michigan, before earning her MFA in sculpture at the University of California, Berkeley.

Her paintings and fiber art have been exhibited extensively in the Bay Area, as well as in solo and group shows around the United States. Ghidini has received scholarships and grants from the Wallace Alexander Gerbode Foundation, the Pollock-Krasner Foundation, the San Francisco Arts Commission, the Marcelle Labaudt Memorial Fund, the Rockefeller Foundation, and the Connecticut Commission on the Arts. She has executed numerous public art commissions in California, and her work is included in many public and private collections.

Tim Harding (b. 1950)

Tim Harding earned a BFA in studio art and painting from Hamline University, Saint Paul, Minnesota, and studied screen-printing, dyeing, shaping, and painting at Minnesota College of Art and Design, Minneapolis. He then became interested in fiber and textiles, adapting painterly concepts to develop a complex, free-reverse appliqué technique, which he used to create distinctive surfaces and patterns for his wall hangings and garments.

Harding's work is included in numerous public and private collections and has been shown in exhibitions worldwide. Wearable works, often in collaboration with his wife, Kathleen, are represented in celebrity and museum collections and have been featured in special showings at Bergdorf Goodman and Neiman Marcus.

Ellen Hauptli (b. 1949)

Ellen Hauptli was born in Chicago. She earned a BS in design, with an emphasis on costume and textiles, from the University of California, Davis, and an MFA in fiber works from the Center for Textile Arts in Berkeley and Lone Mountain College in San Francisco.

Hauptli makes simple, elegant clothing for women using a variety of fabrics. Many of her designs feature geometric patterns and shapes to achieve form and fit, and she strives to create clothing that complements and enhances the personality of the individual wearer.

Hauptli lives with her family in Berkeley and, according to her website, is "closing the gap between semi- and fully retired." No longer purchasing new materials, she now mines her shelves for saved textiles to create new garments and repurposes used items for a collection called Continuation Clothing.

Sharron Hedges (b. 1948)

An influential member of the early art-to-wear movement, Sharron Hedges began her exploration of textile techniques at Brooklyn's Pratt Institute, where she earned a BFA in 1970.

Since then, Hedges has worked as an independent artist and designer, creating crocheted and knit pieces and print design for home, fashion, and paper goods, and operating a full-service textile studio. Her wearable art is included in public and private collections and has been exhibited widely, including at the Museum of Contemporary Crafts, New York; Julie: Artisans' Gallery; and the Philadelphia Museum of Art Craft Show.

Hedges continues to work with fiber and pattern design in North Carolina.

Ana Lisa Hedstrom (b. 1943)

Ana Lisa Hedstrom is known for her signature textiles based on contemporary adaptations of shibori, the Japanese technique of manual resist dyeing to produce patterns on fabric.

Hedstrom has lectured and taught extensively throughout the world. Her work has appeared in numerous books and exhibitions and is included in the collections of institutions such as the Cooper Hewitt, Smithsonian Design Museum, New York; the Museum of Arts and Design, New York; the M. H. de Young Memorial Museum,

San Francisco; Takeda Kahei Shoten, Arimatsu, Japan; and the Aichi Shibori Research and Study Archive, Nagoya, Japan.

Awards include an American Craft Council fellowship, two National Endowment for the Arts Craftsman Grants, and an Idea-como Award at the Third International Textile Competition in Tokyo.

Pat Hickman (b. 1941)

Pat Hickman was born in Morgan, Colorado. She earned a BA from the University of Colorado and an MFA in textile design from the University of California, Berkeley. An educator and fiber artist, Hickman is best known for her use of unusual natural materials, including gut and sinew, to create sculptural installations.

Hickman took her first weaving classes while living in Turkey and became interested in working with animal entrails after a research trip to Alaska, where she saw Eskimo makers creating waterproof garments using seal intestines and fish skins. Later, while living in Hawaii, Hickman found inspiration in the natural landscape there and added bark and branches to the materials she used for sculptures.

Hickman has exhibited throughout the United States, and her work is in museum collections such as the Renwick Gallery, Smithsonian Institution, Washington, DC; the Museum of Fine Arts, Boston; the Pierre Pauli Foundation, Lausanne, Switzerland; and the Denver Art Museum. She has been awarded two grants from the National Endowment for the Arts and was elected a Fellow of the American Craft Council in 2005.

Julia Hill (b. 1947)

Julia Hill attended art school in West Germany, where she earned bachelor's and master's degrees in textile design. Her early work experience included an apprenticeship with Liberty of London Print Shop and assignments with New York design studios.

Hill is known for her unique dyed and painted fabric work. For more than a decade, her seasonal collections were available at Barney's nationwide. She also designed for Broadway and television, and created screens, panels, lanterns, and furnishings for public and private spaces.

Hill's work is in the collection of the Museum of Arts and Design, New York, and has been widely exhibited and published.

Marion Holmes (b. 1949)

A native New Yorker and graduate of the Fashion Institute of Technology and Cooper Union School of Art, Marion Holmes began her career collaborating with Ben Compton, making one-of-a-kind ensembles inspired by their mutual love of Art Nouveau and Art Deco, as well as African, Asian, and Islamic textiles. Their company, Best of Three Worlds, produced garments for Henri Bendel and other high-end boutiques, as well as celebrities and other private clients.

She established her own menswear company on Manhattan's Fifth Avenue and was known for creating design concepts for Dockers, Wrangler, and more. Her work has been featured in many publications, including *New York Magazine*, *Essence*, *Black Enterprise*, and *Menswear*.

Holmes resides in south Florida, where she works as a branding, marketing, and sourcing consultant. Most of her creative time is devoted to painting portraits and landscapes and showing her work in local exhibitions.

Nina Vivian Huryn (b. 1952)

Nina Vivian Huryn was born in England and grew up in Cleveland, where she received a BFA in textile design from the Cleveland Institute of Art.

Early in her career, Huryn moved to New York and began making art in various media, including wearables of leather, fabric, and found objects. Her work has been exhibited worldwide and was shown regularly at Julie: Artisans' Gallery in New York. Rock stars such as Elton John and Freddie Mercury wore Huryn's creations, and celebrities like Dustin Hoffman and Candace Bergen purchased her work from Julie's gallery.

Huryn currently lives in Cleveland and continues to create and exhibit art—occasionally wearables, but also quilts, collages, and sculpture, many of which feature her trademark skeletons and assemblages of found objects.

Joan Ann Jablow (b. 1941)

Joan Ann Jablow studied art education, earning a BA from New York University and an MA from Hunter College, New York, and taught at the High School of Fashion Industries and the Fashion Institute of Technology, New York.

Jablow's work has been featured in exhibitions such as *Fun and Feathers* at the Museum of Contemporary Crafts, New York, and in numerous publications, including *Life*, *Vogue*, the *New York Times*, and *Seventeen*. She also created custom pieces for designers such as Bill Blass and Leo Narducci.

Paul Johnson

Paul Johnson earned a PhD at Teachers College, Columbia University, New York. His macramé jewelry pieces reflect the organic qualities in nature—patterns created by melting snow, cave formations, and crags left behind by the tides—and include materials such as rock crystal, glass beads, and feathers. In his words, his interest is in exploring "how the colors, textures, and forms echo each other."

Johnson's pieces have been featured in exhibitions at the American Folk Art Museum, New York; the Heckscher Museum of Art, Huntington, New York; and The Elements, Greenwich, Connecticut; and in publications such as Virginia I. Harvey's *Color and Design in Macramé* (1971) and Helene Bress's *The Macramé Book* (1999).

Whitney Kent (1913–1999)

Whitney Kent was born in Sault Ste. Marie, Michigan, the daughter of a miner and a school teacher. In high school she struggled with academics but excelled in art. When it became apparent that she might not graduate, her mother arranged for her to paint a mural in the school auditorium in exchange for a passing grade. The mural lasted until the school was demolished many years later.

Kent worked as a commercial artist while attending the Corcoran School of the Arts in Washington, DC. In 1947 she married an army colonel and spent fourteen years traveling and painting portraits and landscapes in Afghanistan, Japan, and Turkey. She settled in New Jersey in 1961 and opened a gift shop, where she began doing woodwork during slow times. Soon she hired a staff so that she could working full time in her studio.

Whitney said of her work: "A crafted piece should be useful, beautiful in design, color and shape, and a pleasure to handle and feel. I feel it should show truth and honesty and I firmly believe it should elevate the human spirit with a positive outlook, full of joy and sophisticated humor."

Candace Kling (b. 1948)

Candace Kling is a fiber artist, teacher, and author. After earning a BFA from the California College of the Arts, Kling traveled the country researching ribbon and fabric embellishment, exploring museum costume and textile collections. She used what she learned to create elaborate textile sculptures—from helmets and headdresses to tiny boxes and monumental waterfalls.

Her works have been exhibited worldwide and are included in the collections of the Museum of Arts and Design, New York; the Metropolitan Museum of Art, New York; and the Fine Arts Museums of San Francisco. Kling's 1996 book *The Artful Ribbon* is still considered a landmark publication on the subject.

Fred Kling (b. 1944)

Fred Kling earned a BFA from the California College of Arts and Crafts and an MFA from Mills College, Oakland. After graduation, he began to paint with Inkodye, a fabric-reactive dye made exclusively for cotton, creating more than five hundred original garments adorned with elaborate designs including animals, birds, butterflies, moons and stars, spaceships, and rainbows.

From 1980 until his retirement in 2013, Kling taught painting, watercolor, and figure drawing at City College of San Francisco. He also teamed with artist Agnes Yau to design and execute interior and exterior murals for Ann Getty & Associates and other clients.

Kling is a member of the California Watercolor Society and the Book Club Van Kleef and continues to exhibit his paintings and drawings.

Dina Knapp (1947–2016)

Dina Knapp was born in Cyprus and spent the first part of her childhood in Haifa, Israel, before emigrating with her family to Brooklyn in 1959. She attended the High School of Music and Art and went on to study at the Brooklyn Museum Art School and Pratt Institute.

Early in her career, Knapp was best known for her fiber work. She exhibited extensively and contributed to Julie Schafler Dale's book *Art to Wear*. Her intricate crocheted works were owned by celebrities such as Bob Marley, Cher, Joanne Woodward, Barbara Walters, Elton John, and Donovan.

After moving to Florida, Knapp focused on wearable art and mixed-media collage. She was also wardrobe mistress for the

Florida Grand Opera, as well as working backstage for the ballet, Broadway theater, and other performing arts.

Jane Kosminsky De Filippis (b. 1948)

Jane Kosminsky De Filippis earned a degree in fashion design from Traphagen School of Fashion, New York. She studied lost wax and lapidary at the Craft Students League, and African and Oceanic Art at the New School for Social Research, both in New York, and is a self-taught leather artist.

From 1978 to 1983, Kosminsky owned a boutique that sold her original creations along with handmade clothing and art objects from around the world. As an independent fine artist and textile designer, she makes wearable art from leather and mixed-media materials.

Kosminsky's works have been exhibited worldwide and are in the collections of the Metropolitan Museum Costume Institute, New York, and the M. H. de Young Memorial Museum, San Francisco.

Ina Kozel (b. 1944)

Ina Kozel is a painter who bases her technique on *roketsuzome*, a Japanese batik process using layers of transparent, hand-painted dyes with a wax resist. Her works range from intimate to large scale, on materials as varied as silk, stainless steel, and wood.

Kozel has exhibited her wearable art and hangings throughout the world and created installations for locations such as Top of the Rock Observation Deck at Rockefeller Center, New York; St. Michael the Archangel Church in Kaunas, Lithuania; the Hotel Hana Iti in French Polynesia; and the Landmark Center in Orlando, Florida.

Her work has been included in numerous national and international publications. She currently lives and works in New York.

Carolyn Kriegman (1933–1999)

Carolyn Kriegman was a New Jersey–based jewelry maker who gained notoriety for her use of plastic as a signature medium when her work was shown in *Objects: USA*, a traveling exhibition that opened in October 1969 at the Smithsonian National Collection of Fine Arts in Washington, DC.

Kriegman's work was subsequently shown in many other museums, including the Museum of Contemporary Crafts, New York; the Newark Museum; and the New Jersey State Museum, Trenton.

In the 1980s, Kriegman worked as a consultant for the Montclair Art Museum and contributed to other institutions in the art and craft community. She was a state representative for the Northeast Region Assembly of the American Craft Council, and served many roles at Northeast Craft Fairs, including board director and member of the awards committee.

Robert Kushner (b. 1949)

Robert Kushner earned a BA in visual arts from the University of California, San Diego. As a painter in the Pattern and Decoration movement, Kushner drew on influences such as Georgia O'Keeffe, Islamic textiles, and Chinese brush artists to create canvases

characterized by rich color, fluid lines, and a blend of natural elements and abstract, geometric forms.

From 1970 until 1982, Kushner made body sculpture, which he called "costumes," from repurposed garments, found objects and textiles, and other materials. The costumes were presented as public performance art in settings such as the Museum of Modern Art, New York; the Berliner Festwochen; the Vienna Performance Festival; the Institute of Contemporary Art, Philadelphia; The Kitchen, New York; and The Clocktower, New York; as well as at many university museums and galleries.

Kushner's work has been exhibited throughout the world, including in three Whitney Biennials and two Venice Biennales, and is in museum collections such as the Metropolitan Museum of Art, New York; the Tate Gallery, London; and the Museum Ludwig, Saint Petersburg, Russia.

Susanna Lewis (b. 1938)
Susanna Lewis is a fiber artist, author, and teacher. After receiving a BA from Michigan University and an MA from Teachers College, Columbia University, New York, she began her fiber arts career by learning hand-knitting, crochet, and lacemaking and using them as sculptural techniques. In the late 1970s, she discovered machine knitting and applied the process to creating architectural hangings and garments.

Lewis's machine-knitted wearable art pieces are in the collections of the Metropolitan Museum of Art, New York, the Brooklyn Museum, and others. Her work is included in numerous publications. She is the author of *Knitting Lace* (1992) and *The Machine Knitter's Handbook* (1989).

Janet Lipkin (b. 1948)
Janet Lipkin attended Brooklyn's Pratt Institute, where she received a BFA. Following graduation, she devoted herself to making garments. Lipkin's elaborate crocheted pieces transform the human figure into a sculptural form, helping to define the field of wearable art. She has also taught workshops, designed sportswear and knitwear, partnered in a sweater company, and worked as boutique manager and custom dresser.

Her work has been published and shown widely and can be found in the collections of institutions such as the Metropolitan Museum of Art, New York; the M. H. de Young Memorial Museum, San Francisco; the Oakland Museum; the Museum of Fine Arts, Boston; and in private collections in the United States, Canada, Africa, and Europe.

Lipkin currently lives and works in Northern California.

Mark Mahall (1949–1978)
Mark Mahall earned a BFA from Ohio State University, where he majored in painting, drawing, and graphics. Early in his career, Mahall created *The Laura Holman Show*, an exhibition of memorabilia depicting the personal life of a fictitious actress and covering thirty-four years of her life. In conjunction, Mahall created a fashion salon of MGM costume replicas, tagged and dated according to

their supposed appearance in the studio's early films. The collection was presented as a fashion show.

In the early 1970s, Mahall turned almost exclusively to set and costume design. He worked on several Broadway shows, including the 1976 production of Stephen Sondheim's *Pacific Overtures*, and also was a freelance artist-designer specializing in clothing and two-dimensional designs. He exhibited his clothing and costumes at Julie: Artisans' Gallery.

K. Lee Manuel (1936–2003)
K. Lee Manuel earned her BFA from the University of California, Los Angeles, and was a member of the Bay Area artist collective Group 9. A painter and fiber artist, Manuel was an important figure in the art-to-wear movement, best known for her hand-painted clothing, including kimonos, as well as her feather collars and other accessories.

Manuel exhibited in numerous galleries and museums in the United States and internationally. Her work is in the collections of the M. H. de Young Memorial Museum, San Francisco; the Museum of Arts and Design, New York; and the Renwick Gallery at the Smithsonian American Art Museum, Washington, DC.

Linda J. Mendelson (b. 1940)
Linda Mendelson earned a BFA from the City College of New York and worked various jobs, including employment counselor, calligrapher, chart maker, co-owner of a shop where she taught machine knitting, and spokesperson for a craft yarn company, before devoting herself to a career as a fiber artist.

Her early works were machine knitted, with designs that frequently incorporated text and themes from popular culture, such as song titles and literary passages. More recent works include structural embroidery pieces and handbags.

Mendelson's work has been widely exhibited, collected and worn by celebrities such as Elton John, and featured in numerous publications. Her pieces are in the collections of the Metropolitan Museum of Art, New York; the Museum of Arts and Design, New York; and the Racine Art Museum, Wisconsin.

Norma Minkowitz (b. 1937)
Norma Minkowitz studied fine arts at the Cooper Union School of Art in New York, where she focused on drawing. Although best known for her representational mesh sculptures and wearable pieces, Minkowitz began her career creating pen-and-ink drawings.

A notable figure in the fiber arts movement of the 1970s, Minkowitz has had work in numerous solo and group exhibitions and national and international publications. Her pieces are in many museum collections, including the Metropolitan Museum of Art, New York; the Philadelphia Museum of Art; the M. H. de Young Memorial Museum, San Francisco; the Houston Museum of Fine Arts; the Contemporary Museum, Honolulu; the Detroit Institute of Arts; and the Kwangju Museum, South Korea.

In 2003, Minkowitz was elected a Fellow of the American Craft Council. She was awarded a Master of the Medium Award

192

from the James Renwick Alliance in 2009, and her artist papers were selected for inclusion in the Smithsonian Archives of American Art in 2015.

Risë Nagin (b. 1950)

Risë Nagin graduated from Carnegie Mellon University, Pittsburgh, with a BFA in painting and worked as a textile colorist and fabric designer before striking out on her own as a textile artist in 1975.

Nagin chose silk, velvet, chiffon, cotton, and other dyed cloth, incorporated glitter and cellophane, and later included acrylic color wash to create her multilayered, appliquéd works. Drawing on her training in papermaking, she expanded her construction techniques and began to use stitching as a graphic element. Around 1984, she changed direction, adopting a rectangular format for abstract pieces that she calls "art quilts."

Her work has been exhibited throughout the United States and is included in collections such as the Smithsonian American Art Museum, Washington, DC: the Philadelphia Museum of Art; the Museum of Arts and Design, New York; the Hermitage State Museum, Saint Petersburg, Russia; the Melbourne Museum, Australia; and in private collections in the United States, Europe, and Japan.

Susan Nininger (b. 1952)

Susan Nininger attended the Rhode Island School of Design and earned a BFA from the University of New Mexico and an MFA from the University of Washington.

The body of work she produced in the 1970s—which she called costumes, body objects, and costume sculpture—included a variety of materials such as fabric, sculpted ceramic pieces, and found objects, and incorporated a strong sense of storytelling. Nininger wanted her works, wearable or not, to be devices for imaginative stimulation.

In the late 1970s, Nininger made the transition from working as a studio artist to designing costumes for the stage, music videos, and feature films. She lives in Los Angeles, where she runs Susan Nininger Studio.

Walter Nottingham (1930–2012)

Walter Nottingham had no formal art training in his early life. After he returned from military service and he and his wife were living in Minnesota, he attended nearby St. Cloud State University and, needing a humanities class to graduate, chose a design course. He soon changed his major from business to art, earning an MA in art education with an emphasis in painting and printmaking.

Nottingham worked briefly as an art consultant for a public-school system in Michigan before being offered a job as head of the art education program at University of Wisconsin (UW), River Falls. While at UW, he taught himself to weave using a how-to book and hand-built loom. During a sabbatical, Nottingham studied at Cranbrook Academy of Art, Bloomfield Hills, Michigan, and earned his MFA.

Throughout his art career, Nottingham worked in a diverse range of mediums, including weaving, crochet, basketry, paper casting, and multimedia with found objects. His work has been shown extensively and is in numerous public and private collections.

Nottingham taught at UW from 1962 until he and his wife retired to Hawaii in 1990.

Pat Oleszko (b. 1947)

Pat Oleszko studied sculpture at the University of Michigan, Ann Arbor, and went on to become an internationally known performance artist whose repertoire ranges from plays and films to oversize inflatables to site-specific performances and public art installations.

Oleszko uses the body as a framework to create work that includes costumes and props for solo performances and films. Her pieces have appeared in diverse settings such as the Museum of Modern Art and the Metropolitan Museum of Art, New York; the Macy's Thanksgiving Day Parade; the Ann Arbor Film Festival; the Andy Warhol Museum, Pittsburgh; and the Prague Quadrennial.

Oleszko has received numerous awards and grants, including a Guggenheim Fellowship, the American Academy in Rome Prize Fellowship, a Jim Henson Foundation Grant, and a National Endowment for the Arts Fellowship.

Marilyn Pappas (b. 1931)

Marilyn Pappas studied education, earning a BS from the Massachusetts College of Art and Design and an MS from Pennsylvania State University. From 1952 to 1994, she taught art, first in elementary schools and later at the college level. For twenty years she was professor of art at Massachusetts College of Art and Design, Boston, and has been professor emerita since 1995.

In the early 1960s, Pappas began to work with cloth and thread, creating stitched and appliquéd cloth hangings based on familiar landscapes. Gradually her work changed from flat pieces to multidimensional reliefs formed by combining manipulated fabric, pieces of clothing, and found objects.

Pappas's work is in many private and public collections, including the Museum of Fine Arts, Houston; the Museum of Arts and Design, New York; the Museum of Fine Arts, Boston; and the M. H. de Young Memorial Museum, San Francisco.

J. Pearson (b. 1948)

J. Pearson's fine crafts and sculpture, primarily in leather, have been in solo and group shows in New Mexico, Colorado, Texas, Minnesota, and California, and his paintings have been shown in galleries and exhibitions in the Southwest.

Pearson's work is in the collections of Coach Leatherwear, New York and Paris; the Mobile Art Museum, Alabama; the Albuquerque Museum, New Mexico; the Greenville County Museum of Art, South Carolina; the Grover M. Hermann Fine Arts Center, Marietta College, Ohio; and in individual collections in the United States and Norway.

Pearson was the recipient of a National Endowment for the Art Grant in Crafts and a Western States Arts Foundation Fellowship.

Jody Pinto (b. 1942)

Jody Pinto attended the Pennsylvania Academy of the Fine Arts (PAFA) and earned a BFA from Philadelphia College of Art (now the University of the Arts). She taught at the Rhode Island School of Design from 1980 to 1983 and at PAFA from 1978 until her retirement in 2018.

Her site-specific works can be found around the globe and involve collaborations with artists, architects, landscape architects, and engineers. Early works include *Triple Well Enclosure*, a performance piece, and *Fingerspan*, located in Philadelphia's Fairmount Park. Pinto has won numerous awards and grants, including from the National Endowment for the Arts. Her work was featured in the Whitney Biennial and the Venice Biennale and is in many public collections, including the Museum of Modern Art, New York; the Whitney Museum of American Art, New York; the Philadelphia Museum of Art; and PS1 in Long Island City, New York.

In 1972, Pinto founded the crisis center Women Organized Against Rape (WOAR) and served as its director until 1974. The organization continues today.

Anna VA Polesny (b. 1944)

Anna Polesny earned degrees in art history, psychology, weaving, textile design, and glass, as well as a certification to teach art. She has also studied studio art, textiles, and leatherwork.

Polesny has exhibited in museums and galleries worldwide, and her work is in the collections of institutions such as the Philadelphia Museum of Art; the Cooper Hewitt, Smithsonian Design Museum, New York; the Los Angeles County Museum of Art; the Stadische Kunsthalle, Germany; and the Stedelijk Museum, Amsterdam.

In her eclectic career, she has produced a documentary, chaired college art departments, managed a baroque orchestra, consulted for nonprofits, and been executive director of Mohawk Trail Concerts, all while continuing to create art.

Yvonne Porcella (1936–2016)

Yvonne Porcella was a self-taught quilter whose work included weavings, garments, wall hangings, and art quilts. She was known for her use of bold colors and unusual titles.

In 1989, Porcella helped found Studio Art Quilt Associates, a nonprofit dedicated to promoting art quilts through education, exhibitions, professional development, and publications. The organization now has more than three thousand members.

Her work has toured in national and international exhibitions and is featured in museums and galleries worldwide, including the Los Angeles County Museum of Art; the Museum of Arts and Design, New York; and the Renwick Gallery of the Smithsonian American Art Museum, Washington, DC. Porcella was inducted into the Quilters Hall of Fame in Marion, Indiana, in 1998.

Diane Prekup (b. 1956)

Diane Prekup is a graduate of Moore College of Art and Design in Philadelphia, where she studied advertising design, photography, and illustration. Early in her career, Prekup worked as art director for a large corporation. In 1988, she formed her own full-service studio, Options Design Group, and in 1994, she became director of Upstate Visual Arts in Greenville, South Carolina, an organization that managed and advocated for local visual artists. During this time, Prekup also taught design at the Greenville Museum of Art.

In 1996, Prekup's creative life took a radical turn when she opened One by One Glass, a company that designed and produced fused-glass pieces for gift shops and boutiques nationwide. Currently, Prekup creates wearable fiber art for her own Diane Prekup Fiber label, sold nationally in galleries and specialty shops.

Debra Rapoport (b. 1945)

Debra Rapoport earned a BFA from Carnegie Mellon University, Pittsburgh, and an MA in textile design from the University of California, Berkeley. For more than fifty years, she has worked with sustainable materials, transforming found objects into multilayered works of wearable art.

From 1970 to 1979, Rapoport taught costume design, personal adornment, and textile design at the University of California, Davis. She also gave a workshop in using recycled clothing at Eileen Fisher, New York, and has taught at the Museum of Modern Art, the Museum of Arts and Design, New York University, and the Eastside Girls Club, among other New York institutions.

Her work has been collected by and exhibited in museums worldwide, including the Metropolitan Museum of Art, New York; the Philadelphia Museum of Art; the Museum of Fine Arts, Houston; the Los Angeles County Museum of Art; and the State Hermitage Museum in Saint Petersburg, Russia.

Rapoport was in the film *Advanced Style* (2018) and in three *Advanced Style* books. She also participated in a TEDx Talk in 2014 with *Advanced Style* creator Ari Seth Cohen.

A New York City native, Rapoport still lives and works there.

Mario Rivoli (b. 1943)

Mario Rivoli grew up in New York, where he attended the School of Industrial Art (now the High School of Art and Design), the Art Students League, and the School of Visual Arts. In the early 1960s, Rivoli moved to Greenwich Village, opened the Tunnel of Love, a vintage clothing shop, and was involved with several galleries, including the Stevens Gallery, where he was first exposed to the concept of wearable art.

Always eclectic in his approach to art, Rivoli found inspiration in the free-wheeling environment of 1960s Greenwich Village. He made paper flowers and illustrated three children's books, but his primary passion was using found objects to create outrageous and provocative works. In 1977, Rivoli relocated to Colorado, where he continued to create assemblage pieces, but shifted the focus from wearables to decorations for the home.

Rivoli's work has been widely exhibited, featured in numerous publications, commissioned for murals, and is included in the private collections of Elton John, Stevie Wonder, Cher, Bob Mackie, and many more.

Ed Rossbach (1914–2002)

Ed Rossbach earned a BA in painting and design at the University of Washington, Seattle, and an MA in art education at Columbia University, New York. After graduation, he joined the Army and served during World War II in Alaska, where he discovered fiber arts. In 1947, he returned to school for an MFA in ceramics and weaving at Cranbrook Academy of Art in Michigan. After teaching briefly at the University of Washington, in 1950 he moved to the University of California, Berkeley, where he remained an esteemed teacher and mentor until his retirement in 1979.

Though Rossbach began his career in ceramics and weaving, he later turned to basket making and became known for his use of unconventional materials such as plastic, metal, food cartons, and old newspapers in his work. His textiles are part of numerous collections, including the Metropolitan Museum of Art, New York; the Museum of Modern Art, New York; the Art Institute of Chicago; and the Smithsonian American Art Museum, Washington, DC.

Rossbach was married to Katherine Westphal, an artist who taught at the University of California, Davis, and is also considered an important figure in contemporary fiber arts.

Evelyn Roth (b. 1936)

Evelyn Roth was born in rural Alberta, Canada, and moved in the 1950s to Edmonton, where she studied art, dance, yoga, and fencing. In 1961, she moved to Vancouver and joined Intermedia, a group of artists, dancers, and film makers.

Roth's involvement in wearable art began in the 1960s, and when recycling became popular in the early 1970s, she used her knitting and crocheting skills to create objects from both traditional and unconventional materials. Her groundbreaking *The Evelyn Roth Recycling Book*, released in 1974, is now available as an e-book.

Roth has created and showed work at countless international events and exhibitions. Her fanciful costumes, used in instant parades she calls the "Nylon Zoo," have been traveling since the late 1990s. She lives and works in Adelaide, Australia.

Miriam Schapiro (1923–2015)

While in high school, Canadian-born Miriam Schapiro took classes at the Museum of Modern Art, New York. She attended Hunter College, New York, and the University of Iowa, where she earned a BA, an MA in printmaking, and an MFA in painting. She also met her future husband, artist Paul Brach, there.

The couple moved to New York in 1951 and became part of the Abstract Expressionist New York School, with Schapiro launching a successful career as a painter. Schapiro moved to California in the 1970s and, with Judy Chicago, founded the Feminist Arts Program at the California Institute of the Arts, Valencia, best known for its collaborative installation and performance space *Womanhouse*. Schapiro's 1976 exhibition *Anatomy of a Kimono* helped establish the kimono as a visual art form in the United States.

Schapiro traveled extensively as a visiting artist, delivering lectures and promoting the women's art movement. She exhibited throughout the United States, and her works are in museum collec-

tions including the National Gallery of Art, Washington, DC, and the Jewish Museum, New York. She received a Distinguished Artist Award for Lifetime Achievement from the College Art Association.

Marjorie Schick (1941–2017)

Marjorie Schick received a BS in art education from the University of Wisconsin and an MFA from Indiana University. After college, she and her husband moved to Kansas and joined the faculty at Pittsburg State University.

Schick established her reputation as an internationally known artist with large-scale works—made from unusual materials such as papier-mâché, wooden dowels, rubber, and string—which were more like body sculpture than jewelry.

Her works are in private collections and museums throughout the world, including the State Hermitage Museum, Saint Petersburg, Russia; the Museum of Arts and Design, New York; the National Museum of Modern Art, Kyoto; the Victoria and Albert Museum, London; and the Philadelphia Museum of Art.

Mary Ann Schildknecht (b. 1947)

A second-generation Californian who grew up in Los Angeles, Mary Ann Schildknecht was fascinated from an early age with painting and other art forms. In high school, she was voted commissioner of fine arts. She went on to San Diego State University, where she majored in fine art.

After a 1970s European adventure, Schildknecht pursued careers in advertising, fashion design, and hospitality, among others. She continues to explore painting in watercolors, acrylics, and oils, working both in her studio and plein air, with subjects that range from landscapes to still life. Her work has been shown in numerous galleries, museums, and other venues, and is in many private collections.

Schildknecht currently teaches elementary school art and enjoys sharing her knowledge of and love for art with her students.

Marian Schoettle (b. 1954)

Marian Schoettle graduated with a BA in sociology from Colgate University, studied multicultural education at the University of Massachusetts, and, in 1978, established Mau Conceptual Clothing. Since that time, she has maintained an independent studio practice in Europe and the United States, creating what she calls "post-industrial folk wear" with materials such as printed Tyvek. She also creates installations and public and community projects and engages in collaborations around idea-based clothing design.

Schoettle has taught adult and children's art workshops since 1975 and served as a studio tutor and lecturer for secondary schools in the Netherlands and at the University of Wales from 1985 to 1995. Her works have been exhibited worldwide and are in the collections of museums such as the Victoria and Albert, London; the Textile Museum of the Netherlands, Tilburg; and the Municipal Museum of The Hague.

Carol Lee Shanks (b. 1957)

Carol Lee Shanks earned a BS in textile and costume design from the University of California, Davis. She designs and handcrafts unique clothing and textile art pieces, allowing the cloth to serve as her inspiration. An integral part of her work is manipulating the fabric to transform the flat, linear pieces into multidimensional silhouettes.

Shanks's work has been shown and sold in galleries throughout the United States and included in international shows and fiber art publications. She currently works and exhibits her clothing and textiles from her studio in Berkeley, California.

Judith Shea (b. 1948)

Judith Shea earned a BFA from the Parsons School of Design, New York. Though trained as a designer, Shea left behind the fashion industry to pursue an art career.

Her first solo show explored color theory using layers of translucent silk on a live model. Other early work investigated clothing and construction, first through flat, minimalist patterns, and then as molded forms draped over implied figures. With support from the National Endowment for the Arts, Shea learned bronze casting, which led her to create hollow-figure compositions for public spaces. After a residency at Chesterwood, home of American public sculptor Daniel Chester French, Shea started to use woodcarving for her large sculptures.

Shea's work is in many public collections, including the Yale University Art Gallery, New Haven; the Museum of Modern Art, New York; the Metropolitan Museum of Art, New York; the Hirshhorn Museum and Sculpture Garden, Washington, DC; the Walker Art Center, Minneapolis; and the Whitney Museum of American Art, New York.

Billy Shire (b. 1951)

Billy Shire's early art training was limited to ceramic classes at the Pasadena Art Museum. After high school, he worked as a carpenter with his father for a year and then, with his mother, opened the Soap Plant, a shop that featured soaps, ceramics by his brother Peter, and leatherwork—mainly belts—by Shire. Many of the belts were made for Bill Whitten, known for outfitting rock stars during the 1970s, and Shire's creations were worn by Edgar Winter, Elton John, and members of groups such as Chicago, Three Dog Night, Steppenwolf, and the Doobie Brothers.

In 1974, Shire gained greater notoriety when a studded jacket he designed won a Levi's "Denim Art" contest and toured in the resulting exhibition. In the early 1980s, Shire became sole owner of the Soap Plant and moved the eclectic shop to Melrose Avenue, where he added books, jewelry, and other items. In 1986, he opened La Luz de Jesus Gallery upstairs from his flagship store, with a goal of bringing underground art and culture to a mass audience. The gallery and stores (including Wacko, which sells toys) are still operating in Los Angeles.

Carter Smith (b. 1946)

Carter Smith has been creating shibori fabrics for five decades. Using his one-of-a-kind textiles, each prepared and hand-dyed by the artist, and his original bias designs, Smith makes timeless garments that have been worn by Elizabeth Taylor, Jane Fonda, Mick Jagger, Alicia Keys, Aretha Franklin, Maya Angelou, and Sarah Jessica Parker, among others.

Articles about his designs have appeared in numerous national publications, including the Washington Post, Los Angeles Times, Chicago Tribune, New York Times, Boston Globe, Vogue, and Threads.

Since 1968, Smith's work has been exhibited in museums and galleries in the United States and Asia, and his unique garments have been part of prestigious fashion collections such as Christian Dior and Halston.

Mimi Smith (b. 1942)

Mimi Smith earned a BFA from the Massachusetts College of Art, Boston, and an MFA from Rutgers University, New Brunswick, New Jersey.

A pioneer in early feminist and conceptual art, Smith focused on clothing sculpture and drawing installation, using personal experience as a starting point to present everyday life in unexpected ways. Smith has exhibited extensively nationally and internationally.

She received a Joan Mitchell Grant, a New York Foundation of the Arts Fellowship, a New York Council for the Arts Project Grant, and a National Endowment for the Arts Fellowship. Smith has been included in numerous books and in the New York Times, Artforum, Art in America, ArtNews, and Frieze, among other publications. Her work is in public collections such as the Institute of Contemporary Art, Tokyo; the Getty Center, Santa Monica, California; and the Museum of Modern Art, New York.

Smith lives and works in New York.

Raoul Spiegel (b. 1946)

Raoul Spiegel was born in Germany and received a BA from Bloomfield College, New Jersey, where he studied philosophy and German literature. Following college, he traveled extensively throughout Europe. Upon his return to New York, Spiegel agreed to help a friend with a featherwork project and became interested in using feathers to make his own designs.

Spiegel moved to California and started making "soft body sculptures" using a fishnet technique similar to the Hawaiian process for constructing feathered garments. The jewelry and other bodywear he creates in his California studio has been sold and exhibited nationwide.

Jo Ann C. Stabb (b. 1942)

Jo Ann C. Stabb is a designer, author, and lecturer focusing on fashion and wearable art. She served on the design faculty of the University of California, Davis, from 1968 to 2002, teaching clothing, fashion, historic and ethnographic costume, and contemporary wearable design. Her work has been exhibited throughout the United States and internationally in Austria, France, England, South Korea, and Australia.

Stabb has published articles and reviews on contemporary wearable art in Surface Design Journal, American Craft, and the

Australian Wearable Art Association Journal, among others. She has lectured nationally and internationally on clothing and wearable design to professional associations, museums, and arts organizations, including the World Crafts Council, Costume Society of America, and the International Textile and Apparel Association.

She was executive producer of *Wearable Art from California* (1985–86), a video series that was distributed nationally through the University of California and internationally through the United States Information Agency.

Stabb continues to lecture, write, publish, and produce studio work.

Joan Steiner (1943–2010)

Joan Steiner graduated from Barnard College, New York, where she majored in philosophy and minored in literature, and did a year of graduate work in philosophy at the University of Chicago.

After holding jobs in advertising and at a nonprofit, in 1975 Steiner left to pursue her interests in art. With no formal art training, she began making soft sculptures that depicted familiar objects such as toasters, portable radios, skates, and sandwiches. Later, she made what she called "2½ dimensional" works that showed more depth, both actual and illusionary.

Steiner's work was shown in solo and group exhibitions throughout the United States and collected by such notable figures as Elton John and Yusuf Islam (aka Cat Stevens). She has been featured in publications such as the *New York Times, Craft Horizons,* and *New York Magazine* and in segments on NBC and German public television.

She was the 1980 recipient of a fellowship from the National Endowment for the Arts.

Arlene Stimmel (b. 1945)

Arlene Stimmel is a California native and graduate of the San Francisco Art Institute who came to crochet and fiber art while pursuing a career as a painter. She was using automotive spray paint and found that crochet helped pass the time it took for numerous coats of paint to dry.

In 1969, Stimmel moved to New York and met fellow art-school graduates who had turned to fiber as their medium. She was inspired by rich and colorful textiles such as Navajo rugs and attracted by the functional aspect of traditional craft, which led her to transition to wearable art, much of which features mystical imagery. She is the author, with Nicki Hitz Edson, of *Creative Crochet* (1973).

Susan Summa (b. 1948)

Susan Summa attended the University of Texas, Austin, and graduated with a degree in interior design. While working at a Dallas architecture firm, she learned to weave tapestries for corporate interiors, then switched to loom knitting after moving to Santa Fe, New Mexico, in 1973. It was there that Summa developed a folkloric knitwear collection that she sold through craft fairs and galleries and to private collectors. Her training in design, architecture, and tapestry weaving led her to explore color, line, and expressive motifs in her clothing.

In 1996, she launched an artisan-centric wholesale trade show in New York, expanding the market for like-minded designers and artisans. She continues to live and work in Santa Fe.

Jamie Summers (1948–1983)

After earning a BFA and an MFA from the San Francisco Art Institute, Summers began sculpting animals to demonstrate her idea that "humor and whimsy are important art forms."

She turned to wearable art, using various textiles and materials including sculpted elements, and later opened her own tattoo-design business. Her work was shown in exhibitions nationwide and in publications such as the *New York Times, Art in America, Artforum,* and *FiberArts Magazine.*

Summers was featured on San Francisco's Channel 5, West German television, and *Today's Woman,* syndicated by Newsweek Broadcasting, New York. In early 1980, she exhibited at the XIII Olympic Games, and later that year participated in the World Crafts Council Conference in Vienna.

Summers died at age thirty-five in a biking accident in New York.

Lenore Tawney (1907–2007)

Lenore Tawney moved to Chicago in 1927 and worked as a proofreader while taking evening classes at the Art Institute. She studied sculpture, drawing, and weaving at the Institute of Design and later studied tapestry at the Penland School of Crafts, North Carolina. She married psychologist George Tawney in 1941 and, after his sudden death eighteen months later, traveled extensively in Mexico, Europe, North Africa, and the Middle East.

Tawney returned to the United States in 1957 and took up residence in New York, where she was introduced to Abstract Expressionism and began making sculptural woven forms. Although she moved away from weaving to explore collage and found objects, her influence on fiber art remains an important part of her legacy.

Awards include the American Craft Council Gold Medal Award and the Visionaries Award from the American Craft Museum. Tawney's work is in national and international collections, including the Museum of Modern Art, New York; the Art Institute of Chicago; the Philadelphia Museum of Art; the Stedelijk Museum, Amsterdam; and the Musée des Arts Decoratifs de Montreal.

Ken Tisa (b. 1945)

Ken Tisa received a BFA from the Pratt Institute, Brooklyn, and an MFA from the Yale School of Art and Architecture.

Tisa's work has been featured in numerous solo exhibitions, including in France and the Dominican Republic, and at institutions such as MoMA PS1 and Artists Space in New York; LaSalle University Art Museum, Philadelphia; Philbrook Museum of Art, Tulsa, Oklahoma; and in the 1975 Whitney Biennial in New York. He has been a contributing author to multiple publications, including *Art to Wear, The New Beadwork,* and *500 Beaded Objects: New Dimensions in Contemporary Beadwork.*

Tisa currently works and lives in New York and is a professor in the painting department at the Maryland Institute College of Art, Baltimore.

Jo-Ellen Trilling (b. 1947)

Jo-Ellen Trilling studied fine art and art education at the State University of New York at New Paltz and began working as an independent artist in the early 1970s.

Trilling's early works were sculptures crafted from cloth and mixed media, including wearable pieces. In 2001, in response to the events of September 11, she expanded her practice to include paintings that, like her sculptures, depict fantastical animals, toys, and magical beings concealing a darker world beneath the surface. Her work has been shown at numerous galleries and was included in the documentary film *The Art of the Doll Maker* (1999). Trilling lives and works in Kingston, New York.

Yoshiko I. Wada (b. 1944)

Yoshiko I. Wada has a BFA from Kyoto City Fine Arts University and an MFA from the University of Colorado. Her work has been exhibited widely, including at the Smithsonian Institution's Renwick Gallery, Washington, DC, and the International Textile Fair, Kyoto.

Wada has curated several exhibitions, including *Art of Memory in Contemporary Textiles* at the Thompson Art Center in Bangkok. She is a producer for Natural Dye Workshop Films, president of the World Shibori Network, founder of Slow Fiber Studios, and co-chair of the International Shibori Symposium.

She has authored and co-authored several books and continues to lead workshops in the subjects of natural dye, resist-dyeing, and reuse of material.

Katherine Westphal (1919–2018)

Katherine Westphal received her BA and MA from the University of California, Davis. While teaching design at the University of Washington, she met her future husband, Ed Rossbach, also an artist. After moving to California, Westphal worked in commercial textile design and, eight years later, took a job teaching industrial design at UC Davis. She retired as professor emerita in 1979.

Though trained as a painter, Westphal worked in various media. In the 1960s, she added quilting to her repertoire, using appliqué, batik, and textile printing to create new art forms in traditional media.

Westphal was elected to the American Craft Council College of Fellows in 1979. She was also an ACC Gold Medalist in 2009.

Kaisik Wong (1950–1990)

Kaisik Wong was born in San Francisco and trained at the city's Pacific School of Fashion Design. A pioneer of wearable art, Wong crafted one-of-a-kind handmade pieces, mostly without the use of patterns.

His designs merged influences from ancient cultures, including Egyptian, Chinese, and Mayan textiles, with futuristic elements to create a unique fashion fusion in his tunics, tapestries, kimonos, embroidery, and appliqué.

Wong was a long-time collaborator with Sandra Sakata, owner of the San Francisco boutique Obiko, and a close friend of Salvador Dalí and his wife, Gala, for whom he created many elaborate costumes.

Dorian (Dohrn) Zachai (1932–2015)

Dorian Zachai earned a BA from the Rochester Institute of Technology and attended the California College of Arts and Crafts, Oakland, and Cooper Union School of Art, New York.

A pioneer of fiber sculpture, Zachai innovated the use of mixed media in weaving to create avant-garde three-dimensional forms and figures. Her *Woman Emancipated* (1960) was included in the groundbreaking 1963 exhibition *Woven Forms* at the Museum of Contemporary Crafts (now the Museum of Arts and Design), New York, which also showcased works by Lenore Tawney, Claire Zeisler, Sheila Hicks, and Alice Adams.

Zachai taught at the Vermont Studio Center, Johnson, which now offers the annual Dohrn Zachai Fellowship to a woman visual artist age sixty-five and up. She also taught at Boston University, the University Akron, Ohio, the University of Oregon, Corvallis, and was artist-in-residence at the Visual Art Center Alaska, Anchorage. She lectured extensively and conducted numerous workshops in the field of fiber art.

Zachai's works are in the collections of the Museum of Arts and Design, New York, and the American Craft Council Library and Archives.

Claire Zeisler (1903–1991)

Claire Zeisler studied at the Institute of Design at the Illinois Institute of Technology, Chicago, where she was taught by the Russian avant-garde sculptor Alexander Archipenko and the Chicago weaver Bea Swartchild.

Her early work in the 1950s used conventional weaving techniques. After being introduced to knotting at the New York studio of Lili Blumenau in the early 1960s, Zeisler's approach to fiber art became more innovative, combining traditional weaving with techniques such as square knotting, wrapping, and stitching to create three-dimensional works. She preferred natural materials such as jute, hemp, wool, and leather, and often left the textiles undyed.

Zeisler has been been the subject of retrospective exhibitions at the Art Institute of Chicago and the Whitney Museum of American Art, New York. She also exhibited in many solo and group shows, including at the Museum of Contemporary Crafts, New York; the Stedelijk Museum, Amsterdam; the Denver Art Museum; the Cleveland Museum of Art; and the Philadelphia Museum of Art.

Her work is included in collections such as the First National Bank, Chicago; the First National Bank, Brussels; the Wisconsin Art Center, Milwaukee; the Art Institute of Chicago; the Stedelijk Museum, Amsterdam; and the Museum Bellerive, Zurich.

Zeisler won the Women's Caucus for Art Lifetime Achievement Award in 1982.

selected art-to-wear
exhibitions and events

1954

Ancient Art of the Andes, Museum of Modern Art (MoMA), New York

Museum of Contemporary Crafts (MCC) founded in New York

1957

Wall Hangings and Rugs, MCC

1959

Anni Albers: Pictorial Weavings, The New Gallery, Charles Hayden Memorial Library, Massachusetts Institute of Technology, Cambridge

1961

Art of Assemblage, MoMA

1962

First International Tapestry Biennial, Lausanne, Switzerland

1963

Woven Forms, MCC

1965

The Art of Personal Adornment, MCC

Fabric Collage, MCC

1966

Mimi Smith receives MA from Rutgers University for "Clothing as Form"

1967

Funk Art, University of California (UC) Berkeley Art Museum

People Figures, MCC

Stitching, MCC

Christo's *Wedding Dress* performance at the Museum of Merchandise, YM/YWHA, New York

Debra Rapoport receives MA from UC Berkeley for "Constructed Textiles Related to the Body"

1968

Body Covering, MCC

Clothing and Environment: Alwin Nikolais, MCC Little and Members Galleries

Jewelry: Arline Fisch, MCC Little and Members Galleries

Textiles: Katherine Westphal and Ed Rossbach, MCC Little and Members Galleries

1969

Earth Art, Andrew Dickson White Museum of Art, Cornell University, Ithaca, NY

Feel It, MCC

Objects: USA, The Johnson Collection of Contemporary Crafts, Smithsonian National Collection of Fine Arts, Washington, DC, and touring across the United States, ending at the MCC in 1972

Wall Hangings, MoMA

Handweavers Guild of America founded

Student strike at Pratt Institute, Brooklyn, results in redesign of art curriculum to focus on individual creativity

1970

Contemplation Environments, MCC

Face Coverings, MCC

First national observance of Earth Day, April 22

Inauguration of Feminist Art Program, Fresno State College, CA

1971

ACTS I, II, III: A Series of Participatory Exhibitions/Events for Total Involvement, MCC

Deliberate Entanglements: An Exhibition of Fiber Forms, UCLA Art Galleries, Los Angeles, and touring to four venues through September 1972; the UCLA exhibition

was accompanied by the conference Fiber as Medium

Furs & Feathers, MCC

Debra Rapoport wears *Fibrous Raiment with Conical Appendages* (1970) at the *Fifth International Tapestry Biennial*, Lausanne

1972

Fabric Vibrations, MCC

Robert Kushner and Friends Eat Their Clothes, Jack Glenn Gallery, Corona del Mar, CA, and Acme Productions, New York

Sculpture in Fiber, MCC

Womanhouse feminist art installation and performance organized by Judy Chicago and Miriam Schapiro in Hollywood, CA

Friends of the Rag founded in Seattle; the group consists of some forty fiber artists, fashion designers, and theater costumers

Obiko opened by Sandra Sakata on Sutter Street, San Francisco

Pacific Basin Center of Textile Arts (PBCTA) founded in Berkeley

1973

Cut My Cote, Royal Ontario Museum, Toronto

Dress Up! Make It, Wear It, Share It!, MCC

Fiberworks: An Exhibition of Works by Twenty Contemporary Fiber Artists, Lang Art Gallery, Scripps College, Claremont, CA

Portable World, MCC

Sewn, Stitched and Stuffed, MCC

Fiberworks Center for Textile Arts founded in Berkeley

Helen Drutt Gallery founded in Philadelphia

Julie: Artisans' Gallery founded in New York

Levi's Denim Art Contest attracts more than two thousand entries and results in a catalogue and traveling exhibition

1974

Baroque '74, MCC

Body Craft: Works of Art to Wear, Portland Art Museum, OR

Bodywear: Clothing as an Art Form, Oakland Museum, CA

Clothing to Be Seen, MCC

Crochet—A Group Show, PBCTA

Denim Art, MCC

Embody Art, Helen Drutt Gallery, Philadelphia

1975

Evelyn Roth—Wrap Up, Robert McLaughlin Gallery, Ottawa

Homage to the Bag, MCC

The Rainbow Show, M. H. de Young Memorial Museum, San Francisco, is accompanied by related events and gallery exhibitions throughout the Bay Area

Folkwear, founded by Barbara Garvey, Alexandra (Jacopetti) Hart, and Ann Wainwright in Forestville, CA, offers patterns from clothing collected by the women during their international travels

Kasuri Dyeworks co-founded by Yoshiko Wada in Berkeley

Robert Kushner's first performance of *The New York Hat Line*, The Clocktower, New York

Stephen Varble leads one-person "Costume Tours" of New York (1975–76)

1976

The Dyer's Art: Ikat, Batik and Plangi, MCC

Fiberarts magazine begins publishing

Surface Design Journal founded

1977

First Philadelphia Museum of Art Craft Show, organized by the museum's Women's Committee, presents a fashion show and exhibition of art to wear organized by Julie Schafler Dale

Fabric Workshop founded in Philadelphia

Folkwear's *The Art and Romance of Peasant Clothes*, featuring garments made from the company's patterns, tours coast to coast

1978

The Great American Foot, MCC

Friends of the Rag perform *Traveling Modes and Devices*, Renwick Gallery, Washington DC

Fiberworks symposium on Contemporary Textile Art, Oakland

1979

Art as Clothing, Spirit Crafts Gallery, Scottsdale, AZ

Art for Wearing, San Francisco Museum of Modern Art

Wearable Art, Ken Phillips Gallery, Denver

Museum of Contemporary Craft reopens as the American Craft Museum (ACM) on West Fifty-Third Street, New York

1980

Felting: Contemporary Work and Historical Precedent, ACM

Maximum Coverage: Wearable Art by Contemporary American Artists, Sheboygan Art Center, WI

Katherine Westphal, Dolph Gotelli, Debra Rapoport, and Jo Ann C. Stabb present a program on American Wearable Art at the World Craft Council Conference, Vienna

Obiko's first fashion show, *Tribute to Erté*, held at John Casablancas Modeling and Career Center, San Francisco

1982

Art Materialized: Selections from the Fabric Workshop, traveling exhibition organized by the Fabric Workshop, Philadelphia

Intimate Architecture: Contemporary Clothing Design, Hayden Gallery, Massachusetts Institute of Technology, Cambridge

1983

Art to Wear: New Handmade Clothing opens at ACM and travels to eight venues across the United States into 1985

Fiber, Fabric & Fashion: A Celebration and Record of Art, Couture and Fashion Excellence in the Bay Area, PBCTA (fashion show and book)

Julie: Artisans' Gallery Tenth Anniversary Exhibition, New York

Poetry for the Body / Clothing for the Spirit, Richmond Art Center, Richmond, CA

1984

Art to Wear: New American Handmade Clothing, organized by the US Information Agency, travels to Japan, Indonesia, Taiwan, and the Philippines

Clothes for the Collector, Detroit Gallery of Contemporary Crafts

1985

Art to Wear—Ten American Artists travels to the Craft Council Gallery, London

1985–86

Wearable Art from California, an educational video series produced at UC Davis by Jo Ann C. Stabb, is released through the University of California Extension Media Center and distributed by ACM and the US Information Agency's Arts America Program. The five thirty-minute programs feature Gaza Bowen, Jean Cacicedo, K. Lee Manuel, Katherine Westphal, and Ellen Hauptli and Candace Kling.

1986

Body Wraps: A Wearable Arts Exhibit, Redding Museum and Art Center, Redding, CA

Craft Today: Poetry of the Physical, ACM

Art to Wear by Julie Schafler Dale published by Abbeville Press

1987

Art to Wear, Cleveland Center for Contemporary Art

Conceptual Clothing, traveling exhibition in the United Kingdom, organized by Ikon Gallery, Birmingham

World of WearableArt (WOW) annual design competition and stage show established by Suzie Moncrieff in Nelson, New Zealand

1988
Finery, North Carolina State University, Raleigh

1989
Art Forms for the Body, Kurland/Summers Gallery, Los Angeles, and Los Angeles County Museum of Art

1990
Pat Olesko: Aloft Souls, ACM

1991
Group 9 founded in the Bay Area and exhibits at San Jose Art League Gallery; the group consists of Gaza Bowen, Jean Cacicedo, Marian Clayden, Marika Contompasis, Ana Lisa Hedstrom, K. Lee Manuel, Candace Kling, Ina Kozel, and Janet Lipkin

1992
First International Shibori Symposium, Nagoya, Japan

World Shibori Network founded by Kahei Takeda and Yoshiko Wada

1993
Empty Dress: Clothing as Surrogate in Art, Neuberger Museum of Art, Purchase, NY

Progressive Project, The Hand and Spirit Gallery, Phoenix

Julie: Artisans' Gallery celebrates twentieth anniversary

1994
Textile Center of Minnesota founded in Minneapolis

1995
The last *International Tapestry Biennial* is held in Lausanne

1996
The Kimono Inspiration: Art and Art-to-Wear in America, The Textile Museum, Washington, DC

1997
Fabric of Life: 150 Years of Northern California Fiber Art History, San Francisco State University Art Department Gallery

Sandra Sakata dies; Obiko closes

World Textile Art founded by Pilar Tobón

1998
Artwear: The Body Adorned, Berkeley Art Center, California

Julie: Artisans' Gallery moves to 762 Madison Avenue

2000
Asian Persuasian, Gayle Wilson Gallery, Southampton, NY

Jean Williams Cacicedo: Explorations in Cloth, Museum of Craft and Folk Art, San Francisco

2003
Julie: Artisans' Gallery celebrates thirtieth anniversary

2004–5
Fashion's Memory: From Peasant Art to Wearable Art, Environmental Design Gallery, UC Davis, and Lethaby Gallery, London

2005
Artwear: Fashion and Anti-fashion, M. H. de Young Memorial Museum, San Francisco

Kimono Variations, Museum of Arts and Design, New York

WOW moves to Wellington, New Zealand

2008
Marian Clayden, Museum of Quilts and Textiles, San Jose, CA

2010
Eco-Fashion: Going Green, Fashion Institute of Technology, New York

2011
Metamorphosis: Breathing New Life into Artefacts, Santa Fe Weaving Gallery, NM

2013
Julie: Artisans' Gallery closes

Obiko Archive published online through the Textile Arts Council, Fine Arts Museums of San Francisco

2014
Marian Clayden: A Dyer's Journey through Art and Fashion, UK traveling exhibition continuing into 2018

Metamorphosis: Clothing and Identity, San Jose Museum of Quilts and Textiles, CA

2015
Body as Agent: Changing Fashion Art, Richmond Art Center

2016
Counter-Couture: Fashioning Identity in the American Counterculture, Bellevue Arts Museum, WA

RAM Collects: Contemporary Art to Wear and *Contemporary Art to Wear, Sensory Overload: Clothing and the Body*, Racine Art Museum, WI

Utopia to Paradise? Anna VA Polesny, Contemporary Art at Historic Northampton, MA

2017
Wearable Expressions Seventh International Juried Exhibition, Palos Verdes Art Center, CA

selected bibliography

Aimone, Katherine Duncan. *The Fiberarts Book of Wearable Art*. New York: Lark, 2002.

Albers, Anni. *On Designing*. New Haven, CT: Pellango, 1959.

_____. *On Weaving*. Middletown, CT: Wesleyan University Press, 1965.

Albers, Josef. *Interaction of Color*. New Haven: Yale University Press, 1963.

American Craft Council. *Fabric Vibrations: Tie and Fold-dye Wall Hangings and Environments*. Exh. cat. New York: Museum of Contemporary Crafts, 1972.

American Craft Museum. *Art to Wear: New Handmade Clothing*. Exh. cat. New York: The Museum, 1983.

Araeen, Rasheed, et al. *Conceptual Clothing*. Exh. cat. Birmingham, UK: Ikon Gallery, 1986.

Archer, Sarah. "Levi's Denim Art Contest." *American Craft Inquiry* 2, no. 1 (June 2018): 70; available online at https://craftcouncil.org/post/levis-denim-art-contest.

Auther, Elissa. *String, Felt, Thread: The Hierarchy of Art and Craft in American Art*. Minneapolis: University of Minnesota Press, 2010.

Barron, Stephanie, Sheri Bernstein, and Ilene Susan Fort. *Made in California: Art, Image, and Identity, 1900–2000*. Berkeley: University of California Press, 2000.

Beagle, Peter S. *American Denim: A New Folk Art*. New York: Abrams, 1975.

Bhatia, Gauri. "Profile: Linda Mendelson." *Macknit* (Fall–Winter 1985): 22–24.

Bourgeois, Louise. "The Fabric of Construction." *Craft Horizons* 29, no. 2 (March–April 1969): 31–35.

Bradley, S. *Wearable Expressions: The Sixth Biennial International Exhibition of the Ultimate in Wearable Art*. Exh. cat. Rolling Hills Estates, CA: Palos Verdes Art Center, 2008.

Brooks-Myers, Inez. *Body as Agent: Changing Fashion Art*. Exh. cat. Richmond, CA: Richmond Art Center, 2015.

Bryan-Wilson, Julia. "Handmade Genders: Queer Costuming in San Francisco circa 1970." In *West of Center: Art and the Counterculture Experiment in America, 1965–1977*, edited by Elissa Auther and Adam Lerner, 77–92. Minneapolis: University of Minnesota Press, 2012.

Bullis, Douglas. "'Colors Have a Life of Their Own': Janet Lipkin's Clothing." *Ornament* 12, no. 3 (1989): 53–57.

_____. "Sandra Sakata: A Generous Spirit." *Ornament* 15, no. 4 (1992): 65, 83.

Burnham, Dorothy K. *Cut My Cote*. Exh. cat. Toronto: Royal Ontario Museum, 1973.

Constantine, Mildred, and Jack Lenor Larsen. *The Art Fabric: Mainstream*. New York: Van Nostrand Reinhold, 1981.

_____. *Beyond Craft: The Art Fabric*. New York: Van Nostrand Reinhold, 1973.

Cotton, Giselle Eberhard, and Magali Junet. *From Tapestry to Fiber Art: The Lausanne Biennials, 1962–1995*. Milan: Skira; Lausanne: Fondation Toms Pauli, 2017.

Dale, Julie Schafler. *Art to Wear*. New York: Abbeville, 1986.

D'Alessandro, Jill, and Colleen Terry, eds. *Summer of Love: Art Fashion and Rock and Roll*. Exh. cat. Berkeley: University of California Press in association with Fine Arts Museums of San Francisco, 2017.

Darwall, Randall. "Color Conversations." *Handwoven* (March/April 2000): 82–85.

De Ruyter, Martin, et al. *Off the Wall: The World of Wearable Art*, 3rd ed. Nelson, NZ: Craig Potton, 2011.

d'Harcourt, Raoul. *Textiles of Ancient Peru and Their Techniques*. Edited by Grace G. Denny and Carolyn M. Osborne. Translated by Sadie Brown. Seattle: University of Washington Press, 1962.

Edson, Nicki Hitz, and Arlene Stimmel. *Creative Crochet*. New York: Watson-Guptill, 1973.

Feldman, Del Pitt. *Crochet: Discovery and Design*. Garden City, NY: Doubleday, 1972.

_____. *The Crocheter's Art: New Dimensions in Free-Form Crochet*. New York: Doubleday, 1974.

Felshin, Nina. "Clothing as Subject." *Art Journal* 54, no. 1 (Spring 1995): 20.

_____. *Empty Dress: Clothing as Surrogate in Recent Art*. Exh. cat. New York: Independent Curators International, 1993.

Fisch, Arline. *Textile Techniques in Metal for Jewelers, Sculptors, and Textile Artists*. New York: Van Nostrand Reinhold, 1975.

Friedland, Shirley, and Leslie A. Piña. *Wearable Art, 1900–2000*. Atglen, PA: Schiffer, 1999.

Goldberg, Jo Ann. "With a Wizard's Hand: Linda Mendelson." *Ornament* 11, no. 2 (1987): 43–47.

Hart, Alexandra Jacopetti. *Native Funk and Flash: An Emerging Folk Art*. 1974; reprint, Bloomington, IN: Trafford, 2013.

Harvey, Virginia I. *Macramé: The Art of Creative Knotting*. New York: Van Nostrand Reinhold, 1967.

Hauptli, Ellen. "Asian Ideas." *American Craft* (February/March 2000): 84–87, 96.

Itten, Johannes. *The Art of Color: The Subjective Experience and Objective Rationale of Color*. Translated by Ernst van Haagen. New York: Reinhold, 1967.

John Michael Kohler Art Center. *Maximum Coverage: Wearables by Contemporary American Artists*. Exh. cat. Sheboygan, WI: The Center, 1980.

Kushner, Robert, and Ed Friedman. *The New York Hat Line*. Video. Public Access Poetry, September 15, 1977, http://writing.upenn.edu/pennsound/x/PAP-2.php.

Larsen, Jack Lenor. *The Dyer's Art: Ikat, Batik, Plangi*. New York: Van Nostrand Reinhold, 1976.

Leventon, Melissa. *Artwear: Fashion and Anti-fashion*. Exh. cat. New York: Thames and Hudson in association with Fine Arts Museums of San Francisco, 2005.

Levi Strauss and Company. *Levi's Denim Art Contest: Catalog of Winners*. Mill Valley, CA: B. Wolman / Squarebooks, 1974.

Levine, Betsy. "A Passion for Elegance: Master Dyer Marian Clayden Creates Clothing by Listening to the Fabric." *Threads*, no. 14 (December/January 1987–88): 36–41.

Lewis, Susanna E., and Julia Weissman. *A Machine Knitter's Guide to Creating Fabrics*. Asheville, NC: Lark, 1986.

Lippard, Lucy. "Sweeping Exchanges: The Contribution of Feminism to the Art of the 1970s." *Art Journal* 40, nos. 1–2 (Fall–Winter 1980): 362–65.

Malarcher, Patricia. "Diana Prekup's Wearable Webs." *Surface Design Journal* (Spring 2011): 30–33.

Mancuso, Jo. "Janet Lipkin: West Coast Innovator." *Macknit* (Summer 1987): 70.

Mendelson, Linda, and Mark Dittrick. *Creative Machine Knitting*. New York: Dutton, 1979.

Museum of Contemporary Crafts. *Fabric Collage: Contemporary Hangings, American Quilts, San Blas Appliqués*. Exh. cat. New York: Museum of Contemporary Crafts of the American Craftsmen's Council, 1965.

Nordness, Lee. *Objects: USA*. Exh. cat. New York: Viking, 1970.

Oakland Museum. *Bodywear: Clothing as an Art Form*. Exh. cat. Oakland: The Museum, 1974.

Obiko Archive, Textile Arts Council, San Francisco Museum of Modern Art, 2013, https://www.textileartscouncil.org/obiko-archive/.

Pierre, Clara. *Looking Good: The Liberation of Fashion*. New York: Reader's Digest Press, 1976.

Quigley, Michael A. *Art Materialized: Selections from the Fabric Workshop*. Exh. cat. New York: Independent Curators, 1982.

Rapoport, Debra Ellen. "Constructed Textiles Related to the Body." Master's thesis, University of California, Berkeley, 1969.

Rowe, Ann Pollard, and Rebecca A. T. Stevens. *Ed Rossbach: 40 Years of Exploration and Innovation in Fiber Art*. Exh. cat. Asheville, NC: Lark Books; Washington, DC: The Textile Museum, 1990.

Santiago, Chiori. "Sandra Sakata: Transcending Gravity." *Ornament* 21, no. 3 (1998): 42.

Schoeser, Mary. *Textiles: The Art of Mankind*. London: Thames and Hudson, 2012.

Schulman, Bruce J. *The Seventies: The Great Shift in American Culture, Society, and Politics*. New York: Da Capo, 2002.

Sheppard, Eugenia. "The Big Costume Party." *Harper's Bazaar* (October 1970): 204.

Stabb, Jo Ann C. "A Time of Renewal: Update on Wearable Art." *Surface Design Journal* (Summer 1994): 8–13.

_____. "Tracking the Art-to-Wear Spirit in the 21st Century." *Surface Design Journal* (Spring 2012): 8–13.

Stabb, Jo Ann C. (producer). *Wearable Art from California: Candace Kling and Ellen Hauptli*. Video. Davis: University of California Extension Media Center, 1985; available online at https://youtu.be/3_FJosZDQAA.

_____. *Wearable Art from California: Gaza Bowen*. Video. Davis: University of California Extension Media Center, 1985; available online at https://youtu.be/w7wc7wKXwJk.

_____. *Wearable Art from California: Jean Cacicedo*. Video. Davis: University of California Extension Media Center, 1986; available online at https://youtu.be/2DJtZZ9fh50.

_____. *Wearable Art from California: K. Lee Manuel*. Video. Davis: University of California Extension Media Center, 1986; available online at https://youtu.be/5a83klw7ino.

_____. *Wearable Art from California: Katherine Westphal*. Video. Davis: University of California Extension Media Center, 1986; available online at https://youtu.be/VbQrBnXn4uo.

Stabb, Jo Ann, et al. *Poetry for the Body, Clothing for the Spirit*. Exh. cat. Richmond, CA: Richmond Art Center, 1983.

Steele, Valerie. *Fifty Years of Fashion: New Look to Now*. New Haven: Yale University Press, 1997.

Stevens, Rebecca A. T., and Yoshiko Iwamoto Wada, eds. *The Kimono Inspiration: Art and Art-to-Wear in America*. Exh. cat. Washington, DC: Textile Museum; San Francisco: Pomegranate, 1996.

Tilke, Max. *Costume Patterns and Designs: A Survey of Costume Patterns and Designs of All Periods and Nations from Antiquity to Modern Times*. New York: Hastings House, 1974.

Turner, Bryan S. *The Body and Society: Explorations in Social Theory*. Oxford: Basil Blackwell, 1984.

Ulrich, Polly. "Beyond Touch: The Body as Conceptual Tool." *Fiberarts* (Summer 1999): 43–44.

Wada, Yoshiko Iwamoto. *Memory on Cloth—Shibori Now*. Bunkyō, Tokyo: Kodansha International, 2002.

"The Wearable Art of Kaisik Wong," *Golden Haze*, May 10 2012, available online at http://goldenhaze.blogspot.com/2012/05/wearable-art-of-kaisik-wong.html.

Willcox, Donald J. *Body Jewelry: International Perspectives*. Chicago: Henry Regnery, 1973.

Witcover, Jules. *The Year the Dream Died: Revisiting 1968 in America*. New York: Warner, 1997.

index of names and works

206

acknowledgments

This book and the accompanying exhibition would not have been possible without Julie Schafler Dale's promised gift to the Philadelphia Museum of Art of the finest examples of American art to wear. I met Julie more than ten years ago through her friend Harrie George Schloss, and since then the three of us have engaged in lively, provocative, and passionate discussions about the American art-to-wear movement, including a day with Paul J. Smith, former director of the Museum of Contemporary Crafts, today the Museum of Arts and Design, New York. Julie and Jim Dale's New York apartment was the perfect setting for these discussions, filled with stellar examples from Britain's Aesthetic and Arts and Crafts movements. Each work in Julie's art-to-wear collection told an intriguing and often very personal story and together with her gallery archives provided more than enough material for many future exhibitions.

We would also like to thank the Women's Committee of the Philadelphia Museum of Art, which in 1977 had the foresight to invite Julie to participate in its first Craft Show, where she mounted an installation of art to wear at Memorial Hall and presented a live runway show and lecture at the museum.

Books and exhibitions always depend on the generosity of others. I am especially grateful to my longtime friend, colleague, and co-author Mary Schoeser, whom I met in London while studying textile conservation at the Courtauld Institute of Art. Mary was on a fellowship, and the two of us ended up sharing a flat in Islington when she enrolled at the Courtauld for an MA in the history of dress. Mary was the perfect choice for co-author and co-curator. A seasoned author of more than forty books and curator of numerous exhibitions on textiles past and present, she also studied under Jo Ann C. Stabb as an undergraduate at the University of California, Davis, the epicenter of textile and art-to-wear college programs on the West Coast. Jo Ann generously shared her considerable knowledge of the movement and also acted as Mary's host and facilitator during research visits to the West Coast, making an immeasurable contribution that is much appreciated.

I am extremely proud to be able to present the work of so many artists in the exhibition and extend my sincere gratitude to those who graciously answered repeated questions about their practice and even uncovered examples from their college years to further our understanding. My heartfelt thanks to the following artists: James Bassler, Gaza Bowen, Jean Williams Cacicedo, Roger Clayden for Marian Clayden, Ben Compton, Judith Content, Marika Contompasis, Louise Todd Cope, Bill Cunningham, Nicki Hitz Edson, Sheila Perez Ghidini, Tim Harding, Ellen Hauptli, Sharron Hedges, Ana Lisa Hedstrom, Julia Hill, Marion Holmes, Nina Vivian Huryn, Joan Ann Jablow, Paul Johnson, Whitney Kent, Candace Kling, Fred Kling, Dina Knapp, Ina Kozel, Carolyn Kriegman, Robert Kushner, Susanna Lewis, Janet Lipkin, Mark Mahall, K. Lee Manuel, Linda J. Mendelson, Norma Minkowitz, Risë Nagin, Susan Nininger, Marilyn Pappas, J. Pearson, Jody Pinto, Anna VA Polesny, Debra Rapoport, Mario Rivoli, Ed Rossbach, Mary Ann Schildknecht, Marian Schoettle, Carol Lee Shanks, Billy Shire, Carter Smith, Raoul Spiegel, Jo Ann C. Stabb, Joan Steiner, Arlene Stimmel, Jamie Summers, Lenore Tawney, Ken Tisa, Jo-Ellen Trilling, Yoshiko Wada, Katherine Westphal, Kaisik Wong, Dorian Zachai, and Claire Zeisler. I also extend my thanks to the following individuals who enthusiastically shared family information: Astra Dorf for Dina Knapp, and Peggie MacLeod for K. Lee Manuel.

I am also deeply grateful to the many private collectors who early on acquired works from the art-to-wear movement and have generously shared them with us for this exhibition: Harriet Abroms, Roger Clayden, Julie Schafler Dale, Helen Drutt English, Daniel and Hilary Goldstine, Susan Zises Green, the Hollingsworth Family in memory of Susie Hollingsworth, Anne Byrne

Kronenfeld, Christine Carter Lynch, Richard E. Lynn, Peggie MacLeod, Mrs. Robert L. McNeil Jr., Constance Pathy, Philip Rickey, Joanna S. Rose, Harrie George Schloss, Jerri Sherman, Bonnie Ward Simon, Candice Goldfarb Simon, Henry Benning Spencer, Susan L. Stowens, and Acey Wolgin.

I am also indebted to colleagues at other museums and institutions for their generous help with research, loans, and photographs. I am especially grateful to the following individuals: at the American Craft Council Archives: Beth Goodrich; at the Art Institute of Chicago: Melinda Watt; at the Fine Arts Museums of San Francisco: Jill D'Alessandro, Laura Camerlengo, Anne Gett, and Sue Grinols; at the Jo Ann C. Stabb Design Collection, University of California, Davis: Adele Zhang; at the Metropolitan Museum of Art: Andrew Bolton and Elizabeth Schaefer; at the Mobile Museum of Art: Deborah Vedders and Rachel Young; at the Museum of Arts and Design, New York: Ellen Holdorf; and at the San Jose Museum of Quilts and Textiles: Nancy Bavor and Ashley Elieff.

This book required many cooks. My special thanks to members of the Costume and Textiles and Textile Conservation departments, particularly Cathy Coho, who tracked down artists, photographers, and permissions; Shen Shellenberger for the artists' biographies; Stephanie Feaster for managing the in-house photography and keeping us organized; Barbara Darlin; Kristina Haugland; textile conservators Sara Reiter and Bernice Morris; Mellon Fellow Kaelyn Garcia; and conservation technician Lisa Stockebrand. For the beautiful design of this catalogue, I am grateful to Barbara Glauber of Heavy Meta, New York. For the exhibition video, I thank Headhouse Media.

There are many people at the Philadelphia Museum of Art without whom this exhibition and catalogue would not have happened. I first wish to thank Timothy Rub, our director, and Alice Beamesderfer, our deputy director for collections and programs,

whose support and encouragement from the onset made this project possible. The following museum colleagues also deserve special mention: in Editorial and Graphic Design, Luis Bravo, Amy Hewitt, and Greta Skagerlind; in Education, Marla Shoemaker and Jenni Drozdek; in Exhibition Planning, Suzanne Wells; in the Photography Studio: Juan Arce, Joseph Hu, and Timothy Tiebout; in Publishing, Katie Reilly, David Updike, and Richard Bonk; in the Registrar's office, Wynne Kettel; and in Information and Interpretive Technologies, Ariel Schwartz and Steve Keever.

Dilys E. Blum
THE JACK M. AND ANNETTE Y. FRIEDLAND
SENIOR CURATOR OF COSTUME AND TEXTILES

Published on the occasion of the exhibition *Off the Wall: American Art to Wear*, November 8, 2019–May 17, 2020, Philadelphia Museum of Art

This exhibition was made possible by Julie Schafler Dale, PNC, The Coby Foundation, the Arlin and Neysa Adams Endowment Fund, Catherine and Laurence Altman, the Center for American Art at the Philadelphia Museum of Art, and other generous donors.

Credits as of August 1, 2019

Produced by the Publishing Department
Philadelphia Museum of Art
Katie Reilly, The William T. Ranney Director of Publishing
2525 Pennsylvania Avenue
Philadelphia, PA 19130-2440
philamuseum.org

Published in association with
Yale University Press
302 Temple Street
P.O. Box 209040
New Haven, CT 06520-9040
yalebooks.com/art

Edited by David Updike
Production by Richard Bonk
Designed by Barbara Glauber and Taylor Woods, Heavy Meta, New York
Color separations, printing, and binding by Conti Tipocolor, Florence, Italy

FRONT COVER: Susanna Lewis, *Off We Go into the Wild Blue Yonder*, 1977 (see fig. 40). Photo by Otto Stupakoff © Julie Schafler Dale
BACK COVER: Anna VA Polesny, *International Levi's*, 1973 (see fig. 58). Photo by Otto Stupakoff © Julie Schafler Dale
PAGE II: Carolyn Kriegman, *Plexi Pectoral*, c. 1971 (see fig. 68)
PAGE VIII: Detail of K. Lee Manuel, *Maat's Collar*, 1990 (see fig. 102)
PAGE 6: Detail of Dina Knapp, *See It Like a Native: History Kimono #1*, 1982 (see fig. 28)
PAGE 42: Detail of Mario Rivoli, *Overdone Jacket*, 1973 (see fig. 78)
PAGE 78: Detail of Carter Smith, *"Amazon Jungle" Scarf Coat*, c. 2001 (see fig. 128)
PAGE 104: Detail of Linda J. Mendelson, *Big Red*, 1995 (see fig. 167)
PAGE 140: Detail of Diane Prekup, *Stained Glass Opera Coat*, 2013 (see fig. 185)

Every attempt has been made to locate the copyright holders of the works reproduced herein. Any omission is unintentional.

ISBN 978-0-87633-291-7

LIBRARY OF CONGRESS
CATALOGING-IN-PUBLICATION DATA
Names: Blum, Dilys, 1947– editor. | Schoeser, Mary, author. | Dale, Julie Schafler, author. | Philadelphia Museum of Art, organizer, host institution.
Title: Off the wall : American art to wear / edited by Dilys E. Blum; essays by Dilys E. Blum and Mary Schoeser; a contribution by Julie Schafler Dale.
Other titles: Off the wall (Philadelphia Museum of Art)
Description: Philadelphia, PA : Philadelphia Museum of Art, [2019] | "Published on the occasion of the exhibition Off the Wall: American Art to Wear, November 8, 2019–May 17, 2020, Philadelphia Museum of Art." | Includes bibliographical references and index. |
Identifiers: LCCN 2019026858 | ISBN 9780876332917 (hardback)
Subjects: LCSH: Wearable art—United States—Exhibitions.
Classification: LCC NK4860.5.U6 O34 2019 | DDC 746.9/2—dc23
LC record available at https://lccn.loc.gov/2019026858

PHOTOGRAPHY CREDITS

Philadelphia Museum of Art photography by Joseph Hu, Juan Arce, and Tim Tiebout

Photographs by Otto Stupakoff © Julie Schafler Dale: front and back cover; figs. 18, 22, 25, 26, 31, 32, 36, 37, 40, 42, 43, 55, 57, 58, 61, 75, 80, 96–98, 101, 104, 110, 125, 134, 136, 137, 141, 142, 144–46, 149–52, 156–58, 160, 161, 163, 212, 217, 218

Other photographs courtesy of the owners and/or the following: © The Steven Arnold Museum and Archives: fig. 89; Art Resource, New York, image copyright © The Metropolitan Museum of Art: fig. 190; Carlos Avendaño: fig. 176; John Bagley: fig. 64; Roger Clayden: fig. 189; James Dewrance: figs. 117, 207; John R. Glembin: fig. 17; © Tim Harding Studio: fig. 208; Kim Harrington: fig. 202; Sam Haskins © 2019, All Rights Reserved, The Sam Haskins Estate: fig. 139; Elaine Keenan: figs. 118, 123, 129, 188, 191; Demetre Lagios: figs. 10, 12; David E. Leach: fig. 100; Roseanne Lynch, CIT Crawford College of Art and Design, Cork, Ireland: fig. 196; Barbara Molloy © UC Regents: fig. 203; Musée de l'Elysée, Lausanne: fig. 16; Digital image © The Museum of Modern Art: fig. 76; Andrew Neuhart: fig. 9; Elizabeth Opalenik: fig. 119; Barry Shapiro: figs. 105, 120, 122; Don Tuttle: figs. 184, 209; Kevin Wright: fig. 206